A Heritage Collection Gift

from the

Friends of the
Santa Ana Public Library

Latin American Women Artists, Kahlo and Look Who Else

Latin American Women Artists, Kahlo and Look Who Else

A Selective, Annotated Bibliography

CECILIA PUERTO
Foreword by Elizabeth Ferrer

GREENWOOD PRESS
Westport, Connecticut • London

Library of Congress Cataloging-in-Publication Data

Puerto, Cecilia.
 Latin American women artists, Kahlo and look who else : a selective,
annotated bibliography / Cecilia Puerto ; foreword by Elizabeth Ferrer.
 p. cm.—(Art reference collection, ISSN 0193–6867 ; no. 21)
 Includes index.
 ISBN 0-313-28934-4 (alk. paper)
 1. Women artists—Latin America—Bibliography. 2. Art, Latin
American—Bibliography. 3. Art, Modern—20th century—Latin
America—Bibliography. I. Title. II. Series.
Z7963.A75P84 1996
[N6502.5]
016.7'092'28—dc20 96–7150

British Library Cataloguing in Publication Data is available.

Library of Congress Catalog Card Number: 96–7150
ISBN: 0-313-28934-4
ISSN: 0193–6867

First published in 1996

Greenwood Press, 88 Post Road West, Westport, CT 06881
An imprint of Greenwood Publishing Group, Inc.

Printed in the United States of America

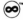

The paper used in this book complies with the
Permanent Paper Standard issued by the National
Information Standards Organization (Z39.48–1984).

10 9 8 7 6 5 4 3

To my parents, Margarita and Oliverio,
for their faith in me
and my children, Isabel, Germán, and Pilar,
who hold the promise of the future

Contents

Photo essay follows page xiv

Foreword

International interest in the art of Latin America has ebbed and flowed in this century, seen, most notably, in the renown attained by the Mexican muralists in the 1930s, as well as in the widespread success that members of a generation of abstract artists from such countries as Venezuela and Colombia achieved in the 1960s. In the last decade, however, the field has witnessed unprecedented growth, whether measured by the numerous traveling exhibitions organized by major museums in the United States and Europe; the much greater attention directed to leading young artists by critics, curators, and collectors; and finally, by the impressive increase in serious scholarship. The recent attention accorded the art of the Americas accompanies a radical shift in perspective that has taken place in the United States since the 1980s; increasingly, we realize that in order to effectively negotiate within a global society, we must be much more cognizant of the cultures of other parts of the world.

Prior to this era of multiculturalism, as it has come to be known, the student of Latin American art typically struggled to obtain adequate information on all but a handful of artists and movements. Sources were few and unreliable, and oftentimes, texts on artists who were well known in their own countries were not to be found in academic or public libraries. Today, this situation has fundamentally changed, especially as a result of the spate of influential exhibitions that were seen by large audiences in the United States and Europe in the last decade. This new-found public attention to the field has developed hand-in-hand with a manifold increase in exhibition catalogues, articles in specialized journals, monographic studies, and volumes that document the collective work of artists based on their nationality, generation, or the movements with which they are affiliated. If the researcher's task remains a difficult one, it is today due to the abundance, rather than paucity of available resources.

This annotated bibliography on twentieth-century women artists is particularly welcome at this time precisely because of the depth and breadth of the new scholarship. By gathering such information, whether published in the United States or abroad, Cecilia Puerto provides valuable and much-needed assistance to

the researcher. Moreover, this volume is a unique contribution to Latin American studies because it underscores the essential role that women have played in the arenas of modern and contemporary art. The Mexican painter Frida Kahlo has certainly become the best known figure in this field, but she is only one of many women who left deep imprints on the cultural landscapes of their countries earlier this century. In several nations, women artists were pioneers in the articulation of modernist idioms. The oeuvres of the Cuban Amelia Pelaez, the Bolivian Maria Luisa Pacheco, and the Brazilian Tarsila do Amaral, for example, have yet to receive the level of recognition that they so deeply merit. While this bibliography references these and other leading figures, it also contains information on lesser-known historic and contemporary artists in Latin America who deserve study and increased exposure. In introducing new subjects to the reader, this work may help to initiate a new phase of art-historical scholarship, one that may ultimately provide an even richer, more complete, and more accurate understanding of visual arts in the Americas.

Elizabeth Ferrer
Head of the Visual Arts Department and Curator of the Art Gallery
Americas Society, New York
December 1995

Preface

My purpose in compiling this bibliography is to raise awareness about the rich and extraordinarily diverse contributions which 20th century women artists in and from Latin America have made to the world of art. The published record of their achievements -- monographs, exhibition catalogues, critical reviews, periodical articles -- is numerous and far flung, making research on the subject complex and time-consuming. More importantly, the lack of a bibliographic tool to harness this body of literature has contributed to the relative invisibility of many of these artists and their work to all but the scholars who are actively engaged in promoting an awareness of women's accomplishments in this arena.

The idea for the work came in 1991 when I realized that persons wanting to find information on women artists from the region had almost no where to turn to for reference. The actual motivation arose out of my work as reference librarian and Latin American Studies bibliographer which made me keenly aware of several things regarding the nature of research on the topic, not only from the standpoint of the question asked but also the type and amount of resources that are available to support the answer. At the top of the list is the Frida Kahlo phenomenon which for some time has driven both the research and the question to the point of almost overshadowing the accomplishments of other women in the region. The sustained interest in Frida has not been entirely unfavorable, however, gradually turning the tide of recognition for other artists revered in their own countries, but virtually unknown in the U.S. At the same time it has helped to jettison attention on a new generation of women whose work will necessarily continue to undergo a process of evaluation before joining the ranks of the most favored.

Who are these women? What are their contributions? Eager to find the answers for myself I embarked on a journey of exploration which yielded wondrous discoveries that I record in this bibliography. It is my hope that those questing for answers to these questions will find direction within these pages, a beginning on which to build our knowledge about this important group of women.

Following the tradition of the *Handbook of Latin American Studies* I have elected to define Latin America geographically. Therefore, in addition to references to artists from Mexico, Central and South America, I have cited works on women from the Caribbean, including the West Indies. Guided by my "discoveries," I include artists active in painting, drawing, printmaking, sculpture, photography, mixed media, installation and performance art, as well as tapestry if the works are considered within the scope of fine arts rather than folk art. Although the majority of artists I "encountered" were born during the 1900s I have also included a few artists born during the late 1800s who produced work during the first quarter of the 20th century. The publication date of cited materials extends through 1994, with one significant exception -- the catalogue for the touring exhibition, "Latin American Women Artists, 1915-1995," representing as it does an important milestone for Latin American women artists in general and the capstone of the research which I began four years ago.

I consider books, periodicals, exhibition catalogues, dissertations, theses, and videorecordings. With the exception of a few in-depth newspaper articles I did not consider newspapers as a source in this bibliography. I found that newspaper reviews were often cursory, as well as difficult to find because they are frequently published in regional editions. I also did not include references to book reviews or index standard national art histories due to space limitations. Finally, in order to avoid duplicating information found in Annick Sanjurjo's work, *Contemporary Latin American Artists: Exhibitions at the Organization of American States 1965-1985,* I have not listed catalogues of OAS exhibitions presented prior to 1986. This compilation which was published in 1993 reproduces the entire text of the catalogues of exhibitions presented at the OAS Museum of Modern Art of Latin America for the time period cited in the title and provides information on close to 300 women.

In a perfect world all references to artists would be grouped together by country under specific artist headings for easy browsing of materials. Such an arrangement would result in duplication of entries, however, especially in the case of collective exhibition catalogues or books dealing with numerous artists. Add to this the fact that in the materials which I found many artists are mentioned only within the context of one group exhibition or article and the issue of multiple entries is compounded. To resolve this difficulty I opted for the following compromise. The Individual Artists section contains references to materials that with a few exceptions deal with a single artist. The General Works section contains references to books devoted in their entirety to women or periodical articles that identify numerous artists. Appendix I lists and analyzes selected collective exhibitions of Latin American art presented in a variety of venues -- many of them major, some of them exclusively dedicated to women. Appendix II groups all of the artists referenced in the bibliography by country. Users are advised to consult the Name Index to ensure that they locate all the information included in this bibliography on a specific artist.

Artists in the Individual Artists section are presented A-Z within an alphabetical country arrangement with a typical entry including name, birth and (if applicable) death date, the place of birth, and the artistic medium(s) if readily apparent in the analyzed publications. Occasionally I found variant birth or death dates which I was unable to verify and I have flagged these with a question mark. One difficulty encountered in the arrangement of the book was the issue of national origin for women born in one country but who identify, or identified, strongly with another. When I was able to determine an artist's unequivocal tie to a specific country I listed her under her "adoptive" country with a notation of her country of birth in the entry in the Individual Artists section. Only one artist, María Teresa Rizzi, referred to as Argentine Colombian by the critic, received a dual listing because I was unable to reconcile these differences from the material in hand. Formats are interfiled alphabetically within each artist's section except in the case of Frida Kahlo and Tina Modotti. References to these artists have been grouped by category of publication in order to make for easier finding of materials.

Although I have analyzed a few books for general content, my annotations are limited principally to periodical articles and only those which I have been able to examine personally. These note, among other things, the presence of biographical details, statements by the artist, information about professional development, themes, and titled/untitled reproductions. Various items did not arrive through interlibrary loan in time for annotation or for inclusion and received only a listing of the bibliographic citation or were excluded.

Some of the materials I examined either were written in parallel translation or had an English-language summary. In my analysis of Spanish-language materials lacking an English translation or summary I freely translated material to convey the writer's intention. In those cases where I felt it was desirable to preserve the flavor or spirit of the writer's original Spanish-language phrase I have attempted to express it as closely as possible in English, enclosing the translation in quotes. I have made a special note in the citation or annotation when the materials contain text in English and/or other languages, noting in between brackets when a translation or summary is separately paginated.

The tension between including substantive materials and those which make passing reference to an artist or artists has not been insignificant, especially in the case of Central America and some of the Andean countries where the lack of material detracts from our knowledge of who, what, when, where and how. Also, emerging artists often go unnoticed because periodical indexes and abstracts do not routinely pick up exhibition reviews, an important source of information on these rising stars. As a result I decided to include most of what I found -- including collective articles, group essays and magazine reviews -- although all of the material is not of equal value.

Solitary endeavors carry with them restrictions. There is other documentation and literature published in the United States, Latin America, Europe and other parts of the world which because of its inaccessibility I was, unfortunately, unable to include in this bibliography. I welcome comments and suggestions as to how we might work collaboratively to fill in the gaps to achieve a more complete picture of Latin American women and their art.

Acknowledgments

I owe a debt of gratitude to various individuals who through their special efforts have knowingly and unknowingly helped to make this volume a reality.

To begin, I am grateful to various persons affiliated with California State University in Bakersfield for helping to get this project off the ground during my tenure at the CSUB Library. Special thanks go to Ray Geigle, Dean of the School of Arts and Sciences, and Steve Arvizu, former Dean of Graduate Studies and Research, for assisting me with travel funds during its exploratory phase, and to Rod Hersberger for granting me time to conduct research during its early stages.

My heartfelt thanks goes to the staff of the University of California at Santa Barbara Art Library for their assistance. Their extensive Art Exhibition Catalogue Collection was an invaluable resource and is the primary source of the exhibition catalogues listed here. I am especially indebted to Shifra M. Goldman, UCLA research associate, for making available her archives to me which yielded rare treasures. Her insight and comments were extremely helpful.

Thanks are due the Interlibrary Loan staffs of the Libraries at California State University in Bakersfield and San Diego State University for their enthusiastic assistance in obtaining materials throughout the life of the project and the Los Angeles County Museum of Art Library staff for providing copies of many of the requested items. Special thanks go to Joyce Green, Sylvia Curtis, and Jim Farned for their time, energy, intelligence, and encouragement.

I cannot thank enough the PC Systems staff at the SDSU Library, namely Keith Burt, Joel Avendano, Anna Marie Barkdoll, John Davison, Kelly Humbert and Corey Wilson for their gracious and never-ceasing assistance with computers and printers during the production of the manuscript. Without their incredible patience and good humor I would not have survived the preparation of this manuscript. This book also benefited from the institutional support granted to me in my present position at the San Diego State University Library and is also greatly appreciated.

Huge thanks go to my daughter Pilar who lovingly lightened the load by proofreading large segments of the manuscript. Last, but not least, the eager interest and care of Ron Oberstein, as always, sustained me and is infinitely appreciated.

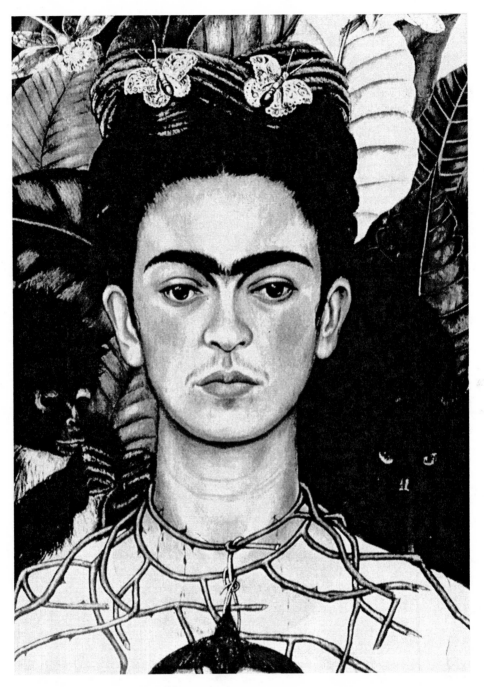

Frida Kahlo, Mexico. *Self-Portrait,* 1940 [with Thorn Necklace and Hummingbird.] Harry Ransom Humanities Research Center, The University of Texas at Austin.

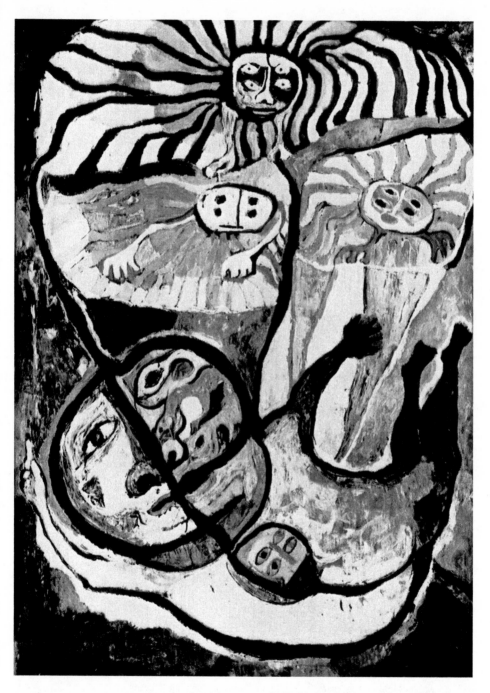

Raquel Forner, Argentina. *Return of the Astronaut*, 1969. National Air and Space Museum, Smithsonian Institution, Washington, D.C.

Ana Mercedes Hoyos, Colombia. *Bazurto*, 1991 (detail of triptych). Private Collection, Monterrey, Mexico.

Amelia Peláez, Cuba. *Hibiscus*, 1943. Art Museum of the Americas, Organization of American States (OAS), Washington, D.C.

Elba Damast. Venezuela. *The House Within*, 1994 (detail of installation)

THE BIBLIOGRAPHY

Individual Artists

ARGENTINA

Aro, Elizabeth, 1961- Buenos Aires Painting

1. Jiménez, Carlos. "Elizabeth Aro." *Art Nexus* 8 (Apr-June 1993): 127 [English trans., 195].
 Review of artist's paintings shown at Victor Martín Gallery in Madrid. Carlos Jiménez notes the influence on Aro's work of Uruguayan artist Joaquín Torres García, who fused pre-Columbian imagery in his art with elements of constructivism and abstraction. *Reproduction: "Sin título" (1992).*

Bessouet, Norma, 1947- Buenos Aires Painting

2. Chavarri, Raúl. "Notes sobre arte: Norma Bessouet y su apocalípsis solitario." *Cuadernos Hispanoamericanos* 346 (Apr 1979): 139-142.
 Raúl Chavarri considers artist's use of the solitary figure as dominant theme in her paintings, suggesting it symbolizes the despair which life in a spiritually alienated society engenders. Includes reproductions of two of Bessouet's works.

3. _____. "Soledad y misterio en la pintura de Norma Bessouet." *Cuadernos Hispanoamericanos* 311 (May 1976): 424-426.
 Considers themes of solitude and silence in artist's Madrid exhibition.

4. Garsd, Marta. "Hide-And-Seek: Looking for 'Woman' in the Work of Norma Bessouet.'" *Woman's Art Journal* 13.1 (Spring/Summer 1992): 29-33. Bibl.
 Marta Garsd profiles Bessouet's training and artistic career, including biographical material she gathered during interviews with the artist. Considers significance of artist's representation of the female body. *Reproductions: "Hide-and-Seek" (1973-1974), "Shadow" (1978), "Traveller, Heart of a Bird" (1983), "I Have of You Absolute Knowledge" (1987), "Cat's Cradle" (1987).*

5. *Norma Bessouet.* Catalogue. [Caracas, Venezuela: Museo de Bellas Artes, 1987]. Essay, John Stringer.

6. *Norma Besouet: Selvaggia and Uccello, 1983-1987.* Catalogue. [Boston, MA: Arden Gallery, 1989]. Text, Whitney Chadwick.

7. Windhausen, Rodolfo A. "Women Artists in Latin America." *Latin American Art* 5.1 (1993): 89 [Spanish trans., 117-118].
 An exhibition in New York's Americas Gallery gathered together works by eleven Latin American women painters exemplifying a variety of tendencies and

themes. In this review Rodolfo Windhausen briefly discusses the work of Norma Bessouet.

Borges, Norah Painting

8. Artundo, Patricia. *Norah Borges: obra gráfica, 1920-1930.* Buenos Aires, Argentina: Fondo Nacional de las Artes, 1994. Bibl.

9. Borges, Jorge Luis. "Norah." Trans. Alfred J. MacAdam. *Review: Latin American Literature and Arts* 39 (Jan-June 1988): 42-46.
 Text of prologue written by noted Argentine author to accompany edition of his sister's 1924 lithographs. Affectionate look which reveals biographical material and her artistic development.

10. Gómez de la Serna, Ramón. *Norah Borges.* Buenos Aires, Argentina: Editorial Losada, 1945. Bibl.

11. Nelson, Daniel Ernest. *Five Central Figures in Argentine Avant-Garde Art and Literature: Emilio Pettoruti, Xul Solar, Oliverio Girondo, Jorge Luis Borges, Norah Borges.* Bibl. Ph.D. Dissertation. University of Texas at Austin, 1989.

Burton, Mildred Painting

12. *Mildred Burton: sutilezas, pinturas.* Catalogue. [Buenos Aires, Argentina: Galería Rubbers, 1986]. Text, Jorge Glusberg. Includes chronology.

Creus, Alicia, 1939- La Plata Painting

13. *Beyond the Surface: Recent Works by Creus, Rabinovich, Sutil.* Catalogue. [New York, N.Y.: Americas Society Art Gallery, 1990]. Bibl. Includes chronology.

Cugat, Delia, 1930- Drawing/Painting/Printmaking

14. Escallón, Ana María. "Delia Cugat: La atmósfera de la condición humana." *Art Nexus* 9 (June-Aug 1993): 88-90 [English trans., 180-181].
 Ana María Escallón writes that Cugat's work "encompasses the solitary everyday world of Edward Hopper, the pictorial reflection of Balthus and the cubist idea of composition of Jacques Villon. . . She has her own world of meanings within herself and her work has already established itself as belonging to that of the Latin American greats." Remarks on the artist's experience as a set designer, noting the centrality of figuration and "urban landscape" in her pieces. Includes reproductions of three untitled works produced in 1984, 1987 and 1988.

15. Fevre, Fermin. *Cugat.* Buenos Aires, Argentina: Centro Editor de América Latina, 1982.

16. Godel, Ana, "Grupo Grabas: Delia Cugat, Sergio Camporeale, Pablo Obelar y Daniel Zelaya: en el paisaje de la comunicación." *Crisis* (Argentina) 2.15 (July 1974): 68-69.

17. *Grabas: Camporeale, Cugat, Obelar, Zelaya.* Catalogue. [Bogotá: Museo de Arte Moderno, 1974].

18. Sulic, Susana. "Delia Cugat." *Art Nexus* 4 (Apr 1992): 174-175 [English summary, 229-230].
 Review of artist's large-scale paintings shown at Galerie de Francony in Paris. Notes her affiliation with the Grabas group which "revolutionized the concept of graphic work," distinguishing her as an innovator in Latin American art. *Reproduction: "Demi-saison" (1990).*

D'Amico, Alicia, 1933- Buenos Aires Photography

19. Agosín, Marjorie. "Alicia D'Amico y el retrato hablado." *Las hacedoras: mujer, imagen, escritura.* Santiago, [Chile]: Editorial Cuarto Propio, [1993]. 231-238. Bibl.

20. D'Amico, Alicia and Sara Facio. *Geografía de Pablo Neruda con glossas autógrafas del poeta.* Barcelona, Spain: Ayma, [1973].

21. _____. *Humanario.* Buenos Aires, Argentina: La Azotea, 1976. [Text] by Julio Cortázar.

22. _____. *Retratos y autorretratos: escritores de América Latina.* Texts, Miguel Angel Asturias, et al. Buenos Aires, Argentina: Ediciones Crisis, [1973].

23. _____. *Sara Facio, Alicia D'Amico: fotografía argentina, 1960-1985.* Buenos Aires: Argentina: La Azotea, 1985. *Prologue, María Elena Walsh.*

24. Gimbernat-González, Ester. "Las fotografías de Alicia D'Amico: cambiando las reglas del juego." *Confluencia* 9.2 (Spring 1994): 3-4.
 Sketch of photographer who, Ester Gimbernat-González suggests, "changed the rules" of photography for women in Latin America. Includes D'Amico's portrait.

25. Jelin, Elizabeth. *Podría ser yo: los sectores populares urbanos en imagen y palabra.* Buenos Aires, Argentina: Cedes, Ediciones de la Flor, 1987. Photographs by Alicia D'Amico.

26. Kogan, Marcela. "A Process of Discovery." *Américas* 38.4 (Jul-Aug 1986): 2-7.
 Profile with numerous of D'Amico's direct statements that give insight into her background and reveal from the inside out, as it were, her approach to her subject matter and to her craft. She says, "We can never see the whole person.

Parts of people are always hidden from public view. . . Photography helps us see the many sides and the complexity of the human condition." Includes reproductions of various of her photographs.

Facio, Sara, 1932- San Isidro Photography

27. Facio, Sara and Alicia D'Amico. *Geografía de Pablo Neruda con glossas autógrafas del poeta.* Barcelona, Spain: Ayma, [1973].

28. _____. *Humanario.* Buenos Aires, Argentina: La Azotea, 1976. Text by Julio Cortázar.

29. _____. *Retratos y autorretratos: escritores de América Latina.* Texts, Miguel Angel Asturias, et al. Buenos Aires, Argentina: Ediciones Crisis, [1973].

30. _____. *Sara Facio, Alicia D'Amico: fotografía argentina, 1960-1985.* Buenos Aires, Argentina: La Azotea, 1985. *Prologue, María Elena Walsh.*

31. Facio, Sara and María Cristina Orive. *Actos de fé en Guatemala.* Photographs by Sara Facio and María Cristina Orive. Texts, Miguel Angel Asturias. Buenos Aires, Argentina: La Azotea, 1980.

32. Potenze, Jaime. *Sara Facio.* Buenos Aires, Argentina: Centro Editor de América Latina, 1982.

Fasce, Hilda Painting

33. Petrova, Tatiana. "'Sé que las aves enjauladas no cantan.'" *América Latina* (USSR) 3 (March 1991): 91-94.
 Essay based on interviews with the artist which considers the symbolism embodied in her recurring images of women. Includes personal statements by Fasce, as well as untitled reproductions of two of her paintings.

Forner, Raquel, 1902-1988 Buenos Aires Drawing/Painting/Printmaking

34. Alva Negri, Tomás. "Raquel Forner: Space Age Artist." *Américas* 24.9 (Sept 1972): 25-30.
 Considers artist's vision of the world and humankind in the themes she depicted in "Space" Series. Includes statements by Forner, as well as excerpts of criticism. Artist's portrait accompanies article. *Reproductions: "The Moons" (1957), "The Journey" (1959), "Men and Moon" (1959), "Satellite" (1958), "Moon" (1960), "Hybrid Being of the Year 3901" (1970), "Earth and Moon," "Astral and Terrestrial World in Mutation" (1971), "Mutant in Another Galaxy" (1971), "Space Monster with Televised Witnesses" (1970-1971).*

35. Barnitz, Jacqueline. "Five Women Artists." *Review : Latin American Literature and Arts* 75 (Spring 1975): 38-41.
 Writer suggests that 20th century Latin American women artists have gained more prominence than their North American counterparts and have forged ahead to become leaders in their respective fields. Raquel Forner is among the five women briefly profiled by Barnitz.

36. Collazo, Alberto. "Raquel Forner: Obituario." *Arte en Colombia* 38 (Dec 1988): 96.
 Brief homage to the artist on the occasion of her death. *Reproduction: "Custodio" (1986).*

37. _____. "Raquel Forner." *Arte en Colombia* 45 (Oct 1990): 107 [English summary, 166].
 Brief commentary on Buenos Aires exhibition honoring deceased artist. Show featured fourteen works by Forner dating from 1931 to 1986 which had women as their subject matter. *Reproduction: "Ser híbrido año 3900" from the series "Mutaciones espaciales" (1970).*

38. _____. "Raquel Forner." *Art Nexus* 10 (Sept-Dec 1993): 128 [English trans., 202].
 Brief review of "Series espaciales, 1957-1988" shown at Fundación Banco Patricios in Buenos Aires. Collazo remarks on the relationship of Forner's thematic concerns to events occurring in the real world. *Reproduction: "El profeta" (1986).*

39. Dorival, Geo. *Raquel Forner*. Buenos Aires, Argentina: Editorial Losada, [1942]. Bibl.

40. Medrano, Carmen. "Raquel Forner." *Todo es Historia* 25.298 (Apr 1992): 40-42.
 Biographical portrait of the artist with details of her background and education. Remarks on the influence which Forner's stay in Europe had on her development, her marriage with artist Alfredo Bigatti and the social context which inspired and defined her work. Includes portraits of the artist. *Reproduction: "Ni ver ni oir hablar" (1945).*

41. Merli, Juan. *Raquel Forner*. Buenos Aires, Argentina: Editorial Poseidon, [1952]. Bibl.

42. *Raquel Forner: Space Mythology = Mythologie Spatiale*. Catalogue. Washinton, D.C.: Corcoran Gallery of Art, [1974]. Bibl. French and English text.

43. *Raquel Forner: retrospectiva*. Catalogue. Buenos Aires, Argentina: Museo Nacional de Bellas Artes, [1983]. Bibl.

44. Romero Brest, Jorge. "Reportaje a Raquel Forner." *Crisis* 36 (Apr 1976): 75.
 Interview in which Forner reveals her attitude towards the creative process and the interrelatedness of her work to her inner life.

45. Rosell, Luisa, et al. *Forner*. Buenos Aires, Argentina: Centro Editor de América Latina, 1980.

46. Squirru, Rafael. "Raquel Forner." *Américas* 20.8 (Aug 1968): 6-12.
 Formal study analyzng artist's treatment of space, color and line. Explores the sense of immediacy and themes she expresses in her paintings. Includes artist's portrait, as well as reproductions of various of her works.

47. Whitelow, Guillermo. *Raquel Forner*. Buenos Aires, Argentina: Ediciones de Arte Gaglianone, 1980. Bibl. Text in English and Spanish.

48. _____. "Raquel Forner: Witness of Two Wars." *Art from Argentina: Argentina 1920-1994*. Ed. David Elliott. Oxford: The Museum of Modern Art, 1994. 50-53.

Grilo, Sarah, 1921- Buenos Aires Drawing/Painting

49. Barrett Stretch, Bonnie. "Six Latin American Women Artists." *Art News* 91 (Nov 1992): 138-139.
 Review of exhibition at Humphrey in New York which Bonnie Barrett Stretch notes "shattered any stereotypes of Latin art that a visitor may have had." Briefly comments on work of Sarah Grilo whom, she writes, was a "pioneer of Abstract Expressionism in Latin America."

50. *Sarah Grilo*. Catalogue. [Madrid, Spain: Museo Nacional de Arte Contemporáneo, 1985]. Bibl. Text, Damián Bayón. Includes chronology.

Helguera, María Painting

51. Bayón, Damián. "María Helguera en la Fundación Miró: 'Otoño en Manhattan.'" *Arte en Colombia* 25: 57 [English trans., 92].
 Considers artist's sketches of New York "real life scenes" shown at Fundación Miró in Barcelona, remarking that the artist "has broken the control of the 'conceptual' and has proven that art is a living thing."

Kohen, Natalia Painting/Printmaking

52. Chavarri, Raúl. "Teoría de los patios: una interpretación de la obra de la pintora argentina Natalia Kohen." *Cuadernos Hispanoamericanos* 351 (Sept 1979): 626-636.
 Detailed analysis of the patio as leitmotif in artist's works. Reproductions of various untitled works are included.

53. *Patios: Natalia Kohen, acuarelas.* Catalogue. Buenos Aires, Argentina: Ediciones del Retiro, 1981. Text, Jorge Luis Borges, Alberto Salas and Oscar Steimberg with critical commentary by Raúl Chavarri.

Madrid, Graciela, 1936- Buenos Aires Painting

54. *Graciela Madrid.* Catalogue. [México, D.F.: Polyforum Cultural Siqueiros, 1984]. Essay, Juan Cervera.

Malagrino, Silvia, 1950- Buenos Aires Photography

55. González, Miguel. "Silvia Malagrino." *Art Nexus* 9 (June-Aug 1993): 127-128 [English trans., 192-193].
 Miguel González considers the meaning of artist's pieces which were presented at the Museo de Arte Moderno La Tertulia in Cali, Colombia. Works incorporated a variety of mediums, including painting, photography and electronic manipulation. *Reproduction: From the exhibition "Llamados de la tierra."*

Marín, Matilde, 1948- Printmaking

56. Collazo, Alberto. "Matilde Marín." *Art Nexus* 10 (Sept-Dec 1993): 128 [English trans., 202].
 Collazo reviews a sampling of artist's work produced over a seven-year period which was shown at Fondo Nacional de las Artes in Buenos Aires. Comments on a variety of engraving techniques she utilizes to achieve her graphic images. *Reproduction: From the series "Fragmento del gesto inicial" (1992).*

Martínez, Cristina, 1938- Bahía Blanca Drawing

57. Bayón, Damián. "Las señales imperceptibles de Cristina Martínez." *Arte en Colombia* 25 [n.d.]: 55 [English summary, 92].
 In this review of artist's exhibition at Galerie des Femmes in Paris, Damián Bayón considers her innovative use of colored pencils to produce work whose "liberated line" is at once form and color. *Reproduction: "Crayones de colores" (1983).*

Martorell, María, 1919- Salta Painting

58. Whitelow, Guillermo. *María Martorell.* Buenos Aires, Argentina: Ediciones de Arte Gaglianone, 1990. Bibl.

Minujín, Marta, 1943- Buenos Aires Performance

59. Collazo, Alberto. "Alicia Peñalba and Marta Minujín." *Art Nexus* 12 (Apr-June 1994): 110-111 [English trans., 178-179].
 Review of artist's sculptures presented at Galería Rubbers, Buenos Aires. Major theme was concept of time.

60. Diehl, Jackson. "Artists Add Cultural Effervescence to Argentina's Political Renaissance." *Washington Post* 5 Jan 1984: sec A: 19.
 Commentary on "happening" staged by artist in Buenos Aires which, Diehl writes, was a "celebration of free expression and democratic values" and a new cultural climate for Argentina under the Raúl Alfonsín government.

61. Glusberg, Jorge. "Marta Minujín: Time and Space in Her Work." *Art from Argentina: Argentina 1920-1994.* Ed. David Elliott. Oxford: The Museum of Modern Art, 1994. 84-89.

62. *Marta Minujín: esculturas recientes.* Catalogue. [Cali, Colombia: Museo de Arte Moderno La Tertulia, 1984]. Essay, Jorge Glusberg. Includes chronology.

63. Minujín, Marta. "La torre de James Joyce empanizada = The James Joyce Tower in Bread." *Artes Visuales* 26 (Nov 1980): 53.

64. _____. "To Turn or the Art of Turning." *The Journal: Southern California Art Magazine* 25 (Nov-Dec 1979): 48-49.

65. Pau-Llosa, Ricardo. "A Convergence of Visual Cultures." *Art International* 6 (Spring 1989): 17-23.
 Ricardo Pau-Llosa examines how visual artists use tropes to create their images. Includes a discussion of Minujín's use of irony when she "dramatizes" the process of "dismantling and fragmenting" her sculptures (18, 20). *Reproductions: "The Panettone Obelisk" (1979), "Seeds for a Visual Combat" (1983).*

66. Squires, Richard. "Eat Me, Read Me, Burn Me: The Ephemeral Art of Marta Minujín." *Performance* (London) 64 (Summer 1991): 18-27.
 Squires writes, "Performing artists could learn a lot from the Argentinian artist Marta Minujín. . . it's surprising that her work is not better known." In this interview with the artist he allows us to experience up front and personal her inventiveness and verve. In irrepressible style Minujín informs, amuses, and flabbergasts with details of her elaborate projects. Includes the artist's portrait. *Reproductions: "Statue of Liberty in Radishes," "Panettone Obelisk" (1979), "Carlos Gardel in Flames" (1981).*

67. *Venus of Cheese.* Catalogue. [Buenos Aires, Argentina: Centro de Arte y Comunicación, 1981].

68. Zinzzer, William K. "The Total Weapon." *Look* 14 Nov 1967: 24.
 Imagine entering a telephone booth and making a phone call. At the sound of your voice you begin to have a strange multisensory experience that includes smoke, garish lights, glass walls that fill up with black liquid around you, a tape recording of your phone conversation and an echo of your voice, howling wind -- all this capped with the realization that you are standing on a TV image of your face! An example of one of Minujín's happenings, writes

Zinzzer, intended to "involve us in an experience where art and life are one. . . This is no genteel bid for aesthetic approval -- it is a blow straight to the nervous system."

Mora, Lola, 1867-1936 Sculpture

69. Correa, Elena. *Lola Mora*. Buenos Aires, Argentina: Centro Editor de América Latina, 1981.

70. Haedo, Oscar Felix. *Lola Mora: vida y obra de la primera escultora argentina*. Buenos Aires, Argentina: Eudeba, 1974.

71. Rosenzvaig, Eduardo. *La espalda de la libertad*. [Tucumán, Argentina]: Universidad Nacional de Tucumán, [1991].
Work of fiction.

72. Santoro, Liliana. *Lola Mora: una vida fascinante*. Buenos Aires, Argentina: Editorial Ameriberia, 1979. Bibl.

73. Soto, Moira. *Lola Mora*. Buenos Aires, Argentina: Planeta, 1991. Bibl.

Orensanz, Marie, 1936- Mar del Plata

74. Sulic, Susana. "Marie Orensanz." *Arte en Colombia* 45 (Oct 1990): 121 [English summary, 171].
 Marie Orensanz works in Carrara marble using techniques such as carving, painting, and design to produce objects which she defines as "unfinished" and "limitless." Susan Sulic writes that in these works "the marble -- a symbol of lasting duration -- becomes fragile, almost ethereal, with several interpretations being left to the discretion of the spectator." *Reproduction: "Tensión" (1990)*.

Peñalba, Alicia, 1918-1982 Buenos Aires Sculpture

75. *Alicia Peñalba*. Catalogue. [Leverkusen, Germany: Stadtisches Museum Leverkusen, 1964]. Bibl. Includes chronology and statements by the artist.

76. *Alicia Peñalba: Sculptures*. Catalogue. [Basel, Switzerland: Galerie d'Art Moderne, 1967]. Includes statements by the artist.

77. Alva Negri, Tomas. *Alicia Peñalba: o de la cadencia musical en la escultura*. Buenos Aires, Argentina: Ediciones de Arte Gaglianone, 1986. Bibl.

78. Collazo, Alberto. "Alicia Peñalba and Marta Minujin." *Art Nexus* 12 (Apr-June 1994): 110-111 [English trans., 178-179].
 Review of artist's sculptures presented at Galería Rubbers in Buenos Aires. Completed by the artist between 1953 and 1982 they are described by Collazo as "open and intensely dynamic."

79. *Cuatro escultores.* Catalogue. Madrid, Spain: Galería Aele, 1974.

80. González Bermejo, Ernesto. "Alicia Peñalba o la ambición del vuelo." *Crisis* (Argentina) 35 (Mar 1976): 66-69.
 Interview in which Peñalba reveals her thoughts on a variety of subjects, including her childhood, the significance of sculpture in her life, and the energy and vision driving her work. Contains some biographical information, as well as details of her education and development. Also includes Peñalba's portrait, facsimile reproductions of handwritten texts by Pablo Neruda, a chronology, and photographs of various of her sculptures.

81. *Peñalba.* Catalogue. [Zurich: Galerie Charles Lienhard, 1961]. Bibl. French, English and German text by Michel Seuphor. Includes chronology.

82. *Peñalba: Sculptures, 1960-1965.* Catalogue. [Paris, France: Creuzevault Gallery, 1965]. Bibl. Includes statements by the artist.

83. Seuphor, Michel. *Alicia Peñalba.* Amriswil: Bodensee-Verlag, 1960. Bibl. French, German and English text.

84. *Totems et tabous: Lam, Matta, Peñalba dans une installation improviseé par Pierre Faucheux.* Catalogue. [Paris, France: Musée d'Art Moderne de la Ville de Paris, 1968].

Piñeiro, Emma

85. Agosín, Marjorie. "Emma Alvarez Piñeiro: paisajes del hielo." *Las hacedoras: mujer, imagen, escritura.* Santiago, [Chile]: Editorial Cuarto Propio, [1993]. 253-258. Bibl.

86. Goodrow, Gérard A. "Emma Piñeiro." *Latin American Art* 4.4 (Winter 1992): 90-91.
 Artist exhibited a series of wooden boxes in New York's Arch Gallery containing objects and artifacts which comment on the Spanish domination that followed the arrival of Columbus to the Americas. In his review of the exhibit, Gérard Goodrow writes that "Emma Piñeiro's boxes are a cry for justice and recognition. . . [they] are wailing walls and memorials, but also treasure chests of wisdom and hope for the future." *Reproductions: "First Steps to Development," "Imposing a New God" (1991).*

87. *Emma Piñeiro: The Quincentennial, A Native View.* New York, NY: Arch Gallery, [1992]. Essays, Shifra M. Goldman and Daniela Montana.

Porter, Liliana, 1941- Buenos Aires Collage/Printmaking/Painting

88. Barrett Stretch, Bonnie. "Six Latin American Women Artists." *Art News* 91 (Nov 1992): 138-139.
Review of exhibition at Humphrey in New York which Bonnie Barrett Stretch notes "shattered any stereotypes of Latin art that a visitor may have had." Briefly comments on Liliana Porter's work, "The Traveler," describing it as the "showstopper" of the show.

89. Bazzano Nelson, Florencia. *Fragments of the Journey: The Art of Liliana Porter.* Bibl. Master's Thesis. University of Texas at Austin, 1989

90. Bergman-Carton, Janis. "Liliana Porter and Regina Vater: Upstairs/Downstairs and Through the Looking Glass." *Woman's Art Journal* 10 (Fall 1989-Winter 1990): 13-18. Bibl.
Janis Bergman-Carton analyzes several of artist's compositions, focusing on her technique for mixing media and superimposing found objects on her work to create painting or print-collages. Explores Alice in Wonderland themes and symbolism which recur in her images, extending the upstairs/downstairs metaphor to include a consideration of the differential treatment accorded art which does not meet established artistic conventions. About her style of Surrealism, author states that "she seeks neither to shock nor dislocate meaning. Her centralized pastiches of delicately tinted objects neither assault nor grab the viewer. In fact, they appear pale and dull on large walls, in photographs, and in slides. Her work requires a reciprocal attention as minute and expansive in possibility as that which the artist commits." Notes influence of Jorge Luis Borges on her work. Contains some biographical information and personal statements by the artist. *Reproductions: "The 16th of September" (1975), "Alice in Wonderland" (1985).*

91. Briante, Miguel. "Entre los espejos que se bifurcan." *Art Nexus* (May 1991): 50-51 [English trans., 138-139].
Miguel Briante explores significance of the artist's statement that "for a work to be what we call a work of art. . . it must generate an idea, perhaps another work." *Reproductions: "Los dos espejos" (1990), "Naturaleza muerta con ángel" (1988).*

92. Buccellato, Laura. *Porter.* Buenos Aires, Argentina: Centro Editor de América Latina, 1982. Bibl.

93. García Montiel, Emilio. "Algo más sobre Liliana Porter." *Casa de las Américas* 29.172-173 (Jan-Apr 1989): 115-121. Bibl.
Emilio García Montiel reviews an exhibition of Porter's work, focusing on the physical and spiritual forces which have impacted on her style. Notes the influence of Braque, Picasso and Jorge Luis Borges in her preference for juxtaposing illusion and reality in her images. Provides information about training, as well as reproductions of various of her works.

94. Kalenberg, Angel. "Liliana Porter: a las vueltas con la realidad." *Art Nexus* (May 1991): 48-50 [English trans., 137-138].

Critic considers various of Porter's works, developing the idea that her compositions "can be compared to the art of the magician, the conjuring up and conjuring away of the things which make up reality." *Reproductions: "El Ratón Mickey" (1990), "Reconstrucción con arte y objetos" (1989), "El 16 de septiembre de Magritte" (1975).*

95. *Liliana Porter.* Catalogue. [Cali, Colombia: Museo de Arte Moderno La Tertulia, 1983]. Includes chronology.

96. *Liliana Porter: Fragments of the Journey: February 20-May 10, 1992.* Catalogue. Bronx, NY: Bronx Museum of the Arts, [1992].

97. *Liliana Porter: obra gráfica 1964-1990: exposición homenaje : IX Bienal de San Juan del Grabado Latinoamericano y del Caribe en conmemoración del encuentro de dos mundos, del 2 de marzo al 28 de mayo de 1991.* Catalogue. San Juan, Puerto Rico: Instituto de Cultura Puertorriqueña, Comisión Puertorriqueña para la Celebración del Quinto Centenario del Descubrimiento de América y Puerto Rico, [1991]. Bibl. Includes biography and chronology.

98. Lippard, Lucy R. *Mixed Blessings: New Art in a Multicultural America.* New York, NY: Pantheon Books, 1990. 130. Bibl.

99. MacAdam, Alfred J. "Liliana Porter: 'Painterly Texts.'" *Review: Latin American Literature and Arts* 33 (Sept-Dec 1984): 83-85.

Review of exhibition at New York's Barbara Tell Gallery. Discusses artist's technique for placing real life objects side by side with their painted images, frequently in combination with literary allusion, to create the multimedia collages or "elegant works," as MacAdam describes them, which have earned for her international recognition. Includes artist's portrait. *Reproductions: "Still Life with Apple" (1983), "The Tear" (1982), "Paraphrase with Green Leaf" (1983).*

100. Rubinstein, Raphael. "Liliana Porter at Steinbaum Krauss." *Art in America* 82.2 (Feb 1994): 107.

Rubinstein describes two of Porter's compositions shown in New York gallery, calling attention to the variety of techniques she uses to create her images. Imagine one of the works, "Misunderstandings," which consists of "a steak knife stabbed into the canvas, an uside-down Minnie Mouse doll, manipulated photo-silk-screen images of a toy goose and a toy house, a ceramic rabbit (with a broken ear) sitting on a tiny shelf attached to the painting, a real hinge and padlock fastening the two panels, and a rear-view image of the bust of Saint Gregorio, whose black hat and jacket inevitably bring to mind Magritte." *Reproduction: "The Limit" (1993).*

101. Torruela Leval, Susana. "Liliana Porter." *Art Nexus* 5 (Aug 1992): 152-153 [English trans., 234-235].
Review of the "Fragments of a Journey" exhibition shown at the Bronx Museum of the Arts. "Porter's work exalts the value of the fragment. It suggests rather than describes, leaving the mystery of the world intact as it tries to capture it," writes Susana Torruela Leval. *Reproduction: "El simulacro," detail (1991).*

102. Urbach, Marina. "Liliana Porter." *Art Nexus* 10 (Sept-Dec 1993): 144 [English trans., 212-213].
Review of the artist's work exhibited in New York's Steinbaum Krauss Gallery in which Porter incorporates a variety of visual resources, including silkscreen, etching, photo transfer and objects to create the "multimedia constructions" which have become her trademark. *Reproduction: "The Limit" (1993).*

103. Windhausen, Rodolfo. "Voyages through Absence and Presence." *Américas* 44.4 (Jul-Aug 1992): 22-27.
Numerous comments by the artist bring to life this profile which traces her education and development. Her statement, "What I question in all my work is whether what we call real is more real than its image or its idea," pretty much sums up the focus of this engaging piece. Includes the artist's portrait. *Reproductions: "I Have Already Thought of It" (1991), "Untitled with Fire" (1989), "Magritte's 16th of September" (1976), "Correction V" (1991), "The Way" (1991), "The Two Mirrors" (1990).*

Presser, Elena, 1940- Collage/Assemblage

104. *Elena Presser: Bach's Goldberg Variations.* Catalogue. [New York, NY: Museum of Contemporary Hispanic Art, 1987]. Text, Nilda M. Peraza. Includes chronology.

105. *Elena Presser: Transpositions: From the Goldberg Variations and the Anna Magdalena Bach Notebooks.* Catalogue. [Philadelphia, PA: Moore College of Art Gallery, 1988]. Text, Rosalyn Tureck and Elsa Wiener Longhauser. Includes artist's statements and chronology.

Rabinovich, Raquel, 1929- Buenos Aires Painting/Sculpture

106. Barnitz, Jacqueline. "Raquel Rabinovich at Benson, Bridgehampton." *Arts Magazine* 45.1 (Sept 1970): 66.
Brief revew of artist's paintings which critic writes have "evolved from real but contemplative landscapes to totally spiritual ones through simplification and gradual elimination of texture without sacrifice to tonal liveliness."

107. *Beyond the Surface: Recent Works by Creus, Rabinovich, Sutil.* Catalogue. [New York, N.Y.: Americas Society Art Gallery, 1990]. Bibl. Includes chronology.

108. Collins, George R. "Raquel Rabinovich." *Arts Magazine* 57.5 (Feb 1983): 4.

George Collins describes one of the artist's pieces which was presented at the Center for Inter-American Relations, writing, "A fascinating aspect of the tinted sheet-glass sculptures of Raquel Rabinovich is their architectural and spatial quality." Direct statements by the artist give insight into her artistic intention, to "touch other aspects [of reality] which are hidden and not visible. . . " *Reproduction: "The Map is Not the Territory" (1982)*.

109. *Raquel Rabinovich: Invisible Cities, 1986, Sculpture and Drawings.* Catalogue. [Bronx, NY: Bronx Museum of the Arts, 1986]. Bibl. Text, Barry Schwabsky. Includes chronology.

Rizzi, María Teresa, 1957- Córdoba Painting

110. Windhausen, Rodolfo A. "María Teresa Rizzi." *Art Nexus* 6 (Oct 1992): 153-154 [English summary, 213].

Referring to this New York-based artist as Argentine-Colombian, Windhausen considers her abstract neo-expressionist oils on canvas which were presented at SoHo's Barnard Biderman Gallery. Notes her "intelligent use of color" and "skillful handling of form." *Reproduction: "Mai di luna" (1991)*

Robirosa, Josefina, 1932- Buenos Aires Painting

111. Fevre, Fermin. "Exposiciones para ver y no olvidar." *Criterio* 48.1724 (Sept 25 1975): 534-535. ⨍

Rosenberg, Sara Installation art

112. Jiménez, Carlos. "Sara Rosenberg." *Arte en Colombia* 44 (May 1990): 113-114 [English summary, 163].

Carlos Jiménez describes several of Rosenberg's installations which were shown in Madrid. Suggests that she is "one of the few Latin American figures who has committed herself seriously to the task of renovation, aggiornamento and the assimilation of the current international art scene." *Reproduction: "El sueño es veloz" (1990)*.

Rybak, Taty, 1943- Buenos Aires Sculpture

113. Stoddart Gould, Veronica. "Rhythm in Steel, Magic on Canvas." *Américas* 34 (Jan-Feb 1982): 55.

Critic briefly describes artist's openwork metal sculptures as "masterfully executed," remarking that they resemble "drawings suspended in air and display the sure hand of a skilled draftsman." *Reproduction: "Pas de Trois."*

Simón, María, 1922- Tucumán Printmaking/Sculpture

114. *María Simón.* Lisbon, Portugal: Fundação Calouste Gulbenkian, 1980. Bibl.

115. Sulic, Susana. "María Simón." *Art Nexus* (May 1991): 120 [English summary: 169].
"If for Malevich a painting was a window opening on an abysm, then for Simón a box is an excuse for exploring the thousand and one possibilities which the world offers us," writes Susana Sulic. Comments on artist's work shown at Eolia Gallery, Paris, focusing primarily on the objects of art she creates from boxes that she finds discarded in the street. Simón explains briefly her fascination with her material and her artistic viewpoint. Some information is included on her training, as well as on her career development. *Reproduction: "Caja desplegada" (1967).*

Soibelman, Elsa, 1941- Buenos Aires Collage/Painting/Printmaking

116. Chavarri, Raúl. "Elsa Soibelman: trayectoria de una pintora argentina." *Cuadernos Hispanoamericanos* 349 (July 1979): 174-178.
Indepth profile exploring three phases of Soibelman's artistic journey and vision as expressed in her collage compositions, her pop treatment of historic Argentine leaders and her use of fantasy to create Kafkaesque bird-like images. Chavarri includes some biographical information and reproductions of various of her works.

Solanas, Julia Painting

117. Chavarri, Raúl. "Notas sobre arte: el bestiario maravilloso de Julia Solanas." *Cuadernos Hispanoamericanos* 346 (Apr 1979): 142-143.
Briefly considers primitive style of artist's depictions of animal wildlife. *Reproductions: "La osa polar," "Rinoceronte azul," and "La leona rosa."*

BOLIVIA

Baptista, Carmen Painting

118. Vartanián, Tatiana. "El optimista arte de Carmen Baptista." *América Latina* (USSR) 9 (1982): 112-123.
Profile of artist whose primitivistic style and subject matter exemplify an interest in the events of everyday life. Briefly reviews the development of naive art in Latin America, particularly in Bolivia Author reviews artist's La Paz exhibition which combined visual image with poetic text by Pablo Neruda, Juana de Ibarbourou, Miguel Hernández and others. Includes artist's portrait. *Reproductions: "En la fiesta de las Alasitas," "Discurso de Bolívar en el Cerro de Potosí," and various other untitled pieces.*

Nuñez del Prado, Marina, 1910- Sculpture

119. Davitiants, Tatiana. "Marina Núñez y la escultura boliviana." *América Latina* (USSR) 8 (1980): 81-89.
Study is in Russian.

120. Núñez del Prado, Marina. *Eternidad en los Andes: memorias.* [Santiago?]: A. Flano, 1973. Bibl.

121. Villaroel Claure, Rigoberto. *Marina Núñez.* La Paz: Dirección Nacional de Informaciones de la Presidencia de la República, 1962. Bibl.

Pacheco, Maria Luisa, 1919-1982 La Paz Painting

122. Barnitz, Jacqueline. "Five Women Artists." *Review : Latin American Literature and Arts* 75 (Spring 1975): 38-41.
Writer suggests that 20th century Latin American women artists have gained more prominence than their North American counterparts and have forged ahead to become leaders in their respective fields. María Luisa Pacheco is among the five women briefly profiled by Barnitz.

123. *Maria Luisa Pacheco.* Catalogue. [New York, N.Y.: Ault Lee Gallery, 1977]. Includes chronology.

124. *María Luisa Pacheco: pintora de Los Andes.* La Paz, Bolivia: La Papelera, [1993?]. Bibl.

125. Sanjurjo de Casciero, Annick. "The Abstract Landscapes of Pacheco." *Américas* 39 (Jan-Feb 1987): 4-17+.
Profile of artist who has won international recognition for her planar interpretations of the Andean landscape. Includes biographical information and direct statements by Pacheco that reveal some of the inner processes and sensibilities driving her creative energy. Includes artist's portrait. *Reproductions: "Morro moreno" (1979), "Untitled" (1961), "Countryside" (1980), "Figure" (1956), "High Plateau" (1958).*

126. *Tribute to María Luisa Pacheco of Bolivia, 1919-1982: Retrospective Exhibition, November 25-December 30.* Catalogue. Washington, D.C.: Museum of Modern Art of Latin America, 1986. Bibl.

127. Volkening, Ernesto. "Maria Luisa Pacheco." *Eco* 236 (June 1981): 192-195.
Review of exhibition at Buchholz Gallery in Bogotá, Colombia. Considers influence of Picasso and Feininger on the artist's work, while stressing her originality of execution and style.

Rodo Boulanger, Graciela, 1935- La Paz Painting

128. *Graciela Rodo Boulanger.* Catalogue. Santiago, Chile: Galería Praxis, [1985]. Essay, Alfredo La Placa.

129. *Graciela Rodo Boulanger.* Catalogue. Greenwich, CT: Lublin Graphics Publishers, 1987. Introduction, José Gómez-Sicre.

BRAZIL

Amaral, Tarsila do, 1886-1973 São Paulo Painting

130. Amaral, Aracy. "Tarsila: modernidade entre a racionalidade e o onírico." *Vozes* 87.4 (July-Aug 1993): 53-59.
Considers artist's personal background, the cultural environment of the 1920's and the impact which the Modernist movement had on her development. Includes a reproduction of one of her works, as well as several portraits.

131. _____. *Tarsila: sua obra e seu tempo.* São Paulo, Brasil: Editora Perspectiva, 1975. Bibl.

132. Baddeley, Oriana and Valerie Fraser. *Drawing the Line: Art and Cultural Identity in Contemporary Latin America.* London; New York: Verso, 1989. 18-20. Bibl.

133. Batista, Marta Rossetti. "Centenario de nascimento de Tarsila do Amaral, 1886-1973." Revista do Instituto de Estudos Brasileiros 26 (1986): 115-129.
Consists primarily of reproductions of the artist's works from the Pau-Brasil period and facsimiles of notations made by Modernist Brazilian writer Mario de Andrade which critic asserts will contribute to a greater understanding of her art. Artist was greatly influenced by Modernist literary tenets which she assimilated into her work. Includes reproduction of 1926 photograph of artist during first solo exhibition in Paris. *Reproductions: "Tiradentes" (1924), "Composição cubista" (1923), "Composição cubista (com ave)" (1923), "São-Paulo (Gazo)" (1924), "Passagem de nivel Mogi das Cruzes" (1925), "Morro da favela" (1924), "A feira I" (1924), "O mamoeiro (Petit point ou Passagem)" (1925), "Pescador" (1925), "As meninas" (1925), "Anjos" (1924), "Vendedor de frutas" (1925), "Auto-retrato."*

134. Bercht. Fatima. "Tarsila do Amaral." *Latin American Artists of the Twentieth Century.* Catalogue. Ed. Waldo Rasmussen. New York: The Museum of Modern Art, 1993. 52-59. Bibl. Includes artist's statements.

135. *De olho no MAC.* Catalogue. São Paulo, Brasil: Museu de Arte Contemporaneo da Universidade de São Paulo, 1992. Bibl. Includes chronology.

136. Gotlib, Nadia Battella. *Tarsila do Amaral*. São Paulo, Brasil: Brasiliense, 1983. Bibl.

137. Lombardi, Mary. *Women in the Modern Art Movement in Brazil: Salon Leaders, Artists and Musicians, 1917-1930*. Bibl. Ph.D Dissertation. UCLA, 1977.
". . . focuses upon the leadership roles and creative works of the women of Modernism's first generation," among them Tarsila do Amaral.

138. Sa Rego, Stella de. "Pau-Brasil: Tarsila do Amaral." *Latin American Art* 2.1 (Winter 1990): 18-22. Bibl.
Discusses evolution of the artist's style from Impressionist to Modernist, focusing on her training in Paris during the '20s and the avant-garde currents she assimilated as a result. Influenced by Brazilian poet Oswalde de Andrade's "Manifesto da Poesia Pau-Brasil," urging artists to adopt a nativist stance, critic notes that she played a leading role in creating art that expressed native themes and subjects in a distinctly Brazilian manner. Stella de Sa Rego writes that "as tropical icons the Pau-Brasil paintings remain unsurpassed for their freshness, charm, and invention." Includes direct comments by the artist, as well as a description of various of her works. *Reproductions: "O mamoeiro" (1924), "A feira II" (1925), "E.F.C.B." (1924), "Morro da favela" (1924), "São Paulo" (1924)*.

139. _____. *Tarsila -- Pau-Brasil: Her Sources in the French Avant-Garde and the Significance of Her Work in the Context of Brazilian Modernism*. Bibl. Master's Thesis. University of Texas at Austin, 1985.

140. Silva Lima, Marcelo Guimares da. *From Pau-Brasil to Antropofágia: The Paintings of Tarsila do Amaral*. Ph.D. Dissertation. University of New Mexico, 1988.

141. Windhausen, Rodolfo A. "Women Artists in Latin America." *Latin American Art* 5.1 (1993): 89 [Spanish trans., 117-118].
An exhibition at New York's Americas Gallery gathered together works by eleven Latin American women painters reflecting a wide range of tendencies and themes. In his review Rodolfo Windhausen remarks that Tarsila's paintings were among the "most outstanding pieces" in the show.

142. Zilio, Carlos. *A querela do Brasil: a questão da identidade da arte brasileira: a obra de Tarsila, Di Cavalcanti e Portinari, 1922-1945*. Rio de Janeiro: Edicão Funarte, 1982. Bibl. Originally presented as author's doctoral dissertation, Université de Paris VIII, under the title: *La question de l'identité de l'art bresilien*.

Arditi, Iracema Painting

143. *Iracema Arditi.* Catalogue. [São Paulo, Brasil: Galeria de Arte André,
1983]. Essays, Leo Gilson Ribeiro, Radha Abramo, Fernando Cerqueira Lemos,
Murilo Mendes. Includes anthology of criticism and chronology.

Baranek, Frida, 1961- Rio de Janeiro Sculpture

144. *Frida Baranek.* Catalogue. São Paulo, Brasil: Gabinete de Arte Raquel
Arnaud, 1993. Text, Catherine Bompuis.

145. *Frida Baranek.* Catalogue. São Paulo, Brasil: Gabinete de Arte Raquel
Armand, [1990]. Text, Aracy Amaral (in Portuguese and English).

146. Tager, Alisa. "Paradoxes and Transfigurations." *Art in America* 82
(July 1994): 44-47.
 Brief mention of artist and her approach to sculpture (45).

Barki, Monica, 1956- Painting

147. *Pinturas recentes: Monica Barki. São Paulo: Galeria Nara Roesler, 12
de agosto a 3 de setembro de 1994; Rio de Janeiro, Paço Imperial, 17 de agosto a
25 de setembro 1994.* Catalogue. Text, Frederico Morais (in Portuguese and
English).

Barreto, Lia Menna, 1959- Rio de Janeiro

148. Tager, Alisa. "Paradoxes and Transfigurations." *Art in America* 82
(July 1994): 44-47.
 Describing Barreto's work, Alisa Tager writes that she "decapitates, amputates
and reconfigures cloyingly cute playthings. . . Barreto's is a world of subversion
and paradox where fun is dangerous and humor is grotesque" (47).
Reproduction: "Sleeping Dolls" (1993).

149. Uchoa Fagundes Jr., Carlos E. "Lia Menna Barreto." *Art Nexus* 12
(Apr-June 1994): 112-113 {English trans., 180].
 Commentary on far from ordinary work created by the artist. Uchoa Fagundes
attributes meaning to a group of pieces shown at Galería Camargo Vilaça in São
Paulo in which Menna Barreto reworks the structure of dolls, stuffed toys, and
other objects drawn from the world of infants, producing startling, juxtaposed
images. *Reproduction: "Sin título" (1993).*

Barros, Mercedes Photography/Video

150. Goodrow, Gérard A. "Mercedes Barros." *Art News* 93 (Jan 1994):
181.
 Gérard Goodrow includes statements by this artist who resides in Cologne,
providing a glimpse into the "Brazilianness" of her vision and the tenacity which
keeps her afloat in an environment that judges her as "different."

151. _____. "Mercedes Barros at Gabriele Rivet." *Art in America* 82 (Nov
1994): 142-143.
 Considers the meaning of the "chemically manipulated photographs and video
installations" of this artist who uses the Zebú, a breed of Brazilian cattle, as a
recurring theme in her work. Her work shown at Frankfurt's L. A. Gallery
concerns itself with "all endangered species and natural environments imperiled
by humankind's dubious quest for progress," writes Goodrow. *Reproduction:*
"Porteira" (1994).

Caram, Marina Painting/Graphic arts

152. *Marina Caram.* Catalogue. São Paulo, Brasil: Museu de Arte, 1985.
Essays, P. M. Bardi, Jean-Yves Hugoniot, Fernand Larue (in Portuguese and
French).

Carmo Secco, Maria do São Paulo Painting

153. *Maria do Carmo Secco: pintura/desenho.* Catalogue. [Rio de Janeiro,
Brasil: Saramenha Gallery, 1983]. Text, Fernando Cocchiarale. Includes
chronology.

Carvalho, Josely São Paulo Mixed Media

154. *Hot Spots: Curator's Choice IV: Irit Batsry, Amir Bey, Josely*
Carvalho, Alexander Drewchin, Paul Graham. Catalogue. [Bronx, NY: Bronx
Museum of the Arts, 1989]. Bibl. Includes chronology.

155. *Josely Carvalho.* Catalogue. New York: INTAR Gallery, 1993.
English and Spanish text.

156. *Josely Carvalho: It's Still Time to Mourn, Dia Mater I. New York,*
N.Y.: Art in General, January 16-March 3, 1993: Tempos de luto, Dia Mater II,
Museu de Arte de São Paulo, February 19-March 21, 1993. Catalogue. New
York, NY: Art in General, 1993. Bibl. English and Portuguese text.

157. *Josely Carvalho: She is Visited by Birds and Turtles.* Catalogue. [New
York, N.Y.: Terne Gallery, 1988]. Bibl. Text, John Michael. Includes
chronology and artist's statement.

158. Lippard, Lucy R. *Mixed Blessings: New Art in a Multicultural America.* New York, NY: Pantheon Books, 1990. 126-127. Bibl.
Includes biographical information and personal statements by the artist.

159. *My Body Is My Country.* Catalogue. Hartford, CT: Real Art Ways, [1991]. Bibl.

160. Sichel, Berta. "Josely Carvalho." Trans. Andrés Salgado. *Art Nexus* 8 (Apr-June 1993): 133-134 [English trans., 199].
Review of an installation by the artist at New York's Art in General. Berta Sichel refers to Carvalho as "versatile," writing that she "continues her practice of making political statements using different layers of meaning, perhaps in part because straight-forwardness is not much considered a vertice in Latin America." *Reproduction: "Todavía es tiempo de lamentar" (1992).*

161. Tinker, Catherine. "A Portrait of Two Latin American Women Artists in New York: Josely Carvalho and Catalina Parra." *Women Artists News* 7.5 (Mar-Apr 1982): 5-8.
Profile exploring questions of cultural influence on work of artist who resides in New York. Comments on the universality of themes which she depicts in her work -- a combination of photography, painting and crayon -- as well as the sensibilities which inspire her work both as woman and as Brazilian. Tinker writes, "Carvalho accepts the existence of two places where she belongs as impetus for her artistic growth." *Reproductions: "Women at Work" (1980), "Mouths Walked by Twenty Toes Into Cavern Like Regions" (1981), "Where is Our Future? asked the bird" (1981), "Hide and Seek at St. Mark's" (1981).*

Catunda, Leda, 1961- São Paulo Assemblage

162. *Leda Catunda: exposição de 30 de outubro, as 21 horas, a 19 de novembro de 1990.* Catalogue. São Paulo, Brasil: Galeria de Arte São Paulo, [1990].

163. Tager, Alisa. "Paradoxes and Transfigurations." *Art in America* 82 (July 1994): 44-47.
Considers progression of Catunda's approach, as well as influences on her work, describing recent pieces which she creates from a wide range of materials as "intentionally unsophisticated and highly personal assemblages" (46-47). *Reproduction: "Two Bellies" (1993).*

Clark, Lygia, 1920-1988 Belo Horizonte Painting/Sculpture

164. Bois, Yve-Alain. "Nostalgia of the Body." *October* 69 (Summer 1994): 85-109.
Bois's recollections of Clark precede a presentation of the Neo-concretist philosophy which informed the artist's work. Includes excerpts from her writings which are valuable for the direct testimony these provide to her inner self and the artistic intention embodied in her "propositions." Contains portraits

of the artist. *Reproductions: "Beast" (1960), "Going" (1964), Three phases of "Going" (1964), "Breathe with Me" (1966, 1968), "Mask with Mirrors" (1967), "Sensorial Glove" (1968), "Relational Object" (1968), "Dialogue" (1966).*

165. Brett, Guy. "Lygia Clark and Hélio Oiticica." *Latin American Artists of the Twentieth Century.* Catalogue. Ed. Waldo Rasmussen. New York: The Museum of Modern Art, 1993. 100-105. Bibl.
 Essay highlighting similar concerns which guided artists' works.

166. _____. "Lygia Clark: In Search of the Body." *Art in America* 82 (July 1994): 56-63+. Bibl.
 "Recognized in Brazil as an artist of the first importance, Clark produced innovative work over a period of three decades. She both anticipated today's concern with the body and broke new ground in examining the relation between art and society," writes Brett. Proclaimed as the first indepth study of the artist's work in English. *Reproductions: "Air and Stone" (1966), Lygia Clark and Hélio Oiticica's "Dialogue of Hands" (1986), "Egg" from the "Unity" series (1958), partial view of artist's installation at Venice Biennale, 1968, "Animal" (1962), "Abyss-Mask" (1968), "Rubber Grub" (1964), "Body Nostalgia" (1968), "Relational Objects in a Therapeutic Context: The Structuring of the Self" (1976-1982), "Antropofágia" (1973), "Baba antropofágica" (1973), artist with "Breathe with Me" (1966), "Sensorial Hood" (1967).*

167. _____. "Hélio Oiticica: Reverie and Revolt." *Art in America* 77 (Jan 1989): 111-121+.
 In this indepth study of Oiticica which also touches on Clark's work, Guy Brett writes, "It is is hard to write about one without also mentioning the other." Discusses Clark's vision which inspired her to break with the idea of art as object merely to be viewed, adopting instead an approach which allowed spectators to experience her nonfamiliar "devices" sensorially and glean "insights into the relationship between the physical and the metaphorical in the body's experience. . ." (111-114).

168. _____. "Lygia Clark: The Borderline Between Life and Art." *Third Text* 1 (Autumn 1987): 65-94.
 Comprehensive examination of Clark's artistic trajectory. Includes statements by the artist that give insight into the intent and meaning of her work, as well as reproductions of numerous examples of her "research," as Clark preferred to call her work.

169. Costa, Eduardo. "Hélio Oiticica, Lygia Pape and Lygia Clark." *Art News* 93.10 (Dec 1994): 153-154.
 Brief review of exhibition at Mario Pedrosa in Rio de Janeiro. Eduardo Costa refers to artists as "the three most significant Brazilian artists of this century." Contains commentary on Clark's works "The I and the You" (1967) and "Rubber Band Net" (1974).

170. Fabrini, Ricardo Nascimento. *O espaço de Lygia Clark*. São Paulo, Brasil: Editora Atlas, S.A., 1994. Bibl.

171. Gullar, Herreira. *Lygia Clark: textos de Herreira Gullar, Mario Pedrosa, Lygia Clark*. Rio de Janeiro, Brasil: Edição FUNARTE, 1980.

172. Milliet, Maria Alice. *Lygia Clark: obra-trajeto*. São Paulo, Brasil: Edusp, 1992. Bibl.

173. Tager, Alisa. "Paradoxes and Transfigurations." *Art in America* 82 (July 1994): 44-47.
Speaks of influence Lygia Clark has had on succeeding generation of Brazilian artists (45).

Correa de Oliveira, Yedamaria, 1932- Printmaking

174. *Yedamaria: A Retrospective*. Catalogue. Northridge, CA: California State University, Art Galleries, 1991. Essay, Mikelle Omari.

Costa Pinto, Valéria, 1952- Sculpture

175. *Valéria Costa Pinto: leitmotiv, esculturas de papel*. Catalogue. Rio de Janeiro, Brasil: Fundação Casa França-Brasil, 1994. Text, Rapulo Sergio Duarte (in Portuguese and English).

Duarte, Clementina Architecture/Jewelry Design

176. Mendoça, Casimiro Xavier de. "Clementina Duarte: Architect of Gems." *Américas* 44.6 (1992): 47-49.
Considers artist's background as an architect and how she has applied her expertise in that field to design and create jewelry which has gained for her worldwide recognition. Includes direct statements by Duarte that reveal what shaped her development in this direction, as well as examples of various of her pieces. Contains artist's portrait.

Freitas, Iole de Sculpture

177. *Iole de Freitas: [de 14 a 31 de agosto]*. Catalogue. São Paulo, Brasil: Gabinete de Arte Raquel Arnaud, [1990?]. Text, Paulo Venancio Filho.

Geiger, Anna Bella, 1933- Rio de Janeiro Painting/Multimedia

178. *Anna Bella Geiger*. Catalogue. [São Paulo, Brasil: Galeria de Arte São Paulo, 1987]. Bibl. Essays, Fernando Cocchiarale and Wilson Coutinho (in Portuguese). Includes chronology.

179. Ashton, Dore. "Ana Bella Geiger." *Review: Latin American Literature and Arts* 48 (Spring 1994): 54-57.
 Profile of the artist emphasizing her individuality and unconventional approach towards the creative process. Ashton remarks on the impact which Brazil's sociopolitical environment has had on Geiger's artistic development. *Reproductions: "EW18 with 'Girl Reading a Letter'" (1989), "Mapa Mundi" from "The New Atlas No. 1" (1977), "Pier and Ocean with Red Drop" (1990), "Pier and Ocean for P.G. with Black Hole" (1989).*

180. *O sorriso do gato de Cheshire em Alice: 27 de outubro a 14 de novembro de 1988.* Catalogue. Rio de Janeiro, Brasil: Galeria Saramenha, 1988. Text, Robert Motherwell, Philip Guston, Willem de Kooning.

Grinspum, Ester, 1955- Recife

181. Herkenhoff, Paulo. "Ester Grinspum: l'oeil et la lumière." *Art Press* (France) 165 (Jan 1992): 40-41.

182. *Paulo Figueiredo Galeria de Arte apresenta stultifera navis, desenhos de Ester Grinspum: de 2 a 20 de setembro de 1986.* Catalogue. São Paulo, Brasil: Paulo Figueiredo Galeria de Arte, 1986. Includes chronology.

Gross, Carmela

183. Rodríguez, Bélgica. "Carmela Gross." *Art Nexus* 11 (Jan-Mar 1994): 151-152 [English trans., 230].
 Review of artist's exhibition in Rio's Museum of Modern Art. Bélgica Rodríguez describes her "conceptual" works, writing that they "can be placed between the constructive abstraction of the 1940s and the new paths that are being explored in the revival of new non-figurative forms." *Reproduction: "Angola" (1993).*

Grostein, Marcia, 1948- São Paulo

184. *Birds in Spirit: Marcia Grostein, Hunt Slonem.* Catalogue. [Venice, Italy: Museo Diocesano di Sant Apollonia, 1988]. Includes chronology.

Janacópulos, Adriana, ? -1978 Sculpture

185. Batista, Marta Rossetti. "A escultora Adriana Janacópulos." *Revista do Instituto de Estudos Brasileiros* 30 (1989): 71-93. Bibl.
 Remarking that Janacópulos's work needs to be taken into account when considering the history of Brazilian art, Marta Rossetti Batista offers a detailed study of this sculptor. Includes biographical details and information on her training, the launching of her career in Europe during the '20s, and the broadening of her thematic concerns after her return to Brazil in 1932. *Reproductions: "Retrato de Matéo A." (ca.1922), "Busto de Prokofieff" (ca.1924), "Busto de Villa-Lobos" (1928), "Busto de Vitalis-Scheftel" (ca.1925),*

"Busto de jovem" (ca.1928-1929), "Cabeça de jovem" (ca.1930-1932), "Túmulo-monumento a Felipe d'Olivera" (1933-1934), "A Vida exterior," "A Vida interior," "Monumento aos estudantes mortos na Revolução de 32" (1935), "Túmulo de Serafim Vallandro," "Mulher" (ca.1938-1940), "Figura ajoelhada," "Meditação," "Mulher ajoelhada," "Mãe e filho."

Leirner, Jac, 1961- São Paulo

186. Amor, Monica. "Jac Leirner." *Art Nexus* 12 (Apr-June 1994): 126-127 [English trans., 190-191].
Review of "Corpus Delicti" presented at New York's Galerie Lelong. Monica Amor considers idea of transgression to analyze meaning and significance of the artist's works. *Reproduction: "Sin título" (from "Corpus Delecti," 1993).*

187. Basualdo, Carlos. "Jac Leirner." *Artforum* 32.5 (Jan 1994): 97.
Carlos Basualdo discusses Leirner's work shown at Galeria Camargo Vilaça in São Paulo within the context of Brazilian Neoconcretism. *Reproduction: "Sem titulo-Corpus Delicti" (1993).*

188. Cembalest, Robin. "Jac Leirner." *Art News* 92 (Summer 1993): 140-141.
Brief profile of artist who has "made a splash" internationally with the art pieces she composes from such mundane materials as airplane ashtrays and boarding passes, bank notes and dollar bills. Robin Cembalest relates the painstaking method she uses to make her creations. Includes Leirner's portrait, as well as some biographical information and personal statements. *Reproduction: "Corpus Delicti" (1992).*

189. Corris, Michael. "Não exotico." *Artforum* 30.4 (Dec 1991): 89-92.
Interpretation of the process and intention underlying the artist's arrangements of various and sundry accumulated objects. *Reproductions: "Pulmão/Lung" (1987), "All Together Now" (1991), "Os cem (pornografia)" (1987), "Ghost" (1991), "Overleaves" (1991).*

190. Edelman, Robert G. "Jac Leirner at Galerie Lelong." *Art in America* 82 (July 1994): 88.
As Robert Edelman puts it, "When Leirner gets it right, the results are uncommon," noting that the pieces which make up her "Corpus Delicti" installation "have an ingenuous charm and elegance that is only enhanced by their fragility." *Reproduction: View of installation "Corpus Deliciti" (1994).*

191. "Jac Leirner." *Transcontinental, An Investigation of Reality: Nine Latin American Artists.* Ed. Guy Brett. With texts by Lu Menezes and Paulo Venancio Filho. [Birmingham, Great Britain: Ikon Gallery, 1990]. 56-63. Bibl.

192. *Jac Leirner*. Catalogue. Oxford, England: Museum of Modern Art (July 14 - September 29, 1991), Glasgow: Third Eye Centre (October - November 1991). Text, David Elliott. Includes chronology.

193. *Jac Leirner*. Catalogue. São Paulo, Brasil: Galeria Camargo Vilaça, 1993. Text, Paulo Herkenhoff. Includes chronology.

194. Lagnado, Lisette. "Jac Leirner." *Art Nexus* 13 (July-Sept 1994): 40-43.

Applies the concepts of time and capital to analyze artist's act of collecting or accumulating, disassembling and reconfiguring everyday objects into works of art. *Reproductions: "Overleaves" (1991), from "Corpus Deliciti" (1993), "The One Hundreds (pornography)" (1987).*

195. Leffingwell, Edward. "Tropical Bazaar." *Art in America* 78 (June 1990): 87-95.

In this critique of the 20th International Bienal of São Paulo, Leirner's "environmental" installation earned Leffingwell's praise: ". . . both her participation in the Bienal and the character of this installation confirmed her position in the vanguard of contemporary Brazilian artists" (89-90).

196. *Pastfuturetense*. Catalogue. Winnipeg, Manitoba: Winnipeg Art Gallery (September 16 - December 2, 1990, Vancouver British Columbia: Vancouver Art Gallery (January 16 - March 17, 1991). Bibl. Texts, Bruce W. Ferguson and Gary Dufour. Includes chronology.

197. Rodríguez, Bélgica. "Jac Leirner." *Art Nexus* 8 (Apr-June 1993): 139-140 [English trans., 202].

Review of the artist's work shown at Hirshhorn Museum. Bélgica Rodríguez writes, "Jac Leirner demonstrates that with talent and sensibility everything is susceptible to being artistically recycled. . . A bill of paper money, an airline ticket, a plastic bag are discarded, they disappear from the hands and return, once and again, without losing their commonplace significance. . . the artist. . . constructs another reality, in this case artistic. . ." *Reproduction: "Blue Phase."*

198. Tager, Alisa. "Jac Leirner." *Art News* 92.7 (Sept 1993): 187.

Review of an exhibition at Galeria Camargo Vilaça in São Paulo. Tager writes that "Leirner manages to bridge Conceptualism and representation, time and space in [her] seriously humorous objects." *Reproduction: "Untitled," from the series "Corpus Delicti" (1993).*

Leontina, Maria, 1917-1984 Painting

199. Leontina, Maria. "Quadrum: Maria Leontina." *Vozes Cultura* 8 Jul 1994: 83-86.

Various reproductions from Leontina's "Estandartes" Series (1960-1970) accompany facsimile of her unpublished manuscript regarding an exhibition at Petite Galerie de São Paulo. Transcription by her son Alexandre Da Costa.

200. *Maria Leontina.* Catalogue. São Paulo, Brasil: Museu de Are Moderna de São Paulo, 12 de abril a 22 de maio de 1994. Bibl. Texts, Vera d'Horta and Lélia Coelho Frota.

Linnemann, Ana Sculpture

201. *Ana Linnemann: 10 de dezembro de 1987 a 6 de janeiro de 1988, Funarte, Galeria Sergio Milliet.* Catalogue. Rio de Janeiro, Brasil: Funarte, 1987. Text, Rodrigo Naves.

Malfatti, Anita, 1889-1964 São Paulo Painting

202. Almeida, Paulo Mendes de. *De Anita ao Museu.* São Paulo, Brasil: Conselho Estadual de Cultura, Comissão de Literatura, [1961].

203. Andrade, Mario de. *Cartas a Anita Malfatti.* Ed. Marta Rossetti Batista. Rio de Janeiro, Brasil: Forense Universitario, 1989. Bibl.

204. *Anita Malfatti (1889-1964): 10 de novembro a 11 de dezembro de 1977.* Catalogue. São Paulo, Brasil: Museu de Arte Contemporanea da Universidade de São Paulo. Bibl.

205. Batista, Marta Rossetti. *Anita Malfatti no tempo e no espaço.* [São Paulo, Brasil]: IBM Brasil, 1985. Bibl. Three exhibition leaflets tipped in.

206. _____. "Centenario de nascimento de Anita Malfatti, 2 dez. 1889 - 6 nov. 1964." *Revista do Instituto de Estudos Brasileiros* 31 (1990): 169-187.

207. Collazo, Alberto. "Anita Malfatti." *Arte en Colombia 44* (May 1990): 116 [English trans., 164].
Review of a show at the Museum of Contemporary Art of the University of São Paulo commemorating the 100th anniversary of the artist's birth. Alberto Collazo recalls Malfatti's education and training in Germany, remarking on the marginalization she experienced in Brazil in 1917 as a result of the European avant-garde principles she incorporated into her work. *Reproduction: "La boba" (1917).*

208. *De olho no MAC.* Catalogue. São Paulo, Brasil: Museu de Arte Contemporaneo da Universidade de São Paulo, 1992. Bibl. Includes chronology.

209. Lombardi, Mary. *Women in the Modern Art Movement in Brazil: Salon Leaders, Artists and Musicians, 1917-1930.* Bibl. Ph.D Dissertation. UCLA, 1977.
". . . focuses upon the leadership roles and creative works of the women of Modernism's first generation," among them Anita Malfatti.

Milhazes, Beatríz, 1960 Rio de Janeiro

210. *Beatríz Milhazes*. Catalogue. Monterrey, México: Galería Ramis Barquet, 1994. Text, Paulo Herkenhoff (in English and Spanish). Includes chronology.

Moraes, Nina, 1960- São Paulo

211. Tager, Alisa. "Paradoxes and Transfigurations." *Art in America* 82 (July 1994): 44-47.
Speaks of influence Lygia Clark has had on succeeding generation of Brazilian artists, some of them women. Describes several of Moraes's "discomfiting, yet often beautiful agglomerations" of "broken glass, powders, gels, wax, oil, costume jewelry. . . up close. . .a colorful compilation of transparent junk; at a small distance. . . almost like an abstract painting" (45-46). *Reproduction: "Crime" (1990)*.

Mota e Silva, Djanira da, 1914-1979 Avaré Painting

212. Barata, Mario. "El arte brasileño de Djanira." *Revista de Cultura Brasileña* 40 (Dec 1975): 33-39.
Profile tracing artist's brief schooling and development, emphasizing her close identification with the common people and their everyday life. Mario Barata writes that her social and artistic sensibilities, together with her honest and direct rendering of Brazilian reality, make her work deserving of the highest recogniition in her native country.

213. Campos, Paulo Mendes. "Djanira." *Revista de Cultura Brasileña* 40 (Dec 1975): 25-32.
Details of Djanira's childhood and of her life as woman and artist emerge in the unfolding of this essay. Interspersed with numerous statements the painter made during the course of an interview with Paulo Mendes Campos.

214. *Djanira*. São Paulo: Editora Cultrix, [1966]. Text, Rodrigo Mello Franco de Andrade.

215. *Djanira*. [Rio de Janeiro: Editora Galeria de Arte Moderna, 1967]. Bibl. Texts, M. Barata, C. Vallandares and C. Chaves (in Portuguese and English). Statements by the artist.

216. *Djanira: acervo do Museu Nacional de Belas Artes*. Catalogue. Rio de Janeiro: Colorama, [1985].

217. *Djanira: (exposição) outubro-dezembro de 1976*. Catalogue. Rio de Janeiro, Brasil: Ministerio da Educação e Cultura: Fundação Nacional de Arte: Museu Nacional de Belas Artes, 1976. Bibl.

218. Jait, Vladimir. "Djanira: pintora popular del Brasil." *América Latina* (USSR) 5 (May 1983): 70-80. Bibl.
 Portrait of artist whose keen perception and festive pictorial approach to her subject matter -- the everyday life and events of Brazil's marginalized -- ranks her among the most important artists of the '50s in Brazil, writes Jait. Considers her autodidactic background and professional development, elements of style and technique, and the influence of popular culture on her work. Includes excerpted criticism and statements by Djanira revealing her artistic sensibilities and attitude towards life. *Reproductions: "Trabajos agrícolas" (1945), "Mineros de oro" (1945), "Paisaje de Sitio de Parati" (1965), "Mercado de Diamantina" (1978).*

219. Pontual, Roberto. "Djanira, la intuición certera." *Revista de Cultura Brasileña* 50 (Dec 1979): 51-60.
 Affectionate homage to self-taught artist of mixed Austrian and Indian heritage which focuses on her intuitive artistic sensibilities Includes the artist's portrait. *Reproductions: "Autorretrato," "Patinadores" (1945), "Señora Santana" (1970), "Fachada do Maranhão" (1970).*

Ohtake, Tomie, 1913- Japan Painting/Printmaking

220. Martins, Marilia. Trans. Marbara Meza. "Tomie Ohtake: The Essence of Simplicity." *Américas* 46.1 (Jan-Feb 1994): 46-47.
 Biographical portrait briefly tracing artist's development, with statements by Ohtake which give insight into what shaped her career from her early years. Marilia Martins likens Ohtake's paintings to "forms and colors that simmer, seduce, and breathe on the surface of the canvas." *Reproduction: "Untitled" (1993).*

221. Mendoça, Casimiro Xavier de. *Tomie Ohtake.* Catalogue. São Paulo, Brasil: Editora Ex Libris, 1983. Bibl. *Exhibition held at Museu de Arte de São Paulo.* Text in English and Portuguese.

222. Nunes, Lygia Bojunga. *Tomie Ohtake -- 7 cartas e 2 sonhos.* Rio de Janeiro, Brasil: Berlendis & Vertecchia Editores, 1983.

223. *Tomie Ohtake: novas pinturas = New Paintings = nuevas pinturas.* Catalogue. Rio de Janeiro, Brasil: Museu de Arte Moderna, 1993. Text, Marcus Lontra Costa (in Portuguese, English and Spanish). Includes chronology.

224. *Tomie Ohtake: novas gravuras.* Catalogue. Text, Olivio Tavares de Araujo. São Paulo, Brasil: Galeria de Arte Monica Filguerias, 1987. Includes chronology.

Olivera, Dina, 1951- Painting

225. *Dina Oliveira.* Catalogue. [São Paulo, Brasil: Sadalla Gallery, 1987]. Text, Olney Kruse. Includes chronology.

Ostrower, Fayga, 1920- Poland Printmaking/Illustration

226. "Cuarenta años de labor en una muestra retrospectiva." *Brasil/Cultura* 10.57 (July 1986): 39-40.
 Review of retrospective exhibition presented by the Museum of Modern Art in Buenos Aires featuring more than 100 of the artist's works completed between 1945 and 1981. Direct commentary by the artist reflects on the evolution of her style which moved from a concern for a figurative depiction of reality, as expemplified in her early compositions, to an expressionistic and, later, abstract description of her subject matter. Autodidactic, Ostrower has distinguished herself in her native country, as well as internationally, by earning numerous important prizes for her work. Includes a portrait of the artist, as well as reproductions of various of her works.

227. *Exposição retrospectiva de Fayga Ostrower: obra grafica, 1944-1983.* Catalogue. Rio de Janeiro, Brasil: Museu Nacional de Belas Artes, Ministerio de Educação e Cultura, Secretaria da Cultura, Fundação Nacional Pro-Memoria, [1983]. Bibl. Text, Antonio Bento and others.

228. *Fayga Ostrower: 20 anos de obra grafica: agosto/septiembre.* Catalogue. México, D.F.: Museo de Arte Moderno, Bosque de Chapultepec, Instituto Nacional de Bellas Artes, 1981.

Pape, Lygia, 1929- Rio de Janeiro Painting/Mixed Media

229. Costa, Eduardo. "Hélio Oiticica, Lygia Pape and Lygia Clark." *Art News* 93 (Dec 1994): 153-154.
 In this brief review of an exhibition at Mario Pedrosa in Rio de Janeiro, Eduardo Costa refers to the artists as "the three most significant Brazilian artists of this century." Contains commentary on Pape's works "The Wheel of Pleasure" (1968) and "Mini-Tteia."

230. *Lygia Pape.* Rio de Janeiro, Brasil: Edição FUNARTE, 1983. Texts, Luis Otavio Pimentel, Lygia Pape, Mario Pedrosa.

231. Milliet, Maria Alice. "Lygia Pape." *Art Nexus* 8 (Apr-June 1993): 115-116 [English trans., 188-189].
 Review of an installation shown at Galeria Camargo Vilaça in São Paulo. Reviewer remarks on Pape's earlier work to emphasize the "experimental" and "radical" nature of her visual production. *Reproduction: "Untitled" (1992).*

Rennó, Rosângela, 1962- Belo Horizonte Photography

232. Hinchberger, Bill. "Rosângela Rennó: Photo Opportunities." *Art News* 93.6 (Summer 1994): 145.
 Rosângela Rennó rearranges photographs collected from a variety of sources to create new images and elicit new interpretations of the material. Includes some biographical detail, as well as artist's own statements revealing elements that

inspire her work. Includes the artist's portrait. *Reproduction:* *"Humorais"* *(1993).*

Saldanha, Ione Painting

233. Barnitz, Jacqueline. "Five Women Artists." *Review : Latin American Literature and Arts* 75 (Spring 1975): 38-41.
Writer suggests that 20th century Latin American women artists have gained more prominence than their North American counterparts and have forged ahead to become leaders in their respective fields. Ione Saldanha is among the five women briefly profiled by Barnitz. Reproduction: "Bamboos" (1969).

234. Harrison, Marguerite Itamar. *Ione Saldanha's Sculptural Forms in the Context of Brazilian Art.* Bibl. Master's Thesis. University of Texas at Austin, 1984.

Santos, Marie-Judite dos Portugal

235. Morgan, Robert C. "Regina Vater, Marie-Judite Dos Santos, Catalina Parra: Three South American Women Artists." *High Performance* 9.3 (1986): 58-62.
Robert Morgan writes that dos Santos has a "perspective on both European and South American cultures that feeds directly into her commentary on the current world situation." Author discusses artist's concern that mass media images "plasticize" reality, considering some of the works she has created to express her ideas. Includes artist's statements and portrait.

236. Santos, Marie-Judite Dos. *Holding Together.* Catalogue. Rochester, N.Y.: Visual Studies Workshop, 1992.

Schendel, Mira, 1919-1988 Zurich Painting/Collage

237. Iriarte, María Elvira. "Mira Schendel." *Art Nexus* 8 (Apr-June 1993): 83-87.
Noting the scarcity of biographical material on this self-taught artist who emigrated to Brazil in 1949, María Elvira Iriarte attempts to piece together details of her life and professional development to offer a profile of her career. Considers five stages of her artistic production and experimentation spanning a 40-year period, describing and analyzing various of her works. Of her rich and complex oeuvre, she writes, "From the beginning her works -- the collages, the elements suspended in space, and the pieces installed vertically on the wall -- engaged all three dimensions." Includes reproductions of various untitled works dating from 1954 to 1988.

Sil, Selma Painting

238. Silveira, Homero. "A pintura em Selma Sil." *Convivium* 29.2 (Mar-Apr 1986): 168-169.
Selma Sil has distinguished herself in capturing the essence of the Brazilian landscape. Silveira notes especially her moving renditions of life in the favelas which gained for her silver medal recognition in Paris and, critic affirms, speak to the misery of those who live in these shantytowns more loudly than any sociological essay on the same topic.

Silveira, Regina, 1939- Porto Alegre Installation Art

239. Basualdo, Carlos. "Regina Silveira." Trans. Vincent T. Martin. *Artforum* 32.3 (Nov 1993): 109.
 Analysis of artist's installation shown in New York City's Ledisflam. *Reproduction: "Masterpieces (In Absentia)," detail (1993).*

240. Torruela Leval, Susana. "Recapturing History: The (Un)Official Story in Contemporary Latin American Art." *Art Journal* 51.4 (Winter 1992): 69-80.
 Author considers ways in which various Latin American artists, among them Regina Silveira, "reinterpret, revise, or challenge versions of past events or periods, accounts coined by dominant cultures and accepted as official over time." *Reproduction: "Encounter" (1991).*

Tavares, Ana Maria, 1958- Sculpture

241. *Ana Maria Tavares.* Catalogue. São Paulo, Brasil: The Gabinete, [1990?]. Bibl. Text in Portuguese and English.

Torbes, Denize, 1959- Painting

242. *Denize Torbes: desenhos e pinturas: exposição, 10 de março a 24 de abril de 1994.* Catalogue. [Brazil]: Banco do Brasil: Centro Cultural, [1994].

Tucci, Sandra

243. Basualdo, Carlos. "Sandra Tucci." *Artforum* 32 (Summer 1994): 99-100.
 In a recent exhibition at Luisa Strina in São Paulo, artist "framed" the gallery space with a varied assortment of "decorative motifs." Describing it as a "complex and delirious show of materials, colors, and textures," critic explores artist's intention using a Minimalist perspective.

244. *Sandra Tucci.* Catalogue. São Paulo, Brasil: Galeria Luisa Strina (May 25-July 23, 1993). Text, Paulo Herkenhoff. Includes chronology.

Vater, Regina, 1943 - Rio de Janeiro Multimedia

245. Bergman-Carton, Janis. "Liliana Porter and Regina Vater: Upstairs/Downstairs and Through the Looking Glass." *Woman's Art Journal* 10 (Fall 1989-Winter 1990): 13-18. Bibl.

Discussion based on interviews with artist that includes information on her training and development and the social and political concerns which have informed her art. Explores mediating role of culture in the work of this expatriate artist, the Alice in Wonderland imagery which she evokes, and her experimentation with performance art and video as way to formulate and implement ideas specifically related to issues of multiple identity. *Reproductions: "Knots" (1973), "Yauti Marandua" (1983), "Nature Morte" (1987).*

246. Lippard, Lucy R. *Mixed Blessings: New Art in a Multicultural America.* New York, NY: Pantheon Books, 1990. 158. Bibl.

247. Morgan, Robert C. "Regina Vater, Marie-Judite Dos Santos, Catalina Parra: Three South American Women Artists." *High Performance* 9.3 (1986): 58-62.

In this essay Robert Morgan discusses how Vater applies "certain primitive truths borrowed from Indian mythological sources" to infuse her film installations with meaning and relevance for a contemporary society. Includes artist's own statements which give insight into her philosophy of life and how it impacts on her artistic expression. *Reproductions: "Self-portrait," "Love Spaces" (1986).*

248. "Regina Vater." *Transcontinental, An Investigation of Reality: Nine Latin American Artists.* Catalogue. Ed. Guy Brett. With texts by Lu Menezes and Paulo Venancio Filho. [Birmingham, Great Britain: Ikon Gallery, 1990]. 88-95. Bibl.

249. Vater, Regina. "On Nationality: 13 Artists." *Art in America* 79 (Sept 1991): 130.

Based on interview with Lilly Wei. Vater says, "In Brazil our grass roots still exist -- our Native American and African peoples. . . have created and preserved a rich cultural tradition that is communicated through images, proverbs, poetry, stories, myth, dance and music. . . As an artist I cannot avoid being deeply touched by this tradition. . ." Includes artist's portrait (125).

250. _____. "Espiritus Sanus in Terra Sana." *New Observations* 81 (Jan-Feb 1991): 23-27.

Vater discusses her ideas about art and her approach to it. She says, "As an artist I am primarily concerned with exploring and experimenting with diverse ideas and media rather than contriving my work into a single formalistic style or thematic idea. I have numerous strong ideas: one is the preservation of this living being we call our Mother Earth; and if possible to work and hope for preservation, not only of the environment but also of the richness of our cultural

pluralism which is directly linked to Mother Earth's physical attributes and wisdom."

251. _____. "Notes on Yauti in Heaven." *Center Quarterly* 11.4 (1990): 26-27.

252. _____. "Regina Vater." *Gallerie* (North Vancouver, B.C.) 9 (Fall 1989): 20-21.
 Artist speaks forthrightly about her life, her ideas about art, and her experience as artist, woman and Latin American in the United States. Includes still image of artist in video "There, Here" (1986). *Reproductions: "Snake Nest" (1988), "Vide o dolorido," video installation (1983).*

253. _____. *Regina Vater Installation Works: Sample of R. Vater Video Work Dealing with Text and Visual Poetry (1991); Elemental (1990-1991); A TV-GLOBO Interview with Bill Lundberg by Regina Vater (1980).* Videocassette.

254. _____. "Women Artists Tell Their Own Stories." *Gallerie: Women's Art* (Canada) 2.2 (Fall 1989):14-30.

Vinci, Laura Sculpture

255. Hinchberger, Bill. "Laura Vinci." *Art News* 93 (Sept 1994): 186.
 Sculptor recently exhibited ten cast-iron works at Galeria Camargo Vilaça in São Paulo which the reviewer likens to "creations of an abstract painter liberal with paint. . . they feel like low reliefs or heavily worked-up two-dimensional art." *Reproduction: View of installation (1994).*

CHILE

Aldunate, Carmen, 1940- Painting

256. *Carmen Aldunate: 10 años de pintura.* Catalogue. [Santiago, Chile: Museo Nacional de Bellas Artes, 1981]. Text, Waldemar Sommer and Mario Carreño. Includes chronology.

257. Galaz, Gaspar and Milan Ivelic. *Chile: arte actual.* Valparaiso, Chile: Ediciones Universitarias de Valparaiso, 1988. Bibl.

258. Ossa Puelma, Nena. "Carmen Aldunate: la mujer y su máscara." *Atenea* 447 (1983): 193-201.
 Essay exploring significance of artist's subject matter, the female face, likening her portraits to a representation of the masks which, critic remarks, women of all times feel obliged to wear to hide true self. Discusses influences on her work and includes direct statements by Aldunate that give insight into her inner self and her source of inspiration. *Reproductions: "Las crueles*

*reminiscencias" (1982), "Lápiz," (1978), "Reunión de familia" (1982), "Un
atuendo para la ocasión" (1982).*

259. Windhausen, Rodolfo A. "Women Artists in Latin America." *Latin
American Art* 5.1 (1993): 89 [Spanish trans., 117-118].
 An exhibition in New York's Americas Gallery gathered together works by
eleven Latin American women painters reflecting a wide range of tendencies and
themes. In his review Rodolfo Windhausen briefly discusses Aldunate's work.

Aranguiz, Ruby Painting

260. Chavarri, Raúl. "Notas sobre arte: una pintora, Ruby Aranguiz Lezaeta,
perfíl de una pintura entre la figura y el paisaje." *Cuadernos Hispanoamericanos*
386 (Aug 1982): 417-418.
 Chavarri comments on artist's paintings shown in Madrid's Instituto de
Cooperación Iberoamericana, remarking on two aspects of her work -- the
figurative, encompassing memories of her Chilean childhood, and the peninsular
landscape compositions that were influenced by an extended stay in Spain.
Includes artist's portrait with one of her works.

261. Mujica, Barbara. "Bright Visions, Fine Contours." *Américas* 43.3
(May-June 1991): 44-51.
 Sketches of ten women, among them Aranguiz, identified by Mujica as being
"on the cutting edge" of their profession. She includes a discussion of the
artist's themes, her styles and technique, remarking that her "luminous canvases
are a veritable celebration of life." *Reproductions: "White Tablecloth" (1988),
"Ibiza Boulevard" (1979), "Woman Wearing a Chinese Robe" (1980), "Macarena
Reading" (1984).*

262. _____. "Ruby Aranguiz Valencia: A World of Joy and Light."
Américas 42.5 (1990): 61-62.
 Brief profile of artist whose paintings were selected by Chilean author Isabel
Allende to illustrate four of her books. Mujica traces artist's education and
development, remarking on her "highly innovative use of light." Includes
artist's portrait, as well as reproductions of various of her works.

Arroyo, Mónica Painting

263. *Mónica Arroyo.* Catalogue. Santiago, Chile: Galería Arte Actual,
1992. Text, Jaime León. Includes biography.

Barrios, Gracia, 1927- Painting

264. "Artes plasticas: Gracia Barrios." *Canción de Marcela: mujer y cultura
en el mundo hispánico.* Ed. David Valjalo. Madrid: Editorial Origenes, 1989.
197-198.

265. Galaz, Gaspar and Milan Ivelic. *Chile: arte actual.* Valparaiso, Chile: Ediciones Universitarias de Valparaiso, 1988. Bibl.

266. *Gracia Barrios: oleos, 1985.* Catalogue. [Santiago, Chile: Galería Epoca, 1985]. Includes chronology.

Bru, Roser, 1923- Barcelona Drawing/Painting/Printmaking

267. Agosín, Marjorie. "Roser Bru o la memoria que desvela." *Plural* 2a época 16 (May 1987): 32-36. Rpt. in Marjorie Agosín, *Las hacedoras: mujer, imagen, escritura.* Santiago, [Chile]: Editorial Cuarto Propio, [1993]. 249-252.
 Includes statement by artist regarding themes of death and memory as a constant in her work. Remarking that Bru is one of Chile's most distinguished printmakers, Marjorie Agosín considers how she develops these themes in works about writer Gabriela Mistral and Lila Valdenegro, one of the many disappeared during the decade of the '70s in Chile. Includes untitled reproductions of various of her prints.

268. "Artes plásticas: Roser Bru." *Canción de Marcela: mujer y cultura en el mundo hispánico.* Ed. David Valjalo. Madrid: Editorial Origenes, 1989. 195-196.

269. Galaz, Gaspar and Milan Ivelic. *Chile: arte actual.* Valparaiso, Chile: Ediciones Universitarias de Valparaiso, 1988. Bibl.

270. González, Miguel. "Pinturas y dibujos de Roser Bru." *Arte en Colombia* 25 [n.d.]: 79-80 [English summary, 99].
 Miguel González remarks on Roser Bru's portraits of art and literary figures which were presented at Museo de Arte Moderno La Tertulia in Cali, Colombia, noting that they defy "the usual limitations of romantic figuration, providing critical analysis." *Reproduction: "Manuel Hernández."*

271. Madrid Letelier, Alberto. "Roser Bru: iconografía de la memoria." *Cuadernos Hispanoamericanos* 510 (Dec 1992): 7-12.
 Considers manner in which artist's photographs of Miguel Hernández serve to recover memory.

272. *Roser Bru.* Catalogue. Santiago, Chile: Galería Praxis, 1991. Essay, Adriana Valdés.

273. *Roser Bru: el deterioro y la memoria.* Catalogue. [Madrid, Spain: Galería Aele, 1976?].

274. Vidal, Virginia. "Roser Bru: presencias/ausencias." *Araucaria de Chile* 47-48 (1990): 247-249.
 Vidal intersperses her discussion of Roser Bru's paintings with artist's own remarks, giving insight into what shaped her development from her early years.

275. Valdés, Adriana. *Roser Bru.* Santiago: Hergar Ediciones, 1991.

Carril, Delia del, 1885-1989 Buenos Aires Painting/Drawing/Printmaking

276. Alberti, Rafael. "La 'Hormiguita' y otras hojas perdidas." *Araucaria de Chile* 46 (1989): 206-208.
Poet reminisces about his association with the artist.

277. "Artes plásticas: Delia del Carril." *Canción de Marcela: mujer y cultura en el mundo hispánico.* Ed. David Valjalo. Madrid: Editorial Origenes, 1989. 193-195.

278. Délano, Barbara. "Conversación con Delia del Carril." *Plural* 2a época 122 (Nov 1982): 32.
Transcript of conversation in which artist talks, among other things, about her philosophy of life and her association with Pablo Neruda. Includes some biographical information.

279. Uspenski, Vladímir. "Una pintora de Santiago de Chile." *América Latina* (USSR) 4 (1991): 72-78.
Writer recounts how he met artist, including anecdotal information that gives insight into her personality. Includes artist's portrait.

280. Vidal, Virginia. "Cumplir cien años." *Araucaria de Chile* 26 (1984): 145-151.
Essay of appreciation interspersed with narrative by the artist revealing details of her life with Pablo Neruda. Briefly discusses thematic content of her work -- large-scale horses -- and the human-like expressiveness with which she endowed them.

Colvin, Marta, 1917?- Chillán Sculpture

281. Arnello, Mario R. "En el Parque de las Esculturas." *Atenea* 458 (1988): 43-46.
 Text of speech delivered in honor of sculptor who carved large-scale stone piece, "Tierra Madre," to inaugurate Santiago's Parque Providencia. Includes photographic reproduction of work.

282. Bindis, Ricardo. "Marta Colvin: medio siglo de pasión artística." *Atenea* 458 (1988): 13-42. Bibl.
 Biographical portrait, tracing training and development of sculptor whose artistic achievements have gained for her worldwide recognition. Discusses various monumental stone and wood sculptures commissioned by public and private institutions at home and abroad. Includes artist's portrait, as well as personal statements giving insight into her ideas about the creative process and the function of art. A listing of her major works, awards and exhibitions appends article. *Reproductions: "Autorretrato" (1950), Busto del escritor Benjamín Subercaseaux, "La paloma de la paz" (1953), "Signal en foret" (1971),*

"Signo solar" (1973), Homenaje a Los Templarios, Ville Nouvelle, "Vigia de los mares" (1983), "El árbol de la vida," "Danza para tu sombra" (1952), "Puerta del sol" (1964), "Monumento a la joven Laura Lagos" (1964), "Encrucijada del espíritu," "L'esprit de l'eau," "Victoria," "Machi," "Caleuche," "Rosa de los Vientos," "Andes," "Madre Tierra."

283. *Cuatro escultores.* Catalogue. Madrid, Spain: Galería Aele, 1974.

284. Galaz, Gaspar and Milan Ivelic. *Chile: arte actual.* Valparaiso, Chile: Ediciones Universitarias de Valparaiso, 1988. Bibl.

285. *Marta Colvin.* Catalogue. [Paris, France: Galerie de France, 1967]. Bibl. Text, Jacques Lassaigne. Includes chronology.

286. *Marta Colvin.* Catalogue. Santiago, Chile: Museo Nacional de Bellas Artes, 20 de diciembre de 1993 al 27 de febrero de 1994. Text, Milan Ivelic and Cecilia Valdés Urrutia.

287. Palacios C. José María. *Doce Premios Nacionales de Arte: pintura y escultura*: [Santiago?]: Depto. de Extensión Cultural del Ministerio de Educación, 1984. 57-59.

Cortés, Ana, 1906-

288. Palacios C. José María. *Doce Premios Nacionales de Arte: pintura y escultura*:: 63-65. [Santiago?]: Depto. de Extensión Cultural del Ministerio de Educación, 1984. 63-65.

Edwards, Alexandra, 1962- Santiago Photography

289. Katzew, Ilona. "Alexandra Edwards." *Review: Latin American Literature and Arts* 48 (Spring 1994): 82-84.
 Brief profile of artist who trained as marine biologist before specializing in photography. Includes reproductions of three untitled works produced in 1990 and 1993.

Edwards, Carolina Drawing/Printmaking

290. *Dibujos y grabados: Carolina Edwards.* Catalogue. [Las Condes, Chile: Instituto Cultural de Las Condes, 1980]. Essays, Victor Carvacho and Connor Everts (in Spanish and English).

Errázuriz, Paz, 1944?- Santiago Photography

291. Agosín, Marjorie. "Paz Errázuriz o las zonas del silencio." *Las hacedoras: mujer, imagen, escritura.* Santiago, [Chile]: Editorial Cuarto Propio, [1993]. 245--247. Bibl.

292. Hernández Carballido, Elvira. "En la vanguardia: Paz Errázuris." *Fem*
17.119 (Jan 1993): 44.
 Very brief summary of photographer's career, emphasizing her sensitive and
humanistic approach to the marginalized peoples who comprise her subject
matter.

293. "Paz Errázuriz." *Review: Latin American Literature and Arts* 49 (Fall
1994): 27-32.
 Offers brief biographical details, as well as five pages of photographs of
couples in a psychiatric hospital.

Errázuriz, Virginia, 1941- Santiago

294. Galaz, Gaspar and Milan Ivelic. *Chile: arte actual.* Valparaiso, Chile:
Ediciones Universitarias de Valparaiso, 1988. Bibl.

Figueroa L., Patricia

295. *Homenaje a America: Patricia Figueroa L: desde el 15 de agosto al 20
de septiembre de 1992.* Catalogue. Santiago, Chile: Galería Arte Actual, 1992.
Includes biography.

Garafulic, Lily, 1914- Antofagasta Sculpture/Printmaking

296. *Lily Garafulic: esculturas, muestra retrospectiva de su obra.* Catalogue.
[Santiago, Chile: Corporación Cultural de las Condes, 1985]. Text, Gema
Swinburn. Includes chronology.

Guilisasti, Josefina, 1963- Painting

297. *Josefina Guilisasti: pinturas recientes.* Catalogue. Santiago, Chile:
Galería Praxis, 1993. Essay, Waldo Gómez.

Humeres, Paulina, 1954- Assemblage

298. *Paulina Humeres: IGNIS - AER - TERRA - ACQUA: obras recientes.*
Catalogue. Santiago, Chile: Galería Arte Actual, [1990]. Bibl. Essay, Eugenio
Miccini.

Israel, Patricia, 1939- Painting/Printmaking

299. "Patricia Israel." *Art Journal* 51.4 (Winter 1992): 10.
 Personal statement by the artist revealing the intention behind her work which
was published in this issue especially dedicated to Latin American art -
"capturing a memory [of the Columbian Encounter] . . . which both haunts and
stimulates us." *Reproducion: "Chilean Codex I" from "The Painted Body of
America" series (1985).*

Izquierdo, Alejandra Printmaking/Collage

300. Chavarri, Raúl. "Notas sobre arte: Alejandra Izquierdo, grabados y fanfarimunsis." *Cuadernos Hispanoamericanos* 346 (Apr 1979): 138-139.
Review of artist's exhibition in Madrid's Centro Iberoamericano de Cooperación. Raúl Chavarri calls attention to the sometimes naif quality of her Surrealist compositions which, he notes, evoke a child's first adventures with paper. Includes reproductions of various of her works.

Matte, Rebeca, 1875-193? Sculpture

301. Fernández Larraín, Sergio. "Rebeca Matte: entre el dolor y la alegría." *Atenea* 439 (Jan-June 1979): 109-129. Bibl.
Essay, including a transcription of personal correspondence, emphasizing events in the sculptor's life which shaped her outlook and artistic production. *Reproductions: "El eco" o "El encantamiento," "El secreto de la Esfinge."*

Morales, Carmengloria, 1942- Painting/Drawing

302. *Carmengloria Morales.* Catalogue. [Livorno, Italy: Peccolo Gallery, 1974]. Text, Nello Ponente. Includes chronology.

Parra, Catalina, 1940- Santiago Mixed Media

303. Adams, Beverly Eva. *The Subject of Torture: The Art of Camnitzer, Núñez, Parra and Romero.* Master's Thesis. University of Texas at Austin, 1992.

304. Blanc, Giulio V. "Catalina Parra." *Art Nexus* 5 (Aug 1992): 154-155 [English trans., 235-236].
Review of "Catalina Parra in Retrospect" shown at Lehman College Art Gallery in the Bronx.

305. *Catalina Parra.* Catalogue. New York, N.Y.: Intar Gallery, 1991. Bibl. Essays, Coco Fusco and Ronald Christ (in English and Spanish).

306. *Catalina Parra in Retrospect: Lehman College Art Gallery, Bronx, New York, February 6-April 4, 1992;: This Exhibition Will Be Presented at the Universidad de Chile, Museum of Contemporary Arts, June-July 1992 = esta exhibición será presentada en el Museo de Arte Contemporáneo de la Universidad de Chile, junio-julio, 1992.* Catalogue. Bronx, N.Y.: Lehman College Art Gallery, 1991. Bibl. Julia Herzberg, curator. In English and Spanish.

307. Christ, Ronald. "Catalina Parra and the Meaning of Materials." *Artscanada* (Mar-Apr 1981): 3-7.
Ronald Christ provides an interesting profile of the artist's career, including details of her personal life which have had a bearing on her work, the rationale she uses for selecting her materials, and the techniques she uses to communicate

meaning in her works. The discussion by Christ is rendered doubly informative by a generous sprinkling throughout of Parra's own statements. Includes the artist's portrait. *Reproductions: "Elers" (1980), "Imbunche" (1977), "Puma" (1980), "Options" (1981), "Diariamente" (1978), "Thirteen Ways to Reach Top Talent" (1980), "The New Romantic Movement" (1980).*

308. Galaz, Gaspar and Milan Ivelic. *Chile: arte actual.* Valparaiso, Chile: Ediciones Universitarias de Valparaiso, 1988. Bibl.

309. Lippard, Lucy R. *Mixed Blessings: New Art in a Multicultural America.* New York, NY: Pantheon Books, 1990. 127-128. Bibl.

310. Merewether, Charles. "El arte de la violencia II." *Art Nexus* 3 (Jan 1992): 132-135 [English trans., 207-209].
 Essay exploring artistic response to various aspects of governmental repression and violence in Latin America. Charles Merewether discusses the work of Catalina Parra at some length, paying particular attention to her choice of materials and their significance to the message she seeks to convey in her work. *Reproduction: "Imbunche" (1977).*

311. Morgan, Robert C. "Regina Vater, Marie-Judite Dos Santos, Catalina Parra: Three South American Women Artists." *High Performance* 9 (1986): 58-62.
 Robert Morgan considers how the meaning of Catalina Parra's "subtle metaphors" is contained in the materials she uses. Parra says, "In Chile we learn how to say things betwen the lines. You say things, but no one can accuse you of saying anything." Includes the artist's portrait. *Reproductions: "Fosa común" (1984), "Welcome Home" (1981).*

312. Salgado, Andrés. "Seis mujeres artistas." *Art Nexus* 4 (Apr 1992): 160-161 [English summary, 223].
 Catalina Parra's politically charged compositions were featured in an exhibition of works by six Latin American women artists at Bucknell University in Lewisburg, PA. Andrés Salgado briefly highlights her prominence in the realm of political art as it relates to the Chilean experience of the '70s. *Reproduction: "La deuda e(x)terna" (1988).*

313. Tinker, Catherine. "A Portrait of Two Latin American Women Artists in New York: Josely Carvalho and Catalina Parra." *Women Artists News* 7.5 (Mar-Apr 1982): 5-8.
 Profile that explores questions of cultural influence on artist's work. Daughter of poet Nicanor Parra and niece of Chilean folklorist Violeta Parra, the artist employs unusual materials in her artworks. Her pieces, which are a combination of newspapers, photographs, gauze, and other materials stitched or bound together and combined with video, depict politically charged images related to Chile and other parts of the world. Tinker notes that "Parra's work became 'radicalized' in New York, to the point where she would not be able to show the same work in Chile." Includes direct statement by the artist that gives insight

into the artistic purpose of her work. *Reproductions:* *"Options"* *(1981)*, *"Liberty Trail" (1980)*.

Parra, Violeta, 1917-1967 Folklorist/Painting

314. Agosín, Marjorie. "La pintura de Violeta Parra." *Las hacedoras: mujer, imagen, escritura.* Santiago, [Chile]: Editorial Cuarto Propio, [1993]. 209-223. Bibl.

315. _____. "Violeta Parra, pintora: su talento desconocido." *Plural* 2a época 19 (Dec 1989): 39-44+. Bibl.
 Chilean poet and essayist focuses on little known aspect of noted folklorist's career as painter, interpreting her work as a pictorial representation of her literary and musical creations. Discusses style and the significance of various of her works. Includes some biographical information. *Reproductions:* *"Las tres Pascualas" and "Contra la guerra."*

316. Alegría, Fernando. "Violeta Parra." *Retratos contemporáneos.* New York: Harcourt, Brace and Jovanovich, 1981. 165-188. Bibl.
 Biographical portrait by noted writer and scholar. Includes a great deal of personal statements by the artist, as well as anecdotal information, excerpts of criticism, and commentary by persons who were close to her, revealing her strong identification with Chilean folk culture and her indomitable spirit in the face of adversity.

317. Dolz Blackburn, Inés and Marjorie Agosín. *Violeta Parra o la expresión inefable: un análisis crítico de su poesia, prosa y pintura.* Santiago, Chile: Planeta, 1992.

Rosenfeld, Lotty, 1943- Video/Installation

318. Diamond, Sara. "Art After the Coup: Interventions by Chilean Women." *Fuse* 11.5 (Apr 1988): 15-24.
 Tells briefly of Rosenfeld's visit to Vancouver and her participation in various art projects at the Video In and at Women in Focus.

319. Galaz, Gaspar and Milan Ivelic. *Chile: arte actual.* Valparaiso, Chile: Ediciones Universitarias de Valparaiso, 1988. Bibl.

Silva, Carmen,1930- Santiago

320. *Carmen Silva en retrospectiva, 13 de noviembre al 13 de diciembre de 1992.* Catalogue. Santiago, Chile: Corporación Cultural de las Condes. Text, Sonia Quintana. Includes biography.

Sutil, Francisca, 1952- Santiago Painting/Collage

321. *Beyond the Surface: Recent Works by Creus, Rabinovich, Sutil: April 19 - June 30, 1990.* Catalogue. [New York, N.Y.: Americas Society Art Gallery, 1990]. Bibl. Essay, Fatima Bercht. Includes chronology.

322. *Francisca Sutil: papel-pintura/Handmade Paper Paintings, 1978-1985.* Catalogue. [Santiago, Chile: Epoca Gallery, 1985]. Spanish and English text. Includes chronology and artist's statement.

323. *Francisca Sutil: Recent Handmade Paper Paintings.* Catalogue. [New York, N.Y.: Nohra Haime Gallery, 1985]. Text, Judd Tully. Includes chronology.

324. *Francisca Sutil.* Catalogue. New York, N. Y.: Nohra Haime Gallery, 1992. Bibl.

325. *Francisca Sutil: Voices of Silence: September 15 - October 17, 1992.* Catalogue. New York, NY: Nohra Haime Gallery, 1992. Bibl. Text, Kate Linker. Includes chronology.

326. *Francisca Sutil.* Catalogue. [New York, N.Y.: Nohra Haime Gallery, 1990]. Bibl. Text, Terry Myers. Includes chronology.

327. Kuspit, Donald. "Francisca Sutil." *Artforum* 31.4 (Dec 1992): 90.
Review of exhibition at New York City's Nohra Haime Gallery. *Reproduction: "Voices of Silence #7" (1991).*

328. Ossa, Nena. "Francisca Sutil." *Art News* 93 (Apr 1994): 183.
Noting that her most recent work presented at Tomás Andreu in Santiago, Chile "embodied the profound maturity Sutil is now expressing in her art," Nena Ossa discusses her technique for applying pigment and layering color. *Reproduction: "Voices of Silence #10" (1991).*

329. _____. "Francisca Sutil in Living Color." *Art News* 93.6 (Summer 1994): 148.
Contains personal statements by the artist explaining the link between her work and her inner life. Describes her method for applying and layering color. Includes some biographical details, as well as the artist's portrait. *Reproduction: "Untitled" (1994).*

Varela, Mariana Painting

330. *Mariana Varela: pinturas.* Catalogue. Santiago, Chile: Galería del Cerro, 1991. Essay, Eugenio Dittborn.

Venturini, Ani Sculpture

331. Herrera, Victor. "La escultora Ani Venturini." *Atenea* 453-454 (1986): 325-331.
 Carvacho Herrera reviews the artist's sculptures with special emphasis on "El inmigrante italiano," a large-scale work erected in 1986 at Scuola Italiana in Valparaiso paying tribute to Italian immigrants and their descendants. Direct commentary by the artist sheds light on her background, training and development in Chile, as well as her approach towards the creative process. Includes a listing of national awards the artist has received and the location of various of her works. *Reproductions: "Brote" (1985), "Rocas" (1983), "Natura" (1984), "El inmigrante italiano" (1986), "Impacto" (1986).*

Vicuña, Cecilia, 1948- Santiago Writer/Painting/Multimedia

332. Lippard, Lucy R. *Mixed Blessings: New Art in a Multicultural America.* New York, NY: Pantheon Books, 1990. 127-128. Bibl.

333. _____. "The Vicuña and the Leopard: Chilean Artist Cecilia Vicuña Talks to Lucy Lippard." *Red Bass / Women's International Arts Issue* 10 (1986): 16-18.
 Essay based on interview with the artist. Contains a great deal of biographical information, as well as details of her artistic development. *Reproductions: "Violeta Parra," "Angel de la menstruación."*

334. Paternosto, César. "Cecilia Vicuña." Trans. Lori M. Carlson. *Review* : *Latin American Literature and Arts* 39 (1988): 16-17.
 Author writes that the artist's painting "articulates symbols, allegories, and realistic narratives that harken back to the Sienese painting she admires. . . she has assimilated the lessons of pre-European knowledge -- especially the silent images of textiles and ceramics that told their stories with greater clarity than any literary text." *Reproduction: "La Vicuña" (1977).*

335. Vicuña, Cecilia. *Sabor a mi.* Illus., Nicholas Battye and Bill Lundberg, trans. Felipe Ehrenberg. Cullompton, England: Beau Geste Press, 1973.
 Collection of texts produced over a period of nearly ten years which "symbolizes the contained fury and the sorrow of her country's present," writes Felipe Ehrenberg in the introductory matter. In Spanish and English.

336. _____. "Basuritas chilenas in New York." *Heresies* 24 (1989): 92.

COLOMBIA

Aguirre, Constanza, 1960- Bogotá Painting

337. Sulic, Susana. "Constanza Aguirre." *Art Nexus* 2 (Oct 1991): 145
[English summary, 197].
 Susana Sulic reviews artist's solo exhibition in Paris, noting her
"neoexpressionistic tone" and her "keen critical and analytical eye."
Reproduction: "Untitled" (1990).

Allina, Trixi Ceramics

338. Gallo de Bravo, Lilia. "Cinco ceramistas." *Arte en Colombia* 28
(Sept 1985): 85-86.
 Offers commentary on works by five Colombian ceramists, including Trixi
Allina, noting that although sculptural principle is latent in her pieces, ceramic
elements predominate. *Reproduction: "Caminante" (1982).*

Amaral, Olga de, 1932- Bogotá Textiles/Weaving/Soft Sculpture

339. Carbonell, Galaor. *Olga de Amaral: desarrollo del lenguaje.* Bogotá,
Colombia: Litografía Arco, 1979.

340. Damian, Carol. "Olga de Amaral y Jim Amaral." *Art Nexus* 11
(Jan-Mar 1994): 165-166 [English trans., 240-241].
 Review of an exhibition of artist's tapestries at Elite Fine Art in Miami. Carol
Damian remarks on the materials and technique she uses to create her woven
masterpieces, commenting that "the works. . . pay tribute to the artifacts of the
ancient world and the mastercraftsmen who created them as objects of myth and
ritual." *Reproduction: "Los Image #14" (1992).*

341. *Olga de Amaral: muros tejidos y armaduras.* Catalogue. [Bogotá,
Colombia: Museo de Arte Moderno, 1972]. Includes chronology

342. *Olga de Amaral: Woven Sculpture.* Catalogue. [New York, NY: Andre
Emmerich Gallery, 1974].

343. Rickenmann, René. "XV Bienal del textil contemporáneo." *Art Nexus*
5 (Aug 1992): 145-146 [English summary, 231-232].
 Review of XV International Lausanne Textile Biennial which included the
work of Olga de Amaral. René Rickenmann notes unparalleled quality of the
artist's work which, he remarks, has gained for her an indisputable position in
the history of contemporary textile art. *Reproduction: "Manto I" (1991).*

344. Rodríguez, Martha. "Olga de Amaral: cuatro tiempos." *Art Nexus* 12
(Apr-June 1994): 76-79 [English trans., 166-168].
 Martha Rodríguez traces artist's development from the '60s to the present in
this review of an exhibition at Bogotá's Museo de Arte Moderno. Critic analyzes

various of her works, emphasizing that the "language" of material and technique, together with "reflective intention," infuse her tapestries with meaning, with "sacred symbolism which recalls. . . the richness of a colonial past," making hers "one of the most important works of Colombian art." Notes appended to the review essay include artist's own statements which contribute to a greater understanding of her artistic vision. *Reproductions: "Gran maraña paramuna," detail (1970), "Lienzo ceremonial No. 24" (1993), "Sol cuadrado No. 2" (1993), "Bandera colombiana" (1984), "Alquimia 83" (1993).*

345. Scarborough, Jessica. "Olga de Amaral: Toward a Language of Freedom." *Fiberarts* 12 (July-Aug 1985): 51-53.
 Jessica Scarborough begins by saying that "Olga de Amaral is one of the artists who has given the textile arts movement its shape and direction." Providing numerous of the artist's own statements, she proceeds to explore how her love of country is reflected in the materials and technique she uses to weave her tapestries. Includes some details regarding her training and professional development. *Reproductions: "Alquimia XIV," "Riscos" (1984).*

346. Soto, Juliana. "Olga de Amaral: Fantasies of Fiber." *Art News* 93 (Dec 1994): 112-113.
 Brief profile tracing artist's background, training and development. Remarks by the artist clarify how she uses "disorder" and color to make her pieces. Includes artist's portrait.

347. Talley, Charles. "Impersonal Suspension: Olga de Amaral Woven Works at Allrich Gallery." *Artweek* 14 Dec 1989: 10-11.
 In this review of a San Francisco exhibiton, Charles Talley describes his response to the "luminosity" of her pieces, writing, "Light flows through, radiates from, and reflects off the surface. . . creating an aura that is at once inviting and yet oddly detached, both 'present' and yet temporally suspended." *Reproduction: "Moonbasket 29" (1989).*

348. _____. "Olga de Amaral." *American Craft* 48.2 (Apr May 1988): 38-45.
 Portrait which includes some biographical information and details about the artist's training and exhibitions. Emphasizes the development of her technique, her experimentation with "monumental form" and gradual passage into more "intimate forms." Numerous statements by the artist reveal the sources which drive her creative energy and her selection of materials. Charles Talley writes, "Even after three decades of research, de Amaral continues to submerge herself in her work -- 'into my own experiences, feelings, memories, even mistakes.'" Stunningly illustrated with close-up examples of her works. *Reproductions: "Vestidura de cal y canto" (1977), "Alquimia verde" (1987), "Fragmento completo" (1975), "Alquimia XIV" (1984), "Obra 504" (1987), "Lienzo ceremonial III" (1987), "Alquimia LIV" (1987), "Tejido polícromo #5" (1985).*

349. _____. "Olga de Amaral." *Latin American Art* 4.1 (Spring 1992): 46-48 [Spanish trans., 104-105].

Profile of the artist discussing her technique for combining elements of textile and architectural design to construct gold plaited tapestries that have earned for her considerable international recognition. Talley states that "the complex woven and plaited tapestries. . .with their patina of indeterminate antiquity, transcend their traditional functional and decorative associations and evoke a golden world of myth, magic, and devotion." Describes the materials de Amaral uses, noting the strong influence which Colombia's ancestral heritage and craft forms have on her work. Includes personal statements by the artist. *Reproductions: "Cesta lunar y plata #1" (1991), "Carátula de plata y oro," detail (1990), "Alquimia XXVII" (1985), "Alquimia plata #2" (1991), "Ríos 4" (1990).*

Arango, Débora, 1910- Medellín Painting

350. Carbonell, Galaor. "Débora Arango: el triunfo de un crítico." *Arte en Colombia* 25 [n.d.]: 20 [English summary, 84].

Notes belated recognition of painter whose work was a source of controversy because of her portrayal of disturbing, yet very real, elements of Colombian society. Includes the artist's portrait.

351. *Débora Arango*. Catalogue. Bogotá, Colombia: Museo de Arte Moderno de Medellín, Villegas Editores, 1986. Bibl. Text, Darío Ruiz Gómez and others.

352. *Débora Arango: exposición retrospectiva, 1937-1984*. Catalogue. [Medellín, Colombia: Museo de Arte Moderno, 1984]. Includes chronology.

353. Londoño, Santiago. "Paganismo, denuncia y sátira en Débora Arango." *Boletín Cultural y Bibliográfico* (Colombia) 12.4 (1985): 3-16. Bibl.

Painter's unfailing commitment to her message and her medium in the face of scathing criticism constitutes the focus of this portrait. Santiago Londoño examines the social context in which Arango produced her work, remarking on the censure she received for her expressionist representation of the female nude and the politically charged content of her work. *Reproductions: "La amiga," (1939), "Amanecer," (1939), "Trata de blancas" (1940), "La lucha del destino" (1942), "Los que entran y los que salen" (ca. 1944), "La viuda" (n.d.), "Las tres fuerzas que derrotan a Gaitán" (n.d.)*

354. Ruíz Gómez, Darío. "Débora Arango: el ícono de lo marginal." *Arte en Colombia* 26 (Feb 1985): 32-35 [English summary, 82-83].

Study of painter whose themes of the grotesque and sordid highlighted and denounced social and political realities in Colombia not previously acknowledged by other artists. *Reproductions: "Contrastes" (1940), "Esquizofrenia," "Matilde posando como actríz retirada," "La masacre del 9 de abril" (1948), "Trata de blancas" (1940), "La danza" (1949).*

Azout, Lydia, 1942- Bogotá Sculpture

355. Cobo Borda, Juan Gustavo. "Lydia Azout." *Arte en Colombia* 36
(Apr 1988): 84-86.
Considers artist's treatment of wood, stone, marble and natural fibers in her
pursuit of abstract forms, noting that they reflect remnants of indigenous
civilizations and cultures. *Reproductions: "Fuerzas rítmicas [Nos.
24, 26 and 29]" (1987), "Fuerzas compactas" (1984).*

356. González, Miguel. "Lydia Azout." *Arte en Colombia* 37 (Sept
1988): 129-130.
Brief review of artist's stone sculptures shown at Museo de Arte Moderno La
Tertulia in Cali. Reviewer characterizes Azout's work as "conceptual and
poetic," evocative of earlier indigenous civilizations. *Reproduction: "Fuerzas
rítmicas No. 30" (1987).*

357. Guerrero, María Teresa. "Lydia Azout." *Art Nexus* 10 (Sept-Dec
1993): 130-132 [English trans., 203-204].
María Teresa Guerrero reviews sculptor's large-scale work shown at Galería
Garcés Velásquez in Bogotá, interpreting the pieces and the artist's choice of
natural materials as an exploration of inner states and of the relationship of the
individual to the environment. *Reproduction: From the series "Soles" (1993).*

Bajder, Perla Painting/Sculpture

358. Collazo, Alberto. "Perla Bajder." *Art Nexus* 5 (Aug 1992): 133.
Review of artist's works shown at Centro Cultural Recoleta in Bogotá.
Alberto Collazo remarks on the fragmentation which Bajder achieves in her
large-scale pieces, likening them to puzzles that permit spectators to put together
their own story. *Reproduction: "Me tienes ahí, al alcance de tu mano" (1991).*

Barney, Alicia, 1952- Cali Painting/Installation Art

359. Aguilar, José Hernán. "En el proceso regional de la
Autobiovanguardia." *Arte en Colombia* 28 (Sept 1985): 69-70 [English
summary, 99-100].
Alicia Barney's ecological art challenge notions of what art is, or should be.
In her installations the artist offers an unusual approach to visualizing problems
of water pollution, deforestation and quality of life. Includes the artist's portrait
with one of her art pieces. *Reproductions: "Río Cauca" (1982), "Mis paticas
inmortalizadas" (1984).*

360. González, Miguel. "Alicia Barney: el paisaje alternativo." *Arte en
Colombia* 19 (Oct 1982): 40-43 [English summary, 74].
Traces the artist's development, focusing on the evolution of her treatment of
landscape themes, with traditional, representational language giving way to more
creative modes of expression that convey ecological concerns. *Reproductions:
"Viviendas" (1975), "Puente sobre tierra" (1975), "Diario objeto No. 2 'Florida"*

(1978-1979), "Diario objeto No. 2 'Boca grande'" (1978-1979), "Estratificaciones de un basurero utópico" (1981).

361. Guerrero, María Teresa. "Alicia Barney." *Art Nexus* 10 (Sept-Dec 1993): 132 [English trans., 204].

The subject of this review is Alicia Barney's installation shown in Bogota's Galería Gartner Torres which depicts the disastrous effects that ecological disasters such as oil contamination of waters have on birds. Author writes, "Ecology is not a favorite theme in the arts. . . [Alicia Barney] deserves our enthusiastic applause for making a statement of her position, and more still, for having done so in the form of an important artistic event." *Reproduction: From the installation "Aves en el cielo" (1993).*

Bernal, María Elena Painting

362. Pini, Ivonne. "María Elena Bernal." *Arte en Colombia* 41 (Sept 1989): 116 [English summary, 159].

Ivonne Pini reflects on the artist's "thought-provoking" solo exhibition at the Colombo-American Center in Bogotá, commenting that her work is "difficult to categorize since it seems to oscillate - like much twentieth century work - between abstraction and figuration." *Reproduction: "Horizonte recortado" from the series "Cajas de resonancia" (1989).*

363. Rodríguez, Marta. "María Elena Bernal: Giros de color desde el plano hasta el volumen." *Art Nexus* (May 1991): 101-102 [English summary, 160-161].

Review of exhibition presented in Manizales and Bogotá combining several mediums which artist presents in serial form in a variety of installations. "For Bernal, art is the expression of thought through visual elements, forms, colors and textures placed in space and given over to their own movement. . . This new show confirmed the conceptual maturity which the artist has now achieved, with a marked emphasis on three-dimensionality and various forms of movement (rotation, etc.)." *Reproduction: "Diferentes lenguajes para un árbol" (1990).*

Bonilla, Patricia, 1949- Bogotá Photography

364. González, Miguel. "Patricia Bonilla: más allá de la fotografía." *Arte en Colombia* 22 [n.d.]: 24-26 [English summary, 71].

Artist combines her acting experience in theater, film and television with photography and collage to explore various aspects of popular culture. Miguel González includes artist's own statements that explain her choice of artistic medium and give insight into the interrelationship of her diverse artistic experiences. *Reproductions: "La Miss" (1980), "El Graff Zeppelín" (1981), "La avioneta aburrida" (1982), "La Madre Patria" (1980).*

Boshell, Tutua Painting

365. Gutiérrez-Cuevas, Carlos. "Persistencia y talento: Tutua Boshell."
Correo de los Andes 57 (Apr-May 1989): 65-70.
 Chronicles development of artist's style from a representational description of
reality to an abstract, more personal mode of expression. Includes some
information on her training and travel in Europe, as well as comments by the
artist explaining her interest in texture and her preference for an abstract mode of
artistic representation. *Reproductions: "Sin título" (1988), "Tequendama" (1988),
"El Dorado" (1988).*

Bursztyn, Feliza, 1936?-1982 Bogotá Sculpture/Assemblage

366. *Camas: Feliza Bursztyn.* Catalogue. [Cali: Museo de Arte Moderno La
Tertulia, 1974]. Essay, Marta Traba.

367. *Feliza Bursztyn: baila mecánica.* Catalogue. [Cali, Colombia: Museo
de Arte Moderno La Tertulia, 1979]. Text, Marta Traba. Includes chronology.

368. González, Miguel. "Feliza Bursztyn." *Arte en Colombia* 17 (Dec
1981): 44-47.
 The transformation of scrap metal into sculptural works of art is the subject of
this article. González traces Bursztyn's artistic journey, emphasizing her
innovative approach to the medium. Includes Bursztyn's own statements which
explain her concept of sculpture. *Reproductions: "Chatarra" (1965),
"Maquinita" (ca.1975), "Cujas" (1974), "Maquinita" (ca. 1970), "Homenaje a
Gandhi," "Baila mecánica."*

369. Traba, Marta. "Feliza Bursztyn." *Eco* 44.267 (Jan 1984): 235-260.
 Indepth study of sculptor -- whom critic calls the "originator of happenings" in
Colombia -- and her "ephemeral situations." Considers splash she made in
Colombia's artistic community in the late '50s and the stimulating effect she had
on the development of plastic arts in that country.

370. _____. *Feliza Bursztyn, Alejandro Obregón: elogio de la locura.*
Bogotá, Colombia: Universidad Nacional, 1986. Bibl.

371. _____. "Feliza Bursztyn: en contra de la historia." *Correo de los
Andes* 13 (Jan-Feb 1982): 33-48.
 Fragments of Eco article above. Includes portrait of the artist. *Reproductions:
"Pequeñas maquinitas" (1969), "Homenaje a Gandhi" (1973), "Acero sobre acero"
(1980), "Acero inoxidable" (1978), "Figuras en bronce" (1980), "Chatarra"
(1962).*

Cardenas, Catalina Painting

372. González, Miguel. "Catalina Cardenas." *Arte en Colombia* 45 (Oct 1990): 132 [English summary, 175].
 Review of artist's first solo exhibition at Galería Figuras in Cali which had death as its theme. Miguel González notes her use of gold and silver paper on the face of her canvases "which evoke the world beyond death, recalling how the Oriental communities communicate with the souls of their dead ones."

Cardoso, María Fernanda, 1963- Bogotá

373. Amor, Mónica. "María Fernanda Cardoso." *Art Nexus* 9 (June-Aug 1993): 138-139 [English trans., 198].
 Mónica Amor reviews artist's installations shown in New York's Nohra Haime Gallery. Assembled from "frogs, au-naturel and gold-leaf covered calabashes, a ball made out of two human skulls and gold droplets," critic suggests that the significance of this exhibition is best understood within an anthropological context which combines pre-Columbian and contemporary themes. *Reproduction: "Oro" (1993)*.

374. Baker, Kenneth. "Galleries: María Fernanda Cardoso Debuts at Artspace." *San Francisco Chronicle* 24 Oct. 1992, final ed., sec. C: 3.
 Artist's sculptures assembled with elements drawn from Colombian culture are the subject of this review. Baker writes that "in her work there is an undercurrent of intelligent satire aimed at modernist art's pretensions to universality."

375. Guerrero, María Teresa. "María Fernanda Cardoso." *Art Nexus* 2 (Oct 1991): 117-118 [English summary: 185].
 Review of artist's solo exhibition at Galería Garcés Velásquez in Bogotá. Guerrero remarks on her original use of materials and life experiences to express the theme of life and death. Guerrero writes, "In the final analysis, her work is not simply an expression of her own personal experiences but rooted in that common memory which is ours as Colombians." *Reproduction: "Corona funeraria" (1991)*.

376. Porges, María. "María Fernanda Cardoso." *Artforum* 31.4 (Dec 1992): 98-99.
 Considers aesthetic response to artist's "arrangements" of foodstuffs and other Colombian products. *Reproduction: "Gourd" (1992)*.

Celis, Tina, 1958- Bogotá Painting

377. González, Miguel. "Tina Celis." *Art Nexus* 8 (Apr-June 1993): 122 [English trans., 192].
 Review of the artist's works shown in Cali's Museo de Arte Moderno La Tertulia which, González suggests, are based not only on memories and

experience but also premonitions and dreams. *Reproduction: "Señora libertad descansando su brazo" (1992).*

Combariza, Martha, 1955- Bogotá Photography

378. Rodríguez, Marta. "Martha Combariza." *Arte en Colombia* 45 (Oct 1990): 130-131 [English trans., 174].
Remarks on the artist's exhibition at the Art Museum in Bogotá's Universidad Nacional, noting that her photographs demonstrate "a keen eye for strange kinds of harmony and unusual color." *Reproduction: "Sin título" (1989).*

Daza, Beatríz, 1928-1968 Drawing/Collage/Ceramics/Painting

379. Iriarte, María Elvira. "Beatríz Daza." *Arte en Colombia* 3 (Jan-Mar 1977): 46-48.
Comprehensive study of multifaceted artist whose artistic production includes ceramics, painting, collages and drawings. *Reproductions: "Muro collage" (1966), "Vasija azul," "Bodegón óleo y arena".*

Delgado, Cecilia Cartagena Painting

380. Rubiano Caballero, Germán. "Cecilia Delgado: o la búsqueda de lo perdido." *Arte en Colombia* 6 (Jan-Mar 1978): 34-37.
In this detailed study of the artist Rubiano Caballero considers various of her exhibitions throughout the '70s, noting the impact which her stay in Europe had on her development. Remarks on the presence of strong colors and the use of slogans in her early pieces which explored and satirized the effect of advertising on a consumer society. Considers skillful use of light and shadow in her later studies of various aspects of Bogotá architecture - doors, windows, etc. Includes reproductions of several untitled pieces.

Duncan, Gloria de Bogotá Ceramics/Sculpture/Painting

381. Gallo de Bravo, Lilia. "Cinco ceramistas." *Arte en Colombia* 28 (Sept 1985): 85-86.
Offers commentary on works by five Colombian ceramists, including Gloria de Duncan, noting some details of her professional development and her technique for applying paint on clay. *Reproduction: "La espera" (1985).*

382. Huff, David C. "Gloria de Duncan." *Emote* (Oklahoma City) (Dec 1994): 12.
Portrait containing many statements by the artist. She says, "My interest in the known and unknown comes from my own experiences as a woman artist living in two worlds and constantly battling with unconscious cultural elements from my own background." Includes the artist's portrait.

383. *Ruminations on Solitude: Paintings and Sculpture.* Catalogue.
Shawnee, OK: Mabee-Gerrer Museum of Art, 1994. Essay, James
Scarborough. Includes statement by the artist.

384. Scarborough, James. "Emote's view: Art." *Emote* (Oklahoma City)
(Dec 1994): 8.
Review of "Ruminations on Solitude" exhibition at Mabee-Gerrer Museum in
Shawnee. Scarborough writes, "Work is biting, but not crass, beautiful but not
kitschy, reverberating but not glitzy."

Durán, Liliana

385. Cristancho, Raúl. "Marta Rodríguez y Liliana Durán: 'Documento
memoria.'" *Arte en Colombia* 44 (May 1990): 118-119 [English trans., 165].
Remarking that the artists have had "distinguished careers," Cristancho
describes a collaborative project that incorporates large-format drawings with
various kinds of objects, "photographs, pieces of lace, memorabilia," and spoken
words, to explore "more essential levels of the feminine conscience." Includes a
view of a fragment of the installation.

Friedemann, Nancy, 1962- Bogotá Painting

386. González, Miguel. "Tavera y Friedemann." *Arte en Colombia* 40
(May 1989): 118 [English summary, 159].
Miguel González notes the "suggestive" and "attractive" qualities of
Friedemann's realistic paintings which were shown in Cali's Museo de Arte
Moderno La Tertulia -- figures of dogs and cats set against colorful tiles or richly
designed carpet. *Reproduction: "Lujuria de tango" (1988).*

García McLean, Clara Painting

387. Rodríguez, Bélgica. "Clara García McLean: confrontando el ser." *Art
Nexus* (May 1991): 125-126 [English summary, 171].
Artist's work was shown at the Museum of Modern Art of Latin America in
Washington, D. C. Reviewer notes that her work which was influenced by
William Butler Yeat's poetry does not follow a traditional line but is "audacious"
and "the strong handling of her materials gives her work considerable strength of
expression." *Reproduction: From the series "Confrontando el ser" (1987).*

Garzón, Amparo Painting

388. Blanc, Giulio V. "Amparo Garzón." *Art Nexus* 13 (July-Sept
1994): 100-101 [English trans., 164-165].
Review of the artist's work presented at Fisher Island Gallery in Miami.
Giulio Blanc has the highest praise for Garzón, remarking on the influence
which her experience as stage designer has on her work. Considers symbolism
of the objects and colors in her compositions, suggesting that her paintings are

"celebratory in their praises of the gifts of the spirit and of physical existence."
Reproduction: "5 sentidos, 3 reinos" (1993).

Gilmour, Ethel U.S.A. Photography/Collage/Painting

389. Cristancho, Raúl. "Ethel Gilmour." *Art Nexus* 11 (Jan-Mar 1994):
156-157 [English trans., 234].
 Like Remedios Varo and Leonora Carrington, this artist has been influenced
by the culture and surroundings of her adopted country where she has made her
residence for many years. Raúl Cristancho reviews an exhibition of her work
shown at Centro Colombo-Americano in which she incorporates elements of the
Colombian landscape with personal and artistic concerns. *Reproduction:
"Mirando T.V." (1993).*

Gómez, Consuelo, 1955- Bogotá Sculpture

390. Martínez, María Clara. "Consuelo Gómez y Hugo Zapata." *Art
Nexus* 9 (June-Aug 1993): 122-123 [English trans, 190].
 María Clara Martínez remarks on the sculptor's pieces shown at Bogotá's
Galería Garcés Velásquez. Refers to her preoccupation with the "eternally
magical, mysterious and feminine idea of the circle," noting the "scrupulous
geometric forms that are. . . warm . . . lucid like the wood or metal that have
taken these forms." *Reproduction: "Cuerpo negro flotante" (1992).*

Gómez, María Clara Bogotá Painting

391. "María Clara Gómez." *Art Nexus* 4 (Apr 1992): 182 [English
summary, 232].
 Brief news item related to recent show of artist's paintings, "Cityscapes,"
presented in Washington, D. C. *Reproduction: "Washington Reflections."*

González, Beatríz, 1938- Bucaramanga Painting

392. Ardila, Jaime. *Beatríz González: apuntes para la historia extensa.*
Bogotá, Colombia: Ediciones Tercer Mundo, 1974.

393. *Beatríz González: exposición retrospectiva.* Catalogue. Bogotá,
Colombia: Museo de Arte Moderno, 1984. Bibl. Includes chronology and
excerpts of criticism by Alvaro Burgos, Miguel González, Marta Traba and
others.

394. *Beatríz González: retrospectiva.* Catalogue. Caracas, Venezuela: Museo
de Bellas Artes 1994. Texts by Katherine Chacón, Roberto Guevara, Carolina
Ponce de León and Germán Rubiano Caballero. Includes chronology.

395. *Beatríz González: una pintora de provincia.* Catalogue. Bogotá,
Colombia: Carlos Valencia Editores, 1988. Ed. Marta Calderón. Texts, Marta

Calderón, Carolina Ponce de León, R.H. Moreno Durán and Marta Traba. Catalogue raisonné.

396. Cristancho, Raúl. "Beatríz González." *Arte en Colombia* 45 (Oct 1990): 126-127 [English summary, 172-173].
Review of the artist's paintings shown at Bogotá's Galería Garcés Velásquez. Raúl Cristancho highlights their "compositional and chromatic comlexity," noting González's "masterful" use of color to heighten psychological tension. "Chaos and confusion, fragmentation and dislocation, these are the sources of the disturbing visual tension of these new works in which the spectator also becomes a protagonist." *Reproduction: "El altar" (1990).*

397. Escallón, Ana María. "Beatríz González: obra reciente y Surrealismo vial." *Arte en Colombia* 28 (Sept 1985): 65-66 [English summary, 99].
Discusses artist's totemic art composed of elements she collects from her native surroundings. Escallón's premise is that in reorganizing these elements of everyday life the artist transforms how people think about and experience reality. *Reproductions: "Angel custodio de Popallanta" (1985), "Todo artista tiene su época dorada" (1985), "Túmulo funerario para soldados bachilleres" (1985).*

398. Gallo de Bravo, Lilia. "Beatríz González: obra reciente." *Arte en Colombia* 45 (Oct 1990): 127-128 [English summary, 173].
Another review of Galería Garcés Velásquez show, calling attention to the themes of anguish and death expressed in the artist's figurative paintings which, Lilia Gallo remarks, reflect a piece of Colombian history. *Reproduction: "Apocalipsis camuflada" (1989).*

399. Gil, Javier. "Beatríz González: década del 80." *Arte en Colombia* 46 (Jan 1991): 134-135 [English summary, 187].
Referring to Beatríz González as one of Colombia's "most solid" contemporary artists, Javier Gil comments on the work she produced in the '80s which was shown at the Art Museum in Bogotá's Universidad Nacional. Examining her process and artistic language, Gil remarks on the way she uses elements drawn from popular culture in her reinterpretation of classic artworks in order to raise awareness about Colombian culture and recontextualize European reality through a native prism. *Reproduction: "Mural para fábrica socialista" (1981).*

400. Gutiérrez, Natalia. "Beatríz González." *Art Nexus* 7 (Jan-Mar 1993): 146 [English summary, 219-220].
According to Natalia Gutiérrez the series of works that Beatríz González presented at Bogotá's Galería Garcés Velásquez sets her apart from her contemporaries. Artist uses her vision and talent to confront the spectator with Colombia's indigenous population in a personal and direct way. *Reproduction: "Bosquejo de 1/500" (1992).*

401. *Los muebles de Beatríz González.* Catalogue. Bogotá, Colombia: Museo de Arte Moderno, 1977. Bibl.

402. Rubiano Caballero, Germán. "Beatríz González." *Arte en Colombia*
25 [n.d].: 77-78 [English summary, 98].
Review of retrospective exhibition at Bogota's Museo de Arte Moderno
showing 155 of the artist's works. Rubiano Caballero writes, "González is,
undoubtedly, the country's best chromatic constructor and each piece is a rich
assembly of color zones that are strong, pure and warm."

403. _____. "Beatríz González." *Arte en Colombia* 39 (Feb 1989): 92
[English summary, 169-170).
Germán Rubiano comments on González's exhibition at Galería Garcés
Velásquez in Bogotá, noting that the '80s marked a turning point for the artist in
terms of thematic content and form. Much of her work during this period makes
critical statements about high ranking political and militiary officials. Germán
Rubiano Caballero writes, "The lines and colors have become violent and bare,
an expression of how sick and tired we have all become of the endless mediocrity
of our leaders." *Reproduction: "El políptico de Lucho" (1988).*

404. _____. "Beatríz González o la historia del arte en Sesquilé." *Arte en
Colombia* 4 (Apr-June 1977): 15-18.
Author considers artist's paintings shown at Bogotá's Museo de Arte Moderno,
remarking on her penchant for reinterpreting works by famous artists such as
Manet, Monet and Gauguin, among others, in "fresh and spontaneous" ways.
Germán Rubiano emphasizes the painter's inventiveness which inspires her to
explore new chromatic possibilities, techniques and approaches in order to create
images that are different from the original. *Reproductions: "Un Bolívar"
(1975), "Vive la France" (1976), "Siga Ud." (1977), "Viva España" (1976),
"Según Botticelli" (1976), "Telón de boca para un almuerzo" (1975).*

405. Traba, Marta. "Beatríz González." *Eco* 28.169 (Nov 1974): 65-73.

González, Patricia, 1958- Cartagena Painting

406. Ahlander, Leslie Judd. "Artistas latinoamericanos de la región del
litoral sureste." *Arte en Colombia* 43 (Feb 1990): 101-102 [English trans.,
158].
Work of Latin American artists residing in the Gulf Coast states was shown at
Hollywood Art Center in Hollywood, Florida. Patricia González was among
the artists whose works were presented and briefly reviewed by Leslie Judd
Ahlander. *Reproduction: "Historia natural" (1987).*

407. Beardsley, John. "Patricia González." *Hispanic Art in the United
States*. Houston: Museum of Fine Arts, 1986. 179-181+.

408. Veciana-Suárez, Ana. "Patricia González." *Notable Hispanic-American
Women*. Detroit: Gale Research, 1993. Ed. Diane Telgen and Jim Kemp. 182-
183.

Hernández, Claudia, 1950- Bogotá Painting

409. Jiménez, Carlos. "Claudia Hernández." *Art Nexus* 10 (Sept-Dec 1993): 141 [English trans., 210].
Review of the artist's paintings shown at Galería Columela in Madrid. Carlos Jiménez likens her painted images - modelled on photographs of sports events - to ghosts, disembodied outlines of bodies which through "rigor and painterly grace" she transforms into "reanimations" of the original reality. *Reproduction: "La final de los cien metros" (1993).*

Hincapié, María Teresa, 1956- Armenia Performance

410. Rodríguez, Marta. "María Teresa Hincapié." *Art Nexus* 5 (Aug 1992): 129-130 [English summary, 226].
Marta Rodríguez describes artist's performance entitled "Impregnation" which was presented during seven consecutive hours daily over a three-day period at Galería Valenzuela Klenner in Bogotá. Includes a photographic reproduction of a fragment of the performance.

411. _____. "María Teresa Hincapié." *Arte en Colombia* 40 (May 1989): 112-114 [English summary, 157-158].
Indepth survey of artist's career, giving details of her acting background, training, and research travels to Europe, India and Japan. Discusses Hincapié's experimentation with oriental acting techniques at some length, an approach that she incorporated into a performance entitled "Vanishing Point" (lasting twelve hours and presented over a three-day period). Author writes that during this time Hincapié performed "the most simple and elementary tasks in the everday life of a woman. . . . to restore the authentic essence of everyday activities, an essence which is at once human, spiritual and metaphysical." Reproduction shows artist performing in "Escenas de Parque para una actríz" (1987).

Holguín y Caro, Margarita, 1875-1959 Painting

412. *Margarita Holguín y Caro: 1875-1959.* Catalogue. [Bogotá, Colombia: Museo Nacional, 1977]. Bibl. Includes chronology.

Hoyos, Ana Mercedes, 1942- Bogotá Painting

413. *Ana Mercedes Hoyos: dibujos y pinturas.* Catalogue. Bogotá, Colombia: Museo de Arte Moderno, 1976. Text, Eduardo Serrano.

414. *Ana Mercedes Hoyos: un decenio.* Catalogue. Bogotá, Colombia: Centro Colombo Americano, 1981. Bibl.

415. Barnitz, Jacqueline. "De la ventana al infinito: las atmósferas de Ana Mercedes Hoyos." Trans., Galaor Carbonell. *Arte en Colombia* 7 (Apr-June 1978): 38-41.
Detailed study which remarks on the influence of Magritte and Monet on the artist's development. Notes ways in which her style has progressed from an abstract geometric mode of expression to the seamless layering of color present in the "Atmósfera" paintings. *Reproductions: "Atmósfera" (1977), "Ventana" (1970, 1974, 1976).*

416. _____. "Five Women Artists." *Review : Latin American Literature and Arts* 75 (Spring 1975): 38-41.
Writer suggests that 20th century Latin American women artists have gained more prominence than their North American counterparts and have forged ahead to become leaders in their respective fields. Ana Mercedes Hoyos is among the five women briefly profiled by Barnitz.

417. Escobar, Patricia. "Seis artistas colombianos." *Arte en Colombia* 43 (Feb 1990):106 [English summary, 160-161].
Review of an exhibition in New York's Rempire Fine Art Gallery. Patricia Escobar comments briefly on the artist's work, writing that "her sense of color is masterly, the result of long years of study of light and shadow in abstract compositions."

418. Serrano, Eduardo. "Ana Mercedes Hoyos." *Latin American Art* 3.3 (Fall 1991): 43-45. Bibl.
Portrait tracing artist's growth from the early years of her career when her work exhibited "American" Pop tendencies to a style and subject matter described by writer as distinctly individualized and rooted in Colombian culture. Describes a series of palenque still lifes in which the artist represents Colombian coastal scenes of women fruit vendors and their colorful fruit platters. Serrano states that "the sensual renderings of the exotic palenqueras of coastal Cartagena, with their tantalizing tropical fruit-filled platters and bowls. . . represent both highlight and turning point in the career of this important Colombian artist." *Reproductions: Several from "Palenquera" series (1988), "Papaya," (1987).*

419. _____. *Ana Mercedes Hoyos: de la luz al palenque.* Bogotá, Colombia: Ediciones A. Wild, 1990. Bibl.

420. Traba, Marta. "Ana Mercedes Hoyos: los espacios del hombre." *Plural* 30 (Mar 1974): 43-46.
Indepth study of artist's paintings. Marta Traba notes the influence of Magritte and Edward Hopper on her work, remarking at the same time on the divergences which affirm an autonomous mode of expression. Includes reproductions of various of her works.

Jaramillo, María de la Paz, 1948- Manizales Printmaking/Painting

421. "Artes plásticas: María de la Paz Jaramillo." *Canción de Marcela: mujer y cultura en el mundo hispánico.* Ed. David Valjalo. Madrid: Editorial Origenes, 1989. 198-200.

422. Cobo Borda, Juan Gustavo. "María de la Paz Jaramillo." *Arte en Colombia* 27 (Feb 1985): 30-33. Bibl.
Considers how artist uses exaggeration and distortion to create images that represent, according to critic, a faithful, albeit caricatured, view of Colombian life. *Reproductions: "Borrasca de amor" (various), "Las parejas," "Sóngoro Cosongo."*

423. González, Miguel. "María de la Paz Jaramillo." *Arte en Colombia* 39 (Feb 1989): 94 [English trans., 171].
Brief review of works from the artist's "Galápagos" series shown at Museo de Arte Moderno La Tertulia in Cali. *Reproduction: From the "Galápagos" series (1988).*

424. Guerrero, María Teresa. "Maripaz Jaramillo." *Art Nexus* 11 (Jan-Mar 1994): 155-156 [English trans., 233].
Commentary on the artist's exhibition of still lifes shown in Bogotá's Diners Gallery. Remarks on the major shift which this genre represents for artist who has established a reputation for her representation of women and men in a variety of contexts. *Reproduction: "El balcón de Rosita" (1993).*

425. *Maripaz.* Bogotá, Colombia: Seguros Bolívar, 1987. Text, Antonio Caballero, Juan Mosca, Juan Gustavo Cobo Borda.

426. Medina, Alvaro. "María de la Paz Jaramillo: lúdica y crítica." *Arte en Colombia* 1.2 (Oct-Dec 1976): 21-25. Bibl.
Indepth study exploring impulse behind the artist's style, technique, and subject matter. Stresses her treatment of women and the psycho-sociological content of her images. *Reproductions: "Mujeres" (1973), "La monja" (1975), "Industria de. . ." (1974), "La exmodelo" (1976).*

427. *Mujer hombre objeto: julio-septiembre 1984.* Catalogue. Monterrey, México: Museo de Monterrey, [1984?]. Bibl.

428. Stringer, John. "Life is a Cabaret." *Américas* 37.2 (Mar-Apr 1985): 40-43.
Brief sketch remarking on the artist's transition from printmaking to painting, emphasizing her interest in celebrating native culture and color through nightclub images. Some biographical material is included, as is information on training and exhibitions. *Reproductions: "Why I Met You" (1980), "Couple" (1983), "The Golden Voice" (1976).*

Lizarazo, Luz Angela, 1966- Bogotá Painting

429. González, Miguel. "Luz Angela Lizarazo." *Art Nexus* 3 (Jan 1992): 153 [English trans., 215].

Review of Luz Angela's paintings shown at Galería Jenni Vilá in Cali in which she presents common everyday objects in "surrealist and fantastic settings." Miguel González refers to her compositions as imaginative, imbued with freshness and a childlike spirit. *Reproduction: "Sin título" (1991).*

Llano, Cristina, 1955- Cali Painting

430. González, Miguel. "Artistas de los ochenta." *Arte en Colombia* 43 (Feb 1990): 98-99 [English summary, 157].

Exhibition of works by five Colombian neo-figurative painters presented by the Buenos Aires Instituto de Cooperación Iberoamericana (ICI) is the subject of this review. Stating that the artists were "in one way or another representative of the intensity which characterized painting in the past decade," Miguel González refers briefly to the works of Cristina Llano who was one of two women included in the show. *Reproduction: Cristina Llano: "Rojo sin frontera" (1988).*

431. _____. "Cristina Llano." *Arte en Colombia* 44 (May 1990): 125-126 [English summary, 167].

Miguel González remarks on the artist's first solo exhibition presented at Cali's Museo de Arte Moderno La Tertulia. "The overall impression is undoubtedly that of violence, as expressed through sex, unhappy love, solitude and death, an impression which is made all the more forceful by the contrapuntal use of color." *Reproduction: "Corredor blanco infinito" (1989).*

Lozano, Margarita, 1936- France Painting

432. Carbonell, Galaor. "Margarita Lozano: el paisaje cautivo." *Arte en Colombia* 4 (Apr- June 1977): 24-27.

A description of artist's preferred subjects - motifs drawn from her native culture - and consideration of her figurative approach. *Reproductions: "Bodegón con papayuelas y cebollas" (1976), "Interior en azul" (1973), "La sopa" (1976), "Bodegón con cafetera y papayuelas" (1976).*

433. *Margarita Lozano.* Bogotá, Colombia: Encuadernaciones LTDA, 1982.

434. *Margarita Lozano: diciembre 13/84-enero 13/85.* Catalogue. Cali, Colombia: Galería Taller, Museo de Arte Moderno La Tertulia, [1984?]. Essay, Gloria Valencia Viago.

435. *Margarita Lozano: Retrospectiva : Banco de la Republica, Biblioteca Luis Angel Arango, septiembre 19-octubre 27 de 1991.* Catalogue. Santa Fé de Bogotá, Colombia: La Biblioteca, [1991]. Bibl. Essays, Edward J. Sullivan and Germán Rubiano Caballero. Includes chronology.

436. Martínez, María Clara. "Margarita Lozano." *Art Nexus* 3 (Jan 1992): 148 [English trans., 213].
Bogotá's Luis Angel Arango Library was the site of a retrospective exhibition of the artist's paintings. In her review María Clara Martínez calls attention to the special vision which fuels Lozano's energies, driving her to embrace not the dark side of humanity but rather the "innocence" of our existence. *Reproduction: "Paisaje de Matute con árbol de copey" (1989).*

437. Romero Buj, Sebastian. "Las bellezas de Margarita Lozano: una fantasía permanente." *Correo de los Andes* 18 (Nov-Dec 1982): 33-48.
Portrait interspersed with artist's own words focusing on her individuality. Lozano pursues a figurative style in spite of prevailing vanguard tendencies. Discusses her artistic development and the influence of artists such as Matisse, Monet, Zurbarán Sánchez Cotán and Luis Menéndez on her work. Includes artist's portrait. *Reproductions: "Pedrito en Caballero Español," "Paquito Romero con gato," "Niña de Primera Comunión," "Interior rojo con silla azul," "Bodegón con molino de café y cebollas," "Canasta de frutas," "Interior con silla rosada," "Carreta con flores."*

438. Rubiano, Germán. "Margarita Lozano." *Arte en Colombia* 39 (Feb 1989): 91 [English summary, 169].
Describing the oil and pastel still-lifes presented by the artist in Bogotá's Alfred Wild Gallery, Germán Rubiano writes, "The joy which emerges from these pictures, their sense of peace and tranquility as well as the use of color and the compositional balance are not due merely to the simplicity of the subject but are the product of the disciplined and rigorous nature of the artist's work. . ." *Reproduction: "Talanguera de flores y árboles" (1988).*

Mayer, Becky Photography

439. González, Miguel. "Becky Mayer." *Arte en Colombia* 41 (Sept 1989): 119 [English trans., 160].
Review of an exhibition of the photographer's work which was presented in Cali's Museo de Arte Moderno La Tertulia. Miguel González stresses Mayer's ongoing reworking of concepts and techniques and her questioning of the boundaries between photography and art. *Reproduction: From "Desastres" series (1989).*

440. Gutiérrez, Natalia. "Becky Mayer." *Art Nexus* 9 (June-Aug 1993): 123-124 [English trans., 190-191].
Natalia Gutiérrez reviews the artist's work shown at Galería Garcés Velásquez in Bogotá, remarking on her preoccupation with and treatment of death in her photographs. *Reproduction: "Eros" (1993).*

441. *A Woman's Eye: Black and White Photography.* Catalogue. Miami, FL: Miami-Dade Community College, Mitchell Wolfson New World Center, 1988. Includes biography and chronology.

Meira, Mónica, 1949- England Painting

442. Rubiano, Germán . "Monica Meira." *Arte en Colombia* 44 (May 1990): 124-125 [English summary, 167].
The subject of Meira's exhibition at Bogotá's Galería Garcés Velásquez was bathers. Germán Rubiano remarks on her precise and elegant rendering of line and form, noting an unusual detail in her work, ". . . namely, that the male body has been a rarely treated subject amongst Colombian female painters. In Meira's case, however, there is no trace of eroticism: her male bathers remain firmly encased in their bathing suits." *Reproduction: "Sin título" (1989).*

Mejía, Catalina Painting

443. Guerrero, María Teresa. "Catalina Mejía." *Art Nexus* 9 (June-Aug 1993): 124-125 [English trans., 191].
María Teresa Guerrero reviews the artist's work which was exhibited at Galería Garcés Velásquez in Bogotá, noting the fragmented pictorial language she uses to create her cityscapes. *Reproduction: "Entrelíneas" (1993).*

444. Palomero, Federica. "III Bienal de Cuenca." *Art Nexus* 3 (Jan 1992): 136-139 [English trans., 209-210].
Federica Palomero considers the relative merit of works exhibited during the III Cuenca Biennial in Ecuador. Among the promising young women artists she identifies is Catalina Mejía. *Reproduction: "Entre líneas" (1990).*

Merino, Gloria Painting

445. Rodríguez, Marta. "Gloria Merino." *Arte en Colombia* 40 (May 1989): 112 [English summary, 157].
 Brief review of an exhibition of the artist's works -- charcoal drawings and reliefs shown at Bogotá's Universidad Nacional -- that had as their subject the "exuberant, dense and humid landscape of the tropical forest." *Reproduction: "Concepciones sobre naturaleza" (1988).*

Morán, María Painting

446. Jiménez, Carlos. "María Morán." *Art Nexus* (May 1991): 108-109 [English summary, 163].
 Carlos Jiménez accords special recognition to the artist's paintings shown at Madrid's Casa del Reloj, noting that with the exception of more established names few Colombian or Latin American artists have the opportunity to show their work in Spain's capital. Especially notes the "passion for color" which predominates in her canvases and offsets any attempt at faithful rendition of detail. *Reproduction: "Musa paradisiaca" (1988).*

Ordóñez, Cecilia Ceramics

447. Escobar, Patricia. "Cecilia Ordóñez: 'en el principio.'" *Arte en Colombia* 41 (Sept 1989): 112 [English summary, 157].
 Review of the artist's "fusiform cylindrical ceramic pieces" shown at the Colombo American Center in Bogotá. "The cylinders were characterized by very different textures, with seeds, earth and various natural elements being fused with the clay. . . the material serving simply as a starting point for the spectator's own. . . journey through the various stages of the geological evolution and formation of the earth," writes Patricia Escobar. *Reproduction: "En el principio" (fragment)*.

448. Gallo de Bravo, Lilia. "Cinco ceramistas." *Arte en Colombia* 28 (Sept 1985): 85-86.
 Offers commentary on works by five Colombian ceramists, including Cecilia Ordónez's "grandiose large-scale pieces," noting general details of the artist's education. *Reproduction: " Sin título" (1984)*.

Ortíz, Gloria Cali Painting

449. *Lorraine Kisly: Ceramic Vessels, Gloria Ortíz: Paintings, Objects and Issues: September 14 - October 16 1992*. Catalogue. Uthica, NY: Edith Barrett Art Gallery, Utica College of Syracuse University, 1992. Essay, Joan Blanchfield.

Pinzón, Betty Painting

450. Martínez Carreño, Aida. "Betty Pinzón: la pintura vital." *Arte en Colombia* 28 (Sept 1985): 67-68.
 Essay draws attention to the significance of the imagery and themes depicted in the artist's paint on metal compositions. Remarks on their forceful expression and denunciation of such vital realities of the female condition as submission, poverty, repression and aggression. Includes portrait of the artist at work. *Reproductions: "El claustro" (1976), "Maternidad" (1979), "Silencio" (1979)*.

Reyes, Emma Bogotá Painting

451. Medina, Alvaro. "Emma Reyes: los 40 años de una línea." *Arte en Colombia* 31 (Oct 1986): 39-41 [English summary, 96].
 Portrait tracing the development of artist's forty-year career. Focuses on her bold use of line, color and volume, which critic remarks imbues her work with its characteristic sensual qualities. Medina notes that the artist "radically denies routine, making her one of the least commercial or repetitive of Colombian painters. . . " *Reproductions: "Cabeza de apio" (1979), "Flor" (1983), "Flor blanca" (1978), "La cartilla del suelo" (1949)*.

452. "Metros y metros de flores." *Correo de los Andes* 57 (Apr-May 1989): 71-72.
Brief description of a mural which the artist was commissioned to paint for the Municipal Library in Perigueux, France. Includes some background information by Reyes on the development of the project, as well as a reproduction of a fragment of the work.

453. Sulic, Susana. "Emma Reyes." *Arte en Colombia* 46 (Jan 1991): 129-130 [English trans., 186].
Briefly reviews monumental thirty-year Paris retrospective of artist's paintings. Susana Sulic remarks that the artist's work "became characterized by its almost perfect handling of color and form in the context of nature where the intellectual, almost mathematical structures recall the classic works of art and their sense of universal culture." *Reproduction: Fragment of fresco hanging at Municipal Library, Perigueux, France.*

454. _____. "Emma Reyes." *Art Nexus* 3 (Jan 1992): 170-171 [English trans., 222-223].
Brief review of exhibition at Galerie R. Treger, Paris. *Reproduction: "Untitled" (1978).*

Rizzi, María Teresa, 1957- Argentina Painting

455. Windhausen, Rodolfo A. "María Teresa Rizzi." *Art Nexus* 6 (Oct 1992): 153-154 [English summary, 213].
Referring to this New York-based artist as Argentine-Colombian, Windhausen reflects on her abstract neo-expressionist oils on canvas which were exhibited in the Barnard Biderman Gallery in SoHo. *Reproduction: "Mai di luna" (1991).*

Rodríguez, Marta

456. Cristancho, Raúl. "Marta Rodríguez y Liliana Durán: 'Documento memoria.'" *Arte en Colombia* 44 (May 1990): 118-119 [English trans., 165].
Remarking that artists have had "distinguished careers," Cristancho describes a collaborative project that incorporates large-format drawings with various kinds of objects, "photographs, pieces of lace, memorabilia," and spoken words, to explore "more essential levels of the feminine conscience." Includes a view of a fragment of the installation.

Rodríguez, Ofelia, 1953- Medellín Painting/Mixed Media

457. Damian, Carol. "The Americas Series." *Art Nexus* 5 (Aug 1992): 233-234.
Review of an exhibition at M. Gutiérrez Fine Arts in Miami showcasing new talent from Colombia. Offers commentary on Rodriguez's paintings and mixed media "constructions," calling the latter "truly 'magical' objects of fantasy, but created with an intellectual purpose."

458. Iriarte, María Elvira. "Ofelia Rodríguez." *Art Nexus* 11 (Jan-Mar 1994): 128-131 [English trans., 224-225]. Bibl.
 María Elvira Iriarte traces the artist's development, remarking that her "schematic" and "primitivistic" compositions have been interpreted by some critics to contain surreal or pop art elements. Iriarte suggests that "her decision a few years ago to 'take risks, break rules and leap into the void' has led to the creation of her own very open and generous kind of language." *Reproductions: "En boca del precipicio" (1993), "Sueño luminoso amarillo de una montaña al vivo" (1992), "Caja mágica con chupos" (1993), "Caja mágica con rinoceronte y cactus" (1991), "Paisaje de Luio por las 3 colas desaparecidas de una iguana."*

Rueda, Ana María, 1954- Ibagué Painting

459. González, Miguel. "Ana María Rueda." *Arte en Colombia* 38 (Dec 1988): 119 [English summary, 167].
 Brief review of the artist's works shown in Cali's Museo de Arte Moderno La Tertulia which had nature as their theme. *Reproduction: From the series "Jardín."*

460. _____. "Artistas de los ochenta." *Arte en Colombia* 43 (Feb 1990): 98-99 [English summary, 157].
 Review of an exhibition of works by five Colombian neo-figurative painters presented by the Buenos Aires Instituto de Cooperación Iberoamericana (ICI). Stating that the artists were "in one way or another representative of the intensity which characterized painting in the past decade," Miguel González refers briefly to the works of Ana María Rueda, one of two women included in the show.

Salcedo, Doris Sculpture/InstallationArt

461. Amor, Mónica. "Doris Salcedo." *Art Nexus* 13 (July-Sept 1994): 102-103 [English translation, 166-167].
 Review and engaging examination of artistic intention in Salcedo's recent work presented in New York's Brooke Alexander Gallery. Mónica Amor describes artist's pieces as "an intertextuality of ideas and materials, forms and evocations" placed "within structures which are determined by. . . [the] life experience of human beings. . . Salcedo endows her installations and works with an affective dimension which is difficult to escape." *Reproduction: "La casa viuda I" (1994).*

462. Cameron, Dan. "Absence Makes the Art: Doris Salcedo." *Artforum* 33.2 (Oct 1994): 88-91.
 Interesting analysis of the artist's treatment of violence, the resultant sensation of loss it engenders and the emotional response her work evokes in the spectator. "An incidental question her work poses is why we in the U.S. tend to dismiss the violence in Colombia as inexplicable, barbarous, or simply corrupt, while rationalizing the equally dehumanizing daily violence of North American cities as an unfortunate but manageable side-effect of the country's role on the world

stage," writes Cameron. *Reproductions: "Atrabilarios" (1993), "La casa viuda" (1992-1994), "Untitled" (1992), "Untitled" (1989-1993).*

463. Gutiérrez, Natalia. "Doris Salcedo: alegrías y tristezas." *Art Nexus* 45 (Oct 1990): 128-129 [English trans., 174].
Review of Salcedo's installations at Bogota's Galería Garcés Velásquez. Natalia Gutiérrez emphasizes the interactive nature of her work, noting that the artist intends spectators to draw from their own "experiences and feelings" to extract meaning from the associations her arrangement of commonplace objects and other materials evokes. *Reproduction: View of installation (1990).*

464. Hirsch, Faye. "Doris Salcedo at Brooke Alexander." *Art in America* 82.10 (Oct 1994): 136.
Commenting on the artist's first solo exhibition in the United States, Faye Hirsch writes that the meaning of her work lies in the "uncanny" association her "unnatural combinations of materials" evoke, suggesting that her installations call forth "a persistent somatic recollection" of dark moments in the history of Colombia, "or elsewhere." *Reproduction: "La casa viuda I" (1992-1994).*

465. Merewether, Charles. "Comunidad y continuidad: Doris Salcedo: nombrando la violencia." English original, trans. by Magdalena Holguín. *Art Nexus* 9 (June-Aug 1993): 104-109 [English, 183-185]. Bibl.
Charles Merewether engages in a scholarly analysis of Salcedo's work , referring to it as a "series of meditations on the subject of violence. . . " He suggests that her intent in using "mundane domestic objects" is to emphasize the "affective" mark which the experience of loss leaves on members of a community. Includes views of several untitled installations dating from 1989 through 1992, including "Atrabiliarios."

466. Salcedo, Doris. "Doris Salcedo." Trans. Christopher Martin. *Flash Art* 171 (Summer 1993): 97.
Consists entirely of commentary by the artist. In her own words she conveys her source of inspiration and the artistic intention encompassed in her work.

Sanín, Fanny, 1938?- Painting

467. Barrett Stretch, Bonnie. "Six Latin American Women Artists." *Art News* 91 (Nov 1992): 138-139.
Review of exhibition at Humphrey in New York which Bonnie Barrett Stretch notes "shattered any stereotypes of Latin art that a visitor may have had." Briefly comments on "rhythmic canvases" of Fanny Sanín. *Reproduction: "Acrylic No. 2 (1989).*

468. Escobar, Patricia. "Seis artistas colombianos." *Arte en Colombia* 43 (Feb 1990):106 [English summary, 160-161].
Review of an exhibition in New York's Rempire Fine Art Gallery . Patricia Escobar comments briefly on the artist's work, stating that "for Sanín color is

the principal objective, providing the dimension of the structure and the sense of composition."

469. *Fanny Sanin.* Catalogue. [México, D.F.: Museo de Are Moderno, 1979]. Bibl. Essays, Fernando Gamboa and Carla Gottlieb. Includes biography and chronology.

470. Gallo de Bravo, Lylia. " Fanny Sanín: retrospectiva del MAM Bogotá." *Arte en Colombia* 34 (Sept 1987): 76-77 [English trans., 122].
 Review of retrospective exhibition at Bogota's Museo de Arte Moderno. Bravo traces Sanín's artistic journey, paying particular attention to the development of her style and technique and her "intuitive and sensitive exploration of geometric forms" that have earned for her international recognition. *Reproductions: "Acrylic No. 4" (1985), "Acrylic No. 2" (1973).*

471. Judd Ahlander, Leslie. "Fanny Sanín." *Art Nexus* 2 (Oct 1991): 133 [English trans., 191].
 Leslie Judd Ahlander's review of Sanín's paintings shown at the Inter-American Gallery in Miami-Dade Community College briefly traces the evolution in style of this geometric abstract painter and also highlights new directions. She writes, "As patterns become forms and diagonals suggest depth in space, Sanín's work picks up a new tension and vitality. . . a toning down of color and simplification of the areas within the composition also play their part in giving the new work a grittiness and rigor that adds immeasurably to their impact." *Reproduction: "Acrílico No. 2" (1989).*

472. Rubiano Caballero, Germán. "El color en las pinturas de Manuel Hernández y Fanny Sanín." *Arte en Colombia* 11 (Dec 1979): 38-39.
 Rubiano Caballero compares and contrasts Sanín's technique for combining color with that of another important abstract Colombian painter. Direct statements by Sanín clarify the relationship between her preliminary study and the finished work. *Reproduction: "Acrílico No. 4" (1979).*

473. _____. "Fanny Sanín." *Art Nexus* 13 (July-Sept 1994): 89 [English trans., 156-157].
 Review of the artist's works presented at Bogota's Garcés Velásquez Gallery. Germán Rubiano Caballero remarks that "after years of work, her acrylic works have now acquired an undeniable maturity, appearing both more intense and more audacious." *Reproduction: "Acrílico No. 2" (1994).*

Sepúlveda, Regina Photography

474. Ruiz, Darío. "Saturnino Ramírez, Rodrigo Isaza, Regina Sepúlveda." *Art Nexus* 6 (Oct 1992): 146-147 [English summary, 211].
 Darío Ruiz provides very brief but not unfavorable commentary on Sepúlveda's photographs shown at Medellín's Bolero Bar, remarking that they are "without doubt the promise of fine things to come." *Reproduction: "Sin título" (1991).*

Suárez, Gilma Ibagué Photography

475. Rodríguez, Marta. "Gilma Suárez." *Art Nexus* 6 (Oct 1992): 135 [English summary, 207].

A series of photographs shown at Galería Garcés Velásquez in Bogotá records the spectator's encounter with art. Marta Rodríguez writes that they are the "fruit of her patient observation of the people who visit art galleries and museums. . . The result is both a subtle and meaningful illustration of the encounter between art and life." Includes a reproduction of an untitled piece.

476. Sulic, Susana. "Gilma Suárez." *Arte en Colombia* 46 (Jan 1991): 130 [English trans., 186].

Review of first solo exhibition by a self-taught photographer who resides in Paris. Includes a reproduction of an untitled work.

Tavera, Patricia, 1941 - Bogotá Painting

477. González, Miguel. "Tavera y Friedemann." *Arte en Colombia* 40 (May 1989): 118 [English summary, 159].

Miguel González comments on artist's solo exhibition in Cali's Museo de Arte Moderno La Tertulia. He writes, "Tavera has now reduced her images to a dense interplay of dark and emotional color which offers a dramatic version of figurative art."

Tejada, Lucy, 1920- Pereira Painting/Drawing/Collage

478. González, Miguel. "Lucy Tejada." *Art Nexus* 8 (Apr-June 1993): 121-122. [English trans., 192].

Retrospective exhibition at the FES Foundation in Cali presented some 100 works produced by Tejada between 1949 and 1992. González traces artist's training and development, remarking on the range of mediums she used in the '60s, "easily distinguishing herself from her contemporaries." *Reproduction: "Color de rosa" (1968).*

479. *Lucy Tejada: Retrospectiva, 1949-1982*. Catalogue. Bogotá, Colombia: Instituto Colombiano de Cultura, [1983].

Torres, Alicia Painting

480. Mujica, Barbara. "Bright Visions, Fine Contours." *Américas* 43.3 (May-June 1991): 44-51.

Sketches of ten women, among them Alicia Torres, identified by Mujica as being "on the cutting edge" of their profession. Artist's own statements give some insight into the purpose of her "geometrical forms." *Reproduction: "Evolution" (1973).*

Uribe, Gloria Painting

481. Rojas Mix, Miguel. "Gloria Uribe: primitivismo o real maravilloso?"
Arte en Colombia 39 (Feb 1989): 81-82 [English trans., 164].
 In his review of Uribe's paintings presented at Benézit Gallery in Paris, Rojas
Mix explores amalgam of realities which gives shape to her artistic vision and
imbues her work with elements of the fantastic. He writes, "Gloria Uribe is
Colombian and the world which she transposes in her painting is the product of
that reality. Her painting, like her world, is fairy-like, a story which has become
a picture, a fable transformed into an image." *Reproduction: "El trabajo"
(1985).*

Varela, Mariana Drawing/Printmaking

482. Rubiano Caballero, Germán. "Las fragmentaciones turgentes de
Mariana Varela." *Arte en Colombia* 10 (Sept 1979): 34-36.
 Germán Rubiano Caballero considers artist's sensuous renderings of the
female figure, using terms such as "photographic realism" and "classicism" to
describe the works. He remarks on her unique power of observation and mastery
of detail which allow her to project the three-dimensionality of everyday objects
such as a laced shoe, a bulging zipper and clothing clasps. Includes
reproductions of various untitled works.

Vélez, Bibiana, 1956- Cartagena Painting

483. González, Miguel. "Bibiana Vélez." *Arte en Colombia* 46 (Jan 1991):
139-140 [English trans., 189].
 Review of an exhibition in Cali's Museo de Arte Moderno La Tertulia.
González remarks on the style and technique the artist uses to achieve an
atmosphere of fantasy in her images of bathers in the water. *Reproduction:
"Flotante" (1989).*

Vieco, María Teresa Bogotá Painting

484. Sulic, Susana. "María Teresa Vieco." *Art Nexus* 3 (Jan 1992): 171
English trans., 223].
 Review of Vieco's work shown in Paris. Sulic remarks that her fusion of
European and African cultural elements with a Latin American vision -- which
Sulic calls "magical" -- imbues her work with vitality and raises questions of
identity. *Reproduction: "Muros" (1991).*

Viteri, Alicia, 1946- Pasto Drawing/Painting/Collage

485. Mejía, Manuel Esteban. "Alicia Viteri." *Art Nexus* 7 (Jan-Mar
1993): 171-172 [English summary, 234-235].
 Manuel Esteban Mejía discusses the artist's works shown at La Galería in
Quito, Ecuador. Observing that her paintings make a statement about power
within the context of historical and contemporary Latin American reality -- and

the pleasures which derive from it -- he notes that Viteri's critique is executed with "humor, irony and subtle sarcasm but also with succinct tenderness." *Reproduction: "Consejo de Ministros" (1991).*

486. Rodríguez, Marta. "Alicia Viteri." *Art Nexus* 4 (Apr 1992): 150 [English summary, 220].
 Review of the artist's work shown in Bogotá's Alfred Wild Gallery. Show consisted of drawings, paintings and collages which, critic notes, drew from the literary realm for their inspiration, especially works by Edgar Allan Poe. "Viteri challenges in these works the established parameters of art and literature. . . using caricature to endow her figures with a sense of the grotesque. . . for Alicia Viteri art is an act of confession and testimony . . . a daring personal condemnation of Latin American reality, with its endless dictatorships and acts of invasion and usurpation," writes Marta Rodríguez. *Reproduction: "Ministro de Relaciones Exteriores" (1989).*

487. _____. "Alicia Viteri: el arte es la vida." *Arte en Colombia* 37 (Sept 1988): 80-83 [English trans., 157-158]. Bibl.
 Material for this essay was gathered primarily from an interview with the artist in 1987. Marta Rodríguez notes the convergence of life and art in Viteri's work, remarking that her canvases and prints cut across objective reality to lay bare the human condition, the hidden "face of the soul." *Reproductions: "Tele" (1975), "El grupo" (1986), from the series "Carnavales" (1983), "El Zonián y la Vedette," detail (1984), "Dibujo" (1981), "Espacios pictóricos," "Hombres de azul" (1984).*

COSTA RICA

Borrase, Carmen, 1959- San José Painting

488. Salazar, Hazel. "La pintura de Carmen Borrase." *Revista del Pensamiento Centroamericano* 42.197 (Oct-Dec 1987): 36-37.
 Essay describing "mystical" content of painter's works. Includes artist's statement, as well as portrait.

Fernandez, Lola, 1926- Colombia Painting/Tapestry

489. Gómez Sicre, José. "Lola Fernández o la unidad de un doble concepto." *Revista del Pensamiento Centroamericano* 42.194 (Jan-Mar 1987): 31-34.
 Study of Costa Rican-based artist which examines her development from figurative to abstract painter during a period, according to Gómez Sicre, when plastic arts were at a standstill in that country. Comments on the technique and style that Fernández uses to produce her images and the influences which have impacted on her work, with special emphasis on those acquired in India and Japan. Identifies her as a precursor of a new mode of artisitic expression and credits her with the flourishing of a national art. Includes a brief biographical sketch. *Reproduction: "Soledad" (1963).*

490. *Lola Fernández: retrospectiva, 30 años de pintura.* Catalogue. [San José, Costa Rica: Museo de Arte Costarricense, 1974]. Includes chronology.

491. Zavaleta Ochoa, Eugenia. "Gestación del arte abstracto en Costa Rica." *Káñina* 17.2 (July-Dec 1993): 245-265. Bibl.
Considers the accomplishments of three artists considered by writer as the precursors of an abstract mode of expression in Costa Rica, among them Lola Fernández (245-247). Includes details of her education and training, emphasizing influence which her travels in Italy had on her break with academic principles.

492. _____. *Los inicios del arte abstracto en Costa Rica, 1958-1971.* San José, Costa Rica: Museo de Arte Costarricense, 1994. 3-4.

Matamoros, Rossella Painting

493. Carbo, Rosie. "Different Strokes." *Hispanic* (Apr 1992): 11-14.
Profile of Washington, D. C.-based artist. Rosie Carbo notes that Matamoros "is not only a born artist, but she is recognized as one of her country's foremost painters, and is rapidly gaining fame in the U. S." Of her work the artist writes, " I think many of my paintings reflect a difficult childhood, my family, my friends, and my ambitions. . . they are very honest in their description of the Latin American woman's experience." Contains information about her education, training and the influences on her work. Includes artist's portrait. *Reproductions: "Angel," "A Different Dimension," "Liberation," "Light."*

494. Mujica, Barbara. "Bright Visions, Fine Contours." *Américas* 43.3 (May-June 1991): 44-51.
Sketches of ten women, identified by Mujica as being "on the cutting edge" of their profession. Includes statements by Matamoros regarding the influence of Latin American culture on her work. *Reproduction: "Untitled" (1990).*

Rojas, Gioconda, 1967- Painting

495. Flores Zúñiga, Juan Carlos. *Magic and Realism: Central American Contemporary Art = Magia y realismo: arte contemporáneo centroamericano.* Trans. Orlando García Valverde. Tegucigalpa, Honduras: Ediciones Galería de Arte Trio's, 1990. 222-227. Bibl.
Brief profile with personal statements by the artist, a portrait and reproductions of various of her works. In English and Spanish.

CUBA

Badías, María Elena, 1959- Havana Painting

496. Gómez Sicre, José. *Art of Cuba in Exile.* Trans. Ralph E. Dimmick. Miami, FL: Editora Munder, 1987. 156.

497. Mujica, Barbara. "Bright Visions, Fine Contours." *Américas* 43.3 (May-June 1991): 44-51.
 Sketches of ten women identified by Mujica as being "on the cutting edge" of their profession. Includes statements by Badías that briefly explain her approach to two of her works. *Reproductions: "The Coming of a Little Love" (1986), "The Color of Summer" (1990).*

Brito-Avellana, María, 1947- Havana Painting/Mixed Media Sculpture

498. Bosch, Lynette M. F. "Metonomy and Metaphor: María Brito." *Latin American Art* 5.3: (Fall 1993): 20-23 [Spanish trans., 74-76]. Bibl.
 Detailed study of Brito's work which gives some biographical information, as well as facts regarding her education. The description and explanation of several of her mixed media sculptures provide a glimpse into the artist's inner world and reveal the concerns which fuel her artistic production. Lynette Bosch writes, "Brito thinks of her work as 'being a bracket in our reality, in the reality we all share, hence I try to offer the spectator a newly transformed alternative vision of that reality through the experience of sharing my perception.'" *Reproductions: "View of My Garden" (1992), "Meanderings" (1985), "After the Conquest" (1984), "A Theory on the Annihilation of Dreams" (1987), "Self-Portrait" (1989), "The Garden and the Fruit" (1987).*

499. Gómez Sicre, José. *Art of Cuba in Exile.* Trans. Ralph E. Dimmick. Miami, FL: Editora Munder, 1987: 203-204.

500. *Islands in the Stream: Seven Cuban American Artists.* Catalogue. Cortland, NY: Dowd Fine Arts Gallery, State University at Cortland, 1993? Essay, Lynette Bosch. Bibl.

501. Krane, Susan and Carrie Przybilla. *Southern Expressions: Tales Untold: Maria Brito. . .* [et al]. Catalogue. Atlanta, GA: High Museum of Art, 1991. Essay, John Stringer. Includes chronology.

502. Lippard, Lucy R. *Mixed Blessings: New Art in a Multicultural America.* New York, NY: Pantheon Books, 1990: 153. Bibl.

503. "Lydia Rubio, César Trasobares, Ricardo Zulueta, Ricardo Viera, María Brito and María Lino." *Art Papers* 17.1 (Jan.-Feb 1993):17-20.

504. *María Brito-Avellana.* [Miami, FL: Miami Dade Community College, Mitchell Wolfson New World Center, 1989]. Text, John Stringer. Includes chronology.

505. *Revelations/Revelaciones: Evanescence and Latino Art.* Catalogue. Ithaca, N.Y.: Herbert F. Johnson Museum of Art, Cornell University, 1993. Ed. José Piedra and Chon Noriega.

506. Veciana-Suárez, Ana. "María Brito." *Notable Hispanic-American Women*. Detroit: Gale Research, 1993. Ed. Diane Telgen, Diane and Jim Kemp. 59-60. Bibl.

Campos-Pons, María Magdalena, 1959- Matanzas

507. Camnitzer, Luis. *New Art of Cuba*. Austin: University of Texas Press, 1994. Bibl. 211-214.

508. Fusco, Coco. "Magdalena Campos-Pons at Intar." *Art in America* 82 (Feb 1994): 106-107.
 Coco Fusco remarks on this expatriate artist's transition from easel painter to visual artist and her use of amate paper, marble, photography and video to investigate and comment on Cuban culture and traditions, particularly Santería. *Reproduction: "The Seven Powers Came by the Sea" (1993).*

Castañeda, Consuelo

509. Camnitzer, Luis. *New Art of Cuba*. Austin: University of Texas Press, 1994. 270-274. Bibl.

510. Cockroft, Eva. "Cuba Exports Postmodernism: Post-Revolution Artists in New York Exhibition." *New Art Examiner* 15 (Apr 1988): 33-34.
 In her review essay of the exhibition, "Signs of Transition: 80s Art from Cuba," Eva Cockroft examines ways in which Cuban artists "struggle to combine nationalism with avant-garde experimentation, while avoiding the trap of derivative colonial dependence." Mentions work of Consuelo Castañeda.

511. *Consuelo Castañeda*. Catalogue. México, D.F.: Ninart Centro de Cultura, 1992. Interview, Nina Menocal. Includes biography.

Cerra, Mirta, 1904- Painting

512. La Duke, Betty. "Interview with Painter Mirta Cerra, Havana Cuba, 1982." *Women Artist News* 9.1 (Fall 1983): 10.
 La Duke notes that this artist who is included "in the first generation of women artists, dating from the 1930's. . . participated in every major exhibit of Cuban art, and established the position of Cuban women in the fine arts." Comments on her training at home and abroad, the cubist influences present in her work, and the Cuban environment which served as inspiration for her painting. Includes statements by the artist. *Reproductions: "3 Figures," "Still Life."*

513. _____. "A Pioneer of Modern Cuban Art." *Américas* 36.3 (May-June 1984): 51-52.

Del Río, Zaida, 1954- Guadalupe Painting

514. Cockroft, Eva. "Cuba Exports Postmodernism: Post-Revolution
Artists in New York Exhibition." *New Art Examiner* 15 (Apr 1988): 33-34.
In her review essay of the exhibition "Signs of Transition: 80s Art from
Cuba," Eva Cockroft examines ways in which Cuban artists "struggle to
combine nationalism with avant-garde experimentation, while avoiding the trap
of derivative colonial dependence." Mentions work of Zaida del Río.

515. *Herencia Clásica.* La Habana, Cuba: Centro de Desarrollo de las Artes
Visuales, 1989. Illustrations by Zaida del Río.

Del Sol, Dania

516. Camnitzer, Luis. *New Art of Cuba.* Austin: University of Texas
Press, 1994. Bibl. 282-286.

Eiriz, Antonia, 1929- Havana Painting

517. Blanc, Guilio V. "Antonia Eiriz: una apreciación." English original,
trans. by Magdalena Holguín. *Art Nexus* 13 (July-Sept 1994): 44-46.
Guilio Blanc offers sketch of the artist and commentary on her paintings
shown at Miami's Weissen Gallery, noting in particular her preference for the
abstract in her stark renditions of man's inhumanity towards humanity.
*Reproductions: "Paisaje 2," "Cruxificción" (1993), "La anunciación" (1964),
"Reencarnaciones" (1993).*

518. *Vision de hoy de la pintura cubana, 21 de abril al 21 de junio 1994.*
Catalogue. Santiago, Chile: Galería Czechowska, 1994. Text, Manuel López
Oliva. Includes biography and chronology.

Galleti, Lia, 1943- Havana

519. Gómez Sicre, José. *Art of Cuba in Exile.* Trans. Ralph E. Dimmick.
Miami, FL: Editora Munder, 1987. 129-130.

García, Rocío Painting

520. Hernández, Erena. "Rocío García." *Art Nexus* 7 (Jan-Mar 1993): 159
[English trans., 227].
Review of the artist's paintings shown in Havana. Erena Hernández interprets
her work as an indictment of female frivolity and superficiality, remarking that
the presence of irony and humor in her paintings render them likable, however,
and place the focus not on the individual but on the foolish habits and customs
which can tie women down. *Reproduction: From the series "Diario de una
dama" (1991).*

García-Ferraz, Nereyda, 1954- Havana Painting

521. Budhoff, Nathan. "Nereyda García Ferraz." *New Art Examiner* (June Summer 1992): 51-52.
Considers painter's work shown at Deson/Saunders Gallery in Chicago. About her imagery Budhoff writes, "Garcia-Ferraz's work is largely about exile. There is a sense of yearning and memory. . . [it] is about a personal journey, and the construction of a space where the memory and sense of a lost world can be refined." *Reproduction: "Dedicado a quien sabe esperar." (1991).*

522. *Nereyda García-Ferraz.* Catalogue. Sprinfield, IL: Illinois State Museum, 1991. Essay, Robert Sill (in English and Spanish).

Gómez de Molina, Clara Painting

523. Friol, Roberto. "Impromptu por la primera exposición de Clara Gómez de Molina." *Revista de la Biblioteca Nacional José Martí* 27.1 (Jan-Apr 1985): 203.
Short appreciative essay on the occasion of the artist's first exhibition.

524. Solís, Cleva. "Exposiciones de pintura de Marta Rodríguez y Clara Gómez de Molina." *Revista de la Biblioteca Nacional José Martí* 29 (Jan.-Apr. 1987): 196-197.
Briefly reviews exhibition at Cuban National Library.

González, María Elena, 1957-Havana

525. Campoamor, Diana. "Hammering Out a Niche in the New York Art World." *Intercambios: A Publication of the National Network of Hispanic Women* 5.1 (Winter 1990): 29.
Profiles the accomplishments of an artist who explores a variety of subjects in her "massive reliefs." Includes artist's portrait and statements.

526. Sangster, Gary. *Cadences: Icon and Abstraction in Context.* Catalogue. New York: NY: New Museum of Contemporary Art, 1991. Bibl. Essays, Gary Sangster, Yve-Alain Bois, and Elizabeth Grosz.

Gronlier, Hortensia, 1933- Havana Painting

527. Gómez Sicre, José. *Art of Cuba in Exile.* Trans. Ralph E. Dimmick. Miami, FL: Editora Munder, 1987. 46-47.

Haya, María Eugenia, 1944-1991 Photography

528. Conger, Amy. "Some Observations about Contemporary Cuban Photography: The Union of Cuban Writers and Artists (UNEAC)." *Studies in Visual Communication* 8.4 (Fall 1982): 62-80. Bibl.

529. Hernández, Erena. "María Eugenia Haya, Constantino Arias." *Art Nexus* 5 (Aug 1992): 160 [English summary, 238].
Pays homage to two outstanding figures in Cuban photography. Erena Hernández writes that "María Eugenia Haya (Marucha) was not only an excellent photographer but also a great promoter of cultural values and a writer of outstanding essays who produced the first and most valuable studies on the history of photography in Cuba." Includes photo portraits.

Herrera, Carmen, 1915- Havana Painting

530. Blanc, Giulio V. "The Cubans Have Arrived." *Art & Antiques* 15 (Dec 1993): 65-73.
Art historian Giulio Blanc quickly guides reader along brief inspection tour of modern Cuban art history, weaving into his selective inventory of major and emerging artists the names and works of a number of women. Provides commentary on artist's work, as well as a portrait (66).

531. *Carmen Herrera: A Retrospective, 1951-1984.* Catalogue. [New York, N.Y.: Alternative Museum, 1985]. Text, Judith Neaman. Includes chronology.

532. *Five Latin American Artists at Work in New York: Alpuy, Herrera, Maza, Mishaan, Yrarrazaval.* Catalogue. [New York, NY: Center for Inter-American Relations, n.d.].

533. Westfall, Stephen. "Carmen Herrera at Rastovski." *Art in America* 77 (Mar 1989): 150-151.
Brief sketch of the artist on the occasion of her exhibition at Rastovski in New York City. *Reproduction: "Lemon Yellow and Cobalt Blue" (1988).*

Lazo, Lilia, 1935- Mantua

534. Gómez Sicre, José. *Art of Cuba in Exile.* Trans. Ralph E. Dimmick. Miami, FL: Editora Munder, 1987. 69-73.

Lino, María, 1951- Havana

535. Lino, María. "Reseña exposición: Enclosure/Incidents." *Areito* 5.19-20 (1979): 50-51.
Artist talks about the relationship of line and space in her sculptural arrangements. Contains some biographical details and information on her training and development, as well as reproductions of various of her works.

536. "Lydia Rubio, César Trasobares, Ricardo Zulueta, Ricardo Viera, María Brito and María Lino." *Art Papers* 17.1 (Jan.-Feb 1993):17-20.

537. *New Images: Carol Levy and María Lino: March 20 - April 17 1986.* Catalogue. Miami, FL: Frances Wolfson Art Gallery, Miami-Date Community College, 1986. Essay, Mary Lee Ataie.

Lloveras, Connie, 1958- Havana Ceramics/Mixed Media

538. Ahlander, Leslie Judd. "Connie Lloveras: magia en arcilla." *Arte en Colombia* 46 (Jan 1991): 118-119 [English trans., 179].
Review of the artist's painted clay sculptures shown at Barbara Gillman Gallery. Leslie Judd Ahlander writes that she is "one of the few Cuban artists who has integrated her experiences of exile and change into a valid art form that turns nostalgia and loss into universal symbols that speak of the totality of human experience." Details about artist's technique are included, as well as artist's own statements regarding the significance of the imagery which she depicts in her work. *Reproduction: "La mano, Mi hacedor."*

Luna, Laura, 1958- Havana Painting/Sculpture

539. Gómez Sicre, José. *Art of Cuba in Exile.* Trans. Ralph E. Dimmick. Miami, FL: Editora Munder, 1987. 56-57.

540. Mujica, Barbara. "Bright Visions, Fine Contours." *Américas* 43.3 (May-June 1991): 44-51.
Sketches of ten women identified by Mujica as being "on the cutting edge" of their profession. Referring to the female imagery seen frequently in Luna's work, Mujica writes that the artist "glorifies womanhood -- including female sensuality and woman's role in procreation -- by liberating it from the traditional, idealized images of women that predominate in Western art." *Reproduction: "The Consequences of Walking and the Inevitable Paths It Leads To" (1990).*

Maggi, Jacqueline Engraving/Sculpture

541. Hernández, Erena. "Jacqueline Maggi." *Art Nexus* 8 (Apr-June 1993): 123-124 [English trans., 193-194].
Describing Maggi as a "paradox in the present Cuban fine arts panorama" Erena Hernández comments briefly on her development and the wood carvings shown recently in Castillo de la Fuerza in Havana. *Reproduction: "Sin título" (1991).*

Martínez-Cañas, María, 1960- Havana Photography

542. Damian, Carol. "María Martínez Cañas: El viaje a casa." *Art Nexus* 9 (June-Aug 1993): 114-117 [English trans., 187-188].
Indepth portrait that includes some biographical data, as well as information on the artist's background and training. Carol Damian describes in detail the techniques that Martínez Cañas uses to assemble her photographic images, the search for her Cuban heritage that serves as inspiration for her work, as well as the influence of Wilfredo Lam's art on her work. "María assembles the eccentric images of old charts and city maps in a fragmented construction of amberlith and image negatives. A 'complete artist,' she is involved in every aspect of her work, from the photographing, to the cutting, the final assembly and

processing," writes Damian. *Reproductions: "Pájaro" (1990), "Con La Habana de fondo" (1991), "Rumbos de un pueblo blanco" (1991), "Quince sellos cubanos: la quinta columna" (1991-1992), "Mi presencia ante tu selva" (1991).*

543. *Manipulations: Photographs by Roger Cutforth, María Martínez-Cañas.* Catalogue. Miami, FL: Miami-Dade Community College, Mitchell Wolfson New World Center, 1988. Includes statements by the artist, as well as a chronology.

544. *María Martínez-Cañas: Encounters.* Catalogue. Tucson, AZ: Center for Creative Photography, 1991. Bibl. Essay, Terence Pitts. Includes artist's statement.

545. *María Martínez-Cañas: "Fragmented Evidence," New Work.* Catalogue. Chicago, IL: Catherine Edelman Gallery, [1991]. Bibl. Essay, Catherine Edelman.

546. *La nueva fotografía puertorriqueña.* [San Juan, Puerto Rico: Museum of Fine Art, University of Puerto Rico, 1986] (Travelling to Colegio Universitario de Cayey; Colegio Tecnológico de Ponce, Colegio de Agricultura y Artes Mecánicas Mayaguez).

547. Turner, Elisa. "María Martínez Cañas." *Latin American Art* 5.1 (Spring 1993): 85-86 [Spanish trans., 114-115].
 Profile of the artist giving details of her training and background and the innovative techniques she has developed to express her search for country and identity. Remarking on the influence of Cuban Surrealist Wilfredo Lam on her work, Elisa Turner describes her photographic assemblages as having "spare elegance" and "bold beauty." Includes statements by Martínez Cañas explaining the stages in her professional development and the driving force behind her most recent work. *Reproduction: "Los fantasmas: lamento" (1991).*

548. _____. "María Martínez-Cañas." *Art News* 91.3 (Mar 1992): 140.
 Review of an exhibition at Miami's Barbara Gillman. Elisa Turner describes artist's technique for creating her images. *Reproduction: "Free Me: Figure with Totem" (1991).*

549. Veciana-Suárez, Ana. "María Martínez-Cañas." *Notable Hispanic-American Women.* Ed. Diane Telgen and Jim Kemp. Detroit: Gale Research, 1993. 263-264. Bibl.

Mendieta, Ana, 1948-1985 Havana Performance/Sculpture

550. *Ana Mendieta.* Catalogue. [Los Angeles, CA: Lace-Los Angeles Contemporary Exhibitions, 1989]. Bibl. Essay, John Perreault (in English and Spanish). Includes chronology.

551. *Ana Mendieta: A Book of Works.* Introduction, Bonnie Clearwater. Miami Beach, FL: Grassfield, 1993. Includes writings by the artist.

552. *Ana Mendieta: A Retrospective.* Catalogue. [New York, NY: New Museum of Contemporary Art, 1987]. Bibl. Petra Barreras del Río and John Perrault, guest curators. Includes chronology and statements by artist.

553. Camnitzer, Luis. "Ana Mendieta en el New Museum de Nueva York." *Arte en Colombia* 38 (Dec 1988): 44-49 [English trans., 133-135].
 Indepth portrait by artist, critic and friend of Ana Mendieta. Luis Caminitzer provides a great deal of information about the artist's background, including details of her childhood and her separation from Cuba at the age of 14. He makes an interesting analogy between Spanglish -- the mixture of Spanish and English to produce, as he says, an "inept hybrid" of the two languages -- and the aesthetic developed by Mendieta. Interesting study which aids in understanding the artist as person, her attitude towards life and her work, and the context in which she produced her images and their underlying meaning. Includes reproductions of various of her sand sculptures and performances.

554. _____. "Ana Mendieta." *Third Text* 7 (Summer 1989): 47-52.
 Later version of above article. *Reproductions: Performance (1974), Photo Etching of Sculpture in Jaruco (1983).*

555. _____. *New Art of Cuba.* Austin: University of Texas Press, 1994. 89-99. Bibl.

556. _____. "Obituario." *Arte en Colombia* 29 (Feb 1986): 74-75.
 Obituary highlighting feminist concerns of artist and her work. *Reproductions: "Untitled" (1984) and "Serie mujeres de arena" (1983).*

557. Eauclaire, Sally. "Ana Mendieta." *Art News* 92 (Apr 1993): 140-141.
 Review of artist's work shown at Laura Carpenter Fine Art. Sally Eauclaire points out that "Mendieta was a modern primitive, honoring the four elements of earth, fire, air and water. She identified with Cuba's landscape so completely that she was repeatedly able to invoke its regenerative powers. Eight years after her untimely death, Ana Mendieta lives on through ancient yet contemporary works that remain at once visceral and spiritual, ephemeral and enduring." Includes view of installation that was on exhibition.

558. Galligan, Gregory. "Ana Mendieta: A Retrospective." *Arts Magazine* 62.8 (Apr 1988): 48-49.
 Gregory Galligan considers the meaning of Mendieta's art on the occasion of her retrospective exhibition at the New Museum of Contemporary Art. He writes that her work "evokes ideas of regeneration and rebirth as much as ruin and unreclaimable loss." *Reproductions: "Figure with Gnanga" (1984), "Guanbancex" (1981), "Untitled" wood slab carved and burnt with gunpowder (1985).*

559. García-Ferraz, Nereyda, Kate Horsfield, and Branda Miller. *Ana Mendieta, fuego de tierra : a videotape*. Videorecording. New York: Video Data Bank, 1988. VHS format.
 This video documents many of Ana's performances while also providing an affectionate glimpse into her early life and the evolution of her work. Her own words and the remarks of family members, former instructors and colleagues aid in understanding the multidimensional significance of her artistic production. In English and Spanish.

560. Goldman, Shifra M. "A Return to Natal Earth." *Artweek* 15 Apr 1989: 1. Rpt. as "Ana Mendieta: A Return to Natal Earth" in Shifra M. Goldman, *Dimensions of the Americas: Art and Social Change in Latin America and the United States*. Chicago: University of Chicago Press, 1994. 236-238.

561. Jacob, Mary Jane. *Ana Mendieta, the Silueta Series, 1973-1980*. Catalogue. New York, NY: Galerie Lelong, 1991. Bibl.

562. Johnson, Ken. "Ana Mendieta at the New Museum of Contemporary Art." *Art in America* 76 (Mar 1988): 153-154.
 Review essay. *Reproduction: Untitled from "Fetish Series" (1977)*.

563. Katz, Robert. *Naked by the Window: The Fatal Marriage of Carl Andre and Ana Mendieta*. New York, NY: Atlantic Monthly Press, 1990.
 Includes various photographs of the artist.

564. Lindsay, Arturo Wesley. *Performance Art Ritual as Postmodern Thought: An Aesthetic Investigation*. Ph.D. Dissertation. New York University, 1990.

565. Lippard, Lucy R. "Made in the U.S.A.: Art from Cuba." *Art in America* 74 (Apr 1986): 27-35.
 Lucy Lippard explores variety of influences at work in the art of young Cuban artists. Examines "Cubanía," or Cubanism, present in the "sensuous, abstracted female figures" Mendieta carved on cave walls in Escaleras de Jaruco (33). *Reproduction: "Rupestrian Sculpture" (1981)*.

566. _____. *Mixed Blessings: New Art in a Multicultural America*. New York, NY: Pantheon Books, 1990. 86. Bibl.

567. Mendieta Harrington, Raquel. "Ana Mendieta: Self-Portrait of a Goddess." *Review: Latin American Literature and Arts* 39 (Jan-June 1988): 38-39.
 Raquel Mendieta, a visual artist, traces her sister's artistic journey from the University of Iowa School of Art in the '70s to Mexico, Cuba in 1981 and Miami in 1982-1983. Performance pieces gave way to the sculpting of female figures on the earth, cave walls, trees and ocean beaches. *Reproduction: "El laberinto de la vida" (1982)*.

568. Morejón, Nancy. "Ana Mendieta." *Hispamérica* 22.66 (Dec 1993): 59-61.
Poem.

569. _____. "Ana Mendieta." *Casa de las Américas* 190 (Jan-Mar 1993): 116-118.
Poem.

570. Mosquera, Gerardo. "Ana Mendieta: esculturas rupestres." *Areito* 7.28 (1981): 54-56.
Gerardo Mosquera describes Escaleras de Jaruco, hilly ranges in western Cuba that served as backdrop for the earthworks that Ana Mendieta sculpted in 1981. Writer remarks that the artist's work was profoundly motivated by the psychological trauma of having to abandon Cuba and her family at an early age. Mendieta's own words give testimony to her strong identification with Cuba and her desire to share her work with others. Includes photographs of various of her works and the surroundings in which she created them.

571. Rauch, Heidi and Federico Suro. "Ana Mendieta's Primal Scream." *Américas* 44.5 (Sept-Oct 1992): 44-48.
Absorbing account of Mendieta's artistic journey. Direct commentary by the artist sheds light on the context in which much of her work was created and her artistic intention. In addition to exploring the influence of Santería beliefs on her work, authors refer to aspects of her personal life which had a bearing on the development of her highly original approach to the creative process. They write that "making no concessions to the standard ideal of beauty, her potent, sometimes crude statements urge the viewer to go beyond the confines of the conventional. The boundless work created by this artist during her tragically brief career guaranteed her a niche in history. . . Mendieta's vision remains as potent as ever, harboring great relevance for coming generations." *Reproductions: "Anima ((Alma/Soul)" fireworks "Silueta" series (1976), "Untitled" from the "Arbol de la Vida (Tree of Life)" series (1977), "Silueta" series with water and vegetation (1979), "Guanbancex, Goddess of the Wind" from the "Esculturas Rupestres" series (1981), "Arbol de la Vida" (1977), "Rastros Corporales (Body Tracks)" series (1982).*

572. Rogoff, Irit. "The Discourse of Exile: Geographics and Representations of Identity." *Journal of Philosophy and the Visual Arts* (UK) 1989: 70-75. Bibl.
Examines the concepts of "deterritorialization" and "reterritorialization" as they apply to the artist's work. *Reproduction: Untitled from "Tree of Life" series (1977).*

573. Sargent Wooster, Ann. "Ana Mendieta: Themes of Death and Resurrection." *High Performance* 11 (Spring/Summer 1988): 80-83. Bibl.
Remarking that the artist's work did not develop "in a vacuum" -- noting how various of her contemporaries also used body and earth as elements in their performances -- she points out cultural particularities in her work and the media

which she used. *Reproductions:* *"Anima" (1976), "Untitled" clay carving (1980), "Untitled" (1977).*

574. Spero, Nancy. "Tracing Ana Mendieta." *Artforum* 30.8 (Apr 1992): 75-77.
 Appreciative essay which includes some direct statements and a short poem by the artist. *Reproductions: Several untitled from the "Silueta" series (1973-1978), "Incantación a Olokun Yemayá" (1977), "Untitled" from "La Jungla" series (1983).*

575. Torruela Leval, Susana. "Recapturing History: The (Un)Official Story in Contemporary Latin American Art." *Art Journal* 51.4 (Winter 1992): 69-80.
 Author considers ways in which various artists, among them Ana Mendieta, "employ historical memory for the recovery of a spiritual dimension, for its restoration to a place of familiarity and importance within contemporary life." *Reproduction: From the series "Esculturas Rupestres/Rupestrian Sculptures" (1981).*

576. Tulley, Judd. "In Homage to Ana Mendieta." *New Art Examiner* 13 (May 1986): 59-60.
 Comments on an exhibition of works by twenty-nine women which was shown at New York's Zeus-Trabia recalling Mendieta's life, death, and work.

Morera, Clara, 1944- Camagüey

577. Blanc, Giulio V. "Clara Morera." *Art Nexus* 12 (Apr-June 1994): 122 [English trans., 187-188].
 In his review of Morera's work which was presented at the Alfredo Martínez Gallery in Miami, Giulio Blanc considers the influence of a variety of belief systems on her art. "The symbols Morera employs: the heart, chalice, eyes, hand, crosses and burning candles all appear in various forms in Eastern mysticism as well as in Western Alchemy and Rosicrucianism. . . [they] relate to concepts of creation and destruction, transformation, and the union of opposites," writes Blanc. *Reproduction: "Autorretrato" (1993).*

578. Vasílieva, Svetlana. "El Apocalipsis afro-cubano." *América Latina* (USSR) 11 (1990): 95-96.
 Considers performances by the artist in Moscow and Leningrad and spectators' responses and interaction.

Peláez, Amelia, 1897-1968 Santa Clara Painting/Ceramics

579. Ahlander, Leslie Judd. "Amelia Peláez." *Arte en Colombia* 39 (Feb 1989): 43-45 [English trans., 147-148].
 In this profile Leslie Judd Ahlander highlights significant aspects of artist's career, including her travel to Europe and the influences she absorbed during her stay, her association with Cuban artist and writer, Lydia Cabrera, and the

subjective character of her work. Ahlander writes, "Working alone, isolated by choice, never compromising her standards to follow the latest fad, Amelia pursued her course, finding infinite riches within the narrow confines of her house and garden. Each flower is painted as though it were a monumental, sculptural, deeply erotic symbol of life and death, carrying within it the seeds, the efflorescence and the slow decay that mirrors life, creating a parable of universal existence from small and intimate things." *Reproductions: "Pez" (1958), "Frutero" (1947), "Hermanas leyendo" (1944), "Hibiscus/Marpacífico" (1943).*

580. Alonso, Alejandro G. *Amelia Peláez.* La Habana, Cuba: Editorial Letras Cubanas, 1990. Bibl.

581. *Amelia Peláez.* Catalogue. [Monterrey, México: Museo de Monterrey], n.d. Bibl. Texts, Carmen Barreda, Marta Arnoja Pérez, Nicolás Guillén, and Alejo Carpentier. Includes chronology.

582. *Amelia Peláez, 1896-1968: A Retrospective = una retrospectiva.* Miami, FL: Cuban Museum of Arts and Culture, 1988. Bibl. Essays, Eloísa Lezama Lima, Giulio V. Blanc and Angel Gaztelu (in English and Spanish).

583. *Amelia Peláez, exposición retrospectiva, 1924-1967: oleos, temperas, dibujos y cerámica.* Catalogue. Caracas, Venezuela: Fundación Museo de Bellas Artes, 1991. Bibl.

584. "Artes plásticas: Amelia Peláez." *Canción de Marcela: mujer y cultura en el mundo hispánico.* Ed. David Valjalo. Madrid: Editorial Origenes, 1989. 191-193. Includes statements by the artist.

585. Blanc, Guilio V. "Amelia Peláez: la artista como mujer." *Arte en Colombia* 5 (Aug 1992): 72-75 [English trans., 214-216]. Bibl.
 Seeks connection between artist's personality, her life circumstances and the subject matter of her paintings. Considers the idea of unfulfilled womanhood as a clue to understanding her work, suggesting themes and symbols of femininity which appear in her paintings to support his viewpoint. Brings to light details of the life of her uncle Julián del Casal and her relationship with Lydia Cabrera who, according to critic, had a profound influence on Peláez and her work. Includes 1950's portrait of the artist. *Reproductions: "Marpacífico" (1936), "Peces" (1958), "Naturaleza muerta" (1949), "El balcón" (1942).*

586. Damian, Carol. "Amelia Peláez." *Latin American Art* 3.2 (Spring 1991): 27-29. Bibl.
 Portrait focusing on artist's training, education, development, and Expressionist and Cubist influences she assimilated in Europe. Remarks on her central theme, a celebration of native culture, which she achieved by using ornamental motifs drawn from her surroundings. Carol Damian writes that "with her strong sense for the aesthetics of composition, spatial organization, and masterful integration of geometric shapes and sinuous lines, Amelia Peláez

introduced a modern European stylistic vocabulary to depict her native Cuba with her own mind's eye rather than reality." *Reproductions: "Naturaleza muerta" (1943), "Los peces" (1943), "Naturaleza muerta" (1964), "Naturaleza muerta" (1966).*

587. González, Miguel. "Amelia Peláez." *Arte en Colombia* 24 [n.d.] : 30-32 [English summary, 80-81].
Biographical profile. Includes information on the influence which Russian artist Madame Exter had on her work, her involvement in illustration, ceramics and mural painting, as well as an excerpt of an interview published in *Revolución y Cultura* ten years after her death, revealing details of the environment in which the artist worked and her approach to painting. Contains statement by Cuban writer Alejo Carpentier and a portrait of the artist. *Reproductions: "Dos mujeres," (1967), "Mujeres" (1958), "Untitled" (1959), "Puertas de La Habana" (1948).*

588. Martínez, María Clara. "Amelia Peláez." *Art Nexus* 5 (Aug 1992): 126-127 [English summary, 225].
Review essay on the occasion of artist's retrospective exhibition at Biblioteca Luis Angel Arango in Bogotá. Questioning the issue of whether or not Latin American culture falls under the rubric of Western civilization -- and the "second class" position which Latin Americans have become accustomed to occupying within that realm -- María Clara Martínez makes the point that Amelia Peláez and her work exemplify the best of two worlds. She affirms that "Peláez was able to use the symbols of her time to say something important about our own special world, a world which both belongs to Western civilization but which is also different and magical. . . both 'creole' and 'cultured.'" *Reproduction: "Naturaleza muerta con melón" (1956).*

589. Turner, Elisa. "Amelia Peláez." *Art News* 88.1 (Jan 1989): 154.
Brief sketch of the artist on the occasion of her first North American retrospective exhibition. *Reproduction: "Fruit Dish" (1947).*

Pellón, Gina, 1926- Havana Drawing/Painting/Printmaking

590. Gómez Sicre, José. *Art of Cuba in Exile*. Trans., Ralph E. Dimmick. Miami, FL: Editora Munder, 1987. 105-107.

Pérez Bravo, Marta María Photography

591. Camnitzer, Luis. *New Art from Cuba*. Austin: University of Texas Press, 1994. 215-219. Bibl.

592. Cockroft, Eva. "Cuba Exports Postmodernism: Post-Revolution Artists in New York Exhibition." *New Art Examiner* 15 (Apr 1988): 33-34.
In her review essay of "Signs of Transition: 80s Art from Cuba," Eva Cockroft examines the way in which Cuban artists "struggle to combine nationalism with avant-garde experimentation, while avoiding the trap of

derivative colonial dependence." Mentions work of Marta María Pérez. *Reproduction: From the Series "To Conceive" (1987).*

593. Gutiérrez, Natalia. "Yaquelín Abdalá, Marta María Pérez." *Art Nexus* 5 (1992): 130-131 [English summary, 227].

Remarking on the autobiographical nature of the artist's work shown at Bogotá's Valenzuela & Klenner Gallery, Natalia Gutiérrez writes that "Marta María Pérez understands very well the documentary strength of photography, in this case the nature of the female body, which she presents in such a way that the spectator rediscovers her (or his) own body." *Reproduction: From the series "Caminos" (1991).*

594. Lippard, Lucy R. "Made in the U.S.A.: Art from Cuba." *Art in America* 74 (Apr 1986): 27-35.

Lucy Lippard explores the variety of influences at work in the art of young Cuban artists. Examines expression of "Cubanía," or Cubanism, in the "performance installations" this artist creates in the landscape (33). *Reproduction: Sculpture from the series "Waters, La Habana" (1984).*

Quesada Collins, Hilda de Painting

595. Mujica, Barbara. "Bright Visions, Fine Contours." *Américas* 43.3 (May-June 1991): 44-51.

Sketches of ten women, among them Hilda de Quesada Collins, identified by Mujica as being "on the cutting edge" of their profession. Considers painter's use of "dramatically contrasting colors. . . to jolt the viewer into an awareness of the conflicts and paradoxes of human existence." *Reproduction: "No!" (1989).*

Ramos, Sandra Printmaking

596. Hernández, Erena. "Sandra Ramos." *Art Nexus* 12 (Apr-June 1994): 118-119 [English trans., 184-185].

Erena Hernández reviews the artist's work which was shown in Havana's Centro de Desarrollo de las Artes Visuales, remarking on the fresh approach Ramos uses to "confront" the harsh realities of Cuban life. Comments on her use of "subterfuge" and the incorporation of text into her work, pointing out that it ranks among the "best" presently being produced in the country. *Reproduction: "La anunciación" (1993).*

Rodríguez, Demi, 1955- Painting

597. Blanc, Giulio V. "Demi." *Art Nexus* 3 (Jan 1992): 164-165 [English trans., 219].

Review of works shown at Galería María Gutiérrez in Key Biscayne which remarks on the hallucinatory power of the artist's paintings. Giulio Blanc cautions against a superficial reading of her work, suggesting that beneath the surface of Demi's images of dressed up children lies a more somber reality. *Reproduction: "Niño con muñeco" (1991).*

Rodríguez, Marta Painting

598. Solís, Cleva. "Exposiciones de pintura de Marta Rodríguez y Clara Gómez de Molina." *Revista de la Biblioteca Nacional José Martí* 29.1 (Jan-Apr 1987): 196-197.
Briefly reviews exhibition at Cuban National Library.

Rubio, Lydia Painting

599. Chaplik, Dorothy. "Cuba - U.S.A.: The First Generation." *Latin American Art* (Spring 1991): 39.
In her review of this show Dorothy Chaplik writes, "The trompe l'oiel landscapes of Lydia Rubio are dazzling works that reflect nostalgia for her Cuban roots." *Reproduction: "North Doorway: South" (1989).*

600. Gladstone, Valerie. "Lydia Rubio." *Art News* 89 (Jan 1990): 178.
Valerie Gladstone comments on an exhibition of the artist's work shown at Gloria Luria in Miami, describing it as a merger between landscape and still life painting. Her placement of palm trees, fabric and other objects side by side, critic observes, "rather than being disturbing. . . entice one to look longer in order to understand the transformation she has wrought." *Reproduction: "She Painted Landscapes" (1989).*

601. "Lydia Rubio, César Trasobares, Ricardo Zulueta, Ricardo Viera, María Brito and María Lino." *Art Papers* 17.1 (Jan-Feb 1993):17-20.

602. Turner, Elisa. "Lydia Rubio." *Art News* 92.10 (Dec 1993): 141.
Review of artist's pen and ink drawings shown at M. Gutiérrez in Miami. *Reproduction: "Island" (1993).*

Sánchez, Zilia, 1934- Havana Graphic Design/Painting

603. *Zilia Sánchez: erótica.* Catalogue. New York, NY: Intar Latin American Gallery, 1984. Bibl.

604. *Zilia Sánchez: tres décadas.* Catalogue. San Juan, Puerto Rico: Museo Casa Roig, [1991]. Essay, Margarita Fernández Zavala.

Sori, Susana, 1949- Camagüey Mixed Media Sculpture/Printmaking

605. Ahlander, Leslie Judd. "Artistas latinoamericanos de la región del litoral sureste." *Arte en Colombia* 43 (Feb 1990): 101-102 [English trans., 158].
The work of Latin American artists residing in the Gulf Coast states was shown at the Hollywood Art Center in Hollywood, Florida. Susana Sori was among the artists whose works were presented and briefly reviewed by Leslie Judd Ahlander.

606. Gómez Sicre, José. *Art of Cuba in Exile.* Trans. Ralph E. Dimmick.
Miami, FL: Editora Munder, 1987. 150-152.

Triana, Gladys, 1937- Camagüey Drawing/Painting

607. *Book's: Three Approaches: Ricardo Benaim, Claudia Belinsky, Gladys
Triana.* Catalogue. New York, NY: Marta Morante Gallery, [1993?]. Essay,
Marysol Nieves.

608. *Dinámica y transformación por el movimiento = Transformation and
Dynamics through Motion: Drawings and Paintings by Gladys Triana.*
Catalogue. Miami, FL: Cuban Museum of Arts and Culture, 1988. Poetic texts
by Reinaldo Arenas. Text, Giulio Blanc (in Spanish and English). Bibl.
Includes chronology.

609. *Gladys Triana.* Catalogue. Santo Domingo, Dominican Republic:
Galería de Arte Nader, 1991. Essay, Marianne de Tolentino (in Spanish and
English), trans. Laureano Corces. Includes chronology.

610. *Gladys Triana: Movement-Fragmentation.* Catalogue. [New York,
N.Y. Museum of Contemporary Hispanic Art, 1990]. Bibl. Texts, John
Stringer and Nicole Marwell. Includes chronology.

611. Gómez Sicre, José. *Art of Cuba in Exile.* Trans., Ralph E. Dimmick.
Miami, FL: Editora Munder, 1987. 165-166.

612. La Rocca, Grazziana. "Ricardo Benaim, Claudia Bielinsky y Gladys
Triana." *Art Nexus* 10 (Sept-Dec 1993): 159-160 [English trans., 223].
 Review of exhibition entitled "Book's Three Approaches" shown at Galería
Sotavento in Caracas. Of artist's work La Rocca writes, "Gladys Triana presents
us the book in an apocalyptic manner. The signs. . . have been erased from the
solidified pages, are now illegible, impenetrable and point evocatively to the
past." *Reproduction: "Dulce como la miel" (1992).*

613. Rodríguez, Bélgica. "Gladys Triana: movimiento-fragmento." *Arte en
Colombia* 45 (Oct 1990): 120 [English summary, 171].
 Review of Gladys Triana's work shown at New York's Museum of
Contemporary Hispanic Art. Bélgica Rodríguez comments on the artist's
creations that begin as carefully executed drawings, are "fragmented" and then
given new form as collages. *Reproduction: "Los límites del demonio" (1985-
1989).*

Trujillo, Carmen Painting/Mixed Media

614. Mujica, Barbara. "Bright Visions, Fine Contours." *Américas* 43.3
(May-June 1991): 44-51.
 Sketches of ten women, among them Carmen Trujillo, identified by Mujica as
being "on the cutting edge" of their profession. Focuses on the sea as a

pervasive element in the artist's work. *Reproductions: "Dreaming on the Beach" (1990), "Woman of the Sea" (1990).*

DOMINICAN REPUBLIC

Azcárete, Graciela, 1947- Drawing/Graphic Arts

615. *Graciela Azcárate.* Catalogue. [Santo Domingo, República Dominicana: La Galería, 1985]. Includes chronology.

Núñez, Elsa Painting

616. *Elsa Núñez.* Catalogue. Santo Domingo, Dominican Republic: La Galería, 1985. Essay, Marianne de Tolentino.

Tavarez, Rosa Painting

617. Nader, Gary Nicolas. *Arte contemporáneo dominicano.* Catalogue. Santo Domingo: Galería de Arte Nader, [1984]. Text, Gary Nicolás Nader (in Spanish, English, and French).

618. *Rosa Tavarez: las máscaras.* Catalogue. [Santo Domingo, Dominican Republic: Nader Gallery, 1985]. Includes chronology.

Tolentino, Inés

619. *Inés Tolentino.* Catalogue. [Santo Domingo, Dominican Republic: La Galería, 1985]. Includes artist's statements and chronology.

EL SALVADOR

Alvarez, Negra, 1948- Painting/Sculpture

620. Flores Zúñiga, Juan Carlos. "Margarita 'Negra' Alvarez." In *Magic and Realism: Central American Contemporary Art = Magia y realismo: arte contemporáneo centroamericano.* Trans. Orlando García Valverde. Tegucigalpa, Honduras: Ediciones Galería de Arte Trio's, 1990. 120-125. Bibl.
 Brief profile with personal statements by the artist, a portrait and reproductions of various of her works. In English and Spanish.

621. C. R. "Negra Alvarez." *Latin American Art* 5.4 (1994): 71-72 [Spanish trans., 102-103).
 Review of an exhibition of the artist's sculptures at Galería Espacio in San Salvador. Reviewer describes her technique for creating art objects from "tree trunks" by a process of "carving and painting." Remarking on the symbolism of the female figures she sculpts, the critic writes, "The fundamental theme is. . .

that of the biological fertility of women and girls, with a dimension of the feminine divinity that this gives them, and the idea of life overcoming death through the generations passed down through them." *Reproduction: "Fruto entero," "Mujer con frutero," "Madre e hija" (1993).*

Hasbun, Muriel San Salvador Photography

622. Hasbun, Muriel. "Selections." *Photo Metro* 100.11 7 June 1992: 7.
 Reproductions of Hasbun's works are accompanied by photographer's own statements about photography as a medium and the intention behind the images she makes -- to suggest a state where "past and present, the imaginary and the real, inner reality and outer reality, absence and presence" intermingle. *Reproductions: "Chevelure II" (1988), "Siamesa" (1988).*

Mena Valenzuela, Rosa, 1924-San Salvador Painting

623. Cea, J. R. *De la pintura en El Salvador.* El Salvador: Editorial Universitaria, 1986. 200-201.

624. Rodríguez, Bélgica. "Rosa Mena Valenzuela." *Art Nexus* 3 (Jan 1992): 171-172 [English trans., 223].
 Bélgica Rodríguez emphasizes the importance of this artist, remarking on the "high artistic quality" of her work. Her highly personal technique and style, according to Rodríguez, infuse her paintings with vitality, leading the spectator beyond the surface of the canvas to capture the essence of her imagery. *Reproduction: "El sueño de Jacob" (1991).*

GUATEMALA

Orive, María Cristina Photography

625. Orive, María Cristina and Sara Facio. *Actos de fé en Guatemala.* Photographs by Sara Facio and María Cristina Orive. Texts, Miguel Angel Asturias. Buenos Aires, Argentina: La Azotea, 1980.

Ruíz, Isabel

626. Goldman, Shifra M. "Isabel Ruíz: The Mythopoetics of Anguish." *Dimensions of the Americas: Art and Social Change in Latin America and the United States.* Chicago: University of Chicago Press, 1994. 239-241.
 Originally appeared as essay in *Historia sitiada: Isabel Ruíz.* Catalogue. Trans. Alejandro Rosas. [Valencia, Venezuela: Ateneo de Valencia, 1992].

627. Rodríguez, Bélgica. "Aproximación al arte de Centroamérica: Guatemala." *Arte en Colombia* 46 (1991): 78-82.
 Part of a projected book-length study of Central American art. Bélgica Rodríguez surveys the development of plastic arts in Guatemala during the 20th

century, remarking briefly on the thematic concerns and style of Isabel Ruíz. *Reproduction: Untitled work by Isabel Ruiz (1988).*

Sánchez, Magda, 1946- Painting

628. Flores Zúñiga, Juan Carlos. *Magic and Realism: Central American Contemporary Art = Magia y realismo: arte contemporáneo centroamericano.* Trans. Orlando García Valverde. Tegucigalpa, Honduras: Ediciones Galería de Arte Trio's, 1990. 38-43. Bibl.
 Brief profile with personal statements by the artist, a portrait and reproductions of various of her works. In English and Spanish.

HAITI

Turnier, Luce, 1924- Jacmel Painting

629. Pietrodangelo, Donato. "A Haitian Original." *Américas* 37.5 (Sept-Oct 1985): 39-41.
 Essay based on an interview with the artist profiling her studies abroad, as well as the artistic events which shaped her career. Writer comments on her accomplishments in the context of Haitian society where, he points out, art has been a male-dominated tradition and critical attention has been concentrated on primitive rather than modern styles of expression. Direct statements by the artist reveal her individualistic approach to her craft which she characterizes as a response to instinct rather than a philosophy. Includes Turnier's portrait, as well as reproductions of various of her paintings.

HONDURAS

Mejía, Xenia Painting

630. Rodríguez, Bélgica. "Aproximación al arte de Centroamérica II: Honduras." *Art Nexus* (May 1991): 84-87 [English trans., 153-155].
 Bélgica Rodríguez provides an overview of the history of Honduran art, identifying trends and artists who have been prominent in the field. Of these, only one is a woman, Xenia Mejía, whom she describes as "one of the most interesting of the new artists in the country. Her work can be placed within a markedly neoexpressionist figurative tendency: the violent brush strokes and 'defiguration' give her art considerable force of expression." *Reproduction: "Mujer" (1989).*

Jamaica

Manley, Edna, 1900-1987 England Sculpture

631. Boxer, David. "Edna Manley: From Quiet Carvings to Shattered Light." *Américas* 32.6-7 (June-July 1980): 23-29.
 David Boxer paints portrait of Jamaica's "foremost sculptor," tracing the development of her career from her early years in England, with particular emphasis on the work she produced in Jamaica. Notes the social and historical contexts that framed her work, including personal statements by Manley which reveal the impact that the country had on her development. Includes biographical material, as well as sculptor's portrait. *Reproductions: "Eve," "The Beadseller" (1922), "Negro Aroused" (1935), "Horse in the Morning" (1944), "In the Beginning" (1939), "Paul Bogle" (1965), "Woman" (1971), "Journey" (1975), "The Message" (1977), "Manchild" (1978), "The Trees are Joyful" (1979).*

632. _____. "Edna Manley: Sculptor." *Jamaica Journal* 18.1 (Feb-Apr 1985): 25-40. Bibl.
 Indepth study with numerous of sculptor's statements that enhance this pictorial review of her career. *Reproductions: "Portrait of Ellie Swithenbank" (1921), "The Beadseller" (1922), "Torso" (1927), "Dance" (1930), "Man with Bird" (1934), "Negro Aroused" (1935), "The Prophet" (1935), "The Diggers" (1936), "Tomorrow" (1939), "Prayer" (1936), "Generations" (1943), "Horse of the Morning" (1943), "New Moon" (1944), "Morning" (1947), "The Hills of Papine" (1949), "Crucifix" (1951), "Bogle" (1965), "The Grief of Mary" (1968), "Angel" (1970), "Mountain Women" (1971), "Ghetto Mother" (1980), "The Listener" (1984).*

633. Brown, Wayne. *Edna Manley, The Private Years, 1900-1938.* London, England: Deutsch, [1976]. Bibl.

634. Bryan, Patricia. "Edna Manley, Sculptor in Retrospect." *Jamaica Journal* 23.1 (Feb-Apr 1990): 28-36.
 Detailed review of the "Edna Manley Retrospective" at the National Gallery of Jamaica presenting seven decades of the sculptor's wood and stone pieces. Patricia Bryan calls attention to Manley's technique, especially her use of texture to achieve aesthetic effect, as well as her humanist perspective. Remarks on her thematic concerns, including information about the historical and biographical contexts from which much of the artist's work springs. Bryan points out that "more than that of any other aritst, her work chronicles the struggle for nationhood in Jamaica." *Reproductions: "Horse of the Morning" (1943), "Forerunner" (1941), "Pocomania" (1936), "Prophet" (1935), "Negro Aroused" (1935), "Norman" (1924), "Tyger" (1963), "Market Women" (1936), "Phoenix" (1971), "Ghetto Mother" (1981), "New Moon" (1980), "Moon" (1943), "Dispossessed" (1940), "Study for Ghetto Mother."*

635. *Edna Manley, Sculptor. A Retrospective at the National Gallery, May 30-Oct. 27th, 1990.* Catalogue. Kingston, Jamaica: National Gallery of Jamaica, 1990.

636. *Edna Manley: Sculptures, Drawings and Photographs.* Catalogue. [Atlanta, GA: Spellman College, Fine Arts Building, 1973]. Includes chronology.

637. *Edna Manley: The Diaries.* Kingston, Jamaica: Heinemann Publishers (Caribbean), 1989. Ed. Rachel Manley.

638. *Edna Manley, the Seventies: A Survey of the Artist's Work of the Past Decade.* Catalogue. [Kingston, Jamaica]: National Gallery of Jamaica, [1980]. Bibl. David Boxer, catalogue notes.

639. *Looking Back: Drawings by Edna Manley, 1939-1970.* Catalogue. Kingston, Jamaica: Bolivar Gallery, [1970].

MEXICO

Agar Painting

640. H. R. "Pintora del trópico: Agar pide un sistema de ecoturismo para preservar Huatulco." *Proceso* 23 Oct 1989: 54.
 Artist talks about strong ecological impulse behind the work she presented at Mexico's Museo de Arte Moderno. Her concern for nature inspires her not only to incorporate elements of it into her paintings, but also to fight to preserve the habitat of hundreds of marine and other wildlife species. Includes artist's portrait.

641. Rubín, Marcela. "Lo bello y lo 'feo' en la pintura de Agar." *Plural* 2a época 15 (Mar 1986): 32-37.
 Writer considers extrapictorial elements which the painter applies to her works, bits and pieces of the Oaxacan coastal wildlife which, the artist affirms, have a shamanistic significance. Includes direct comments by Agar which reveal her artistic intention. *Reproductions: "Visión cósmica," "Abatimiento felinizante," "La caída del Quinto Sol," Mural realizado en La Barceloneta, España, Mural realizado en la biblioteca del Instituto Tecnológico Autónomo de México, "Barrileteando," "Garcificatos."*

Almeida, Lourdes Photography

642. Almeida, Lourdes. "Lo que el mar me dejó." *Mexico en el Arte* 21 (Spring 1989): 77-80.
 Consists entirely of reproductions from series "Lo que el mar me dejó" -- mermaid and other female images by the sea.

643. *Corazón de mi corazón: 13 años de fotografía Polaroid de Lourdes Almeida.* Catalogue. México, D.F.: Museo Estudio Diego Rivera, 1993. Essays, David Huerta and José Antonio Rodríguez. Includes chronology and text of interview.

644. Oxman, Nelson. "Lourdes Almeida." *Artes de México* 7 (Spring 1990): 91.
 Nelson Oxman refers to photographer's oeuvre as a kind of "fantastic zoology charged with sensual elements." Suggests that Almeida's cardinal achievement is her ability to leap beyond the documentary qualities of photography to engage the medium as "an instrument of the imagination." *Reproduction: "Korai II" (1989).*

645. Rodríguez, José Antonio. "Lourdes Almeida y el mito como escritura fotográfica." *Artes de México* 22 (Winter 1993-1994): 109-111.
 Detailed essay emphasizing innovative talent of this photographer whose montages of fragmented Polaroid images, writes Rodríguez, "push" the expressive possibilities of photography to the limit. Focuses on her incorporation of myth into her work which, he writes, is a "constant interplay of fantasy and reality." *Reproductions: "San Martín Caballero" (1993), "Virgen de la Concepción de la media luna" (1993).*

Alvarez Bravo, Lola, 1905-1993 Jalisco Photography

646. Alvarez Bravo, Lola. *Escritores y artistas de México: fotografias.* México, D.F.: Fondo de Cultura Económica, 1982.

647. _____. *Lola Alvarez Bravo: recuento fotográfico.* México, D.F.: Editorial Penelope, 1982.

648. Blanco, José Joaquín. "Lola Alvarez Bravo: donde pone la lente surge la sorpresa." *México en el Arte* 8 (Spring 1985): 62-66.
 José Joaquín Blanco writes of Alvarez Bravo's photographs that "rarely has Mexican life been defined so precisely, profoundly, authentically or dynamically." *Reproductions: "Ya viene l'agua." "Yesero," "Los gorrones," "Esperando el caldo," "Vecindad," "Capataz," "Tiburoneros," "Remodelación."*

649. Crespo de la Serna, Jorge. "Estampas fotográficas de Lola Alvarez Bravo." *México en la Cultura* 4 Oct 1953: 6.

650. *Einsame Begegnungen: Lola Alvarez Bravo fotografiert Frida Kahlo.* Catalogue. Bern: Benteli, 1992.

651. *Elogio de la fotografía: Lola Alvarez Bravo: Centro Cultural Tijuana, 30 de enero al 15 de febrero de 1985.* Catalogue. [México]: Programa Cultural de las Fronteras/SEP Cultura, [1985?]. Text, Olivier Debroise.

652. Ferrer, Elizabeth. "Lola Alvarez Bravo: A Modernist in Mexican Photography." *History of Photography* 18.3 (Autumn 1994): 211-218. Bibl.
 Calling attention to the fact that most of the information on this photographer is written in Spanish, Elizabeth Ferrer comments that her essay "introduces her achievements to the English reader." Based largely on material she gathered during an interview with the artist, Ferrer weaves in many personal details of photographer's life, including her marriage to Manuel Alvarez Bravo and her friendship with Frida Kahlo. *Reproductions: "Entierro en Yalalag" (1946), "Unos suben y otros bajan" (ca.1940), "En su propia carcel" (1950), "Frida Kahlo with Ringed Hand Under her Chin" (1944), "El sueño de los pobres," "El ensueño" (1946).*

653. *Frida y su mundo: fotografías.* Catalogue. México, D. F.: Galería Juan Martín, 1991. Essays, Carlos Pellicer and Carlos Monsiváis.

654. *Galería de mexicanos: 100 fotos de Lola Alvarez Bravo.* Catalogue. [México, D.F.]: Instituto Nacional de Bellas Artes, [1965]. Text, Luis Cardoza y Aragón.

655. González Rodríguez, Sergio. "Lola Alvarez Bravo: la luz en el espejo." *Nexos* 16.190 (Oct 1993): 16-20.
 Considers how Lola Alvarez Bravo's work serves to "produce" and "enrich" the concept of cultural prestige. Includes reproductions of two of her Frida Kahlo photographs.

656. *Lola Alvarez Bravo: fotografías selectas, 1934-1985.* Catalogue. Mexico, D.F.: Centro Cultural/Arte Contemporáneo/Fundación Cultural Televisa, 1992. Bibl.

657. *Lola Alvarez Bravo: reencuentros: 150 años de la fotografía México.* Catalogue. Mexico, D.F.: Consejo Nacional para la Cultura y las Artes, Instituto Nacional de Bellas Artes, Museo Estudio Diego Rivera, 1989. Essay, Olivier Debroise.

658. *Lola Alvarez Bravo: The Frida Kahlo Photographs.* Catalogue. Dallas, TX: Society of Friends of the Mexican Culture, [1991]. Introduction and interview, Salomón Grimberg.

659. Palencia, Ceferino. "El arte en la fotografía de Lola Alvarez Bravo." *México en la Cultura* 17 June 1951: 5.

660. Tario, Francisco. *Acapulco en el sueño.* Photographs, Lola Alvarez Bravo. México, D.F., [s.l.]: 1951.

661. Toro Gayol, Marybel. "Olga Costa and Lola Alvarez Bravo." *Voices of Mexico* 25 (Oct-Dec 1993): 60-70.
 Essay which offers some biographical information, as well as statements by the photographer regarding her autodidactic background and the loss of vitality

she experienced in her later years. Includes artist's portraits. *Reproductions: "Olga Costa," "Lya Kostakowsky de Cardoza y Aragón," "Ruth Rivera Marín," "Francisco Tario," "Manuel Alvarez Bravo," "Computer I," "The Dream of the Poor II," "Some Go Up, Some Go Down," "The Daydream, Portrait of Isabel Villaseñor," "Mermaids of the Air."*

662. Urrutia, Elena. "El tercer ojo." *Fem* 34 (June-July 1984): 57-58. Essay of appreciation. Includes statements by the photographer.

663. Villagómez, Adrián. "Lola Alvarez Bravo: semblanza de una artista mexicana." *México en la Cultura* 4 May 1952: 5.

664. Woodard, Josef. "From the Fringes: 'Compañeras de México: Women Photograph Women' at the Ventura County Museum of History & Art." *Artweek* 23 May 1991: 9-10.
 Josef Woodard reviews Southern California exhibition of works by women who figure prominently in the shaping of a Mexican photographic tradition. Commenting that "history and art collide" in her work, he offers commentary on Lola Alvarez Bravo's photographs of Frida Kahlo.

Anderson, Laura, 1958- Drawing

665. *Laura Anderson: el sacrificio.* Catalogue. México, D.F.: Museo de Arte Carrillo Gil, 1992. Renato González Mello, curator. Text, Elizabeth Ferrer (in Spanish and English). Includes chronology.

666. *Laura Anderson: tiempo de cuaresma, instalaciones, dibujos y técnicas mixtas.* Monterrey, México: Museo de Monterrey, 1992. Text, Luis Carlos Emerich.

Andrade, Yolanda, 1950- Villahermosa Photography

667. Fusco, C. "Essential Differences: Photographs of Mexican Women." *Afterimage* 18 (Apr 1991): 11-13. Bibl.
 Fusco compares and contrasts work of Graciela Iturbide, Lourdes Grobet and Yolanda Andrade. *Reproductions: "Aztecas punk" (1985), "El y ellas" (1981), "Mona Lisa, pintora" (1986).*

668. *Yolanda Andrade: los velos transparentes, las transparencias veladas.* Catalogue. Villahermosa, Tabasco, 1988. Presentation, Carlos Monsiváis.

Arellano, Jocelyn, 1957- Photography

669. *Jocelyn Arellano: Mayo 1992.* Catalogue. México, D.F.: Galería de Arte Mexicano, 1992. Essay, Alejandro Castellanos (in English and Spanish).

Baez, Conchita Painting

670. Marti, Laura. "Pinto mujeres porque es lo que conozco." *Fem* 14.91
(July 1990): 11-13.
 Interview in which painter reflects on the limitations which family and social
expectations place on women's development and artistic commitment. Includes
information about her training in Mexico, her two-year residence in Chile, and
her attitude toward the creative process. She states that she draws from her
experience as a woman for her source of inspiration, preferring to focus on the
outer and inner worlds of women for her subject matter. Includes portraits of the
artist.

Beloff, Angelina, 1905- Leningrad Drawing/GraphicArts

671. *Angelina Beloff: ilustradora y grabadora.* Catalogue. México, D.F.:
Museo Estudio Diego Rivera, 1989. Bibl. Text, Olivier Debroise. Includes
chronology.

672. *Angelina Beloff, su obra, 1879-1969: Museo del Palacio de Bellas
Artes.* México, D.F.: SEP, 1986.

673. Beloff, Angelina. *Memorias.* Introduction, Bertha Taracena.
Epilogue, Raquel Tibol. México, D.F.: Coordinación de Difusión Cultural,
Universidad Nacional Autónoma de México, SEP, 1986.

674. Flores-Sánchez, Horacio. *El retrato mexicano contemporáneo.* Essays,
Paul Westheim and Justino Fernández. México, D.F.: Museo Nacional de Arte
Moderno, 1961. Includes brief biography.

Benavides, Conchita Painting/Installation Art

675. *Conchita Benavides: "empaques."* Catalogue. Monterrey, México:
Rubio Alfonso Gallery, 1985. Text, Eduardo Rubio.

Bracho, Coral

676. *Tierra de entraña ardiente.* Catalogue. México, D.F.: Galería López
Quiroga, 1992.

Cabrera, Geles Sculpture

677. Saavedra, Aurora Marya. "Geles Cabrera y el principio de otra actitud
en la escultura." *Cuadernos Americanos* 266. 3 (May-June 1986): 119-124.
 Saavedra writes, "Cabrera is a precursor of the contemporary movement in
Mexican sculpture, distinguishing herself in her constant refusal to conform to
the precepts of a naturalist, figurative mode of expression . . . and in her
rebellion against a nativist focus in her subject matter." Remarks on the
sculpture museum she established in Coyoacán in 1966 to assist other artists in

showing their work. Includes sculptor's portrait and photographic reproductions of several of her pieces.

Campos, Susana, 1942- Mexico City Printmaking/Painting

678. Goldman, Shifra M. "Las mujeres en el arte mexicano moderno." *Plural* 2a época 11 (Feb 1982): 39-51. Bibl.
Remarking on women's relative lack of artistic presence in Mexico until 1930, Shifra Goldman notes the emergence of various Mexican women artists during the '60s and '70s. She explores the life and work of six artists, among them Campos, calling attention to her background, training, and development. Contains some biographical information, as well as an untitled reproduction of one of her works.

679. _____. "Six Women Artists of Mexico." *Woman's Art Journal* 3.2 (Fall 1982/Winter 1983): 1-9. Bibl. Rpt. in Shifra M. Goldman, *Dimensions of the Americas: Art and Social Change in Latin America and the United States.* Chicago: University of Chicago Press, 1994. 179-194. Bibl.
Later version of Spanish-language article in #678.

680. Ocharán, Leticia. "'Metro' y 'Burlesque' en la temática de Susana Campos." *Plural* 2a época 19 (May 1990): 70-71.
Describes artist's technique for manipulating concept of space and time in her paintings "Metro" and "Burlesque."

681. Tibol, Raquel. "La nueva objetividad de Susana Campos." *Proceso* 11 June 1990: 56+.
Review of artist's Sexo-Metro Urbano show at Mexico City's Salón de la Plástica Mexicana. Emphasizes the realistic, unsentimental quality of her paintings, noting similarities in her approach to that of German artists George Grosz and Otto Dix, among others. *Reproduction: "Las descocadas."*

Carmona, Estrella, 1962- Veracruz Painting

682. Tibol, Raquel. "'Ejercicios de guerra' de Estrella Carmona." *Proceso* 22 Apr 1991: 53-54.
Raquel Tibol notes artist's precocious interest in the arts, tracing her training to the age of ten and a first exhibition at fourteen years of age. Reflects on "Ejercicios de Guerra" exhibition shown in Mexico City's Museo Carrillo Gil -- with its depiction of objects of war and destruction -- and the humanist philosophy underlying this young artist's concept of life. *Reproduction: "Lucha por la vida."*

Carrillo, Lilia, 1929-1974 MexicoCity Drawing/Painting/Printmaking

683. García Ponce, Juan. "Homenaje a Lilia Carrillo." *Plural* (Mexico)
36 (Sept 1974): 72-77.
Essay of appreciation honoring the artist and her work on the occasion of her
death. Includes a chronology with many biographical details. *Reproductions:*
"Evaluación al presente" (1969), "Anticipación al olvido" (1970), "Compás
cotidiano" (1966), "Principio de eclipse" (1970), "Condición primera" (1967).

684. _____. "Lilia Carrillo." *Nueve pintores mexicanos.* México, D.F.:
Ediciones Era, [1968]. 29-30.

685. *Lilia Carrillo, homenaje: 10 de octubre al 25 de noviembre de 1974.*
Catalogue. México, D.F.: Instituto Nacional de Bellas Artes y Literatura,
[1974]. Essay, Juan García Ponce.

686. Manrique, Jorge Alberto. "Lilia Carrillo." *Revista de Bellas Artes* 2nd
series 18 (Nov-Dec 1974): 55-59.
Essay focuses on artist's technique for achieving a nonrepresentational style of
painting and the experimental elements she incorporated into various of her
works. Remarks on her informal style of painting and the atmosphere of
harmony which exudes from her compositions. Includes artist's portrait.
Reproductions: "Mediodía," "Diciembre," "Realidad cambiante," and various
untitled pieces.

687. Moreno Villarreal, Jaime. *Lilia Carrillo: la constelación secreta.*
México, D.F.: Consejo Nacional para la Cultura y las Artes, 1993.

688. _____. "Retrato de Lilia Carrillo ante la tela en blanco." *Vuelta*
16.191 (Oct 1992): 57-60. Bibl.
Detailed study which includes statements by the artist regarding her approach
towards the creative process and the blank canvas in particular. Offers some
biographical information and details of her training, as well as references to
artists who may have had an influence on her work, including Manuel
Felguérez, Wolfgaang Paalen, Vieira da Silva, and Arshile Gorky.

689. *Retrato de Lilia Carrillo ante la tela en blanco = Portrait of Lilia*
Carrillo in Front of the White Canvas, septiembre-octubre de 1992. Catalogue.
Monterrey, México: Museo de Arte Contemporáneo de Monterrey, 1992. Text,
Jaime Moreno Villareal (in Spanish and English).

690. Villoro, Juan. "Lilia Carrillo: la constelación secreta." *Artes de*
México 26 (Sept.-Oct. 1994): 88-89.

Carrington, Leonora, 1917- England Writer/Painting

691. Agosín, Marjorie. "Las hienas celestes: tras la huella de Leonora Carrington." *Las hacedoras: mujer, imagen, escritura.* Santiago, [Chile]: Editorial Cuarto Propio, [1993]. 191-197. Bibl.

692. Andrade, Lourdes. "De la monstruosidad carringtoniana." *México en el Arte* 16 (Summer 1992): 102-103.
Lourdes Andrade explores the roots of the "monstrous" figures which inhabit Carrington's canvases, suggesting they have their origin in medieval imagery and Mexican indigenous myth.

693. _____. "Tres mujeres del surrealismo." *México en el Arte* 11 (Winter 1985/1986): 28-31.
Compares Surrealist works of Leonora Carrington, Alice Rahon and Remedios Varos noting shared commonalities, among them an interest in the occult, a pictorial representation of air, earth, fire, and water, and the production of literary works by each of of the painters. Includes individual portraits of the artists.

694. Balakian, Anna. "Surrealism and Leonora Carrington." *Review* 75.16 (Winter 1975): 75-78.
Paper presented by the author during the artist's retrospective at the Center for Inter-American Relations Gallery. Remarks on specific Surrealist qualities of artist's paintings, writing that she is a poet because she "preserves the metaphoric communication between humans and animals, and the cabbage and the rose, and the panther and the steed, all connected with a universal animism." *Reproduction: "Bird Pong" (1949).*

695. Chadwick, Whitney. "Leonora Carrington." *Latin American Art* 4.1 (Spring 1992): 42-44 [Spanish trans., 102-103]. Bibl.
Scholarly analysis of artist focusing on her years in Mexico, the sources which inspired her work - among them Celtic myths and literature and the writings of Carl Jung and Marie von Franz - and the Surrealist approach she took to her subject matter. Includes some biographical information. *Reproductions: "Palatine Predella" (1946), "Chiki Your Country" (1947), "Journey to Alkahest" (1974), "El mundo mágico de los Mayas" (1963), "Lepidóptera" (1969).*

696. _____. "Leonora Carrington: Evolution of a Feminist Consciousness." *Woman's Art Journal* 7.1 (Spring/Summer 1986): 37-42. Bibl.
Traces artist's growth, highlighting the events in her life which impacted on the development of her feminist perspective. Discusses themes, symbolism and style of various of her early writings and paintings, as well as those executed during the later Mexican years when artist adopted a new mode of expression to reflect her spiritual and psychic evolution. Remarks on her association with Remedios Varo, another exiled artist living in Mexico who also worked within the Surrealist tradition, and the creative vision they shared. *Reproductions: "Self-Portrait" (ca. 1938), "Horses" (1941), "The House Opposite" (ca.1947).*

697. _____. "The Muse as Artist: Women in the Surrealist Movement."
Art in America 73.7 (July 1985): 120-129. Bibl.
 Considers work of women associated with the Surrealist movement, including
Leonora Carrington. *Reproductions: "Self-Portrait" (ca. 1938), "Garden" (1946).*

698. _____. *Women Artists and the Surrealist Movement.* New York:
Thames and Hudson, 1985.

699. Colle, Marie-Pierre. *Latin American Artists in Their Studios.* New
York: Vendome Press, 1994. Bibl. 80-91.

700. Conde, Teresa del. "Leonora Carrington en Londres." *Nexos* 15.171
(Mar 1992): 16-19.
 Presents biographical information pertaining to artist's English roots and
commentary on her retrospective exhibition in Serpentine Gallery which, author
remarks, was the first comprehensive show of her work mounted in London.

701. Helland, Janice. "Surrealism and Esoteric Feminism in the Paintings
of Leonora Carrington." *Canadian Art Review* 16.1 (1989): 53-61. Bibl.
 Detailed examination of Carrington's paintings and her development within the
Surrealist tradition. Emphasizes the influence which Carl Jung and Robert
Graves had on her worldview and the manner in which she articulated this
consciousness in her imagery, presenting "women as active, as protagonists,
rather than as they are more commonly presented in Surrealism, as passive or
submissive figures or even as victims."

702. Heller, Nancy. *Women Artists: An Illustrated History.* New York,
N.Y., London: Abbeville Press, 1987, 1991. Bibl.

703. *Leonora Carrington.* México, D.F.: Ediciones Era., 1974. Text, Juan
García Ponce and Leonora Carrington.

704. *Leonora Carrington, a Retrospective Exhibition.* Catalogue. New
York: Center for Inter-American Relations, 1975. *Exhibition held at Center for
Inter-American Relations, New York City, November 26 - January 4, 1976 and
University Art Museum, the University of Texas at Austin, January 18-
February 29, 1976.* Includes chronology.

705. *Leonora Carrington: Paintings, Drawings and Sculptures, 1940-1990.*
Catalogue. London: Serpentine Gallery, 1991. Bibl. Ed. Andrea Schlieker.
Essays. Marina Warner, Whitney Chadwick and Edward James.

706. *Leonora Carrington: The Mexican Years, 1943-1985.* Catalogue. San
Francisco: Mexican Museum; [Albuquerque, N.M.] Distrib., University of New
Mexico Press, 1991. Essay, Whitney Chadwick, interview, Paul de Angeles.
Includes chronology.

707. Orenstein, Gloria. "Leonora Carrington's Visionary Art for the New Age." *Chrysalis* 3 (1978): 65-77. Bibl.
Detailed study of the artist and her work that examines the symbolism concealed in her images, as well as the Celtic myths and legends that inform them. Includes details of Carrington's life and excerpts from her writings demonstrating "her identification with the female principle in all its earthly and spiritual manifestations and her desire to restore to its rightful place a female power and feminine wisdom. . ." *Reproductions: "Molly Malone's Chariot" (1970), "The Garden of Paracelsus" (1957), "The Godmother" (1968), "Grandmother Moorhead's Aromatic Kitchen" (1975), "Lepidopterus, The Butterfly People Eating a Meal" (1967), "Stageset," "Penelope."*

708. Rodríguez Prampolini, Ida. *El surrealismo y el arte fantástico de México.* México, D.F: Universidad Nacional Autónoma de México, Instituto de Investigaciones Estéticas, 1969. 73-75. Bibl.

709. Tanner, Marcia. "From an Occult Realm: 'Leonora Carrington: The Mexican Years, 1943-1985' at the Mexican Museum." *Artweek* 23 Jan 23 1992: 8-9.
Many details of artist's life are included in this not entirely favorable critique of exhibition at Mexican Museum. *Reproductions: "Night Nursery Everything," "Portrait of Madame Dupin" (1947), "The Magdalena" (1986), "Ikon" (1988), "The Dog Child of Monkton Priori" (1950).*

710. Urrutia, Elena. "Leonora Carrington y sus muñecas." *Fem* 45 (Apr-May 1986): 40-41.
Artist explores the source of inspiration behind Carrington's ceramic, wooden and fabric dolls, pointing out that they impart for her a sense of "continuity" which, Urrutia remarks, allows her to transcend time and space. Includes photographs of some of her dolls.

711. Witzling, Mara R. "Leonora Carrington." In *Voicing Our Visions: Writings by Women Artists.* New York: Universe, 1991. 306-319. Bibl.
Portrait with much biographical information. Includes excerpts from Carrington's writings. *Reproduction: "The Magic Witch" (1975).*

Caso, Beatríz, 1929- Mexico City Sculpture

712. *En escultura una revelación: Beatríz Caso.* Catalogue. [México, D.F.: Palacio de Bellas Artes, 1984]. Essay, Elena Poniatowska.

713. Monteforte Toledo, Mario. *Beatríz Caso.* Catalogue. México, D.F.: Universidad Nacional Autónoma de México, 1979.

Castañeda, Pilar, 1941- Mexico City Painting/Collage

714. Goldman, Shifra M. "Las mujeres en el arte mexicano moderno."
Plural 2a época 11 (Feb 1982): 39-51. Bibl.
 Remarking on women's relative lack of artistic presence in Mexico until 1930,
Shifra Goldman notes the emergence of various Mexican women artists during
the '60s and '70s. She explores the life and work of six artists, among them
Castañeda, calling attention to her training, subject matter and her preference for
a representational style of expression. Includes untitled reproductions of two of
her paintings.

715. _____. "Six Women Artists of Mexico." *Woman's Art Journal* 3.2
(Fall 1982/Winter 1983): 1-9. Bibl. Rpt. in Shifra M. Goldman, *Dimensions of
the Americas: Art and Social Change in Latin America and the United States.*
Chicago: University of Chicago Press, 1994. 179-194. Bibl.
 Later version of Spanish-language article in #714.

716. Tibol, Raquel. *Pilar Castañeda.* Puebla, Mexico: Casa de la Cultura,
1974.

Castillo, Gilda, 1955- Mexico City Drawing/Painting

717. *Gilda Castillo: dibujo, este camino conduce a una línea.* Catalogue.
México, D.F.: Museo Universitario del Chopo, 1992. Includes brief biography
and chronology.

718. *Gilda Castillo: héroes y ciudades.* Catalogue. México, D.F.: Casa del
Lago, 1988. Essay, Noé Jitrik. Includes biography and chronology.

719. *Gilda Castillo, obra reciente: hay poco cielo aquí pero las cosas fluyen.*
Catalogue. México, D.F.: Galería Juan Martín, 1992. Includes chronology.

720. *Gilda Castillo: el reposo del tiempo, obra reciente.* Catalogue. México,
D.F.: Galería Juan Martín, 1989. Essay, Lorenzo Rafael Avila.

721. Medina, Cuauhtémoc. "Naturalezas." *Art Nexus* 10 (Sept-Dec 1993):
151-152, [English trans., 218].
 Review of "Naturalezas" exhibition in Mexico City's Galería Metropolitana
that had nature as its theme. Remarks briefly on the different approaches the
four artists took to their subject matter, noting the "fluidity and spontaneity" of
their styles as exemplification of the theme itself.

722. Mercado, Tununa. "Ciudad y memoria: Gilda Castillo en la Casa del
Lago." *México en el Arte* 19 (Winter 1987): 90.
 Briefly considers artist's approach to landscape theme during the '80s,
remarking on style, line and color. Includes some biographical information.

723. Tibol, Raquel. "Dibujos y óleos de Gilda Castillo." *Proceso* 24 Aug 1992: 53-55.
 Gilda Castillo presented thirteen oils in Galería Juan Martín and seventeen drawings in Museo del Chopo in Mexico City almost simultaneously. In her review Raquel Tibol comments on both shows, noting the superior quality of her drawings which depict subtle and intentional variations of a landscape theme. *Reproduction: "El espíritu del árbol" (1991).*

Castillo, Mónica

724. *Aquí y allá* Catalogue. Los Angeles, CA: Los Angeles Municipal Art Gallery, 1990. Spanish and English text.

725. Emerich, Luis Carlos. "Mónica Castillo: prohibido sopear." *Figuraciones y desfiguros de los '80s.* México, D.F.: Editorial Diana, 1989. 71-74.

726. Goldman, Shifra M.. "The Heart of Mexican Art." *New Art Examiner* 21 Dec 1993: 12-15+.
 Shifra Goldman considers symbolism of the body in the works of a variety of Mexican artists, among them Mónica Castillo. *Reproduction: "The Meat of ..." (1987).*

727. *Mónica Castillo: presentación en sociedad.* Catalogue. México, D.F.: Galería OMR, 199?. Essay, Charles Merewether. Includes chronology.

728. *Mónica Castillo: salvavidas bajo su piel = Lifevest Under Your Skin.* Catalogue. México, D.F.: Galería OMR, 1994. Essay, Cuauhtémoc Medina (in Spanish and English). Includes chronology.

Catlett Mora, Elizabeth, 1919- U.S.A. Painting/Sculpture

729. Berlind, Robert. "Elizabeth Catlett." *Art Journal* 53.1 (Spring 1994): 28-30.
 Text of an interview with African American artist who resides in Cuernavaca, Mexico. Tells of her years in the United States as a teacher before her departure for Mexico. *Reproduction: "Head of Man" (1992).*

730. Catlett, Elizabeth. *Elizabeth Catlett.* México, D.F.: Litógrafos Unidos, 1973.

731. *A Courtyard Apart: The Art of Elizabeth Catlett and Francisco Mora.* Catalogue. Biloxi, MI: Mississippi Museum of Art, [1990]. Bibl. Essays, Floyd Coleman, introduction, Margaret Walker Alexander.

732. Crawford, Marc. "My Art Speaks for Both My Peoples." *Ebony* (Jan 1970): 94-96+.
 Remarking that she was "the first woman professor of sculpture at Mexico's National University" and head of the sculpture department there for five years, Crawford includes numerous direct statements by Catlett that reveal her ideas about nationalism and how it should nourish the creative process. Contains various portraits of the sculptor at work and with her students.

733. Driskell, David C. *Two Centuries of Black American Art: Los Angeles County Museum of Art, the High Museum of Art, Atlanta, Museum of Fine Arts, Dallas, the Brooklyn Museum.* Catalogue. Los Angeles, CA: Los Angeles County Museum of Art, 1976. Bibl.

734. *Elizabeth Catlett: Sculpture/Francisco Mora: Watercolors.* Catalogue. [Tempe, AZ: Arizona State University, 1987]. Bibl. Includes chronology.

735. *Elizabeth Catlett: Works on Paper, 1944-1992.* Catalogue. Hampton, VA: Hampton University Museum, 1993. Bibl. Ed. Jeanne Zeidler, essays, Samella Lewis, Richard J. Powell.

736. Fax, Elton C. "Elizabeth Catlett." *Seventeen Black Artists.* New York, N.Y.: Dodd, Mead, [1971].

737. Goldman, Shifra M. "Las mujeres en el arte mexicano moderno." *Plural* 11.125 (Feb 1982): 39-51. Bibl.
 Remarking on women's relative lack of artistic presence in Mexico until 1930, Shifra Goldman notes the emergence of various Mexican women artists during the '60s and '70s. She explores the life and work of six artists, among them Catlett, providing a brief profile which highlights some of her thematic concerns and the influences which have impacted on her work. Contains some biographical data, as well as a untitled reproduction of one of her sculptures.

738. _____. "Six Women Artists of Mexico." *Woman's Art Journal* 3.2 (Fall 1982/Winter 1983): 1-9. Bibl. Rpt. in Shifra M. Goldman, *Dimensions of the Americas: Art and Social Change in Latin America and the United States.* Chicago: University of Chicago Press, 1994. 179-194. Bibl.
 Later version of Spanish-language article in #737.

739. Gouma-Peterson, Thalia. "Elizabeth Catlett: 'The Power of Human Feeling and of Art.'" *Woman's Art Journal* 4.1 (Spring/Summer 1983): 48-56.
 In-depth profile which includes many biographical details, personal statements by the artist, and a discussion of numerous of her works. Contains information on her life and work in Mexico. *Reproductions: "Mother and Child" (1940), "Special House" (1946-1947), "Blues" (1947), "Tired" (1946), "Mother and Child" (1959), "Maternity" (1979), "Figure" (1962), "Mother and Child" (1970), "Target Practice" (1970), "The Torture of Mothers" (1970), "Harriet" (1975), "Louis Armstrong" (1975-1976), "Glory" (1981).*

740. Hewit, Mary Jane. "Elizabeth Catlett." *International Review of African American Art* 7.2 (1987): 26-33.

741. Lewis, Samella. *The Art of Elizabeth Catlett.* Claremont, CA: Hancroft Studios, 1984. Bibl.

742. Little, Carl. "Elizabeth Catlett at June Kelly." *Art in America* 81.11 (Nov 1993): 130-131.
Ten of the sculptor's works were presented in this New York exhibition which, reviewer Carl Little notes, "attest to the technical brilliance and perfectionist sensibility of this African-American artist." Includes some biographical information, as well as references to influences which have impacted on her work. *Reproduction: "Nude Torso" (1987).*

743. Merriam, Dena. "All History's Children: The Art of Elizabeth Catlett." *Sculpture Review* 42.3 (Nov 1993): 6-11.
In this profile, Dena Merriam writes, "There is a quiet dignity, a poised presence and a self-affirmation in Elizabeth Catlett's sculptural forms that makes visible the very essence of humanity. It is to the portrayal of the value of human life and the respect due all humankind that Catlett has dedicated her artistic oeuvre." *Reproductions: "Mother and Child" (1971), "Head of Woman" (1992), "Mother and Child" (1993), "Figure" (1961), "Woman Walking" (1987).*

744. Tibol, Raquel. "The Work of Elizabeth Catlett." *Los Universitarios* (Nov 1975): 15-16.
Biographical portrait interspersed with numerous statements by the artist. Gives insight into the strong influence which her Mexican residence and affiliation with Taller de la Gráfica Popular had on the development of her work. Includes reproductions of two untitled works.

745. Witzling, Mara R. "Elizabeth Catlett." In *Voicing Our Visions: Writings by Women Artists.* New York, NY: Universe, 1991. 334-348. Bibl.
Portrait with some biographical information. Includes excerpts of Catlett's writings. *Reproduction: "Homage to My Young Black Sisters" (1968).*

Cesarman, Jósele Painting

746. Goeritz, Mathias. "Realismos: a propósito de la obra de Jósele Cesarman." *Plural* 2a época 11 (Sept 1982): 33-36.
Goeritz defends artist's figurative renditions of landscape themes reminiscent of 19th century painting on the basis of her innovative use of color which produces a conflictive emotional response. Includes untitled reproductions of various of the painter's works.

747. *Jósele T. Cesarman.* Catalogue. México, D.F.: Centro Cultural San Angel, 1992. Presentation, Carlos Fuentes (in Spanish and English).

Chapa, Marta, 1946- Painting

748. Chapa, Martha. *Cartas a Martha Chapa.* [Mexico? : M. Chapa, 1981?
(Mexico?] : Diseño e impresion, Imprenta Madero). Preface, Ali Chumacero.

749. Mercado, Tununa. "Manzanas, muñecas, mujeres: última exposición de
Marta Chapa." *Fem* 37 (Dec 84-Jan 85): 58-59.
 Offers commentary on Chapa's exhibition of paintings in Nuevo León,
remarking on connotations of the feminine, the sexual and the forbidden which
her doll/apple compositions evoke. Includes untitled reproductions of two of her
works.

Checchi, Ana, 1960- Mexico City Painting

750. *Ana Checchi, René Freire, Santiago Rebolledo, Jesús Reyes.*
Catalogue. México, D.F.: Galería Pecanins, [1985]. Includes chronology.

751. Tejada, Roberto. "Anita Checchi." *Artes de México* 8 (Summer
1990): 96.
 Considers style, technique and meaning in artist's abstract compositions
shown at Mexico City's Galería Pecanins. *Reproduction: "Sin título" (1989).*

Climent, Elena Painting

752. *Elena Climent: In Search of the Present = en busca del presente.*
Catalogue. New York, NY: Mary-Anne Martin/Fine Art, 1992 in association
with the Galería de Arte Mexicano. Text, Salvador Elizondo. Inteview by
Edward J. Sullivan. Includes chronology.

753. Herrera, Hayden. "Elena Climent at Mary-Anne Fine Art." *Art in
America* 80 (Oct 1992): 151.
 Hayden Herrera comments on a selection of artist's still lifes, remarking that
her "trompe-l'oeil treatment of toys and sweets, like their placement in shallow
and enclosed spaces, stimulates the viewer's impulse to touch and possess."
Reproduction: "Yellow Kitchen" (1991).

Cohen, Laura, 1956- Mexico City Photography

754. Coronel Rivera, Juan. "Laura Cohen." *Artes de México* 6 (Winter
1989): 108.
 Emphasizes plastic element in Cohen's work.

755. Ferrer, Elizabeth. "Laura Cohen." Trans. Francisco Martínez Negrete.
Artes de México 19 (Spring 1993): 106-109. Bibl.
 Analyzes recent exhibition of artist's still life compositions, works which
Elizabeth Ferrer notes demonstrate a departure in style from that of other
contemporary photographers. Focuses on human element which, critic suggests,
although explicitly absent from the images is pervasive symbolically in the

associations and recollections which her work evokes. *Reproductions: "Flor,"*
"Piñanona y pelota," "La discordia II."

756. *Laura Cohen.* Catalogue. [México, D.F.: Galería OMR, 1992]. Bibl.
Text, Elizabeth Ferrer (in Spanish and English). Includes chronology.

757. Woodard, Josef. "From the Fringes: 'Compañeras de México: Women
Photograph Women' at the Ventura County Museum of History & Art."
Artweek 22 May 23 1991: 9-10.
 Josef Woodard reviews Southern California exhibition featuring the work of
women who figure prominently in the shaping of a Mexican photographic
tradition. Offers commentary on Cohen's work, calling artist "perhaps the most
refreshing photographer of the show. . ."

Compañ, Victoria, 1951- Villahermosa Painting

758. Tibol, Raquel. "Ser pintora." *Proceso* 2 Apr 1990: 52.
 On the occasion of the artist's exhibition at Galería Arte Contemporáneo,
Raquel Tibol considers forces that inspired artist to embrace painting as her life's
work. Contains some biographical information and details of the painter's
schooling, as well as personal statements. Includes Compañ's portrait.

Costa, Olga, 1913-1993 Germany Painting

759. Flores-Sánchez, Horacio. *El retrato mexicano contemporáneo.* Essays,
Paul Westheim and Justino Fernández. México, D.F.: Museo Nacional de Arte
Moderno, 1961. Includes brief biography.

760. Glantz, Margo. "Los cuadros en el portal: recuerdos de juventud."
México en el Arte 1 (1983): 8-14.

761. Martínez, Jesús. "Olga Costa: 'in memoriam.'" *Plural* 22 (Aug
1993): 68-69.
 Artist Jesús Martínez offers affectionate recollections of the painter on the
occasion of her death.

762. *Mexico Nine: México nueve.* Catalogue. [Albuquerque, New Mexico]:
Tamarind Institute, 1987. Bibl. Text in English and Spanish.
 Includes chronology and transcription of conversation with Mary Grizzard
during artist's stay at Tamarind Institute to prepare lithographs with other
Mexican artists as part of binational project between the U. S. and Mexico.

763. Morales, Sonia. "La pintora del color, Olga Costa: de los horrores de
su infancia al miedo del homenaje que le rinde el FIC." *Proceso* 2 Oct 1989:
52-53.
 Artist reminisces with author about her early life, her tutelage under Carlos
Mérida, memories of her native country and her relationship with painter
husband José Chávez Morado. Includes portrait of the artist in her studio.

764. *Olga Costa: exposición homenaje.* Catalogue. Guanajuato, México: XVII Festival Internacional Cervantino, 1989. Bibl. Includes interview.

765. Pitol, Sergio. "Las flores del desierto y un croto tropical." *México en el Arte* 1 (1983): 16-19.

766. _____. *Olga Costa.* Catalogue. [Guanajuato, México]: Gobierno del Estado de Guanajuato, 1983.

767. Tibol, Raquel. "Olga Costa en el MAM." *Proceso* 22 Jan 1990: 53-55.
 Raquel Tibol notes in her critique of this Museo de Arte Moderno exhibition that although there were 241 works by the artist on display none was a self-portrait. Includes direct statements by Costa in which she makes clear her preference for "reproducing life, truth, simplicity" without "theatricality."

768. Toro Gayol, Marybel. "Olga Costa and Lola Alvarez Bravo." *Voices of Mexico* 25 (Oct-Dec 1993): 60-70.
 Biographical essay with some personal statements by the artist. "Recognition for Olga Costa's art was late in coming. Only in the 1980s were there significant retrospective exhibitions of her painting, as her pictures began to fetch high prices at New York auctions," writes Toro Gayol. *Reproductions: "I Went to the Field and Picked Them" (1986), "Girl of Janitzio" (1951), "Blue Flowers" (1987), "Two Women in the Forest" (1945), "Souvenirs of Silao" (1954), "Dead Child" (1944), "Tropics" (1990), "Girl with Cat," "The Duel" (1942), "The Valenciana Mine" (1955), "Selfish Heart" (1951), "Pilgrims" (1957), "Still Life with Lollipops" (1983), "Garden with Poinsettias" (1985).*

Díaz Abreu, Paloma, 1958- Painting

769. Tibol, Raquel. "El neoxpresionismo de Paloma Díaz Abreu." *Proceso* 27 Apr 1992: 53-54.
 Considers artist's development and the works she presented in Mexico City's Galería Kin depicting primitive sexual rituals. *Reproduction: Fragment of "Kismet."*

Escobedo, Helen, 1934- Sculpture

770. Eder, Rita. *Helen Escobedo.* Trans., Asa Zata. México, D.F.: Universidad Nacional Autónoma de México, Coordinación de Humanidades, 1982. Bibl. Spanish and English text.

771. Escobedo, Helen. "Reflections on My Work in Mexico." *Mexican Art of the 1970s: Images of Displacement.* Ed. Leonard Folgarait. Nashville: Vanderbilt University, Center for Latin American and Iberian Studies, 1984. 25-28.

772. _____. "Site-Specific Sculpture or the Mythology of Place." *Leonardo* (UK) 21.2 (1988): 141-144. Summary in English.
Artist presents the beliefs and motivations which drive her designs for specific sculptures and environments. Includes photographic reproductions of her work.

773. _____. "Reflections on My Non-Permanent Environmental and Permanent Outdoor Sculptures." *Leonardo* 13.3 (1980): 177-181. Bibl.
Includes reproductions of various of the sculptor's works.

774. Haupt, Gerhard. "La fascinación de vivir en dos continentes: una conversación con Helen Escobedo." *Humboldt* 103 (1991): 68-73.
Transcript of interview in which Escobedo talks freely about her approach to her work, including the change in emphasis from permanent sculpture to ecologically focused ephemeral installations, as well as the benefits she derives from living part of the year in Germany. Includes portrait of the sculptor. *Reproductions: "Espíritu de los árboles" (1990), "La muerte de la ciudad" (1990), "Las brujas del norte" (1990).*

775. *Helen Escobedo - instalaciones - René Derouin.* Catalogue. México, D.F.: Museo Rufino Tamayo. Bibl. Includes chronology.

776. *Helen Escobedo: diciembre de 1974-enero de 1975, Museo de Arte Moderno.* Catalogue. México, D. F.: Instituto Nacional de Bellas Artes, [1975?]. Text, Juan Acha (in Spanish and English).

777. *Instalaciones: Museo Rufino Tamayo, junio-agosto de 1992.* Catalogue. México, D.F.: Consejo Nacional para la Cultura y las Artes, 1992. Bibl. Text by the artist.

778. *Manifesta muestra de instalaciones y performance de Felipe Ahrenberg, Helen Escobedo, Marcos Kurtycz.* Catalogue. México, D.F.: INBA, 1993. Includes chronology.

779. Reichardt, J. "Helen Escobedo's Projects for Public Sculptures." *Studio International* 195.991/992 (1981): 80.
Includes the sculptor's portrait and reproductions of various of her works.

780. "The Route of Friendship - Ruta de la amistad - Mexico City." *Studio International* 195.991/992 (1981): 81.
Includes reproductions of the sculpture Escobedo made for 1968 Mexico Olympic Games..

781. Urrutia, Elena. "La escultura monumental y las mujeres." *Fem* 33 (Apr-May 1984): 29-31.
Focuses on the contributions of sculptors Helen Escobedo and Angela Gurría to modern Mexican urban landscape. Artists distinguished themselves by being the only women in a group of eighteen international artists commissioned to create sculpture monuments for the 1968 Olympic games. Essay includes

numerous direct comments by the artists regarding their training and the influences on their work.

782. *Woman as Subject.* Catalogue. México, D.F. : Museo de Arte Moderno, 1975.

Figueroa, Antonieta Drawing

783. *Antonieta Figueroa-Correspondencias: técnicas mixtas y dibujos.* Catalogue. [México, D.F.: Museo de Arte Moderno, 1981]. Text, Jorge Alberto Manrique, Armando Torres Michúa, Alfonso de Neuvillate, José Gómez Sicre, Fernando Gamboa. Includes chronology.

Figueroa, María Eugenia Painting

784. Ramírez, Fermín. "María Eugenia Figueroa, pintora de luz y tierra." *Plural* 22.267 (Dec 1993): 41-48.
 In this interview artist responds to questions about influences on her work and the elements she includes in her paintings. *Reproductions: "La servilleta," "Rayuela," "Paisaje," "Con luz de cuarto menguante," "Acertijo," "Homenaje a Tamayo," "Homenaje a Nishizawa," "Homenaje a Toledo," "Gata soñando," "Las cuentas claras," "Corazonada," "Luna nueva."*

Garduño, Flor, 1957- Mexico City Photography

785. Castro, Fernando. "Doña Flor and Her Two Shamans." *Foto Metro* 11.109 (June/July 1993): 3-20. Bibl.
 "With a cultivated photographic sensibility Garduño probes into that hermetic yet magical world strewn throughout Latin America," writes Fernando Castro. Considers Garduño's place in Mexican photography using her recent "Witnesses of Time" exhibition as backdrop for his discussion. Is her work documentary or is it artistic? Does it reflect the Surrealist tradition? How does her work differ from that of other Mexican photographers? These are but a few of the questions Castro considers in his essay. *Reproductions: Mexico: "Agua," (1983), "Las negras" (1982), "Macho y hembra" (1982), "Bande mixe" (1982), "Este es un gallo" (1981), "Bicéfalo" (1981), "Gobernador Tarahumara" (1991), "Tortuga" (1987), "Minotauro" (1984), "Caballito de Soyaltepec II" (1982), "Suave viento" (1982), "La mujer que sueña" (1991), "Magueyes" (1986), "País de las nubes" (1982), "Matrimonio zinacanteco" (1987); Bolivia (1990): "Milluni," "Músico en la nada," "Música, baile y viento," "Camino a la bendición," "Fiesta de la Santa Cruz," "Ch'alla," "El abuelo del tiempo," "Yatiri," "Sixto," "El Tío Jorge," "El rayo," "Marcos y Simona;" Guatemala (1989): "Umbral del incienso," "Regreso a la tierra," "La dueña de la granmesa," "Canasta de luz," "Reina"; Ecuador: "Aquí nomás" (1991), "Don Perro" (1988), "Falleció María Verónica" (1988), "Taita Marcos" (1988).*

786. _____. "Flor Garduño: Testigos de un mismo sueño." *Art Nexus* 11 (Jan-Mar 1994): 138-143 [English trans., 219-222]. Bibl.

This article is at once a critique of the book *Witnesses of Time*, reflecting ten years of work by Garduño, and a discussion of whether or not Surrealist tendencies are present in her photography. *Reproductions: "La mujer que sueña", "Matrimonio zinacanteco" (1987), "Canasta de luz" (1989), "Guardián del cementerio" (1990), "Kings of Canes" (1981).*

787. _____. "FotoFest 92." *Art Nexus* 5 (Aug 1992): 62-67 [English trans., 208-211].

Castro provides detailed analysis of the most noteworthy Latin American contributions to this 152nd yearly artistic event which took place in Houston. Referring to Flor Garduño and her work as one of the "highlights" of the show, he mentions her training with Mexico's preeminent photographer, Manuel Alvarez Bravo, and Kati Horna, and examines various elements present in her images. "With the resources of her sensibility and her technique, she describes a world of mystical ritual which, however, she leaves intact. She herself has said that she is a witness of a theater with many scenes which portray her own dreams, obsessions and fantasies," writes Castro. *Reproduction: "La mujer" (1987).*

788. Coronel Rivera, Juan. "Flor Garduño." *Artes de México* 8 (Summer 1990): 97. *Reproduction: "Herbarium" (1988).*

789. Ferrer, Elizabeth. "Flor Garduño." *Review: Latin American Literature and Arts* 41 (July-Dec. 1989): 15-21.

Profile of photographer providing some information on her education and training. Ferrer discusses a series of photographs Garduño made in Guerrero and Puebla depicting Mexican traditional celebrations. *Reproductions: "Minotauro" (1984), "Caballero águila" (1986), "Toros de petate" (1987), "Tortuga" (1987).*

790. "Flor Garduño." *Creative Camera* 5 (1989): 24-27.

Consists entirely of examples of photographer's work. *Reproductions: "Emblem," Zinacantan, Chiapas, "Deluxe," Amantenango, Chiapas, "Offering," Zinacantan, Chiapas, "Knives," Tlacuitiapa, Guerrero (1987).*

791. Garduño, Flor. *Flor Garduño: Bestiarium.* Zurich, Switzerland: U. Bar Verlag, 1987.

792. _____. *Magia del juego eterno: fotografías.* Presentation, Eraclio Zepeda. Juchitán, Oaxaca, México: Publicación Guchachi Reza A.C., [1985].

793. Hugunin, James. "Flor Garduño." *New Art Examiner* 20 (Nov 1992): 32-33.

Review of an exhibition of the photographer's prints at the Art Institute of Chicago. James Hugunin argues that Garduño only gives the spectator a "semblance of a documentary insight" into the lives of the Central and South American Indians she photographs, observing that they are "decontextualized"

and suspended in a time frame which is illusory, "the past in the present is read in nostalgic terms, and little is done to critically elucidate the impact of the present on that past."

794. Martínez, Jesús. "Flor Garduño, fotógrafa." *Plural* 22 (Oct 1992): 73.
Essay of appreciation.

795. Sokoloff, Ana. "Flor Garduño." *Art Nexus* 9 (June-Aug 1993): 138 [English trans., 198].
Review of Garduño's photographs shown at New York's Americas Society Gallery. Commenting on her style of photography, Sokoloff points out that through photographic reporting Garduño creates her own language in which the report loses its value and gives way to a sensitivity for the spiritual and profane that borders on Surrealism." *Reproduction: "Cofrade" (1989)*.

796. *Witnesses of Time*. Introduction, Carlos Fuentes. Trans. Alfred MacAdam. New York, N.Y.: Thames and Hudson, 1992.

797. Wolf, Sylvia. *Focus: Five Women Photographers: Julia Margaret Cameron, Margaret Bourke-White, Flor Garduño, Sandy Skoglund, Lorna Simpson*. Morton Grove, IL: A Whitman, 1994. Bibl.
For young readers.

Garza, María Teresa Painting

798. *María Teresa Garza*. Catalogue. Monterrey, México: Galería Estela Shapiro, 1982. Text, Estela Shapiro.

Gascón, Elvira Spain Painting/Printmaking

799. *100 dibujos de Elvira Gascón*. México, D.F.: Siglo Veintiuno, [1972].

800. "La belleza íntima: entrevista con Elvira Gascón." *Universidad de Mexico* 40.411-412 (1985): 25-32.
Interview with Spanish exiled artist giving insight into her training and work. Considers Hellenistic influences on her style and the erotic quality of her nude paintings, as well as her ideas about art and life. Includes portraits of the artist and untitled reproductions of various of her works. Offers some biographical information.

801. Blackhaller, Eduardo R. "Elvira Gascón: intensidad creadora." *Revista de la Universidad de México* 31.3 (Nov 1976): 1-3.
Considers way artist uses modern pictorial language to rework themes found in classical culture. *Reproductions: "Hoy voy a bailar" (1957), "Muerte de Pentesilea" (1970), "Tras de ceñir un talle" (1956), "Autorretrato" (1962)*.

Generali, Manuela, 1948- Switzerland Painting

802. Mercado, Tununa. "La incesante producción de la pintura: Manuela Generali y Herlinda Sánchez Laurel." *Fem* 44 (Feb-Mar 1986): 56-57.
 Of Italo-Swiss origin, this artist emigrated from Argentina to Mexico. Tununa Mercado points out that in her work presented at Museo de Arte Carrillo Gil she draws from her European background and life in Mexico to create images grounded in both realities.

803. Palomero, Federica. "III Bienal de Cuenca." *Arte en Colombia* 49 (1992): 136-139.
 Federica Palomero considers the relative merit of works exhibited during III Cuenca Biennial in Ecuador. Among the promising young women artists she identifies is Manuela Generali. *Reproduction: "La mar estaba serena, serena estaba la mar."*

González, Laura, 1962- Mexico City Photography

804. Hixson, Kathryn. "Crossing Borders." *Flash Art* 161 (Nov-Dec 1991): 165.
 Kathryn Hixson considers photographer's exhibition at Chicago's Sazama, remarking that she "examines the site of her own body as a physical bearer of conflicting cultural symbols." *Reproduction: "Journal of the Body," detail (1991).*

González Salazar, Consuelo Painting

805. Tibol, Raquel. "El continente convulso de Consuelo González Salazar." *Proceso* 25 Aug 1986: 52+.
 Artist's own statements aid in understanding her conception of life and her metaphoric representation of this triumph over struggle in her paintings. Raquel Tibol considers elements of style and technique she uses to achieve her intention. *Reproduction: "Involución" (1962).*

Gradwohl, Ilse, 1943- Austria Painting

806. Brumm, María. "Una exposición diferente." *Fem* 33 (Apr-May 1984): 55-56.

807. Medina, Cuauhtémoc. "Naturalezas." *Art Nexus* 10 (Sept-Dec 1993): 151-152, [English trans., 218].
 Review of "Naturalezas" exhibition in Mexico City's Galería Metropolitana that had nature as its theme. Remarks briefly on the different approaches the four artists took to their subject matter, noting the "fluidity and spontaneity" of their styles as exemplification of the theme itself.

Grizá, Irma Mexico City Painting

808. *Irma Grizá: paisajes desdoblados, del 1 de marzo al 3 de abril de 1990.*
Catalogue. México, D.F.: Galería HB, 1990. Essay, Alberto Ruy Sánchez.
Includes chronology.

809. León G., Francisco. "Irma Grizá: las cuatro estaciones de la mirada."
Artes de México 10 (1990): 100-101.
Interview in which artist talks about her attitude towards her work and the
creative process. *Reproduction: "Tríptico tropical" (1990).*

810. Tibol, Raquel. "Imaginarios paisajes de Irma Grizá." *Proceso* 27 May
1991: 55-56.
Raquel Tibol traces the artist's education, training and development, offering a
detailed analysis of her paintings which were shown at Mexico City's Galería
HB. Emphasizes Grizá's nonrealist treatment of the landscape. *Reproduction:
"Del trópico."*

Grobet, Lourdes, 1940- Mexico City Photography

811. Fusco, C. "Essential Differences: Photographs of Mexican Women."
Afterimage 18 (Apr 1991): 11-13. Bibl.
Fusco compares and contrasts work of Graciela Iturbide, Lourdes Grobet and
Yolanda Andrade. *Reproductions: "La Venus" (1985), "Reina Gallegos -- La
Monster -- Panther from the South" (1985).*

812. García Canclini, Nestor and Patricia Safa. Photographs, Lourdes
Grobet. *Tijuana: la casa de toda la gente.* [México, D.F.?]: INAH-ENAH,
Programa Cultural de las Fronteras: UAM-Iztapalapa/Conaculta, 1989. Bibl.

813. Goldman, Shifra M. "Las mujeres en el arte mexicano moderno."
Plural 2a época 11 (Feb 1982): 39-51. Bibl.
Remarking on women's relative lack of artistic presence in Mexico until 1930,
Shifra Goldman notes the emergence of various Mexican women artists during
the '60s and '70s. She explores the life and work of six artists, among them
Grobet. Goldman gives detailed information on this photographer, calling
attention to her background, training, subject matter, approach and influences
which have impacted on her work. Contains personal statement by the artist
which reveals the socially engaged nature of her work. Includes untitled
reproductions of various of her works.

814. _____. "Six Women Artists of Mexico." *Woman's Art Journal* 3.2
(Fall 1982/Winter 1983): 1-9. Bibl. Rpt. in Shifra M. Goldman, *Dimensions of
the Americas: Art and Social Change in Latin America and the United States.*
Chicago: University of Chicago Press, 1994. 179-194. Bibl.
Later version of Spanish-language article in #813.

815. Grobet, Lourdes. "Sobre mi labor fotográfica." *Los Universitarios* (México) 111-112 (Jan 1978): 18-19.

816. _____. "Todos los días. . . el pan nuestro." *México en el Arte* 22 (Summer 1989): 82-85.

817. Hernández Carballido, Elvira. "En la vanguardia: Lourdes Grobet." *Fem* 17.119 (Jan 1993): 44-45.
Very brief biographical summary of this accomplished photographer that includes some information about her training and exhibitions. Includes artist's own statements emphasizing her drive for originality and authenticity of expression.

818. Woodard, Josef. "From the Fringes: 'Compañeras de México: Women Photograph Women' at the Ventura County Museum of History & Art." *Artweek* 22 May 23 1991: 9-10.
Josef Woodard reviews Southern California exhibition featuring works by women who figure prominently in the shaping of a Mexican photographic tradition. Offers commentary on Grobet's images of women wrestlers.

Gruner, Sylvia Video/Performance

819. Rubinstein, Raphael. "Catching the Trade Winds." *Art in America* 82 (May 1994): 36-37.
In a discussion about the thriving Mexican art scene and the "enthusiastic explosion of activity among a new generation" of artists, Rubinstein mentions Sylvia Gruner's work, referring to it as a "heavy mixture of video photography and performance." *Reproduction: Installation detail from "Destierro" (1992).*

Guerrero, Antonia, 1946- U.S.A. Painting/Drawing

820. *Antonia Guerrero, Carmen Parra: oleos, acrílicos, pasteles, esculturas.* Catalogue. [México, D.F.: Museo de Arte Moderno, 1978]. Presentation, Fernando Gamboa. Includes artist's statements and chronology.

Guerrero, Rosario

821. Navarrete, Sylvia. "Guía de la estación: Rosario Guerrero." *Artes de México* 8 (Summer 1990): [103].

Gurría, Angela Sculpture

822. Urrutia, Elena. "La escultura monumental y las mujeres." *Fem* 33 (Apr-May 1984): 29-31.
Article focuses on the contributions of sculptors Helen Escobedo and Angela Gurría to modern Mexican urban landscape. Artists distinguished themselves by being the only women in a group of eighteen international artists commissioned to create sculpture monuments for the 1968 Olympic games. Essay includes

numerous direct comments by the artists regarding their training and the influences on their work. Gurria discusses the tensions she experienced as a woman struggling to break conventional boundaries to establish herself as an artist in her own right. Includes a photograph of the large-scale work she sculpted for the Olympic games.

Guttin, Becky, 1954- Mexico City Sculpture

823. *Becky Guttin: soluble al tiempo.* Catalogue. Guadalajara, México: Secretaría de Cultura, Fundación Cultural de Jalisco, A.C., 1993. Essays, Carlo Federico Teodoro and Carlos Blas Galindo.

824. *Vau: Becky Guttin.* Catalogue. México, D.F.: Museo Universitario del Chopo, 1994. Text, Jorge Juanes.

Hernández, Anamario Painting

825. Mujica, Barbara. "Bright Visions, Fine Contours." *Américas* 43.3 (May-June 1991): 44-51.
 Sketches of ten women, among them Anamario Hernández, identified by Mujica as being "on the cutting edge" of their profession. Mujica considers the "architectural quality" of her still lifes, remarking that she is at "the more traditionalist end of the spectrum." Includes statements by the artist. *Reproductions: "Pirinolas" (1990).*

Horna, Kati, 1915- Spain Photography

826. Rodríguez Prampolini, Ida. *El surrealismo y el arte fantástico de México.* México, D.F: Universidad Nacional Autónoma de México, Instituto de Investigaciones Estéticas, 1969. Bibl. 78-80.

Hussong, Estela, 1950- Ensenada Painting

827. *Estela Hussong.* México, D.F., Galería OMR, (May 1993); Chihuahua, México: Centro Cultural Chihuahua, (June-July 1993). Includes biography.

Isaac, Lucero, 1936- Mexico City Set Design/Assemblage

828. Chadwick, Whitney. "Lucero Isaac: Translating the Imaginary." *Latin American Art* 6.1 (Spring 1994): 29-33.
 "Working within the tradition of Latin American Magic Realism, Lucero Isaac's enchanting assemblages and collages -- found and fabricated objects with powerful associative properties -- illuminate the interplay between the worlds of theater, film, art, and literature," writes Chadwick. *Reproductions: "Madre acusada de ser madre" (1994), "Retrato de la Señora Andrade" (1989), "La Niña Isabel" (1989), "Pompa y cera-perdida" (1990), "Desert Sprouts" (1992), "Ojalá yo fuera una singer" (1989).*

829. Isaac, Claudio. "Lucero Isaac: su relojería estática." *Artes de México* 16 (Summer 1992): 106-107.
Claudio Isaac writes that because he grew up surrounded by the objects his mother created he became used to thinking of her enormous creative energy and rich imagination as something natural and spontaneous. He uses literary allusion to define her artwork, referring to her pieces as "galleries of the soul rather than arquitectural projects." *Reproductions: "Especialista en cerebro" (1991), "Página anterior" (1991), "Sacudiendo la tristeza" (1991).*

830. Katzew, Ilona. "Lucero Isaac." *Review : Latin American Literature and Arts* 48 (Spring 1994): 21-22.
Sketch of artist including some biographical data and information on the development of her career. *Reproduction: "No Turning Points" (1992).*

831. Melkonian, Neery. "Lucero Isaac." *Arts Magazine* 66.4 (Dec 1991): 71.
Review of Isaac's work at Gerald Peters Gallery in Santa Fé. "Pieces of old lace, brocade, and silk tassels; fragments of used dolls, rosaries, and charms, old watches, typewriters, and cigar boxes; glittering labels of brandy, tea, and chocolate. . .; photographs of officials in the regalia of another era; stained books, prints, and post cards; cutouts of muses, women of leisure, and Hollywood celebrities -- these make up a partial list of the props Lucero Isaac uses to stage her recent series of assemblages," writes Neery Melkonian. Includes a photograph of one of her works.

Iturbide, Graciela, 1942- Mexico City Photography

832. Caujolle, Christian. "Graciela Iturbide, Donna Ferrato: Femmes au pouvoir, femmes battues = Women in Power, Battered Women." *Camera International* 28 (Spring 1991): 44-53.
Briefly compares work of the two photographers. French/English language text. Includes several untitled reproductions from "Juchitán de las mujeres" series.

833. Esteves, Juan. "Graciela Iturbide." *Vozes* 87.5 (Sept-Oct 1993): 98.

834. *External Encounters, Internal Imaginings: Photographs by Graciela Iturbide = Encuentros externos, imaginerías internas: fotografías de Graciela Iturbide.* San Francisco, CA: Museum of Modern Art, 1990. Spanish and English text.

835. Ferrer, Elizabeth. "'Encountering Difference': Four Mexican Photographers." *Center Quarterly* 14.1 (1992): 6-17. Bibl.
Essay by curator of "Encountering Difference," project highlighting "difference" from a variety of perspectives. Gives details on development of photography in Mexico and briefly considers background and work of four photographers, including Graciela Iturbide. *Reproductions: "Christina," "White Fence, East L.A.," "Rosario, Christina y Liza, East L.A." (1986).*

836. _____. "Manos poderosas: The Photography of Graciela Iturbide."
Review: Latin American Literature and Arts 47 (Fall 1993): 69-78.
 Portrait exploring Iturbide's training and development, as well as her standing relative to other Mexican photographers. Ferrer discusses artist's direct approach to her subject matter -- scenes depicting indigeneous Mexican culture -- placing particular emphasis on the photographs she made in Juchitán. *Reproductions: "Manos poderosas, Juchitán" (1988), "Chismosas, Juchitán" (1986), "Cholos, Harpys, East Los Angeles" (1990), "Na" Lupe pan, Juchitán," (1986), "Rosario, Christina, and Lisa, White Fence, East Los Angeles" (1986).*

837. Fusco, C. "Essential Differences: Photographs of Mexican Women."
Afterimage 18 (Apr 1991): 11-13. Bibl.
 Fusco compares and contrasts work of Graciela Iturbide, Lourdes Grobet and Yolanda Andrade. *Reproduction: "Untitled" from "Juchitán de las mujeres" (1989).*

838. *Graciela Iturbide: Museo del Palacio de Bellas Artes, septiembre-octubre de 1993, Ciudad de México.* Catalogue. México, D.F.: Fotoseptiembre, 1993. Spanish/English text.

839. Harrison, Christina Marie. *Feminism and Contemporary Mexican Photography: Graciela Iturbide's Photographs of Juchitán.* Bibl. Master's Thesis. University of Texas at Austin, 1993.

840. Hopkinson, Amanda. "All's Well Down Mexico Way." *British Journal of Photography* 30 Nov 1989: 10-13.
 On the occasion of the 150th anniversary of the invention of photography Amanda Hopkinson takes a look at figures who have played a prominent role in the development of Mexican photography. Makes brief mention of Graciela Iturbide (13). *Reproductions: "Comadres" (1979), "Our Lord of Images" (1982).*

841. _____. "Dreams, Death and Solitude." *British Journal of Photography* 9 Feb 1989: 10-11.
 Focuses on Iturbide's approach towards her work. "Wherever I go and whatever I document I know that my work is not objective: it reveals as much about me as my subject. What I haven't lived I have dreamed," she says. *Reproductions: "First Day of Summer" (1981), "The Cock" (1985), "Our Lady of the Iguanas."*

842. _____. "A Dynasty of Mexican Photographers." *Creative Camera* 10 (1989): 38-39.
 Includes commentary on Iturbide's "Juchitán de las Mujeres" series which was presented at the Camden Arts Centre. Remarks on censorship which occurred when exhibition was shown in Darlington, England. *Reproduction: from Series "Juchitán de las mujeres."*

843. Iturbide, Graciela. "Graciela Iturbide: ¡Oye! ¿y a mí no me vas a retratar?" *México en el Arte* 19 (Winter 1987): 83.
"At times I think that I make photographs due to some sort of fear of death. It's like I wanted to entrap reality in order to rob from it a piece of life. . . to draw from it some permanence." Iturbide "talks" briefly, among other things, about her training with Manual Alvarez Bravo, women as a constant in her photographs, and the artistic intention behind her work. Includes photographer's portrait.

844. _____. *Juchitán de las mujeres*. Text, Elena Poniatowska. México, D.F.: Ediciones Toledo, 1989.

845. _____. *Sueños de papel*. México, D.F.: Fondo de Cultura Económica, [1985]. Presentation, Veronica Volkow.

846. Joskowicz, Alfredo. "La fotografía de Graciela Iturbide." *Artes Visuales* 5 (Jan-Mar 1975): 15-18.

847. Matus, Macario. "Graciela Iturbide: Rites of Fertility." *Aperture* 109 (Winter 1987): 14-27.
Description of the Zapotecan ceremonies which Graciela Iturbide recorded in her photographs in the Isthmus of Tehuantepec. *Reproductions: "Sacred Hands" (1986), "Girl with a Comb" (1980), "Rosa" (1980), "Magnolia with Sombrero" (1986), "Serafina" (1986), "The Ascension" (1985), "La Señora Guadalupe" (1987), "Magnolia" (1986), "Hens" (1980), "The Chickens" (1980), "Our Lady of the Iguanas, Juchitán" (1980).*

848. *On the Art of Fixing a Shadow: One Hundred and Fifty Years of Photography*. Catalogue. Washington, D.C.: National Gallery of Art, 1989.

849. Rivera Scott, Hugo. "Con guantes de seda: entrevista con Graciela Iturbide." *Casa de las Américas* 30.178 (Jan-Feb 1990): 88-99.
Interview exploring Iturbide's training, her association with photographer Manuel Alvarez Bravo, and her ideas about photography as a medium of artistic expression. Rivera Scott reflects on her approach towards her subject matter and discusses the development of various projects, among them "Juchitán de las mujeres." Includes photographer's portrait. *Reproductions: Several from series "Juchitán de las mujeres."*

850. Volkow, Veronica. "Graciela Iturbide: Senses of Solitude." *Creative Camera* 10 (Oct 1988): 26.
Contains excerpt from *Paper Dreams*, author's book of works by Iturbide, whom Volkow asserts is "one of Mexico's most prominent photographers." Discusses essential Mexican character of her images, relating the atmosphere which her works exude to the spirit of solitude referenced in works by Rufino Tamayo, Juan Rulfo and Octavio Paz.

851. Woodard, Josef. "From the Fringes: 'Compañeras de México: Women Photograph Women' at the Ventura County Museum of History & Art." *Artweek* 22 May 23 1991: 9-10.

Josef Woodard reviews Southern California exhibition featuring works by women who figure prominently in the shaping of a Mexican photographic tradition. Offers commentary on Iturbide's images, drawing parallels between her work and that of Mariana Yampolsky.

Izquierdo, Maria, 1902-1955 San Juan de los Lagos Painting

852. Bautista, Ruben. "María Izquierdo." *Artforum* 27.9 (May 1989): 163-164.

Brief but informative sketch of the artist on the occasion of her retrospective in Mexico City's Centro Cultural/Arte Contemporáneo. Bautista writes that Izquierdo's "personal approach to seeing and painting made her an important and influential artist in the Mexican art stage." *Reproduction: "Alacena con paloma" (1954).*

853. Billeter, Erika. "Frida and Maria." *Images of Mexico: The Contribution of Mexico to 20th Century Art.* Dallas, TX: Dallas Museum of Art, 1987. 129-136.

854. Cervantes, Miguel and others. "María Izquierdo sitiada y situada." *Vuelta* 12.144 (Nov 1988): 21-27.

Revised text of conversation between Miguel Cervantes, Robert Littman and Octavio Paz which brings to light, among other things, details of the artist's life, influences at work in her paintings, and her association with such literary figures as Antonin Artaud and Pablo Neruda. Paz makes interesting contrast between Izquierdo and her contemporary, Frida Kahlo. Includes the artist's portrait. *Reproductions: "Rebozo rojo" (1944), "Escena de circo" (1945).*

855. Ferrer, Elizabeth. "María Izquierdo." In *Latin American Artists of the Twentieth Century.* Ed. Waldo Rasmussen with Fatima Bercht and Elizabeth Ferrer. New York: The Museum of Modern Art, 1993: 116-121. Bibl.

856. Gorostiza, José. "La pintura de María Izquierdo." *Proceso* 30 Jan 1989: 54- 55.

Text of essay written by prominent Mexican poet for catalogue of 1933 exhibition of artist's paintings and watercolors. Includes untitled reproduction of one of her works.

857. *María Izquierdo.* Mexico, D.F.: Centro Cultural/Arte Contemporáneo, 1988. Bibl. Essays (in Spanish), Fernando Gamboa, José Pierre, Olivier Debroise, Sylvia Navarrete and Lourdes Andrade.

858. *María Izquierdo: nacionalismo cultural.* Mexico, D.F.: Partido Revolucionario Institucional, Comité Ejecutivo Nacional, Secretaría de Información y Propaganda, Subsecretaría de Publicaciones, 1988. Bibl.

859. Marquet, Antonio. "La pintura de María Izquierdo." *Plural* 19 (Nov 1989): 69.
Notes sensual characteristics of artist's paintings, contrasting the cheerfulness of her earlier works with the anguish and despair in those of her later life.

860. Monsiváis, Carlos. *María Izquierdo*. México, D.F.: Casa de la Bolsa Cremi, 1986.

861. Rodríguez Prampolini, Ida. *El surrealismo y el arte fantástico de México*. México, D.F: Universidad Nacional Autónoma de México, Instituto de Investigaciones Estéticas, 1969. 86-87. Bibl.

862. Sullivan, Edward J. "Mexico City: María Izquierdo." *The Burlington Magazine* 131 (Mar 1989): 247.
Describing her as a "painter of almost equal stature and originality" as Frida Kahlo, Edward Sullivan profiles artist's life and influences on her work on the occasion of an exhibition of her paintings at the Centro Cultural/Arte Contemporáneo in Mexico City. *Reproductions: "Portrait of Henri de Chatillon" (1940), "Red Snappers" (1946).*

863. Tibol, Raquel. "El catálogo '88 de María Izquierdo." *Proceso* 12 Dec 1988: 52-55.

864. _____. "María Izquierdo." *Latin American Art* 1.1 (Spring 1989): 23-25. Rpt. in installments in Spanish as "En los 90 años de María Izquierdo" in *Proceso* (7 Sept 1992: 53+), *Proceso* (14 Sept 1992: 53-54), *Proceso* (21 Sept 1992: 55+).
Biographical portrait by art historian and critic tracing the artist's development and career. Focuses on her anti-academic, primitivistic approach to subject matter, shedding light on the close relationship she maintained with Rufino Tamayo and the mutual influence their association brought to bear on their work. Tibol notes that her paintings "reflect an intimate and genuine relationship with the roots of her Mexican heritage." Includes artist's own statements which reveal her feminist stance in the face of chauvinistic attitudes about women's social roles, while also giving insight into her source of inspiration. *Reproductions: "Mother and Child" (1944), "Retrato del turista" (1940), "The Circus" (ca. 1940).*

865. Valdés, Carlos. "Evocación de Hector Xavier: muerte de María Izquierdo, dolor de Frida Kahlo." *Revista de la Universidad de México* 33.8 (Apr 1979): 29-33.
Conversation with artist Héctor Xavier who was informally associated with the Mexican School of Painting La Esmeralda where Izquierdo and Kahlo were instructors. Xavier reminisces and provides anecdotal accounts of his association with both artists, the supposed rivalry between Kahlo and Izquierdo, and Izquierdo's decline and death.

Jiménez, María Elena, 1955- Painting

866. *María Elena Jiménez Huerta*. México, D. F.: Museo Estudio Diego Rivera, 1990.

Kahlo, Frida, 1907-1954 Coyoacán Painting

Books and other monographic works:

867. Arquin, Florence. *Diego Rivera: The Shaping of an Artist, 1889-1921*. Norman, OK: University of Oklahoma Press, [1971]. Bibl.

868. Bartra, Eli. *Mujer, ideología y arte: ideología y política en Frida Kahlo y Diego Rivera*. Barcelona, Spain: La Sal, 1987. Bibl.

869. Chadwick, Whitney. *Women Artists and the Surrealist Movement*. New York: NY: Thames and Hudson, 1991.

870. D'Ambrosio, Vinnie-Marie. *Mexican Gothic: Poem*. [Lincoln, Nebraska]: Blue Heron Press, 1993.
 Limited edition of poetry by the artist.

871. Del Conde, Teresa. *Frida Kahlo, la pintora y el mito*. México. D.F.: Instituto de Investigaciones Estéticas, Universidad Nacional Autónoma de México, 1992. Bibl.

872. Drucker, Malka. *Frida Kahlo: Torment and Triumph in Her Life and Art*. New York, NY: Bantam, 1991.

873. Flores Guerrero, Raúl. *Cinco pintores mexicanos: Frida Kahlo, Guillermo Meza, Juan O'Gorman, Julio Castellanos, Jesus Reyes Ferreira*. México, D.F.: Universidad Nacional Autónoma de México, 1957.

874. Frazier, Nancy. *Frida Kahlo: Mysterious Painter*. Woodbridge, CT: Blackbirch, 1992. Bibl.
 For young readers.

875. *Frida Kahlo*. México, D.F.: Forjadores de México, 1988.

876. *Frida Kahlo: la cámara seducida*. Trans. Elena Frutos. Photographs, Ansel Adams; memoir, Elena Poniatowska; essay, Carla Stellweg. México, D.F.: La Vaca Independiente, 1992. Bibl.

877. *Frida Kahlo: nacionalismo cultural*. México, D.F.: Partido Revolucionario Institucional, Comité Ejecutivo Nacional, Secretaría de Información y Propaganda, Subsecretaría de Publicaciones, 1988. Bibl.

878. *Frida Kahlo Postcards*. San Francisco, CA: Chronicle Books, 1991.

879. *Frida Kahlo: The Camera Seduced.* Photographs, Ansel Adams; memoir, Elena Poniatowska; essay, Carla Stellweg. San Francisco, CA: Chronicle Books, 1992. Bibl.

880. García, Rupert. *Frida Kahlo: A Bibliography.* Berkeley, CA: Chicano Studies Library Publications Unit, University of California, 1983.

881. Garza, Hedda. *Frida Kahlo: Mexican Painter.* New York, NY: Chelsea House, 1994.

882. Heller, Nancy. *Women Artists: An Illustrated History.* New York, NY: London, England: Abbeville Press, 1987, 1991. Bibl.

883. Herrera, Hayden. *Frida: A Biography of Frida Kahlo.* New York, NY: Harper and Row, 1983.

884. _____. *Frida Kahlo & Ignacio Aguirre: cartas de una pasión.* México D.F.,: Editorial Trabuco y Clavel, 1994.

885. _____. *Frida Kahlo: Her Life, Her Art.* Ph.D. Dissertation. City University of New York, 1981.

886. _____. *Frida: una biografía de Frida Kahlo.* México, D.F.: Editorial Diana, 1985. Bibl.

887. _____. *Frida Kahlo: The Paintings.* New York, NY: HarperCollins, 1991. Bibl.

888. Herrera, Juan Felipe. *The Roots of a Thousand Embraces: Dialogues.* San Francisco, CA: Manic D Press, 1994.

889. *Images of Frida Kahlo.* Introduction, Angela Carter. London: Redstone Press, 1989.

890. Jamis, Rauda. *Frida Kahlo: autoportrait d'une femme.* Paris, France: Presses de la Renaissance, 1985. Bibl.

891. _____. *Frida Kahlo: autorretrato de una mujer.* Trans. Stella Mastrangelo. México, D.F.: Edivisión, 1987. Bibl.

892. Le Clezio, Jean-Marie Gustave. *Diego et Frida.* Paris, France: Stock, 1993. Bibl.

893. Lowe, Sarah M. *Frida Kahlo.* New York, NY: Universe, 1991.

894. Monsiváis, Carlos. *Frida Kahlo: una vida, una obra.* México, D.F.: Consejo Nacional para la Cultura y las Artes, Ediciones Era, 1992. Bibl.

895. Motian-Meadows, Mary. *Frida Kahlo: The Personal and Political.* Master's Thesis. California State University, Fullerton, 1982.

896. *Museo Frida Kahlo.* [México, D.F.: Museo Frida Kahlo, 1968]. Includes chronology.

897. Olmedo, Lola. *The Frida Kahlo Museum.* [México, D.F.: M. Gales, 1970].

898. Richmond, Robin. *Frida Kahlo in Mexico.* San Francisco, CA: Pomegranate Artbooks, 1994. Bibl.

899. Rico, Araceli. *Frida Kahlo: fantasía de un cuerpo herido.* México, D.F.: Plaza y Valdés, 1987.

900. Rivera Marin, Guadalupe and Marie-Pierre Colle. *Frida's Fiestas: Recipes and Reminiscences of Life with Frida Kahlo.* Trans. Olga Rigsby. New York, NY: Clarkson Potter, 1994.

901. Rodríguez Prampolini, Ida. *El surrealismo y el arte fantástico de México.* México, D.F: Universidad Nacional Autónoma de México, Instituto de Investigaciones Estéticas, 1969. Bibl.

902. Silberstein, Bernard G. *Diego & Frida: A Print Collection of Photographs.* San Francisco, CA: B. Wiggins, 1988.

903. Sills, Leslie. *Inspirations: Stories about Women Artists: Georgia O'Keeffe, Frida Kahlo, Alice Neel, Faith Ringgold.* Niles, Illinois: Albert Whitman, 1989. Bibl.
For young readers.

904. Stellweg, Carla. *Frida Alive: A Photographic Portrait of Frida Kahlo.* Ghent, Belgium: Imschoot, 1991.

905. Tibol, Raquel. *Frida Kahlo: crónica, testimonios y aproximaciones.* México, D.F.: Ediciones de Cultura Popular, 1977. Bibl.

906. _____. *Frida Kahlo: uber ihr Leben und ihr Werk, nebst Aufzeichnungen und Briefen.* Trans. Helga Prignitz. Frankfurt, Germany: Verlag Neue Kritik, 1980. Bibl.

907. _____. *Frida Kahlo: An Open Life.* Trans. Elinor Randall. Albuquerque, NM: University of New Mexico, 1993. Bibl.

908. _____. *Frida Kahlo: una vida abierta.* México, D.F.: Editorial Oasis, 1983. Bibl.

909. Turner Robyn. *Frida Kahlo*. Boston, MA: Little, Brown, 1993.
Part of series, *Portraits of Women Artists for Children.*

910. Zamora, Martha. *Frida Kahlo: el pincel de la angustia*. [La Herradura,
México]: M. Zamora, [1987]. Bibl.

911. _____. *Frida Kahlo: The Brush of Anguish*. Abridged and trans.
Marilyn Sode Smith. San Francisco, CA: Chronicle Books, 1990. Bibl.

Periodical articles and book chapters:

912. Agosín, Marjorie. "Las ceremonias del cuerpo calado: Frida Kahlo."
Las hacedoras: mujer, imagen, escritura. Santiago, [Chile]: Editorial Cuarto
Propio, [1993]. 225-229. Bibl.

913. "Artes plásticas: Frida Kahlo." *Canción de Marcela: mujer y cultura en
el mundo hispánico*. Ed. David Valjalo. Madrid, Spain: Editorial Origenes,
1989. 189-191.

914. Baddeley, Oriana. "'Her Dress Hangs Here': De-frocking the Kahlo
Cult." *Oxford Art Journal* 14.1 (1991): 10-17. Bibl.
Study which begins by examining the significance of the popular press
fascination with Kahlo's "physical appearance," culminating in an analysis of
feminist and political statements that appear to be embedded symbolically in her
personal and artistic adoption of the Tehuana costume. *Reproductions:
"Portrait of Frida Kahlo" (1931), "Self-Portrait with Cropped Hair" (1940),
"Frida Kahlo: The Mask" (1945), "The Tree of Hope" (1946), "The Suicide of
Dorothy Hale" (1939), "My Dress Hangs There" (1933), "Self-Portrait on the
Border" (1932).*

915. Bakewell, Lisa. "Frida Kahlo: A Contemporary Feminist Reading."
Frontiers 13.3 (Spring 1993) 165-189. Bibl.

916. Barnitz, Jacqueline. "Five Women Artists." *Review : Latin American
Literature and Arts* 75 (Spring 1975): 38-41.
Writer suggests that 20th century Latin American women artists have gained
more prominence than their North American counterparts and have forged ahead
to become leaders in their respective fields. Frida Kahlo is among the five
women briefly profiled by Barnitz.

917. Barrie, Lita. "An Alternative Art: 'Aspects of Contemporary Mexican
Painting' at the Santa Monica Museum of Art." *Artweek* 30 Jan 1992: 8-9.
This exhibition brought together the paintings of artists whose works do not
fit within a "particular art trend or convention," writes Lita Barrie. Remarks on
palpable influence of Frida Kahlo on various of the exhibiting artists, noting
that she is a "reference point for many contemporary Mexican artists who strive
for a greater depth of self-examination in their work."

918. Bergman-Carton, Janis. "Like an Artist." *Art in America* 81 (Jan 1993): 35-37+. Bibl.
Art historian explores "manipulation of gender conventions" and "resistance of fixed identity boundaries" in personal lives and work of Kahlo and Madonna. Analyzes advertising strategy that "exploits" performer's identification with the artist. *Reproductions: "The Little Deer" (1946), "My Birth" (1932).*

919. _____. "Strike a Pose: The Framing of Madonna and Frida Kahlo." *Texas Studies in Literature and Language* 35.4 (Winter 1993): 440-452. Bibl.
Earlier version of above article, study explores "Madonna-Kahlo connection." *Reproduction: "My Birth" (1932).*

920. Billeter, Erika. "Frida and Maria." *Images of Mexico: The Contribution of Mexico to 20th Century Art.* Dallas, TX: Dallas Museum of Art, 1987. 129-136.

921. _____. "The World of Frida Kahlo: The Self-Portrait as Autobiography." *Southwest Art* 23 (Aug 1993): 94-98.
Excerpted from catalogue published for touring exhibition, "The Blue House: The World of Frida Kahlo." Contains biographical information, as well as small fragments of a letter the artist wrote to Alejandro Gómez Arias in 1926. *Reproductions: "Thinking About Death" (1943), "Roots" (1943), "The Broken Column" (1944), "The Little Deer" (1946), "Diego and I" (1949).*

922. "Bomb Beribboned." *Time* 14 Nov 1938: 29.
Commentary on first show by Frida in the United States at Manhattan's Julien Levy Gallery. "Little Frida's pictures, mostly painted in oil on copper, had the daintiness of miniatures, the vivid reds and yellows of Mexican tradition and the playfully bloody fancy of an unsentimental child."

923. Breslow, Nancy. "Frida Kahlo: A Cry of Joy and Pain." *Américas* 32.3 (Mar 1980): 33-39.
Biographical portrait of the artist. Breslow considers the sources and multiple meanings of Kahlo's symbolism, writing that "what her paintings lacked in quantity, they made up for in the combination of poetry and honesty that gave her images the power of myth and the ability to nourish the viewer." *Reproductions: "Self-Portrait" (1940), "Self-Portrait with Monkeys" (1943), "My Dress Hangs There" (1933), "Frida and the Miscarriage" (1932), "What the Water Has Given Me," "Luther Burbank" (1931).*

924. Breton, André. "Frida Kahlo de Rivera." *México en el Arte* 14 (Fall 1986): 6-7.

925. _____. "Frida Kahlo de Rivera." *Surrealism and Painting.* Trans. Simon Watson Taylor. New York: Harper & Row, 1972. 141-144.

926. Brett, Guy. "Diego Rivera and Frida Kahlo." *Art Monthly* 109 (Sept 1987): 7-9.

927. Chadwick, Whitney. "The Muse as Artist: Women in the Surrealist Movement." *Art in America* 73 (July 1985): 120-129. Bibl.
Considers work of women associated with the Surrealist movement, including Frida Kahlo. *Reproductions: "The Broken Column" (1944), "Moses" (1947).*

928. Conde, Teresa del. "Lo popular en la pintura de Frida Kahlo." *Anales del Instituto de Investigaciones Estéticas* 45 (1976): 195-203. Bibl.
Teresa del Conde examines aspects of the popular in Kahlo's paintings, pointing out circumstances in the artist's life that may have fueled that aesthetic response in her work. *Reproductions: "Autorretrato con aeroplano" (1929), "Autorretrato" (1946), "Las dos Fridas," detail (1939) "El difuntito Dimas" (1937).*

929. Cooey, Paula M. *Religious Imagination and the Body: A Feminist Analysis.* New York, NY: Oxford University Press, 1994. 94-108. Bibl.

930. Estrada, Arturo. "Remembranza de Frida Kahlo." *Plural* 13 (July 1984): 32-37.
Kahlo began to teach at the Escuela de Pintura y Escultura La Esmeralda in 1943. Arturo Estrada, director of the school in 1984, was at the time one of the "Fridos" -- as the group of students devoted to Kahlo and her style of teaching was named. In his recollections he offers intimate and valuable insights into a side of Kahlo that is generally unknown, among other things, her attitude towards the teaching process and her unfailing and generous commitment to her students, many of whom forged ahead to become successful artists in their own right. Includes portrait of Kahlo with various of her students.

931. "Free La Frida." *Southwest Art* 21.10 (Mar 1992): 18+.
Focuses on what the Social and Public Art Resource Center has done to release Frida from "the entangling snare of capitalist commercialism."

932. "Frida Fever." *Southwest Art* 21.3 (Aug 1991): 23.
How did Kahlo fare at Christie's Latin American Paintings, Drawings and Sculpture Auction in 1991? This news item shows she was at the head of the pack. *Reproduction: "Self-Portrait with Loose Hair."*

933. Goldman, Shifra M. "The Intense Realism of Frida Kahlo." *Chisme Arte* 1.4 (Fall/Winter 1977): 8-11.
Biographical sketch. Of Kahlo's images Shifra Goldman writes that they were not conceived of "dreams and nightmares filtered through Freudian consciousness but the realties of her life transformed by the magical qualities of Mexican folk tradition and her own indomitable spirit." *Reproductions: "Autorretrato como tehuana" (1943), "Autorretrato" (1946), "Raices" (1943), "La venadita" (1946), "La novia que se espanta de ver la vida abierta."*

934. _____. "The Heart of Mexican Art: Image, Myth and Ideology." *New Art Examiner* 21 Dec 1993: 12-15+.
 Shifra Goldman considers symbolism of the body in the works of a variety of Mexican artists, among them Frida Kahlo.

935. Glusker, Peter. "Self-portrait of Frida Kahlo." (Letter to the editor). *The Journal of the American Medical Association* 271.14 (13 Apr 1994): 1078-1079.
 Close friend of Kahlo and Rivera offers alternate view, among other things, as to why artist's paintings frequently include monkeys and exotic flowers disputing, he remarks, Hayden Herrera's interpretation of their symbolism.

936. González, Miguel. "Frida Kahlo." *Arte en Colombia* 31 (Oct 1986): 34-38. Bibl.
 Miguel González writes "that Kahlo was probably a genius, having an extraordinary impact on the development of 20th century art." *Reproductions: "Autorretrato" (1943), "Autorretrato con el pelo cortado" (1940), "Autorretrato en la frontera de México y Estados Unidos" (1932), "Mi nana y yo" (1937), "Moisés" (1945), "Las dos Fridas" (1939).*

937. Greenstein, M. A. "A Conversation with Malka Drucker." *Artweek* 20 Aug 1992: 26.
 Transcript of conversation with Malka Drucker, author of Kahlo book for fourteen-year olds.

938. Grimberg, Salomón. "Frida Kahlo's 'Memory.'" *Woman's Art Journal* 11.2 (Fall 1990/Winter 1991): 3-6. Bibl.
 Psychoanalytic discussion of "Memory," using Saint Teresa of Avila's testimony of her Transver-beration as a point of reference. Draws analogies between the lives of the two women, suggesting that Kahlo's fascination with Saint Teresa and her frequent use of religious iconography in her paintings reflect a psychological need to seek refuge in religion as a means of allaying pain caused by her life circumstances. *Reproduction: "Memory."*

939. Gripp, Rosa-María "¡Contra el culto! Frida Kahlo en Francfort." Trans. Gabriela Fonseca. *Humboldt* 109 (1993): 66-69.

940. Helland Janice. "Aztec Imagery in Frida Kahlo's Painting: Indigenity and Political Commitment." *Woman's Art Journal* 11.2 (Fall 1990-Winter 1991): 8-13. Bibl.
 Departure from the customary psychoanalytic approach to the artist's work. Discusses her use of imagery and symbolism specific to Aztec culture to express her love of country and her political ideas. Includes artist's own statements which disclose the attitude that guided the execution of her style. *Reproductions: "Self-Portrait on the Border Between Mexico and the United States" (1932), "My Dress Hangs Here" (1933), "Self-Portrait With Thorn Necklace and Hummingbird" (1940).*

941. _____. "Frida Kahlo: The Politics of Confession." *Latin American Art* 3.4 (Winter 1991): 34-36. Bibl.
Argues that Frida's work must be studied and understood within the cultural context it was produced to save it from "total trivialization" and "fetishization as a commodity." *Reproductions: "Roots (The Pedregal)" (1943), "The Broken Column" (1944), "Self-Portrait with Loose Hair" (1947), "Henry Ford Hospital" (1932).*

942. Herrera, Hayden. "Frida Kahlo: Her Life, Her Art." *Artforum* 14.9 (May 1976): 38-44. Bibl.
Detailed and engrossing look at the artist and her work. Interspersing her study with statements by Kahlo, Herrera remarks on aspects of life which she made manifest in her paintings, her relationship with Diego Rivera, and the impact of Mexican colonial and popular art on her work. Includes portrait of Kahlo and Diego Rivera. *Reproductions: "Broken Column" (1944), "Self-Portrait" (1943), "Portrait of Diego" (1949), "Frida and Diego Rivera" (1931), "The Two Fridas" (1939), "My Nurse and I" (1937), "Self-Portrait with Cropped Hair" (1940), "Henry Ford Hospital" (1932).*

943. _____. "Frida Kahlo: The Palette, the Pain, and the Painter." *Artforum* 21.7 (Mar 1983): 60-67.
Portrait of artist emphasizing aspects of her medical history resulting from the bus collision that left her with multiple physical injuries. Includes excerpts from her diary and letters she wrote revealing not only her physical and psychological trauma, but also the spirit which sustained her throughout the various stages of her ordeal. Contains portraits of the artist. *Reproductions: "Self-Portrait with the Portrait of Dr. Farill" (1951), Frida Kahlo painting "Living Nature" (1952), "They Ask for Planes and Only Get Straw Wings" (1938), "Self-Portrait with Small Monkey" (1945), "Memory" (1937), "Tree of Hope" (1946), "The Little Deer" (1946), "Self-Portrait" (1948), "Thinking About Death" (1943).*

944. _____. "Making an Art of Pain." *Psychology Today* 17 (March 1983): 86.

945. _____. "Native Roots: Frida Kahlo's Art." *Artscanada* 36.3 (Oct-Nov 1979): 25-28.
Considers "parallels" in Kahlo's paintings and Mexican folk art expressions (pulquería murals and retablos), as well as the reasons why Kahlo may have adopted primitivism as a "manner of approach to style and imagery."

946. _____. "A Painter's Passion." *House and Garden* (Aug 1983): 98+.
A guided tour of the Frida Kahlo Museum in Coyoacán, Kahlo's birthplace and home. "Full of wit, color, exuberance, and, of course, pain, the Frida Kahlo Museum is like Frida Kahlo's paintings: it illustrates and makes vivid the lives of the two extraordinary painters who called it home," writes Herrera. Includes portraits of the artist. *Reproductions: "My Grandparents, My Parents and I" (1936), "The Little Deer" (1946), "Self-Portrait as a Tehuana" (1943).*

947. _____. "Portrait of Frida Kahlo as a Tehuana." *Heresies* 4 (1978-1979): 57-58.

Remarking that it was "for her both mask and frame," Herrera probes reasons why Frida may have chosen to dress in Tehuana costume -- from identification with the "exotic" to a "flamboyant" way of disguising a foot disfigured by childhood polio." Includes photograph of the artist in Tehuana costume. *Reproduction: "Self-Portrait" (1948).*

948. _____. "Why Frida Kahlo Speaks to the 90's." *New York Times* 28 Oct 1990, sec 2: 1+.

Herrera writes that Kahlo's "greatest appeal is her strength in adversity," noting also, among other things, the magnetic draw of her work among feminists, Mexican-Americans and others who see her "unconventional approach to gender as liberating." *Reproductions: "Frida and Diego Rivera," "Self-Portrait as a Tehuana."*

949. Hinds, Harold E., Jr. "Frida Kahlo: Artist and Woman of Modern Mexico." *De Colores* 3.3 (1977): 50-67.

950. Hull Webster, Mary. "The Kahlo Enigma: 'Pasión por Frida' at the Mexican Museum." *Artweek* 20 Aug 1992: 25.

Review of exhibition at Mexican Museum in San Francisco featuring various of artist's paintings, as well as Frida look-alikes, memorabilia, and work by artists who have been influenced by Kahlo.

951. Jenkins, Nicholas. "Calla Lilies and Kahlos." *Art News* 90 (Mar 1991): 104-105.

Description of the Mexico City house in which Frida and Diego Rivera lived and which is now a museum. Includes photographs of the house and artist's studio, as well as of Kahlo and Rivera.

952. Jordan, Jim. "A House as Biography." *Artweek* 18 26 Dec 1987: 12.

Review of Debra Bloomfield's "Frida's Blue House" series at San Francisco's Robert Koch Gallery. Jim Jordan emphasizes "very effectively edited tour of Kahlo's environment" which she provides viewer. *Reproduction: "Untitled" from the Series (1987).*

953. Kozloff, Joyce. "Frida Kahlo." *Women's Studies* 6 (1978): 43-59. Bibl.

Joyce Kozloff reviews Kahlo's life and examines the "life-cycle" issues which weave themselves in and out many of her works. *Reproductions: "Diego and Frida Rivera" (1931), "My Grandparents, My Parents and Me" (1936), "Luther Burbank" (1931), "The Little Dove" (1946), "The Two Fridas" (1939), "Self-Portrait with Cropped Hair" (1940), "Without Hope" (1945), "Thinking about Death" (1943).*

954. Lida, David. "Fotografías de Frida." *Art Nexus* 1 (May 1991): 116-118 [English trans. 167-168].
Photographs of Frida that read like a biography, asserts David Lida, in his commentary on the Frida pictures shown at New York's Carla Stellweg Gallery. Taken by various photographers, among them such friends as Lola Alvarez Bravo and Lucienne Bloch, the photos captured artist in a variety of settings and, according to Lida, reflect the anguish she portrayed in her own self-portraits. *Reproduction: Lola Alvarez Bravo: "Frida pensando."*

955. Lyall, Sarah. "Frida Kahlo's Journal, A Likely Eye-Opener." *New York Times* 10 Aug 1994, late ed. final, sec. C: 9.
News item related to projected auction of Kahlo's journal -- "170 pages of musings, poetry, letters to Kahlo's husband, the great muralist Diego Rivera, and drawings and paintings that have never been exhibited. . ." *Reproduction: Detail of "Diego and I."*

956. Márquez, Francisco. "Frida Kahlo: ¡Viva la vida!" *Nueva Sociedad* 89 (May/June 1987): 75-81. Bibl.
"¡Viva la vida!" is the title Frida gave her vibrant still-life of watermelons painted one month before her death. Francisco Márquez probes the impact which artist's life circumstances had on her work. *Reproductions: "Las dos Fridas" (1939), "The Broken Column" (1944).*

957. McMurray, George R. "Latin American Art Gaining in Prestige." *Hispania* (USA) 74.1 (Mar 1991): 113-114.
Refers to sale of "Diego y yo" for close to $1,500,000 at Sotheby's and the increased interest and valuation of art from Latin America.

958. "Mexican Autobiography." *Time* 27 Apr 1953: 90.
Short piece on the occasion of Frida's first public exhibition in Mexico. Includes personal statements by the artist. Reproduction: "The Little Deer."

959. Monsiváis, Carlos. "De todas las Fridas posibles." *Nexos* 15.169 (Jan 1992): 69-70.
Reevaluation of the artist and the phenomenon Monsiváis describes as "Fridomania."

960. _____. "Frida Kahlo: 'Que el ciervo vulnerado / por el otero asoma.'" *México en el Arte* 2 (Fall 1983): 64-71.

961. Mulvey, Laura and Peter Wollen. "Frida Kahlo and Tina Modotti." In *Visual and Other Pleasures*. Ed. Laura Mulvey. Bloomington, IN: Indiana University, 1989. 81-107. Bibl.
Text appeared originally in catalogue for 1982 exhibition "Frida Kahlo and Tina Modotti" presented at London's Whitechapel Gallery.

962. Murray, Joan. "Kahlo/Trotsky: Photographs by Debra Bloomfield." *Artweek* 7 Nov 1991: 27.

Joan Murray refers to this exhibition at the University of California at Berkeley Art Museum as "one of the most visually dramatic exhibitions in the history of Bay Area photography." Comments on the "sense of intimate contact" with Kahlo which Bloomfield's photographs of artist's home evoke. *Reproduction: From "Frida's Blue House" Series (1987).*

963. Newman, Michael. "The Ribbon Around the Bomb." *Art in America* 71 (Apr 1983): 160-169. Bibl.

Writer considers parallels and divergences in the lives of Tina Modotti and Frida Kahlo, examining factors which affected the development of each artist's style and technique. Includes the artist's portrait. *Reproductions: "Frida and Diego Rivera" (1931), "Self-Portrait" (1940), "Self-Portrait as a Tehuana" (1943), "What the Water Gave Me" (1938), "Self-Portrait" (1932), "Self-Portrait with the Portrait of Dr. Farill" (1951), "Self-Portrait with Cropped Hair" (1940).*

964. Ocampo, Estela. "La pasión de Frida Kahlo." *Quimera* 75 (1989): 34-41.

Reflecting on the issue of "feminine" art, Estela Ocampo remarks on the relationship between Kahlo's life and her work. Includes reproductions of various of Kahlo's paintings.

965. O'Connor, Francis V. "The Psychodynamics of the Frontal Self-Portrait." *Psychoanalytic Perspectives on Art* 1 (1985): 169-221.

Considers the work of several artists, among them Frida Kahlo (205-208).

966. Orenstein, Gloria. "Frida Kahlo: Painting for Miracles." *Feminist Art Journal* 2.3 (Fall 1973): 7-9. Bibl.

Gloria Orenstein examines various of the artist's paintings from a feminist perspective, noting significance of Aztec symbols present in these works. Includes some biographical data, as well as statements by husband Diego Rivera and André Breton. *Reproductions: "Hospital Henry Ford" (1932), "Las dos Fridas,"/"The Two Fridas," "Sin esperanza"/"Without Hope" (1945), "Mi nana y yo"/"My Nurse and I" (1937), "Columna rota"/"The Broken Spine" (1944).*

967. Plagens, Peter. "Frida On Our Minds: With a Record Sale at Christie's and a Biography That Keeps Selling the Late Mexican Painter Ranks with the Greats. Do We Need a Movie With Madonna?" *Newsweek* 27 May 1991: 54-55.

Subtitle imparts flavor of this general interest piece. Includes a portrait of Kahlo and Diego Rivera. *Reproductions: "Self-Portrait," "Two Nudes in a Forest" (1939).*

968. Rodríguez Prampolini, Ida. "Remedios Varo y Frida Kahlo: dos exposiciones recientes." *Plural* 13 (Dec. 1983): 31-39.

Analysis of the artist's works based on Andre Breton's concept of Surrealism and his perception that elements in Mexican reality lend themselves to the

expression of that concept. Includes some biographical information, personal statements by the artists and reproductions of various of their works.

969. Samsel, Roman. "Frida Kahlo: 'Era como un relámpago. . .'" Trans. Aleksander Bugajski. *Plural* 13.154 (July 1984): 38-40.
Excerpted from the book *Bunt i Gwalt (Rebellion and Violence)*, Roman Samsel frames his essay about Kahlo with reminiscences of his visit to Kahlo's house/museum in Coayacán. Includes portrait of the artist.

970. Sánchez, Elena. "Frida Kahlo." *Hispanic* (July 1993): 23+.
Engaging and comprehensive profile incorporating direct statements by the artist, as well as husband Diego Rivera and Frida scholars. Elena Sánchez elaborates on the significance of "The World of Frida Kahlo" exhibition at Houston's Museum of Fine Arts, remarking that it was "one of the most comprehensive surveys of art work by Kahlo ever assembled." *Reproductions: Gelatin silver photograph of Frida Kahlo in Manuel Alvarez Bravo's studio (1930's), "Diego and I" (1949), "The Broken Column" (1944), "My Nurse and I" (1937), "Roots" (1943).*

971. Schaefer, Claudia. "Frida Kahlo's Cult of the Body: Self-Portrait, Magical Realism, and the Cosmic Race." *Textured Lives: Women, Art, and Representation in Modern Mexico.* Tucson: University of Arizona Press, 1992. 3-36. Bibl.

972. Schjeldahl, Peter. "Frida Kahlo." *Mirabella* (Nov 1990): 64-67.
In this biographical sketch Peter Schjeldahl emphasizes Kahlo's authenticity of self-expression, suggesting that it is this "giving of herself away" in her self-images that continues to captivate and fascinate. Includes photo portraits of the artist. *Reproductions: "Self-Portrait with Thorn Necklace and Hummingbird" (1940), "Self-Portrait with Monkey" (1940), "My Birth" (1932), "Roots" (1943), "The Little Deer" (1946).*

973. Smith, Terry. "From the Margins: Modernity and the Case of Frida Kahlo." *Block* 8 (1983): 11-23.

974. Sullivan, Edward J. "Frida Kahlo." *Latin American Art* 3.4 (Winter 1991): 31-34. Bibl.
Explores the significance of "Self-Portrait Dedicated to Dr. Eloesser" and other works produced during the same period. *Reproductions: "Self Portrait Dedicated to Dr. Eloesser" (1940), "Self-Portrait with Thorn Necklace and Hummingbird" (1940), "The Dream" (1940), "The Earth Itself (Two Nudes in a Jungle)" (1939), "A Few Small Nips" (1935).*

975. _____. "Frida Kahlo in New York." *Arts Magazine* 57.7 (Mar 1983): 90-92. Bibl.
Using 1938 exhibition at New York's Julien Levy Gallery as his point of departure Edward Sullivarn draws reader into an engrossing review of her life and numerous of her paintings, interweaving into his study incidental facts of her

life, her husband Diego Rivera, and the Mexican environment which nourished her imagination. Remarks on the interrelatedness of her work writing that "every picture. . . is connected to every other by an inextricable cord -- a cord of meaning, vitality -- a cord, like her spinal column. . .which could be injured or bent but could never be broken." *Reproductions: "The Bus" (1929), "The Dream" (1940), "Henry Ford Hospital" (1932), "Deceased Dimas" (1937), "The Two Fridas" (1939) Imogen Cunningham's "Portrait of Frida Kahlo" (1931), "Frida Kahlo painting 'Family Tree'" (1950-1951).*

976. Tully, Judd. "The Kahlo Cult." *Art News* 93 (Apr 1994): 126-133.
 Fascinating look into origin of artist's "superstar status." Makes revealing statements about how she is perceived in Mexico. Includes information on controversy surrounding Dolores Olmedo, Director of the Frida Kahlo Museum and Chair of the Diego Rivera Trust, and the tight control she exerts over Kahlo's paintings and writings. *Reproductions: "Self-Portrait with Loose Hair" (1947), "Diego and I" (1949), "The Tree of Hope Stands Firm" (1946).*

977. Ullán, José-Miguel. "Fondo sin fondo." *Vuelta* 9.106 (Sept 1985): 64-65.
 In this tribute to the artist Spanish poet and art critic Ullán combines the best of two worlds, an eye for the visual and the heart of a poet.

978. Urrutia, Elena. "Frida Kahlo y Tina Modotti: por el hecho de ser mujeres." *Fem* 8.30 (Oct-Nov 1983): 58-60.
 Text of lecture presented at roundtable discussion organized in conjunction wiith the "Frida Kahlo-Tina Modotti" exhibition presented in Mexico City's Museo Nacional de Arte. Includes portraits of the artists.

979. Valdés, Carlos. "Evocación de Héctor Xavier: muerte de María Izquierdo, dolor de Frida Kahlo." *Revista de la Universidad de México* 33.8 (Apr 1979): 29-33.
 Conversation with artist Héctor Xavier who was informally associated with the Mexican School of Painting La Esmeralda where Izquierdo and Kahlo were instructors. Xavier reminisces and provides anecdotal accounts of his association with both artists, the supposed rivalry between Kahlo and Izquierdo, Izquierdo's decline and death, and Kahlo's artistic outings with her students.

980. Witzling, Mara R. "Frida Kahlo." *Voicing our Visions: Writings by Women Artists.* New York, NY: Universe, 1991. 288-304. Bibl.
 Includes numerous entries which Kahlo wrote in her diary from 1944 until 1954.

981. Wolfe, Bertram D. "Rise of Another Rivera." *Vogue* 1 Nov 1938: 64+.
 Interesting early article in English, written on the occasion of "Madame Rivera's" first U.S. exhibition in New York's Julien Lévy Gallery. Writer includes anecdotal information and various statements by Kahlo which reveal a

"gay, passionate, witty, and tender personality." *Reproductions: "Self-Portrait with Heart," "Fulang-Chang and I," "Self-Portrait."*

982. Yau, John. "The Phoenix of the Self." *Artforum* 27.8 (Apr 1989): 145-151. Bibl.
Explores representation of the self in art by various painters, including Frida Kahlo.

983. "You're a Million-Dollar Baby." *Américas* 42.3 (May-June 1990): 2-3.
News item that has information on record-breaking sale of "Diego y yo" for $1,430,000 at New York gallery. Includes reproduction of work.

Exhibition Catalogues:

984. Alvarez-Bravo, Lola. *Lola Alvarez-Bravo: The Frida Kahlo Photographs.* Introduction and interview, Salomón Grimberg. Dallas, TX: Society of Friends of the Mexican Culture, [1991].

985. _____. *Frida y su mundo: fotografías.* México, D.F.: Galería Juan Martin, 1991. Essays, Carlos Pellicer and Carlos Monsiváis.

986. *The Art of Frida Kahlo: 1990 Adelaide Festival, Art Gallery of South Australia, March 1-April 8, 1990; Art Gallery of Western Australia, April 19-May 20, 1990.* Adelaide, S. Australia: Adelaide Festival of Arts, 1990. Text, María del Conde and Charles Merewether. Bibl.

987. *The Blue House: The World of Frida Kahlo: Schirn Kunsthalle Frankfurt, March 6-May 23, 1993, Museum of Fine Arts, Houston, June 6-August 29, 1993.* Ed. Erika Billeter. Frankfurt, Germany: Schirn Kunsthalle, 1993. Bibl. Translation of *Die Welt der Frida Kahlo.* Bibl.

988. *Diálogos con Frida: dibujos de Lucía Maya.* México, D.F.: Kyron Ediciones Gráficas, 1986. Essays, Salvador Elizondo and others (in Spanish and English).

989. *Frida Kahlo and Tina Modotti.* Catalogue. London, England: Whitechapel Gallery, 1982. Bibl. Text, Laura Mulvey and Peter Wollen.

990. *Frida Kahlo: das Gesamtwerk.* Texts, Helga Prignitz-Poda, Salomón Grimberg and Andrea Kettenmann. Trans. Gabriela Walterspiel and Veronica Reisenegger. Frankfurt, Germany: Verlag Neue Kritik, 1988. Bibl. Catalogue raisonné.

991. *Frida Kahlo: exposición nacional de homenaje, septiembre-noviembre, Sala Nacional, Palacio de Bellas Artes, Instituto Nacional de Bellas Artes, SEP, México, D.F., 1977.* México, D.F.: Instituto Nacional de Bellas Artes, 1977. Bibl.

992. *Frida Kahlo: Museo de Monterrey: septiembre-octubre de 1983,*
Monterrey, México, Centro Cultural Vanguardia, noviembre de 1983, Saltillo,
Coahuila. Monterrey, México: Museo de Monterrey, [1983]. Bibl.

993. *Frida Kahlo, 1907-1954: Salas Pablo Ruíz Picasso, Madrid, 30 de abril-*
15 de junio de 1985. Madrid, Spain: Ministerio de Cultura, [1985]. Bibl.

994. *Frida Kahlo, 1907-1954: the Collection of Dolores Olmedo Patiño.*
Los Angeles, CA: Plaza de la Raza, 1986. Bibl.

995. *Frida Kahlo, 1907-1954: Pain and Passion.* Koln: Benedikt Taschen,
1992. Text, Andrea Kettenmann.

996. *Frida Kahlo, 1910-1954.* [Chicago, IL: Museum of Contemporary Art,
1978]. Essay, Hayden Herrera.

997. *Frida Kahlo: The Unknown Frida, the Woman Behind the Work.*
Beverly Hills, CA: Louis Newman Galleries, 1991. *Exhibition of "an unedited,*
private collection of letters from Frida Kahlo to Diego Rivera and other
documents." English and Spanish text.

998. *Frida Kahlo, Tina Modotti: Museo Nacional de Arte, Sala de*
Exposiciones Temporales, México, D.F., junio-agosto, 1983. México, D.F.:
Instituto Nacional de Bellas Artes, 1983. Bibl.

999. *Frida Kahlo und Tina Modotti.* [Frankfurt, Germany]: Verlag Neue
Kritik, [1982]. Bibl. Text, Karin Monte.

1000. Grimberg, Salomón. *Frida Kahlo: 17 February to 16 April 1989, the*
Meadows Museum, Southern Methodist University, Dallas, Texas. Dallas, TX:
Southern Methodist University, Meadows Museum, [1989]. Bibl. Essay,
Salomón Grimberg. Includes chronology.

1001. *Pasión por Frida: Museo Estudio Diego Rivera, De Grazia Art and*
Cultural Foundation, 1991-1992. [México, D.F.]: Instituto Nacional de Bellas
Artes, [1992]. Bibl. Presentation in English.

Videorecordings:

1002. *Frida: naturaleza vida.* Los Angeles, CA: Connoisseur Video
Collection, 1989. Videocassette release of a 1984 motion picture by Clasa
Film Mundiales, S.A. Produced by Manuel Barbachano, directed by Paul Leduc,
written by Paul Leduc and José Joaquín Blanco. Los Angeles, CA: Connoisseur
Video Collection, 1984. Spanish dialogue, English subtitles. Commentary by
Hayden Herrera. VHS format, 108 mins.

1003. *Frida Kahlo, 1910-1954.* RM Arts. Produced by Eila Hershon, Roberto Guerra and Wibke von Bonin. Munich, Germany: RM Arts, 1983. VHS format, 62 mins.

1004. *Frida Kahlo: Portrait of a Woman.* Producer, editor, videographer, Esther Reyes. Princeton, N.J.: Films for the Humanities and Sciences, 1992. VHS 20 mins.

Krauze Broid, Perla, 1953- Mexico City Painting

1005. Ruy Sánchez, Alberto. "El horizonte en la piel." *Vuelta* 9.108 (Nov 1985): 60-61.
Alberto Ruy Sánchez discusses artist's use of line in her paintings.

Landau, Myra

1006. *Myra Landau, 1965-1985: abril-junio de 1987.* Catalogue. México, D.F.: Museo de Arte Moderno, 1987.

Lara, Magali, 1956- Mexico City Painting

1007. *El árbol del cuerpo: Magali Lara.* Catalogue. México, D.F.: Galería de Arte Mexicano, 1994. Essays, Roberto Tejada, Maurice Blanchot and Robert Duncan (in Spanish and English). Includes chronology.

1008. Boullosa, Carmen. "Herbalarios y libros de Magali Lara." *Artes de México* 7 (Fall 1992): 100-101.
Words of praise for two books of recent drawings by artist, *Del verbo y Fragilidad*, described by noted writer as "indispensable."

1009. *De la misma, la misma habitación.* Catalogue. Coyoacán, México: Galería Los Talleres, 1984. Essay, Patricia Mendoza and transcription of interview with Javier Cadena. Includes chronology.

1010. Espinosa de Monteros, Santiago. "Magali Lara." *Arte en Colombia* 41 (Sept 1989): 104-105 [English summary, 154].
Review of work produced by the artist during a six-month stay in Havana which was shown at Mexico City's Rafael Matos Gallery. Espinosa de Monteros comments on her application of new techniques, ". . . the cutting up of pieces from earlier canvases and their incorporation in new pictures. . ." Includes a reproduction of one of the artist's works.

1011. *Herbalarios: Magali Lara.* Catalogue. México, D.F.: Galería del Sur, Universidad Autónoma Metropolitana, 1992. Presentation, Rina Epelstein.

1012. Medina, Cuauhtémoc. "Naturalezas." *Art Nexus* 10 (Sept-Dec 1993): 151-152, [English trans., 218].
Review of "Naturalezas" exhibition in Mexico City's Galería Metropolitana that had nature as its theme. Remarks briefly on the different approaches the four artists took to their subject matter, noting the "fluidity and spontaneity" of their styles as exemplification of the theme itself. Reproduction: "La luna, la mujer y la serpiente," detail (1993).

1013. Mercado, Tununa. "Rowena y Magali: dos narradoras visuales." *Fem* 33 (Apr-May 1984): 51.

Lara, Marisa Painting

1014. Emerich, Luis Carlos. "Marisa Lara y Arturo Guerrero: máscaras contra caballetes." *Figuraciones y desfiguros de los '80s*. México, D.F.: Editorial Diana, 1989. 91-96.

1015. Tibol, Raquel. "México en la XIX Bienal Internacional de São Paulo (II)." *Proceso* 12 Oct 12 1987: 53-55.
Considers representation of contemporary idols (singers, bullfighters, composers, etc.) in the paintings which Marisa Lara and Arturo Guerrero produce jointly. Artists were two of five representing Mexico during XIX São Paulo Biennial.

1016. _____. "La producción artística como terquedad." *Proceso* 10 July 1989: 52.
Tibol remarks that Marisa Lara and Arturo Guerrero, who work jointly on the same project, have developed a "progressive visual discourse" around a variety of urban themes. Includes some information on training, as well as commentary on various of their paintings. *Reproduction: "Cero en conducta" (1989).*

Laville, Joy, 1923- England Painting

1017. Driben, Lelia. "Joy Laville: el sueño soñado por la pintura." *Vuelta* 9.105 (Aug 1985): 55.
Essay of appreciation on a painter who has lived in Mexico since 1956 and whose work, writer suggests, compares with the likes of the most accomplished native-born artists to emerge during last fifty years, namely Frida Kahlo, Lilia Carrillo and María Izquierdo.

1018. García Ponce, Juan. "Obras de Joy Laville en el Museo de Arte Moderno." *Vuelta* 1.11 (Oct 1977): 50-51.
Essay on occasion of the artist's exhibition at Mexico´s Museum of Modern Art. *Reproductions: "El malecón en invierno - Roquetas," "Estatua en Italia."*

1019. Grimberg, Salomón. "Landfalls and Departures: Images of Mourning in Joy Laville's Art." *Woman's Art Journal* 10.2 (Fall 1989-Winter 1990): 3-6. Bibl.

Analysis of artist's paintings before and after plane crash which claimed the life of her writer-husband Jorge Ibarguengoitia and other Latin American writers, Angel Rama, Martin Scorza and Marta Traba. Based on psychoanalytic theory which suggests that mourners go through four stages of grief before achieving healing from loss. Contains biographical information, including details about her training and development in Mexico. *Reproductions: "Woman With Flowers and Plane" (1984), "Encuentros y Despedidas II" (1986).*

1020. Ibarguengoitia, Jorge. "Mujer pintando en cuarto azul." *Vuelta* 9.100 (Mar 1985): 52-53.

Brings together fragments of essays written by artist's husband previously published in a number of Laville's exhibition catalogues. Valuable for the personal recollections and anecdotal information he brings to light. He writes that her art is "a window into a mysteriously familiar world. . .not anguished. . . but joyful, sensual, a bit melancholy, and a bit funny."

1021. *Joy Laville, paisajes, interiores y figuras: veinte años en México, junio-julio de 1985.* Catalogue. México, D.F.: Instituto Nacional de Bellas Artes, 1985.

1022. Mekler, Gilda. "Joy Laville." *Nuevos momentos del arte mexicano = New Moments in Mexican Art.* Catalogue. Mexico, New York: Turner Parallel Project, 1990. 158-161. Bibl. Text in Spanish and English.

1023. *Pintora anglo-mexicana Joy Laville: un mundo luminoso y transparente, obras recientes, oleos, acrílicos, acuarelas y pasteles.* Catalogue. [México, D.F.: Museo de Arte Moderno, 1977]. Includes chronology.

Lavista, Paulina, 1945- Photography

1024. Colina, José de la. "La vista y las fotos de (Paulina) Lavista" *Vuelta* 5.54 (May 1981): 42-43.

Commentary on "Fototextos" exhibition of Lavista's photographs at Museo de Arte Moderno which proposes that "text" embedded in photographic images must be "read," not just seen. Includes untitled reproductions of various of Lavista's photographs.

1025. Hernández Carballido, Elvira. "En la vanguardia: Paulina Lavista." *Fem* 17.119 (Jan 1993): 44.

Very brief biographical summary of this self-taught artist emphasizing her universality of vision. Includes some information on her cinematographic training.

1026. Hopkinson, Amanda. "All's Well Down Mexico Way." *British Journal of Photography* 30 Nov 1989: 10-13.
 On the occasion of the 150th anniversary of the invention of photography, Amanda Hopkinson takes a look at figures who have played a prominent role in the development of Mexican photography. Briefly mentions Lavista's work (13). *Reprodution: "Damaso Pérez Prado" (1974).*

1027. *Paulina Lavista: sujeto, verbo y complimento, 150 fotografías.* Catalogue. México, D.F.; Museo de Arte Moderno, 1981. Text, Fernando Gamboa and Salvador Elizondo.

Leñero, Isabel, 1962- Mexico City

1028. Tibol, Raquel. "'Geografías' de Isabel Leñero." *Proceso* 29 June 1992: 52-53.
 Sketch written to coincide with artist's show at Galería Expositium. Includes information on her education, as well as Tibol's interpretation of Leñero's treatment of the landscape.

Levy, Ana Painting

1029. Patiño, Maricruz. "Ana Levy: azul profundo." *Artes de México* 16 (Summer 1992): 112.
 Maricruz Patiño comments on artist's exhibition, noting that for her painting is a "personal adventure in which the rules of the game are freedom, authenticity and continuity." Includes portrait of the artist with one of her works.

López, Julia Painting

1030. Ruy Sánchez, Alberto. "Julia López: el instinto de la belleza." *Artes de México* 11 (Spring 1991): 107.
 Ruy Sánchez does not spare metaphor in his admiration of this artist's work which he likens to poetry and the fullness of a song bursting with color and harmony. *Reproduction: "El mensaje" (1989).*

Lozano, Agueda, 1944- Cuauhtémoc, Chihuahua Painting

1031. *Agueda Lozano.* Catalogue. (México, D.F.: Galería Estela Shapiro, 1983). Text, Louis Anquez. Includes chronology.

1032. *Agueda Lozano: pintura geometría fantástica.* Catalogue. [México, D.F.: Museo de Arte Moderno, 1976]. Essays, Fernando Gamboa and André Parinaud.

Maldonado, Rocío, 1951- Tepic, Nayarit Painting

1033. Barrie, Lita. "An Alternative Art: 'Aspects of Contemporary Mexican Painting' at the Santa Monica Museum of Art." *Artweek* 23 Jan. 30 1992: 8-9.
This exhibition brought together the paintings of artists whose works do not fit within a "particular art trend or convention," writes Lita Barrie. Refers briefly to artist's work.

1034. Emerich, Luis Carlos. "Rocío Maldonado: de corazón a corazón." *Figuraciones y desfiguros de los '80s*. México, D.F.: Editorial Diana, 1989. 99-102.

1035. Gómez Haro, Germaine. "Rocío Maldonado." *Latin American Art* 5.1 (Spring 1993): 92 [Spanish trans., 120].
Review of artist's works presented at Mexico City's OMR Gallery. Germaine Gómez Haro writes, "Maldonado's works are dominated by the human figure as a tool to reconcile immediate reality with her own interior, emerging as fragmented, decapitated, unfinished torsos. . . lopsided Venuses or Apollos that, under her dynamic brush, become icons of a different kind of beauty." *Reproduction: "Espinas" (1990)*.

1036. Heller, Nancy. *Women Artists: An Illustrated History*. Rev. and expanded ed. New York, N. Y.: London, England: Abbeville Press, 1991. Bibl.

1037. Kline, Andrew. "Rocío Maldonado." *Latin American Art* 2.4 (Fall 1990): 114-115.
Portrait with some biographical information, as well as details of the artist's training and development. Kline considers themes, style and technique in various of her works, remarking that "the existential crisis of women is a concern in much of Maldonado's work." *Reproductions: "Untitled" (1986), "La mano" (1990)*.

1038. *Rocío Maldonado*. Catalogue. México, D.F.: Galería OMR, 1990. Text, Edward J. Sullivan. Includes chronology.

1039. "Rocio Maldonado." In *Aspects of Contemporary Mexican Painting*. Catalogue. Edward Sullivan, curator. New York, N.Y.: Americas Society, 1990. 79-86.

1040. *Rocío Maldonado: obra reciente*. Catalogue. México, D.F.: Galería OMR, 1992. Text, Elizabeth Ferrer (in Spanish and English). Includes chronology.

1041. Schneider Enríquez, Mary. "Rocío Maldonado." *Art News* 92 (Feb 1993): 124.
In this review of artist's exhibition at Galería OMR in Mexico City, Mary Schneider Enríquez describes three of her works, remarking that they are "filled

with fragmentary studies" which "seduce and quietly unnerve. . . leaving the viewer slightly unsure of her message." *Reproduction: "Untitled" (1992).*

1042. Sullivan, Edward J. "Rocio Maldonado." *Nuevos momentos del arte mexicano = New Moments in Mexican Art.* Mexico, New York : Turner Parallel Project, 1990. 57-60. Bibl.
 Text in Spanish and English.

Marcos, Eugenia Painting

1043. Orellana, Margarita de. "Eugenia Marcos: los frutos prohibidos." *Artes de México* 19 (Spring 1993): 110.
 Margarita de Orellana comments on the sensual imagery of the artist's canvases shown at Galería de la Casa del Lago. *Reproduction: "La higuera" (1991).*

Márquez Huitzil, Ofelia, 1959- Mexico City Drawing/Engraving/Painting

1044. Mercado, Tununa. "Ofelia Márquez Huitzil: lo que fue México." *Fem* 6.23 (June-July 1982): 76.
 Tununa Mercado considers artist's female images within a historical and cultural perspective. Includes a reproduction of one of the artist's works.

1045. Tibol, Raquel. "Ofelia Márquez Huitzil: un arte propio." *Proceso* 7 Dec 1987: 50.
 Review of artist's show at Mexico City's Foro de Arte Contemporáneo that drew its inspiration from folklore. Raquel Tibol likens artist to Marc Chagall, noting the originality of her mermaid images and their bold chromatic, lyrical and sensual qualities, Gives details of her education and training. *Reproductions: "Como el viento," "La sirena."*

Martens, Carmen Potosí Painting

1046. Koprivitza, Milena. *"Casa Tlaxcala, Ocotlán: Textura en ocres." Fem 13.78 (June 1989): 44.*
 Review of artist's paintings shown in Casa Tlaxcala depicting ancient architectural structures. *Reproduction: "Mineral del Real de Catorce."*

Maya, Lucía, 1953- U.S.A. Drawing

1047. *Abismos, enigmas y perversiones: Lucía Maya, Liliana Mercenario Pomeroy.* Catalogue. México, D.F.: Centro Cultural José Guadalupe Posada, 1985.

1048. *Diálogos con Frida: dibujos de Lucía Maya.* Catalogue. México, D.F.: Kyron Ediciones Gráficas, 1986. Essays, Salvador Elizondo and others (in Spanish and English).

1049. Emerich, Luis Carlos. "Lucía Maya: como 'Las dos Fridas' no hay dos." *Figuraciones y desfiguros de los '80s.* México, D.F.: Editorial Diana, 1989. 107-110.

1050. Goldman, Shifra M. "The Heart of Mexican Art: Image, Myth and Ideology." *New Art Examiner* 21 Dec 1993: 12-15+.
Shifra Goldman considers symbolism of the body in the works of a variety of Mexican artists, among them Lucía Maya.

1051. Navarrete, Sylvia. "Guía de la estación: Lucía Maya." *Artes de México* 13 (Fall 1991): 114.

1052. *Sueños y ombligos: Lucía Maya.* Catalogue. Guadalajara, México: Cuarto Menguante Editores, 1982.

Mayer, Mónica, 1954- Mexico City Painting/Drawing

1053. Hernández Carballido, Elvira Laura. "Mónica Mayer. . . arte feminista." *Fem* 18.139 (Sept 1994): 38-39.
Hernández Carballido includes statements by Mayer that communicate her ideas and thoughts about feminist art.

1054. *Novela rosa o me agarró el arquetipo: Mónica Mayer.* Catalogue. México, D.F.: Museo de Arte Carrillo Gil, 1987. Text, Magali Tercero. Includes chronology.

1055. Tibol, Raquel. "Mónica Mayer interioriza su femenismo." *Proceso* 21 Sept 1987: 51-52. Detailed analysis of artist's works shown at Museo de Arte Carrillo Gil. *Reproduction: Fragment of "Mi vientre" (1987).*

Mercenario Pomeroy, Liliana Painting

1056. *Abismos, enigmas y perversiones: Lucía Maya, Liliana Mercenario Pomeroy.* Catalogue. México, D.F.: Centro Cultural José Guadalupe Posada, 1985.

1057. Rosales, Sofía. "Reflexiones a propósito de Liliana Mercenario Pomeroy." *Fem* 11.53 (May 1987): 43-44.
In this essay Rosales highlights the creative spirit and energy which guide artist's painting, suggesting that her themes and individualistic style derive from a need for self-affirmation.

Metthez, Renatta Painting

1058. Hernández Carballido, Elvira Laura. "Renatta Metthez." *Fem* 18.134 (Apr 1994): 46.
Reflections on the artist's work, emphasizing her vision of woman as represented in her canvases.

Miller, Carol, 1933- U.S.A. Sculpture

1059. Neuvillate, Alfonso de. "El movimiento de Carol Miller." *Fem* 61 (Jan 88): 36-37.
 Alfonso de Neuvillate suggests that Carol Miller is perhaps the most creative of Mexican sculptors, placing special emphasis on the vitality and dynamism which exude from the images she makes of human figures in movement.

Modotti, Tina, 1896-1942 Italy Photography

Books:

1060. Barckhausen Christiane. *Auf den Spuren von Tina Modotti.* Koln: Pahl-Rugenstein, 1988. Bibl.

1061. _____. *Verdad y leyenda de Tina Modotti.* La Havana, Cuba: Casa de las Américas, 1989. Bibl.

1062. Cacucci, Pino. *Tina, ou la beaute incendieé.* Trans. Pierre Galet. Paris, France: Belfond, 1993.

1063. Constantine, Mildred. *Tina Modotti: A Fragile Life, An Illustrated Biography.* New York, NY: Paddington Press, [1975]. Bibl.

1064. _____. *Tina Modotti: A Fragile Life.* San Francisco, CA: Chronicle Books, 1993.

1065. Gibson, Margaret. *Memories of the Future: The Daybooks of Tina Modotti: Poems.* Baton Rouge, LA: Louisiana State University Press, 1986.

1066. Hooks, Margaret. *Tina Modotti: Photographer and Revolutionary.* London: San Francisco: Pandora, 1993. Bibl.

1067. Modotti, Tina. *The Letters from Tina Modotti to Edward Weston.* Tucson, AZ: Center for Creative Photography, University of Arizona, 1986.

1068. _____. *Tina Modotti.* Milan, Italy: Gruppo Editoriale Fabbri, 1983. Bibl.

1069. _____. *Tina Modotti: photographe et revolutionnaire.* Texts by Maria Caronia and Vittorio Vidali. Trans. Mireille Zanuttini. Paris, France: Des Femmes, 1981. Bibl.

1070. _____. *Tina Modotti: Photographin und Revolutionarin.* Texts by Maria Caronia, Vittorio Vidali and Peter Weiermair. Trans. Thomas Aichhorn and Dorothea Locker. Wien: Locker, 1981. Bibl.

1071. _____. *Tina Modotti: fotografa e rivoluzionaria.* Texts by Vittorio Vidali. et al. Milan, London: IE, 1979. Bibl.

1072. _____. *Tina Modotti: Photographs.* Texts by Maria Caronia, Vittorio Vidali. Translation from Italian, C.H. Evans. Westbury, N.Y.: Idae Editions & Belmark Book Co., 1982. Bibl.

1073. Poniatowska, Elena. *Tinísima: Novela.* México, D.F.: Ediciones Era, 1992.

1074. Saborit, Antonio. *Una mujer sin país: [las cartas de Tina Modotti a Edward Weston, 1921-1931].* México, D.F.: Cal y Arena, 1992. Bibl.

1075. Vidali, Vittorio. *Retrato de mujer: una vida con Tina Modotti.* Trans. Antonella Fagetti. Puebla, México: Universidad Autónoma de Puebla, 1984.

Periodical articles and exhibition catalogues:

1076. Capistrán, Miguel. "Me sedujo sobretodo la época, no el personaje de Tina Modotti: Elena Poniatowska." *Proceso* 2 Nov 1992: 54-55.
 Transcript of interview in which novelist-critic Poniatowska talks about various aspects of her research as she prepared to write *Tinísima*, a biographical novel about the artist. Includes Modotti's portrait.

1077. *Frida Kahlo and Tina Modotti..* Catalogue. London, England: Whitechapel Gallery, 1982. Bibl. Text, Laura Mulvey and Peter Wollen.

1078. *Frida Kahlo, Tina Modotti.* Catalogue. México, D.F. Instituto Nacional de Bellas Artes, 1983. Bibl.

1079. Garcés, Carlos. "Tina Modotti en la leyenda y la verdad con Christiane Barckhausen-Canale." *Casa de las Americas* 29.169 (July-Aug 1988): 109-115.
 Interview with the author of *Verdad y leyenda de Tina Modotti* in which she talks about her research for the book, with special emphasis on the photographer's relationship with Julio Antonio Mella.

1080. Hooks, Margaret. "Assignment, Mexico: The Mystery of the Missing Modottis." *Afterimage* 19.4 (Nov 1991): 10-11.
 Margaret Hooks presents information demonstrating that on her return to Mexico in 1939 Modotti didn't return to making photographs. She suggests that this could affect the market value of the small number of Modotti prints in existence.

1081. Hopkinson, Amanda. "All's Well Down Mexico Way." *British Journal of Photography* 30 Nov 1989: 10-13.
 On the occasion of the 150th anniversary of the invention of photography, Amanda Hopkinson takes a look at figures who have played a prominent role in the development of Mexican photography. Included in her review is a brief

mention of Tina Modotti and her "photographic innovation," with references to several of her works (12).

1082. _____. "Without Walls." *British Journal of Photography* 2 Feb 1992: 8.

In this preview of a TV documentary on the artist, Amanda Hopkinson interjects details of her life and career, remarking that the "photographic testament" she left behind was "a pitifully small collection by any account, but one whose breathtaking beauty, like her fullblown roses, generates phenomenal attraction and admiration." *Reproduction: "Roses, Mexico."*

1083. Jiménez, Carlos. "Tina Modotti en Madrid." *Art Nexus* 9 (June-Aug 1993): 130-131 [English trans., 194].

Review essay on occasion of exhibit of Modotti's work in Madrid's Casa de América. Jiménez writes, "There have been few women such as Tina Modotti, capable of embodying the spirit of America, melting pot of continents, peoples, cultures of history and tragedy, and still young and vigorous." *Reproduction: "Tehuana con Jicalpextle."*

1084. Lowe, Sarah M. "The Immutable Still Lifes of Tina Modotti: Fixing Form." *History of Photography* 18 (Fall 1994): 205-210. Bibl.

Notes that one of Modotti's prints, "Roses, Mexico" sold for "record breaking price" of $165,000 in 1991. Sarah Lowe considers the artist's life, her background, and her attitude towards the photographic process, as well as her association with Edward Weston as a means of understanding how she achieved "such an elegant and perceptive practice of picture making." Analysis draws on key statements made by Modotti in letters to Weston. *Reproductions: "Flor de Manita" (1924), "Corn, Sickle, Bandolier" (1927).*

1085. Melinkoff, Ellen. "Who was Tina Modotti?" *Art & Antiques* 9 (Sept 1992): 58-63.

Sheds light on photographer's life, her years in Mexico, political convictions and association with Edward Weston and Julio Antonio Mella, among others. *Reproductions: "Roses," "María Marín Orozco" (1925), Julio Antonio Mella's typewriter (1929), "Woman Carrying Olla" (ca. 1926), "Hands with Shovel" (1926).*

1086. "Modotti Prints in Vogue at New York Photo Sales." *British Journal of Photography* 23 Apr 1992: 4.

News item relating how three of Modotti's photographs "led the pack" in price at Sotheby's sale of 19th and 20th century photographs.

1087. Modotti, Tina. "Sobre la fotografía / On Photography." *Mexican Folkways* 5 (Oct-Dec 1929):196-198.

Modotti's thoughts about the medium. Includes reproduction of one of her works.

1088. Monsiváis, Carlos. "Tina Modotti y Edward Weston en México."
Revista de la Universidad de México 31.6 (Feb 1977): 2-4. Bibl.
 Biographical sketch of photographer. Includes 1924 portrait of Modotti and
Weston, as well as reproduction of Weston's photograph of Modotti, "Tina en la
azotea."

1089. Mulvey, Laura and Peter Wollen. "Frida Kahlo and Tina Modotti." In
Visual and Other Pleasures. Ed. Laura Mulvey. Bloomington, IN: Indiana
University, 1989. 81-107. Bibl.
 Text appeared originally in the catalogue for the 1982 exhibition "Frida Kahlo
and Tina Modotti" presented in London's Whitechapel Gallery.

1090. Newman, Michael. "The Ribbon Around the Bomb." *Art in America*
71 (Apr 1983): 160-169. Bibl.
 Writer considers parallels and divergences in the lives of Tina Modotti and
Frida Kahlo, examining factors which affected the development of each artist's
style and technique. Includes photographer's portrait. *Reproductions: "Hands of
a Puppeteer" (1926), "El machete," "Composition with Guitar, Ammunition,
Belt and Sickle," (1927), "March of the Workers," "Two Tehuana Women,"
"Elegance and Poverty."*

1091. Poniatowska, Elena. "De Tina Modotti." *Casa de las Américas*
28.165 (Nov-Dec 1987): 46-67.
 Excerpt from Poniatowska's novel.

1092. Squiers, Carol. "Susie Tompkins Markets Modotti." *American Photo*
4 (Mar-Apr. 1993): 16.
 Tells of acquisition of "Roses" print at auction by sportswear designer and
planned reproduction of it on clothing hangtags.

1093. *Tina Modotti, gli anni luminosi*. Catalogue. Pordenone: Cinemazero,
1992. Bibl.

1094. *Tina Modotti: Photographien & Dokumente*. Catalogue. Berlin,
Germany: Sozialarchiv e.V., [1991?].

1095. Urrutia, Elena. "Frida Kahlo y Tina Modotti: por el hecho de ser
mujeres." *Fem* 8.30 (Oct-Nov 1983): 58-60.
 Text of a lecture presented at a roundtable discussion organized in conjunction
wiith the "Frida Kahlo-Tina Modotti" exhibition in Mexico's Museo Nacional de
Arte. Includes portraits of the artists.

Mora, Yolanda, 1960- U.S.A. Painting

1096. Schneider Enriquez, Mary. "Yolanda Mora." *Art News* 91.10 (Dec
1992): 134.
 In this review Schneider Enriquez considers artist's paintings which were
presented at the Contemporary Art Gallery in Mexico City, characterizing them

as "somewhere between loose abstraction and unpracticed figuration." Reproduction: "Untitled" (1992).

1097. *Yolanda Mora: obra reciente, septiembre 1992.* Catalogue. México, D.F.: Galería Ramis Barquet, 1992. Essay, Edward J. Sullivan (in English and Spanish).

Morales, Rowena, 1948- Ciudad Obregón

1098. Mercado, Tununa. "Rowena y Magali: dos narradoras visuales." *Fem* 33 (Apr-May 1984): 51.

1099. *Rowena Morales.* Catalogue. México, D.F.: Museo de Arte Moderno, 1985. Essays, Armando Torres Michúa and Elena Urrutia.

Morán, Teresa Painting

1100. *Teatro de la noche: pinturas de Teresa Morán: marzo-abril 1994, Museo del Palacio de Bellas Artes.* Catalogue. [México, D.F.]: Instituto Nacional de Bellas Artes, [1994].

1101. *Teresa Morán: oleos recientes.* Catalogue. México, D.F.: Museo de Arte Moderno, 1980. Essays, Fernando Gamboa and Rita Eder. Includes chronology.

Nuñez, Dulce María, 1950- Mexico City Painting

1102. Barrie, Lita. "An Alternative Art: 'Aspects of Contemporary Mexican Painting' at the Santa Monica Museum of Art." *Artweek* 23 Jan. 30 1992: 8-9.
 This exhibition brought together the paintings of artists whose works do not fit within a "particular art trend or convention," writes Lita Barrie. Refers briefly to artist's work. *Reproduction: "Totem" (1989).*

1103. *Dulce María Nuñez.* Catalogue. Monterrey, México: Museo de Arte Contemporáneo de Monterrey, 1993. Bibl. Clayton C. Kirking and Edward J. Sullivan, curators; text, Luis Carlos Emerich, Charles Merewether, Elena Poniatowska and María Novaro. Interview, Clayton Kirking and Edward Sullivan.

1104. "Dulce María Núñez." In *Aspects of Contemporary Mexican Painting.* Catalogue. Edward Sullivan, curator. New York, N.Y.: Americas Society, 1990. 74-79.

1105. *Dulce María Núñez: mitos y realidades.* Catalogue. México, D.F.: Galería OMR, 1989. Essay, Elena Poniatowska.

1106. *Dulce María Núñez: obra reciente, septiembre-octubre de 1992.*
Catalogue. México, D.F.: Galería OMR, 1992. Essay, Edward J. Sullivan (in
Spanish and English).

1107. Emerich, Luis Carlos. "Dulce María Núñez: gótica mexicana."
Figuraciones y desfiguros de los '80s. México, D.F.: Editorial Diana, 1989.
119-122.

1108. *Pintura mexicana de hoy.* Catalogue. Monterrey, México: Centro
Cultural ALFA, Galería Arte Actual Mexicano, 1989. Text, Edward J. Sullivan.

1109. Poniatowska, Elena. "Dulce María Núñez." *Nuevos momentos del arte
mexicano = New Moments in Mexican Art.* Catalogue. Mexico, New York :
Turner Parallel Project, 1990. 117-119. Bibl. In Spanish and English.

1110. Tibol, Raquel. "Mitos y realidades de Dulce María Núñez." *Proceso*
24 July 1989: 52+.
 Raquel Tibol has written an indepth profile of the artist to coincide with her
exhibition at Galería OMR in Mexico City. Includes biographical information,
as well as details of her education, artistic development, and her approach to her
subject matter. *Reproduction: "Totem" (1989).*

1111. ____. "Retrospectiva de Dulce María Núñez en Monterrey." *Proceso*
11 Jan 1993: 53.

Ocharán, Leticia, 1942- Tabasco Sculpture/Painting/Printmaking

1112. *Coches choques--y otros hechos: Leticia Ocharán, obra reciente.*
Catalogue. [México, D.F.]: Instituto Nacional de Bellas Artes, Consejo Nacional
para la Cultura y las Artes, [1990?].

1113. Híjar, Alberto. *Leticia Ocharán, Eros y Tanatos : lo simple y lo
complejo.* México, D.F.: Universidad Nacional Autónoma de Mexico,
Coordinación de Humanidades, 1987.

1114. "Leticia Ocharán: vitalidad y sabiduría integradas." *Plural* 2a época 17
(Oct 1987): 53.
 Short essay of appreciation which calls attention to her long and brilliant
career as painter, printmaker, sculptor, teacher and critic. Includes untitled
reproduction of one of her works.

1115. Rodriguez, Antonio. "Leticia Ocharán: artista y critica." *Plural* 2a
época 15 (Jan 1986): 31-36.
 Considers various works by renowned artist and critic, calling attention to
erotic qualities she imparts to her abstract images. Remarks on high standards
which her perspective as critic oblige her to place on her own art.
*Reproductions: "Muros de agua," "Nocturno," "Forma roja," "Estoa," "Eros-
ión," "Grafias," "86," "Primavera," "Juana de Asbaje," "Oposición," "Magenta."*

Olín, Nahui (Mondragón, Carmen), 1893-1978 Painting

1116. Andrade, Lourdes and Tomás Zurián. "Nahui Olín: musa de pintores y poetas." *México en el Arte* 10 (Fall 1985): 65-68.
Drawing from the writings of painter Gerardo Murillo (Dr. Atl), as well as Olín's own writings and statements, this profile imprints indelible image of artist's personality and creative energy. Reveals spirit of woman whose role as "muse of painters and literary figures," authors suggest, may have overshadowed significance of her own work. *Reproductions: Nahui Olín: "Autorretrato," Dr. Atl: "Retrato de Nahui Olín," "Nahui Olín" from cover of Revista Ovaciones (1928).*

1117. Herner, Irene. "Nahui Olín: años de gato." *Nexos* 16.185 (May 1993): 20-22.
Profile brings together little known details of this artist's life, unearthed in preparation for 1992 exhibition presented at Museo Estudio Diego Rivera. Considers themes, style and social context in which she worked, including statements she made that reveal a spirit which refused to be confined by the conventions of her day. *Reproductions: "Gatos," "Nahui en una corrida de toros," "Nahui y Agacino frente a la isla de Manhattan."*

1118. Malvido Arriaga, Adriana. *Nahui Olín: la mujer del sol.* México, D.F.: Diana, 1993. Bibl.
Includes poetry written by the artist.

1119. *Nahui Olín: una mujer de los tiempos modernos.* Catalogue. México, D.F.: Museo Estudio Diego Rivera, 1992. Bibl. Text, Rafael Tovar de Teresa, Gerardo Estrada Rodríguez, Blanca Garduño and Tomás Zurián.

1120. Navarrete, Sylvia. "Guía de la estación: Nahui Olín." *Artes de México* 18 (Winter 1992): 102.

1121. Ponce, Armando. "'Nahui Olín, una mujer de los tiempos modernos,' en el Museo Estudio Diego Rivera: la primera exposición total de Carmen Mondragón." *Proceso* 7 Dec 1992: 54-55.
Background information on exhibition of Olín's works in Museo Estudio Diego Rivera. Includes excerpt of text written by Tomás Zurián for the exhibition catalogue, bringing to light how he discovered work of this 1920s artist, described by Armando Ponce as a precursor of women's liberation. Includes portrait of the artist, as well as reproductions of various untitled works.

Ordóñez, Sylvia, 1956- Monterrey Painting

1122. García Cavazos, Patricia. "Sylvia Ordóñez." *Nuevos momentos del arte mexicano = New Moments in Mexican Art.* Mexico, New York : Turner Parallel Project, 1990. 122-125. Bibl. In Spanish and English.

1123. *Sylvia Ordóñez, 1988-1993.* Catalogue. Monterrey, México: Museo de Arte Contemporáneo de Monterrey, 1993. Fernando Treviño Lozano, curator. In Spanish and English. Includes chronology.

Padín, Carmen, 1930- Featherwork/Tapestry/Soft Sculpture

1124. *Carmen Padín: 32 obras de arte plumario de hoy en técnicas diversas.* Catalogue. [México, D.F.: Museo de Arte Moderno, 1980]. Text, Fernando Gamboa, Raquel Tibol, Salvador Toscano, and the artist.

Palacios, Irma, 1943- Iguala, Guerrero Painting

1125. *Espejismo mineral: Irma Palacios, pintura reciente: del 6 de mayo al 1 de agosto, Sala Antonieta Rivas Mercado.* México, D.F.: Museo de Arte Moderno, 1993. Catalogue. Bibl. Text, Teresa del Conde (in Spanish and English). Trans. Arturo de Alba Jaidar.

1126. *Irma Palacios: obra reciente.* Catalogue. México, D.F.: Galería López Quiroga, 1988. Text, Teresa del Conde. Includes chronology.

1127. López, Gabriela. "Irma Palacios: los elementos terrestres." *Nexos* 16.186 (June 1993): 89-90.

1128. Medina, Cuauhtémoc. "Naturalezas." *Art Nexus* 10 (Sept-Dec 1993): 151-152, [English trans., 218].
 Review of "Naturalezas" exhibition in Mexico City's Galería Metropolitana that had nature as its theme. Remarks briefly on the different approaches the four artists took to their subject matter, noting the "fluidity and spontaneity" of their styles as exemplification of the theme itself.

1129. *Pintura y escultura abstracta contemporánea.* Catalogue. Monterrey, México: Galería Ramis F. Barquet, 1992. Includes chronology.

1130. Tibol, Raquel. "Irma Palacios: de la pintura a la escultura." *Proceso* 19 Nov 1990: 50.
 In her review of artist's show at Mexico's Galería López Quiroga, Raquel Tibol focuses on Palacio's experimentation with other mediums, remarking especially on her venture into the area of sculpture. Discusses her style and technique and considers the symbolism in various of her pieces. Includes a portrait of the artist at work in her studio.

1131. *Tierra de entraña ardiente.* Catalogue. México, D.F.: Galería López Quiroga, 1992.

Palau, Marta, 1934- Spain Painting/Printmaking/Textiles

1132. Dzikowska, Elzbieta. "Tejidos de Marta Palau." *América Latina* (USSR) 10 (1980): 104-105.

1133. Eder, Rita. *Marta Palau: la intuición y la técnica.* Catalogue. México, D.F.: Comité Editorial del Gobierno de Michoacán, 1985. In Spanish and English.

1134. *Marta Palau: escultura, pintura e instalaciones.* Monclova, México: Museo Biblioteca Pape, 1992.

1135. *Marta Palau: mis caminos son terrestres.* Catalogue. [México, D.F.: Palacio de Bellas Artes, 1985]. Essays, Rita Eder, Emilio Carballido and Teresa del Conde.

1136. *Marta Palau: 30 esculturas en materiales textiles.* Catalogue. [México, D.F.: Museo de Arte Moderno, 1978]. Bibl. Presentation, Fernando Gamboa, essays, Joop Belijón, and Jorge Alberto Manrique. Includes chronology.

1137. Rodríguez, Bélgica. "Marta Palau." *Art Nexus* 4 (Apr 1992): 164-165 [English summary, 225].
 Galería Expositium in Mexico City presented work by the artist created from a variety of materials. "Handmade paper, clay, feathers, earth, salt are all used in the context of her profound interest in the ancestral sentiments of mankind," writes Bélgica Rodríguez. *Reproduction: "El convidado de piedra" (1991).*

1138. Tibol, Raquel. "Los caminos de Marta Palau y del tapiz en México." *Universidad de México* 40.415 (Aug 1985): 25-28.
 Briefly reviews European tapestry exhibitions shown in Mexican museums in 1956, 1966, and 1967 preceding Palau's emergence into the world of textile art. Discusses artist's training in Mexico and Spain and the impact which the latter had on the development of her artistic language and technique. Remarks on her innovative blend of disparate fibers, materials and native elements to achieve texture, form and a uniquely Mexican flavor in her large and small-scale woven pieces. *Reproductions: "Escultura," "Mis caminos son terrestres II, IX, XI."*

1139. _____. "México en la XIX Bienal Internacional de São Paulo (II)." *Proceso* 12 Oct 1987: 53-55.
 Briefly traces Palau's career, remarking on her choice of materials for her woven pieces -- in particular corn husks and amate paper -- and their culturally emblematic value. Artist was one of five who represented Mexico in XIX São Paulo Biennial. Includes artist's portrait.

Parra, Carmen, 1944- Mexico City Painting/Sculpture

1140. *Antonia Guerrero, Carmen Parra: oleos, acrílicos, pasteles, esculturas.* Catalogue. [México, D.F.: Museo de Arte Moderno, 1976]. Includes chronology.

1141. *Memoria barroca de Carmen Parra: la Catedral de México . . . Sala Justino Fernández, Museo del Palacio de Bellas Artes: marzo-abril 1993.* Catalogue. México, D.F. Ediciones Gurnika, 1993.

Paz, Marie José France Collage

1142. Gimferrer, Pedro. "Marie José Paz en el país de las maravillas."
Vuelta 15.181 (Dec 1991): 53.
Text written for catalogue prepared for artist's Madrid exhibition. Compares
her collage compositions to poetry, with their juxtaposition of dissimilar
elements and unexpected associations.

1143. Nieto, Margarita. "Marie José Paz." *Latin American Art* 5.2
(Summer 1993): 53-54 [Spanish trans., 92-93].
Portrait containing some biographical information, as well as direct comments
by the artist revealing the influence which Mexico has had on her creative
endeavors. Nieto considers three of Paz's works, remarking on the frequent
equivocal "chain of associations" which they engender in the spectator. "This
sense of ambiguity mingles with the spontaneous blend of humor and nostalgia,
and a profound understanding of historical continuity brings a poetic sense of
drama to these works," writes Nieto. *Reproductions: "El huevo de Colón"
(1991), "Roman á clef" (1990), and "Ring Travellers" (1990).*

1144. Paz, Octavio. "La vuelta de los días: la espuma de las horas." *Vuelta*
14.163 (June 1990): 43-44.
Essay excerpted from exhibition catalogue. Mexican writer remarks on wife's
collages on occasion of her first exhibition at Galería de Arte Contemporáneo in
Mexico City. Includes untitled reproduction of one of the artist's works.

1145. Tomlinson, Charles, et al. "Tres versiones de los collages de Marie
José Paz." *Artes de México* 15 (Spring 1992): 98-99.
A poem and two essays offer three interpretations of artist's collages.

1146. Volkow, Verónica. "El ruido del mar." *Vuelta* 14.165 (Aug 1990):
68.
The trivial becomes significant, everyday objects and clippings transcend
boundaries of meaning, become metaphors for memories, feelings. Collage
becomes poetry.

Peláez, Guadalupe Painting

1147. Constante, Alberto. "Guadalupe Peláez: fulgor de lo visible." *Plural*
22 (Dec 1992): 46-47.
Considers elements of alchemy and magic in artist's paintings.

1148. Silva Camarena, Juan Manuel. "La mirada interior de Guadalupe
Peláez." *Plural* 22 (Dec 1992): 41-45.
*Reproductions: "Lothlórein" (1992), "El juego de la muñeca" (1990), "El
espacio de Patma" (1991), "Endimión y Selene" (1990), "Cuadros para una
exposición" (1991).*

Polin, Marisa Painting/Ceramics

1149. Benavides, J. A. "Marisa Polin." *Art Nexus* 5 (Aug 1992): 144-145 [English summary, 231].
 In this essay J. A. Benavides discusses development of painter who resides in The Hague. Benavides points out that although Marisa Polin's work is not "particularly Mexican or Latin American," her European audience perceives that she is a "Latin American artist." Polin indicates that throughout her brief career she has sought in vain to discover what defines a Latin American artist, acknowledging that she paints only what she feels. *Reproduction: "Viento Alcahuete" (1992).*

Prado, Nadine Painting

1150. *Nadine Prado.* Catalogue. [México, D.F.: Museo de Arte Moderno, 1975]. Text, Homer Aridjis. Includes chronology.

Quintana, Georgina, 1956- Mexico City Painting

1151. Emerich, Luis Carlos. "Georgina Quintana: la intimidad rodeada." *Figuraciones y desfiguros de los '80s.* México, D.F.: Editorial Diana, 1989. 131-134.

1152. "Georgina Quintana." In *Aspects of Contemporary Mexican Painting.* Catalogue. Curated by Edward Sullivan. New York, N.Y.: Americas Society, 1990. 86-91.

1153. Tibol, Raquel. "La geografía pensada de manera antibélica." *Proceso* 15 May 1989: 53-54.
 Traces Quintana's development, including information about her training and technique. Tibol remarks on the themes which concern the artist, with special emphasis on her series, "Campos geográficos," conceived as an argument for "a planet free of warriors, canons and all type of destructive activities." *Reproduction: "Campos geográficos."*

1154. _____. "21 cuadros de Georgina Quintana en la OMR." *Proceso* 5 July 1987: 51-52.
 In this review Raquel Tibol traces artist's trajectory, including detailed information about her education, training and development. Considers work shown in Mexico's Galería OMR within a feminist framework, suggesting that she makes a solid contribution not only to the world of "new" painting but also to feminist art. Includes untitled reproduction of one of her works.

Rabel, Fanny, 1924- Poland Drawing/Printmaking/Painting

1155. *Fanny Rabel: 50 años de producción artística: exposición retrospectiva: octubre 1993, Consejo Nacional para la Cultura y las Artes, Instituto Nacional*

de Bellas Artes, Museo del Palacio de Bellas Artes. Catalogue. México, D.F.:
Instituto Nacional de Bellas Artes, Museo del Palacio de Bellas Artes, 1993.

1156. Flores-Sánchez, Horacio. *El retrato mexicano contemporáneo.* Essays,
Paul Westheim and Justino Fernández. México, D.F.: Museo Nacional de Arte
Moderno, 1961. Includes brief biography.

1157. Goldman, Shifra M. "Las mujeres en el arte mexicano moderno."
Plural 2a época 11 (Feb 1982): 39-51. Bibl.
 Remarking on women's relative lack of artistic presence in Mexico until
1930, Shifra Goldman notes the emergence of various Mexican women artists
during the '60s and '70s. She explores the life and work of six artists who reside
in Mexico, among them Rabel, providing a brief profile which highlights her
background, training, subject matter, and the particular approach she takes to her
work. Contains some biographical information, as well as comments regarding
her thematic concerns. Untitled reproductions of two of her works are included.

1158. _____. "Six Women Artists of Mexico." *Woman's Art Journal* 3.2
(Fall 1982/Winter 1983): 1-9. Bibl. Rpt. in Shifra M. Goldman, *Dimensions of
the Americas: Art and Social Change in Latin America and the United States.*
Chicago: University of Chicago Press, 1994. 179-194. Bibl.
 Later version of Spanish-language article in #1157.

1159. Gual, Enrique F. *La pintura de Fanny Rabel.* [Mexico]: Anáhuac,
1968.

1160. Híjar, Alberto. "Del tiempo de Fanny Rabel." *Revista de Bellas Artes*
(Mexico) Nueva Epoca 24 (Nov-Dec 1975): 52-55.
 Alberto Híjar considers social and political contexts in which painter produced
her work. Analyzes Rabel's paintings shown in retrospective "Del tiempo,"
remarking on her technique for achieving social commentary.

1161. Moscona, Myriam. "Como garbanzos de a libra." *Fem* 33 (Apr-May
1984): 37-38.
 Based on an interview with the artist in which she discusses the limitations
which class and gender impose on female artists. Includes a reproduction of one
of her works.

1162. *Requiem por una ciudad: 40 obras de Fanny Rabel.* México, D.F.:
Universidad Nacional Autónoma de México, 1984. Texts, Arturo Sotomayor,
Marie Claire Acosta and José de Santiago.

Rahon, Alice, 1910-1987 France Writer/Painting

1163. *Alice Rahon: exposición antológica.* Catalogue. [México, D.F.:
Museo del Palacio de Bellas Artes, 1986]. Bibl. Essays, César Moro, Jorge
Crespo de la Serna, Margarita Nelken, and Enrique F. Gual. Includes
chronology.

1164. Andrade, Lourdes. "Tres mujeres del surrealismo." *México en el Arte* 11 (Winter 1985/1986): 28-31.
Compares Surrealist works of Leonora Carrington, Alice Rahon and Remedios Varos noting shared commonalities, among them an interest in the occult, a pictorial representation of air, earth, fire, and water, and the production of literary works by each of of the painters. Includes individual portraits of the artists.

1165. Chadwick, Whitney. *Women Artists and the Surrealist Movement.* New York: Thames and Hudson, 1991.

1166. Deffebach, Nancy. "Alice Rahon: Paintings in Free Verse." *Latin American Art* 2.3 (Summer 1990): 43-47.
Biographical survey exploring artist's evolution from French poet to Mexican Surrealist painter, a shift which Nancy Deffebach describes as being more of a "change in medium than professions." Explores features of her poetry which carry over into her painting, namely thematic content, an interest in color and in prehistoric time, considering a variety of her works, including the painting "The Ballad of Frida Kahlo." Deffebach writes "that a close reading of Rahon's poetry would lead to a more complete understanding of her paintings and promote a more holistic view of her oeuvre." Details of her association with artist Wolfgang Paalen and romantic liaison with Pablo Picasso are included, as is direct commentary by artist giving insight into the sources which inspired her work. *Reproductions: "Self-Portrait" (1951), "Music Box" (1944), "Painting for a Little Ghost Who Couldn't Learn to Read" (1947), "The Ballad of Frida Kahlo," detail.*

1167. Flores-Sánchez, Horacio. *El retrato mexicano contemporáneo.* Essays, Paul Westheim and Justino Fernández. México, D.F.: Museo Nacional de Arte Moderno, 1961. Includes brief biography.

1168. Rodríguez Prampolini, Ida. *El surrealismo y el arte fantástico de México.* México, D.F: Universidad Nacional Autónoma de México, Instituto de Investigaciones Estéticas, 1969. 73. Bibl.

Ramírez, Noemí, 1957- Weaving/FiberArt/Soft Sculpture

1169. *Noemí Ramírez: presencias, altos relieves en fibras.* Catalogue. [México, D.F.: Museo de Arte Carrillo Gil, 1985]. Text, Elvira García. Includes chronology.

Rendón de Olazábal, Eugenia Photography

1170. Hoy, Anne H. "Eugenia de Olazábal." *Nuevos momentos del arte mexicano = New Moments in Mexican Art.* Mexico, New York : Turner Parallel Project, 1990. 173-174. Bibl. In Spanish and English.

1171. Urrutia, Sofía. "Eugenia de Olazábal: el tacto de la luz." *México en el Arte* 25 (Spring 1990): 64+.
Considers photographer's series of large-scale polaroid prints, "Idolos," shown at Galería OMR in Mexico City. Urrutia remarks on "precision" and "perfection" of her technique and the light which Olazábal manipulates to "mold" her nude female figures, likening them to "sculptural images." Includes untitled reproductions of various of her works.

Rippey, Carla, 1950- U.S.A. Graphic Arts

1172. *Carla Rippey: dos décadas de obra gráfica: del 12 de agosto al 13 de septiembre de 1992, Museo Nacional de la Estampa.* Catalogue. [México, D.F.]: Consejo Nacional para la Cultura y las Artes: Instituto Nacional de Bellas Artes, [1992]. Bibl. Essays, Beatríz Vidal de Tico, Margo Glantz, José Manuel Springer. Includes biography.

1173. *Carla Rippey: el sueño que come al sueño: del 24 de junio al 26 de septiembre, Galería Fernando Gamboa.* Catalogue. México, D.F.: Museo de Arte Moderno, 1993. Bibl. In Spanish and English.

Romero, Betsabée

1174. Ganado Kim, Edgardo. "Betsabée Romero: cruce de nostalgias." *Artes de México* 23 (Spring 1994): [122].
 Considers artist's images which, author writes, awaken the hopes and desires of the present by evoking memories of the past. *Reproduction: "Cielo de castas."*

Romero, Josefina, 1960- Mexico City

1175. Tibol, Raquel. "Entre manos de Josefina Romero." *Proceso* 11 Mar 1991: 52-54.
 Traces Romero's education, training and development, offering commentary on her second solo exhibition in Mexico City entitled "Entre manos," a series of works showing a pair of hands (the artist's?) holding various types of objects. Considers autobiographical and sociological context/meaning of these works which she executes using a combination of photomontage and photocopying.

Sada, María Painting

1176. *María Sada: obra reciente.* Catalogue. México, D.F.: Galería de Arte, 1993. Essays, Jan M. William and Jorge Alberto Lozaya. Includes biography.

1177. William, Jan M. "María Sada: sonatina en gris mayor." *Artes de México* 21 (Fall 1993): 102.
 Metaphor knows no bound in this lyrical essay which personifies and extols the power of color "to seduce." *Reproduction : "La avispa" (1993).*

Sánchez Laurel, Herlinda, 1941- Ensenada Painting

1178. Mercado, Tununa. "La incesante producción de la pintura: Manuela
Generali y Herlinda Sánchez Laurel." *Fem* 44 (Feb-Mar 1986): 56-57.
 Remarks on artist's paintings shown in Museo de Arte Carrillo Gil and the
illusion of infinity which they impart to the viewer.

1179. Ocharán, Leticia. "La magia lírica en la pintura de Herlinda Sánchez
Laurel." *Plural* (Mexico) 19.227 (Aug 1990): 70.
 Likens chromatic balance of artist's paintings to the harmony of music. Notes
the "rupestrian" landscape of Baja California and her own life experiences as
sources of inspiration for her work.

Sauret, Nunik, 1951- Mexico City Painting/Printmaking/Sculpture

1180. *Nunik Sauret: dibujo, grabado, oleo, ex-libris.* Catalogue. [México,
D.F.: Galería de Arte Mexicano, 1981]. Essay, Margo Glantz. Includes
chronology.

1181. Tibol, Raquel. "Nunik Sauret: simbolizaciones y glorias." *Proceso*
17 Sept 1990: 50-52.
 Raquel Tibol traces Nunik Sauret's trajectory on the occasion of her
retrospective at Mexico's Museo Nacional de la Estampa spanning twenty-one
years of work. Offers details of her training, as well as a discussion of her style
and the subject matter that predominates in her work. Likens the erotic
symbolism of her delicately executed fruits and flowers to the visual imagery of
Georgia O'Keeffe. Includes portrait of the artist.

Serrano, Teresa, 1936- Mexico City Painting/Sculpture

1182. *Teresa Serrano.* Catalogue. [New York, NY: Plumb Anne Gallery,
1990]. Text, David Shapiro (in Spanish and English).

1183. *Teresa Serrano.* Catalogue. Garza García, México: Galería Ramis F.
Barquet, [1991]. Essay, Antonio Espinosa (in English and Spanish).

1184. *Teresa Serrano: esculturas, junio de 1993.* Catalogue. México, D.F.:
Galería Ramis Barquet. Essay, Meyer Raphael Rubinstein.

1185. *Teresa Serrano: flores concretas - Concrete Flowers, mayo-junio, 1993.*
Catalogue. México, D.F.: GAM, 1993. Text, Terry R. Myers (in Spanish and
English).

Siegmann, Naomi, 1933- Sculpture

1186. *Naomi Siegmann.* México, D.F.: Editorial Katun, 1985. Bibl. Text,
Graciela Kartofel (in English and Spanish).

1187. *Naomi Siegmann*. Catalogue. México, D.F.: Galería López Quiroga, 1988.

1188. *Naomi Siegmann, artista mexicano-norteamericana: esculturas.* Catalogue. [México, D.F.: Museo de Arte Moderno, 1979]. Text, Teresa del Conde. Includes chronology.

1189. Schneider Enriquez, Mary. "Naomi Siegmann." *Art News* 91.6 (Summer 1992): 149.
Considers Siegmann's sculptures shown in Mexico City's López Quiroga that capture the lifelike characteristics of various items of clothing she carves from solid mahogany. *Reproduction: "Mexican Blouse" (1991).*

Sierra, Susana, 1942?- Mexico City Painting

1190. *Interioridades: obra reciente, técnicas mixtas.* Catalogue. México, D.F.: Museo de Arte Moderno, Bosque de Chapultepec, Instituto Nacional de Bellas Artes, 1981.

1191. Tibol, Raquel. "El tema del agua en la pintura de Susana Sierra." *Proceso* 16 Jan 1989: 50-51.
Raquel Tibol considers artist's paintings and prints on the occasion of her show at Museo de Arte Moderno, remarking on her technique and use of color to achieve her water images. Includes Sierra's portrait, as well as information about her development.

Tamborell Guerrero, Gisela S c u l p t u r e

1192. Tamborell Guerrero, Gisela. "Reflexiones sobre mi obra." *Mexican Studies* 3.1 (Winter 1987): 211-221.
Personal narrative in which artist discusses her background, training, and the concerns which inform her art - an interest in exploring the roots of her Hispanic and indigenous heritages and a strong identification with elements of her natural environment. Includes artist's portrait. *Reproductions: "Eclipse," "Mujer I," "Víbora sol," "Maíz," "Cuatro caracoles," "Caracol," "Mariposa," "Sol."*

Tanguma, Marta Sculpture/Painting

1193. Híjar, Alberto. "Marta Tanguma: lo útil y lo bello." *Plural* 2a época 14 (Apr 1985): 32-36.
Study illustrating artist's progression from imitative, Surrealist style to more innovative forms of expression. Several of her works are reproduced, including murals and modular sculptures designed with the intention that they be handled by spectators. These are exhibited in public places where, critic points out, they serve not only a decorative purpose but also evoke an emotional response from passers-by.

Torres, Patricia Painting

1194. *Patricia Torres: entre movimientos intestinales y columnas vertebrales,*
9 de julio al 10 de agosto de 1991. Catalogue. México, D.F.: Praxis Arte
International, [1991]. In Spanish and English.

1195. Tibol, Raquel. "Otro discurso feminista de Patricia Torres." *Proceso*
15 July 1991: 57+.
 Raquel Tibol considers artist's feminist treatment of the body in her series of
works shown at Praxis. The carrot appears in these works as a pervasive
element amidst sundry commonplace objects and figures, referring in a
conceptual and tangential way, Tibol suggests, to aspects of everyday life that
either regulate or enslave. *Reproduction: "Para llegar" (1991).*

Urrusti, Lucinda, 1929-

1196. Flores-Sánchez, Horacio. *El retrato mexicano contemporáneo.* Essays,
Paul Westheim and Justino Fernández. México, D.F.: Museo Nacional de Arte
Moderno, 1961. Includes brief biography.

1197. *Un mundo etéreo: la pintura de Lucinda Urrusti.* Nelken. . . et al.
México: Secretaría de Educación Pública, 1976.

Urueta, Cordelia, 1908- Coyoacán Painting

1198. Barragán, Elisa García. *Cordelia Urueta y el color.* México, D.F.:
Universidad Nacional Autónoma de México, 1985. Bibl.

1199. Colle, Marie-Pierre. *Latin American Artists in Their Studios.* New
York: Vendome Press. 1994. Bibl. 212-221.

1200. Guadarrama, Guillermina. "Cordelia Urueta." *México en el Arte* 12
(Spring 1986): 95.
 Artist's progression from figurative to abstract painter and her search for voice
to protest social injustice is the subject of this essay. Guadarrama reflects on her
themes, including the denunciation of petroleum contamination of oceans and
rivers, remarking on some of the works which convey her message of ecological
concern. Includes artist's portrait.

1201. Rosales y Jaime, Sofía. "Cordelia Urueta: extraordinaria artista." *Fem*
5.17 (Feb-Mar 1981): 101-102.
 Essay of appreciation based on an interview with the artist. Notes the
sensibilities which drive her creativity, as well as her thoughts on the feminine
condition and on woman's contribution to its perpetuation.

1202. Tibol, Raquel. "Oleos 91-92: Cordelia Urueta." *Proceso* 1 June 1992: 50-51.
 Raquel Tibol considers artist's paintings shown at Galería Arte Contemporáneo. Remarks on her visual handicap and age which, nevertheless, fail to drain her creative energy. Includes statements by Urueta (excerpted from interview with Tibol in 1961) that give insight into her attitude about life and her concept of art, emphasizing her desire to depict the "inner dimension" of the figures she represents in her work. *Reproduction: "Mi casa." (1957).*

1203. Urrutia, Elena. "Cordelia Urueta: desde adentro hacia afuera." *Fem* 33 (Apr-May 1984): 18-19.
 Includes extensive personal narrative in which artist reflects on her struggle to achieve personal and professional freedom, the need for change in a world rife with crisis, and her vision of art as a transformative, liberating force from the problems afflicting humankind. *Reproduction: "Somos testigos" (1975).*

1204. Wilson, Janet. "Galleries: Urueta at Kimberly." *Washington Post* 20 Apr. 1991 final ed., sec. D: 2.
 This reviewer has only glowing words for Urueta and her works which were shown at the Kimberly Gallery. Referring to artist's love of painting, Wilson notes that "for Urueta, it's a love affair that's been going on for more than 60 years, bringing her accolades in Mexico as one of the country's leading abstract painters."

1205. *X Bienal de São Paulo/Brasil 1969.* [São Paulo, Brazil: São Paulo Biennial, 1969]. Catalogue. In Spanish and Portuguese. Includes chronology.

Vargas Daniels, Eugenia, 1949- Chile Performance/Photography

1206. Costa, Eduardo. "Eugenia Vargas." *Flash Art* 175 (Mar-Apr 1994): 108.
 Review of exhibition at Carla Stellweg in New York. Eduardo Costa writes that photographer's images, created by affixing "snapshots" onto her body, "portray a rich imagination and an analytical, frequently critical capacity to incorporate experience."

1207. Drillis, Catherine. "Eugenia Vargas, Kukuli Velarde." *Art News* 92.10 (Dec 1993): 135.
 Brief review of photographer's work shown at New York's Carla Stellweg.

1208. *Eugenia Vargas.* Catalogue. Long Beach, CA: University Art Museum, California State University, 1991. Essay, Diana C. du Pont.

1209. Ferrer, Elizabeth. "Embodying Art: Eugenia Vargas Daniels." *New Observations* 81 (Jan-Feb 1991): 28-31.
 Artist covers her body with mud and other materials and photographs herself in a variety of positions and contexts. Elizabeth Ferrer writes that for the artist, "the body serves as a medium that links divergent realms: the personal with the

public, the physical with the spiritual, and contemporary concerns with an acute consciousness of the past." Discusses her use of earth on her body as a "medium of transport," allowing her to create "connections to more universal realms -- the earth, and ultimately, to spiritual states of being." Reproductions of several untitled self-portraits made in 1987 are included.

1210. Greenstein, M. A. "Eugenia Vargas Daniels." *High Performance* 15.2-3 (Summer/Fall 1992): 80-81.
Describing the variety of artistic intentions and materials in artist's works, Greenstein remarks that she "exploits an intermedia patois" to convey her message. *Reproduction: "Earth Series" (1986-1987).*

1211. Rubinstein, Raphael. "Catching the Trade Winds." *Art in America* 82 (May 1994): 36-37.
In a discussion about the thriving Mexican art scene and the "enthusiastic explosion of activity among a new generation" of artists, Rubinstein mentions the work of Eugenia Vargas, who combines performance and photography in her artistic production. *Reproduction: "Untitled" (1993).*

1212. Tejada, Roberto. "Eugenia Vargas: el proscenio inevitable." Trans. Paloma Díaz Abreu. *Artes de México* 21 (Fall 1993): 98-99.
Roberto Tejada explores way in which the photographer represents the theme of confinement in a triptych of three photographs. Remarks that Vargas challenges preconceived ideas about what Mexican women should attempt to create in their art because, among other things, she "usurps and rejects the small format traditionally reserved for women" and also "undermines the 'transparent' quality of conventional photography." Includes reproductions of various untitled works.

Varo, Remedios, 1908-1963 Spain Painting

1213. Adams, Brooks. "Hidden Heroines: Passionate Perspectives." *Harper's Bazaar* 121 (Apr 1988): 102-103+.
Brief biographical sketch. *Reproduction: "Origin of the Orinoco River" (1959).*

1214. Agosín, Marjorie. "Las casas de Remedios Varo." *Las hacedoras: mujer, imagen, escritura.* Santiago, [Chile]: Editorial Cuarto Propio, [1993]. 199-208. Bibl.

1215. Andrade, Lourdes. "Remedios y la alquimia." *México en el Arte* 14 (Fall 1986): 66-71.
Discusses manner in which Varo uses alchemic symbols as a pervasive element in her work. Includes untitled reproductions of several of her paintings.

1216. _____. "Tres mujeres del surrealismo." *México en el Arte* 11 (Winter 1985/1986): 28-31.
Compares Surrealist works of Leonora Carrington, Alice Rahon and Remedios Varos, noting shared commonalities, among them an interest in the occult, a pictorial representation of air, earth, fire, and water, and the production of literary works by each of of the painters. Includes individual portraits of the artists.

1217. Caillois, Roger. "Remedios Varo." Trans. Laura López Morales. *Plural* 20.235 (Apr 1991): 37-45.
Study of elements that Varo represents in her "enigmatic" and "fantastic" universe of images -- substances, architecture, beings, machinery.

1218. Chadwick, Whitney. "The Muse as Artist: Women in the Surrealist Movement." *Art in America* 73.7 (July 1985): 120-129. Bibl.
Considers work of women associated with the Surrealist movement, including Remedios Varo. *Reproductions: "Harmony" (1956), "Celestial Pablum" (1958).*

1219. _____. *Women Artists and the Surrealist Movement.* New York: Thames and Hudson, 1991.

1220. *Consejos y recetas de Remedios Varo: pinturas, manuscritos y dibujos.* Monclova, México: Museo Biblioteca Pape, 1988. Bibl.

1221. Duran, Gloria. "The Antipodes of Surrealism: Salvador Dali and Remedios Varo." *Symposium* (Washington, D. C.) 42 (Winter 1989): 297-311. Bibl.
Indepth study contrasting approach of two artists to Surrealism. Suggests that factors such as gender, personality, life philosophy and experiences played a significant role in the treatment of their subject matter and the emotional response which their work elicits. Remarks that Varo's thematic interpretations are guided by a conception of reality which views woman not as object, but as subject or "creator" in search of spiritual and psychic development. Notes Jungian symbolism present in artist's paintings supporting this view. Contains biographical information, including discussion of artist's stay in Paris and direct statements which reveal details of her association with other Surrealist artists.

1222. Engel, Peter. "The Art of Remedios Varo: A Struggle Between the Scientific and the Sacred." *Technology Review* 89 (Oct 1986): 66-74.
Considers several of Varo's works, exploring how she combined scientific principles with elements of the supernatural to represent her special vision of the world. Includes artist's portrait. *Reproductions: "Phenomenon of Anti-Gravity" (1963), "Insubmissive Plant" (1961), "Spiral Transit" (1962), "Embroidering the Terrestrial Mantle" (1961), "The Revelation or The Clock-Maker" (1955), "Fabric of Space-Time" (1956), "The Useless Science or The Alchemist" (1958), "Harmony" (1956), "Still Life Reviving" (1963).*

1223. _____. "The Traveler: The Surrealist Whose Works are Seldom Seen." *Connoisseur* 218 (Feb 1988): 94-98.

Peter Engel provides indepth profile of artist who used fantasy and Surrealism to create images which writer asserts record metaphysical and spiritual journey. He writes that "although Varo is nearly unknown in the United States and in Europe, in Mexico she is regarded as a national treasure." Analyzes symbolism drawn from Middle Ages that recurs in her work, noting style and meticulous handling of detail. Offers biographical remarks and personal statements by artist, as well as laudatory remarks by André Breton and Diego Rivera. Includes portrait of the artist. *Reproductions: "In Exploration of the Origins of the Orinoco River," "Embroidering the Terrestrial Mantle," "The Troubador," (1959), "Capillary Locomotion," (1960).*

1224. Espinosa de los Monteros, Santiago. "Remedios Varo." *Arte en Colombia* 40 (May 1989): 102-103 [English summary, 152-153].

Review of artist's work shown in Mexico's Museo de Monterrey. Espinosa de los Monteros establishes differences between her work and that of Leonora Carrington, with whom she has been compared. *Reproduction: "Exploración de las fuentes del río Orinoco" (1959).*

1225. Gómez Campos, Rubí de María. "La creación de mundos de Remedios Varo." *Fem* 15.108 (Dec 1991): 33-35.

Considers artist's work within feminist framework, emphasizing the mysterious and dreamlike qualities of her Surrealist images. Includes untitled reproductions of several of her works.

1226. Heller, Nancy. *Women Artists: An Illustrated History.* New York, N.Y.: London, England: Abbeville Press, 1987, 1991. Bibl.

1227. Isaak, Dinorah. "Remedios Varo (1908-1963)." *Voices of Mexico* 27 (Apr-June 1994): 67-69.

Review essay on the occasion of an exhibition of the painter's work in Mexico City's Modern Art Museum. Includes personal statements and portraits of the artist. *Reproductions: "Revelation or The Watchmaker" (1955), "The Lovers" (1963), "The Farmworker" (1958), "Weightless" (1963), "Star Huntress" (1956), "Icon" (1945), "Portrait of Dr. Ignacio Chávez" (1957), "Discretion" (1958), "The Pauper" (1958), "The Encounter" (1962).*

1228. _____. "Remedios Varo: A Magical Journey." *Voices of Mexico* 28 (July-Sept 1994): 17-22.

Dinorah Isaak adds to an understanding of Remedios Varo and her work by including the text of interviews she conducted with her widower, Walter Gruen, her biographer, Janet Kaplan, and Isabel Castells, compiler of *Remedios Varo: cartas, sueños y otros textos,* a collection of "intimate, spontaneous, secret and personal" texts written by the artist. *Reproductions: "Useless Science or The Alchemist" (1955), "Towards the Tower" (1960), "Embroidering the Earthly Mantle" (1961), "The Flight" (1961), "Solar Music" (1955), "Les Feuilles*

Mortes" (1956), "Disquieting Presence" (1959), "Rupture" (1955), "Tailleur Pour Dames" (1957), "The Flautist" (1955).

1229. Jaguer, Edouard. *Remedios Varo.* Trans. José Emilio Pacheco. México, D.F.: Ediciones Era, 1980. French and Spanish text.

1230. Kaplan, Janet A. "Art Essay: Remedios Varo." *Feminist Studies* 13.1 (Spring 1987): 38-48.
In this essay Janet Kaplan succinctly remarks on Varo's preeminent status within the Mexican art world, noting various sources which inform her style and the impact of exile on her work. *Reproductions: "Mimesis" (1960), "Unexpected Presence" (1959), "Celestial Pablum" (1958), "Woman Leaving the Psychoanalyst's Office" (1960), "Exploration of the Sources of the Orinoco River" (1959), "Solar Music" (1955), "Harmony" (1956), "Still Life Reviving" (1963).*

1231. _____. *Remedios Varo (1913-1963): Spanish-Born Mexican Painter, Woman Among the Surrealists.* Ph.D. Dissertation. Columbia University, 1983.

1232. _____. "Remedios Varo: Voyages and Visions." *Woman's Art Journal* 1.2 (Fall 1980/Winter 1981): 13-18. Bibl.

1233. _____. *Unexpected Journeys: The Art and Life of Remedios Varo.* New York, NY: Abbeville Press, 1988. Bibl.
First biography of artist in English which has also been published in Spanish, German and Japanese.

1234. Lauter, Estella. "The Creative Woman and the Female Quest: The Paintings of Remedios Varo." *Soundings* 63.2 (Summer 1980): 113-134. Bibl. Rpt. in Estella Lauter, *Women as Mythmakers: Poetry and Visual Art by Twentieth-Century Women.* Bloomington, IN: Indiana University Press, 1984. 79-97.
Estella Lauter writes, ". . . recent research allows us to see that Varo's images of the creative process occur in the context of a female quest. . ." Using that perspective she considers various of Varos' paintings, at times including artist's own statements which "reveal her starting point." Contains some biographical information. *Reproductions: "Música solar" (1955), "La creación de las aves" (1958), "Naturaleza muerta resucitando" (1963), "Nacer de nuevo" (1960), "La llamada" (1961).*

1235. Marquet, Antonio. "La metamorfosis de Remedios Varo." *Plural* 23.273 (June 1994): 41-49.
Study of elements of order/control and movement in various of Varo's paintings. *Reproductions: "El fenómeno de la ingravidez" (1963), "La llamada" (1961), "Retrato del Dr. Ignacio Chávez" (1957), "Mujer saliendo del psicoanalista" (1961), "Au bonheur des citoyens" (1956), "La inútil ciencia" o*

*"El alquimista" (1955), "Locomoción capilar" (1960), "Cazadora de estrellas"
(1956).*

1236. *Remedios Varo.* [México, D.F.: Ediciones Era, 1966]. Text, Octavio
Paz and Roger Caillois.

1237. *Remedios Varo, 1908-1963: del 25 de febrero al 5 de junio, Sala Carlos
Pellicer.* Catalogue. México, D.F.: Museo de Arte Moderno, 1994. Bibl.
Ricardo Ovalle, curator. Text, Teresa del Conde and Francisco Serrano.

1238. *Remedios Varo: Sala de Exposiciones, Banco Exterior de España, Paseo
de la Castellana 32, noviembre de 1988-enero de 1989.* Catalogue. Madrid,
Spain: Fundación Banco Exterior, 1988. Bibl.

1239. Rodríguez Prampolini, Ida. "Remedios Varo y Frida Kahlo: dos
exposiciones recientes." *Plural* 13.147 (Dec. 1983): 31-39.
 Analysis of artist's works based on Andre Breton's concept of the Surrealist
and his perception that elements in Mexican reality lend themselves to the
expression of that concept. Includes some biographical information and personal
statements by Varo, as well as untitled reproductions of various of her works.

1240. _____. *El surrealismo y el arte fantástico de México.* México, D.F:
Universidad Nacional Autónoma de México, Instituto de Investigaciones
Estéticas, 1969. 75-78. Bibl.

1241. Schneider Enriquez, Mary. "Remedios Varo." *Art News* 93.8 (Oct
1994): 199.
 Mary Schneider Enríquez describes several of the paintings which were shown
at an exhibition of the artist's work in Mexico City's Museum of Modern Art.
Reproduction: "De Homo Rodans" (1959).

1242. *Science in Surrealism: The Art of Remedios Varo.* Catalogue. [New
York, N.Y.: New York Academy of Sciences, 1986]. Bibl.

1243. Tibol, Raquel. "El catálogo '88 de Remedios Varo." *Proceso* 26 Dec
1988: 50- 52.

1244. _____. "Remedios Varo en España." *Proceso* 21 Nov 1988: 50-52.

1245. Varo, Beatríz. *Remedios Varo: en el centro del microcosmos.* México,
D.F.: Fondo de Cultura Económica, 1990. Bibl.

1246. _____. *Remedios Varo: cartas, sueños y otros textos.* [?, Mexico:
Universidad de Tlaxcala, Instituto Nacional de Bellas Artes, 1994?].

Vergara, Esperanza Painting

1247. *La pintura ecuestre de Esperanza Vergara.* México, Edamex, 1993.
Introduction, Carlos Elizondo.

Yampolsky, Mariana, 1925- U.S.A. Printmaking/Photography

1248. Agosín, Marjorie. "Los sortilegios de la mirada: la fotografía de
Mariana Yampolsky." *Fem* 18.136 (June 1994): 42-45. Bibl.
 Describing Yampolsky as one of the most prolific and sensitive Mexican
photographers since the decade of the '40s, Marjorie Agosin considers her attitude
towards her subject matter. Includes commentary by Elena Poniatowska, as well
as untitled reproductions of two of Yampolsky's works.

1249. Brittain, David. "Mariana Yampolsky: Drinking from the Roots."
Creative Camera (May 1989): 16+.
 Interview with artist revealing her identification with, and affinity to, Mexican
life and culture. Discusses her involvement with Taller de Gráfica Popular, her
early work as engraver and art book editor, and the social orientation of her
photography. Identifies influences which have played a significant role in her
work and the cultural themes and motifs which root her photographs in the
Mexican experience. *Reproductions: "Maguey Castrated," "Mother from
Campeche," "Woman from Tlacotalpan," "Boneyard."*

1250. Coronel Rivera, Juan. "Mariana Yampolsky: el acto fotográfico."
Artes de Mexico 12 (Summer 1991): 117. *Reproduction: "Santiaguero."*

1251. Ferrer, Elizabeth. "'Encountering Difference': Four Mexican
Photographers." *Center Quarterly* 14.1 (1992): 6-17. Bibl.
 Essay by curator of "Encountering Difference" project highlighting "difference"
from a variety of perspectives. Gives details on development of photography in
Mexico and briefly considers background and work of four photographers,
including Mariana Yampolsky. *Reproductions: "Mujeres Mazahua" (1989),
"Caricia" (1990), "Patio de la carcel" (1987), "En espera del padrecito" (1980s).*

1252. Goldman, Shifra M. "Las mujeres en el arte mexicano moderno."
Plural 2a época 11 (Feb 1982): 39-51. Bibl.
 Remarking on women's relative lack of artistic presence in Mexico until
1930, Shifra Goldman notes the emergence of various Mexican women artists
during the '60s and '70s. She explores the life and work of six artists who reside
in Mexico, among them Yampolsky, providing a brief profile which highlights
her background, training, editorial activities, and the sociopolitical context in
which she frames her work. Contains some biographical information, as well as
untitled reproductions of two of her works.

1253. _____. "Six Women Artists of Mexico." *Woman's Art Journal* 3.2
(Fall 1982/Winter 1983): 1-9. Bibl. Rpt. in Shifra M. Goldman, *Dimensions of*

the Americas: Art and Social Change in Latin America and the United States. Chicago: University of Chicago Press, 1994. 179-194. Bibl.
Later version of Spanish-language article in #1252.

1254. Hernández Carballido, Elvira. "En la vanguardia: Mariana Yampolsky." *Fem* 17.119 (Jan 1993): 45.
Very brief biographical summary of artist. Calls attention to her early training at San Carlos Academy which was then headed by Dolores Alvarez Bravo.

1255. Hopkinson, Amanda. "All's Well Down Mexico Way." *British Journal of Photography* 30 Nov 1989: 10-13.
On the occasion of the 150th anniversary of the birth of photography, Amanda Hopkinson takes a look at figures who have played a prominent role in the development of the medium in Mexico. Briefly mentions Yampolsky's work (13). *Reproduction: "Pablo y María O'Higgins" (1960).*

1256. Rábago Palafox, Gabriela. "Mariana Yampolsky, the Singing Camera." *Voices of Mexico* 27 (Apr.-June 1994): 57-61.
Text of an interview which reveals much about Yampolsky as artist and person. The photographer talks about her exhibition in Iceland, her interest in architecture as a source of inspiration, and the value of considering differences in artistic expression as a measure of uniqueness instead of superiority. Includes various portraits of Yampolsky. *Reproductions: "Mazahua Mother," "Otomí Woman," "The Store," "Lace Curtains," "House of Bones," "The Kitchen," "The Barber," "Angels," "Wall of Thorns."*

1257. Woodard, Josef. "From the Fringes: 'Compañeras de México: Women Photograph Women' at the Ventura County Museum of History & Art." *Artweek* 22 (May 23 1991): 9-10.
Josef Woodard reviews Southern California exhibition featuring works by women who figure prominently in the shaping of a Mexican photographic tradition. Offers commentary on Yampolsky's images, drawing parallels between her work and that of Graciela Iturbide.

1258. Yampolsky, Mariana. *La casa en la tierra.* Text, Elena Poniatowska. [México, D.F.]: INI-Fonapas, [1980?].

1259. _____. *La casa que canta: arquitectura popular mexicana.* México, D.F.: Fondo de Cultura Económica, 1982.

1260. _____. *Haciendo poblanas.* México, D.F.: Universidad Iberoamericana, 1992. Bibl. Text, Ricardo Rendón Garcini.

1261. _____. *La raíz y el camino.* México, D.F.: Fondo de Cultura Económica, 1985. Presentation, Elena Poniatowska.

1262. _____. *Mazahua*. Toluca, México: Gobierno del Estado de México, 1993. Text, Elena Poniatowska.

1263. _____. *The Traditional Architecture of Mexico*. New York: Thames and Hudson, 1993. Text, Chloe Sayer.

1264. _____ and Elena Poniatowska. *Tlacotalpan*. [Veracruz, México?]: Instituto Veracruzano de la Cultura, 1987. In Spanish and English.

1265. _____. *Estancias del olvido*. Pachuca, [México]: Biblioteca de Cultura Hidalguense del Centro Hidalguense de Investigaciones Históricas, 1987.

Zamora, Beatríz

1266. Rosenblum, Robert. "Beatríz Zamora." *Diálogos* (México) 15.86 (Mar-Apr. 1979): 37-38.
 Seeks meaning of artist's "black canvases" in geological, astronomical, and anthropological terms, suggesting that she "submerges herself in earth's primordial elements to recreate ancestral mysteries."

Zimbrón, Teresa Painting

1267. Schneider Enríquez, Mary. "Teresa Zimbrón." *Art News* 93.6 (Summer 1994): 191.
 Schneider Enríquez considers paintings presented by the artist at Galería Ramis Barquet in Monterrey, Mexico, writing that they are "medieval in their deep colors, rich surface and haunting imagery." *Reproduction: "Familia de cobra."*

Zorilla, Begoña, 1956- Tampico Painting

1268. Tibol, Raquel. "Cultos ambigüos según Begoña Zorrilla." *Proceso* 17 Aug 1987: 51-52.
 Feminist reading of artist's panoply of images drawn from the religious sphere and the profane which were shown at the Foro de Arte Contemporáneo. *Reproduction: "Palabras sueltas" (1987).*

1269. _____. "Mito-grafías de Begoña Zorrilla." *Proceso* 23 July 1990: 56+.
 Profile tracing painter's education and development. Considers themes of gender in her series "Historias del corazón" which was shown in Mexico City's Galería Juan Martín. *Reproduction: "Trazos de una devoción."*

NICARAGUA

Ortíz de Manzanares, Ilse, 1941- León Painting

1270. Balladares Cuadra, José Emilio. "La pintura de Ilse Ortíz de
Manzanares." *Revista del Pensamiento Centroamericano* 43.199 (Apr-June
1988): 56-57.
 Brief essay reflecting on the dynamic qualities which the artist achieves in her
unusual compostions. Includes portrait of artist and chronology. *Reproduction:
"Lámina III" (1987)*.

PANAMA

Arias, Susana Sculpture/Painting

1271. Stoddart Gould, Veronica. "The Primitive Intuitive Being." *Américas*
39.5 (Sept-Oct 1987): 55-57.
 Reviews exhibition of multimedia artwork shown at Museum of Modern Art
of Latin America in Washington, D.C., calling attention to innovative style of
this San Francisco-based artist. Remarks on her "Urban Reference" series in
which, critic writes, Arias "uses architecture to express man's relationship to his
environment." Artist describes the incorporation of ritual and tradition into her
work as an expression of the "syncretization of cultures." Includes artist's
portrait and untitled reproductions of two of her works.

1272. *Susana Arias of Panama*. Catalogue. [Washington, D.C.: Museum of
Modern Art of Latin America, 1987].

Calderón, Coqui

1273. Judd Ahlander, Leslie. "Coqui Calderón." *Arte en Colombia* 45 (Oct
1990): 120-121 [English summary, 171].
 Review of artist's works shown at Panamá's Museo de Arte Contemporáneo.
Leslie Judd Ahlander writes that Coqui Calderón is "one of Panama's brightest
young painters. . ." [who] "has shown her work regularly in Miami, where she
is admired for her loose, free brushwork and emotionally charged expressionist
approach." Critic describes artist's treatment of violence as it was recently
experienced in her native country. Includes reproduction of untitled work.

Eleta, Sandra Photography

1274. Renfrew, Nita M. "Sandra Eleta: Portobelo Unseen." *Aperture* 109
(Winter 1987): 48-57.
 Offers commentary on Eleta's photographs which capture the seen and unseen
realities of Panama's Portobelo. *Reproductions: "Catalina, Queen of the
Congos" (1980), "Pajita", "Filio" (1984), "Glory, Palm Sunday" (1972),*

"Josefa, Healer of the Evil Eye" (1980), "Ventura and Palanca" (1972), "Congo Laganiza" (1983), "The Congo Players, Moon and Sun" (1982).

Icaza, Teresa, 1940- Painting/Collage

1275. Damian, Carol. "Teresa Icaza." *Latin American Art* 5.3 (1993): 65 [Spanish trans., 85].
In this review Carol Damian describes artist's treatment of color and line in the abstract "fantastic forests" she creates. *Reproduction: "Dawn of Colors" (1993).*

1276. Flores Zúñiga, Juan Carlos. "Teresa Icaza." In *Magic and Realism: Central American Contemporary Art = Magia y realismo: arte contemporáneo centroamericano.* Trans. Orlando García Valverde. Tegucigalpa, Honduras: Ediciones Galería de Arte Trio's, 1990. 266-269. Bibl.
Brief profile with personal statements by the artist, a portrait, and reproductions of various of her works. In English and Spanish.

Lichacz, Sheila E., 1942- Monagrillo Drawing/Painting

1277. "Lively Still Lifes." *Américas* 33.10 (Oct 1981): 46.
Review of exhibition at Museum of Modern Art of Latin America, Washington, D. C. Critic remarks briefly on artist's technique for achieving sculpted effect in her pastel on canvas representation of motifs found in her native country. Artist's own words reveal her concept of the artistic process as it relates to her work. *Reproduction: "Jugs" (1978).*

1278. *Sheila Lichacz: Oil Paintings and Pastels.* Catalogue. [Santa Fe, New Mexico: Santa Fe East Galleries, 1984]. Bibl. Includes chronology.

1279. *Sheila Lichacz: Selected Works, 1981-1989.* Catalogue. Irvine, CA: University of California, Fine Arts Gallery, 1989. Melinda Wortz, curator. Bibl. Includes chronology.

Obaldía, Isabel de, 1957- Painting

1280. Flores Zúñiga, Juan Carlos. "Isabel de Obaldía." In *Magic and Realism: Central American Contemporary Art = Magia y realismo: arte contemporáneo centroamericano.* Trans. Orlando García Valverde. Tegucigalpa, Honduras: Ediciones Galería de Arte Trio's, 1990. 270-275. Bibl.
Brief profile with personal statements by the artist and reproductions of various of her works. In English and Spanish.

PARAGUAY

Morselli, Margarita, 1952- Asunción Painting

1281. *Margarita Morselli of Paraguay: Paintings.* Catalogue. Washington, D.C.: Museum of Modern Art of Latin America, 1987.

1282. Palomero, Federica. "III Bienal de Cuenca." *Art Nexus* 3 (Jan 1992): 136-139 [English trans., 209-210].
 Federica Palomero considers the relative merit of works exhibited during III Cuenca Biennial in Ecuador. Paraguay was represented with paintings by Margarita Morselli whose individualistic style earned for her favorable commentary from this critic who stated that the quality of her work should have been acknowledged and recognized with an award. *Reproduction: "Escala ascendente."*

Romero, Susana Argentina Painting

1283. Bach, Caleb. "On the Edge of Reality." *Américas* 46.3 (May-June 1994): 50-51.
 Biographical portrait that reveals many details of Romero's background and professional development. Caleb emphasizes her expressionist style of painting, writing that she "embraces that moment of transition between what is and what could be. Her paintings are about feelings and choices, nostalgic 'what ifs' that wash over her players time after time." Includes remarks by Romero that offer a glimpse of the woman and the artist from her own perspective. *Reproductions: From "Los ritos" cycle (1993), "Cabeza de hombre" (1983).*

PERU

Amorós, Grimanesa, 1962- Lima Painting

1284. Damian, Carol. "Grimanesa Amorós." *Art Nexus* 9 (June-Aug 1993): 134-135 [English trans., 196].
 Review of artist's paintings shown at Javier Lumbreras Fine Art in Miami. Carol Damian comments on Amorós's "painterly and expressive" style and the "sexual energy" which exudes from her canvases, pointing out that "there is a sense of the whimsical in her depictions of humans, as crosses between science fiction creatures and cartoons . . . she creates a magical environment for their existence." *Reproduction: "Amantes obsesionados " (1992).*

1285. *Grimanesa Amorós: The World: April 21-May 31, 1994.* Catalogue. New York, NY: Carolyn J. Roy Gallery, [1994]. Essay, Dan Cameron.

1286. Padurano, Dominique. "Grimanesa Amorós: Mysteries and Metaphors." *Latin American Art* 5.1 (Spring 1993): 67-69 [Spanish trans., 108-109].
Portrait of the artist with information about her training, background and development. Critic writes, ". . . embodying mystery and erotic passion. . . [her] paintings examine the drama of human emotions and relationships with bold fields of color and dynamic, expressive brushstrokes and texture." Dominique Padurano includes comments by the artist that give insight into the predominant themes she depicts in her work. Includes artist's portrait. *Reproductions: "The Tortoise is Watching" (1992), "The Power of Light" (1992), "Transformations" (1991), "The Red Devils" (1992).*

1287. Mujica, Barbara. "Bright Visions, Fine Contours." *Américas* 43.3 (May-June 1991): 44-51.
Sketches of ten women, among them Amorós, identified by Mujica as being "on the cutting edge" of their profession. Briefly considers influence on artist's work, as well as her preferred themes. *Reproduction "Self-Portrait" (1990).*

1288. Windhausen, Rodolfo A. "Women Artists in Latin America." *Latin American Art* 5.1 (1993): 89 [Spanish trans., 117-118].
An exhibition in New York's Americas Gallery gathered together works by eleven Latin American women painters reflecting a wide range of tendencies and themes. In his review Rodolfo Windhausen briefly remarks on this artist's paintings, noting a strong relationship between her work and that of Raquel Forner.

Gálvez, Cristina Drawing/Sculpture

1289. Checa, Margarita, et al. "Cristina Gálvez." *Debate* (Peru) 13 (n.d.): 98-102.
Homage by eight close friends and associates of the artist on the occasion of her death. Includes several portraits and untitled reproductions of various of her works.

1290. Ortíz de Zevallos M., Augusto. "Entrevista a Cristina Gálvez." *Debate* (Peru) 8 (n.d.): 8-17+.
Transcript of interview in which the artist answers questions about her life as a woman in Lima, the development of her career, and the dualistic character of her images, among other topics. Includes several portraits of the artist, as well as an untitled reproduction of one of her works.

Hamann, Johanna Sculpture

1291. Jarque, Fietta. "Johanna Hamann: el perfíl de lo intacto." *Hueso Húmero* 18 (July-Sept 1983): 163-167.
Review of artist's pieces exhibited at Lima's Galería Forum that had various aspects of maternity as their theme. Fietta Jarque remarks on artist's innovative

use of materials, noting the relatively smaller number of Peruvian artists
dedicating themselves to sculpture as compared to painting.

Loli, Nelly Painting

1292. *Imagen y color en la pintura de Nelly Loli.* Catalogue. Lima, Peru:
[n.p.], 1984.

1293. Mirónenko, Olga. "Simbolismo y color en la pintura de Nelly Loli."
América Latina (USSR) 8 (Aug 1987): 64-69. Bibl.
 Considers symbolism in artist's paintings and her metaphoric use of color,
noting strong presence of pre-Incan and mythological elements in her work.
Includes details of her training, as well as statements by the artist.
*Reproductions: "Mensaje de paz," "Gestación," "Comunicación," "Mujer
andina," "Máscaras. Amor exvivencial."*

Mutal, Lika, 1939- Netherlands Sculpture

1294. Oviedo, José Miguel. "The Age of Stone: The Sculpture of Lika
Mutal." Trans. Lori M. Carlson. *Review: Latin American Literature and Arts*
40 (Jan-June 1989): 22-23.
 Describes skills and process by which artist "conquers" the seemingly
immutable nature of stone to unlock in her pieces "its ceaseless energy." Noting
that Mutal's extended residence in Peru impacted on the development of her art,
José Miguel Oviedo writes that "these objects are not merely products of patient
work and an unhurried technique: they are fruits of a personal relationship, of an
intimate understanding of stone and its mythological force." *Reproduction:
"Split Second" (1986).*

1295. Waterman, Daniel. "Lika Mutal" *Art News* 88.7 (Sept 1989): 182-
183.
 Lika Mutal lived and worked for eighteen years in Peru. In this review of her
exhibition in New York City's Nohra Haime Gallery, Daniel Waterman remarks
that Mutal's "large-scale pieces. . . reveal the profound influence that Mayan and
pre-Columbian culture has had on her work." *Reproduction: "Tonatiuh" (1988).*

Noriega, Charo Painting

1296. Ledgard, Reynaldo. "La pintura de Charo Noriega: una poética de la
conciencia." *Hueso Húmero* 18 (July-Sept 1983): 176-183.
 Examines development of artist's painting from her early association with
Taller Huayco - with its emphasis on collective endeavors and identification with
Andean popular culture - to her more recent artistic proposals. These, according
to Ledgard, demonstrate a simplification of form and the engagement of
metaphor to construct meaning. Considers social context in which Noriega has
produced her politically charged compositions.

Ortíz Osorio, Jeanette Mixed Media

1297. Mujica, Barbara. "Bright Visions, Fine Contours." *Américas* 43.3
(May-June 1991): 44-51.
 Sketches of ten women, among them Jeanette Ortíz Osorio, identified by
Mujica as being "on the cutting edge" of their profession. Considers mixed
media images which artist creates by combining photographs with painting
filters. Artist's own remarks give some insight into the sources of her
inspiration and the range of expression she strives for. *Reproduction:*
"Untitled" (1990).

Prager, Sonia Sculpture

1298. Lama, Luis. "Monolítica Prager." *Debate* (Peru) 13.65 (July-Sept
1991): 66-67.
 Prager, who carves massive blocks of stone into a variety of forms, has
established herself as an important sculptor in her native country. Suggesting
that an interrelationship between architecture and sculpture is present in her
monoliths, Lama also notes their dynamism, originality and timeless quality
which, he suggests, contribute to making hers one of the most coherent bodies
of sculpture in Peru. Includes untitled reproductions of various of her works.

Tsuchiya, Tilsa, 1932-1984 Painting

1299. Baddeley, Oriana and Valerie Fraser. *Drawing the Line: Art and*
Cultural Identity in Contemporary Latin America. London; New York: Verso,
1989. 32-35. Bibl.

1300. Moll, Eduardo. *Tilsa Tshuchiya, 1929-1984.* Lima, Peru: Editorial
Navarrete, 1991.

1301. Ortíz de Zevallos, Augusto. "Dos pintores marginales." *Textual*
(Peru) 3 (Dec 1971): 80-81.
 Author briefly explores why he considers artist and her work from a
perspective of difference. Includes artist's portrait.

Velarde, Kukuli Sculpture

1302. Drillis, Catherine. "Eugenia Vargas, Kukuli Velarde." *Art News*
92.10 (Dec 1993): 135.
 Review of artist's clay pieces shown at New York's Carla Stellweg.
Catherine Drillis comments on themes of repression and self- expression
represented in Velarde's works. *Reproduction: "La mujercita ideal: santa*
chingada (The Ideal Woman: Screwed Saint)" (1992-1993).

PUERTO RICO

Báez, Myrna, 1931- Santurce PaintingPrintmaking

1303. Arce de Vásquez, Margot. "Acrílicos y serigrafías de Myrna Báez." *Sin Nombre* 11.2 (July-Sept 1980): 55-59.
Ranking Myrna Báez among Puerto Rico's "three or four most distinguished artists," Arce de Vásquez examines the change in focus and "pictorial language" of the paintings and prints that she presented in a studio exhibition.

1304. *Myrna Báez: diez años de gráfica y pintura, 1971-1981.* Catalogue. [New York, N.Y.: Museo del Barrio, 1982]. Bibl. Includes chronology.

1305. Rodríguez, Nora. *The Construction of an Original Response: Myrna Báez, a Role Model.* Master's Thesis. Vermont College, Norwich University, 1988.

1306. Somoza, María Emilia. *Graphic Art in Puerto Rico from 1949 to 1970: A Historical Perspective and Aesthetic Analysis of Selected Prints.* Ph.D. Dissertation. New York University, 1983.

1307. Tibol, Raquel. "Tres décadas gráficas de Myrna Báez." *Universidad de México* 43.455 (Dec 1988): 29-33. Bibl.
A reproduction of the essay published in the exhibition catalogue for "Tres décadas gráficas de Myrna Báez." Considers person, artist and work, with excerpted passages from various other exhibition catalogues. *Reproductions: "Autorretrato" (1963), "Arrabal" (1962), "Vaca" (1985), "Gallo" 1985).*

1308. *Tres décadas gráficas de Myrna Báez, 1958-1988: exposición homenaje: VIII Bienal de San Juan del Grabado Latinoamericano y del Caribe, Museo de Arte de Puerto Rico, Instituto de Cultura Puertorriqueña, San Juan, Puerto Rico, 28 de septiembre de 1988 al 31 de diciembre de 1988.* Catalogue. San Juan: Cooperativa de Seguros Múltiples de Puerto Rico, 1988. Bibl. Essays, Raquel Tibol, Margarita Fernández Zavala and J.A. Torres Martino. Includes transcript of interview with Manuel García Fonteboa.

Blanco, Sylvia, 1943- Santurce Ceramics

1309. Frambes-Buxeda, Aline. "La tierra latinoamericana como historia de mitos en sus manos: Sylvia Blanco y la 'escultura de barro' contemporánea." *Hómines* 13.1 (Feb-July 1989): 12-16. Bibl.
Essay focusing on the Latin American history and myth which is embodied in the clay the sculptor uses to make her pieces. *Reproductions: "Los críticos del arte," (1985), "Testigo," (1988), "Cosmos I," (1979).*

Delano, Irene, 1919-1982 U.S.A. Graphic Design

1310. *Homenaje a Irene Delano.* Catalogue. Viejo San Juan, Puerto Rico: Casa el Libro, 15 de mayo al 30 de diciembre de 1988. Includes chronology.

1311. *Irene y Jack Delano en Puerto Rico.* San Juan, Puerto Rico: Afirmación Cultural, 1981. Bibl.

Emmanuel, Cristina U.S.A.

1312. Cherson, Samuel B. "Los altares no tan secretos de Cristina Emmanuel." *El Nuevo Dia* (Puerto Rico) 28 June 1986: 59.
Review of "Altares y secretos" exhibition.

1313. Ramírez de Arellano de Nolla, Olga. "Las pintoras ayer y hoy." *Homines* 13.1 (Feb-July 1989): 54-58.
Review essay by Puerto Rican poet attributing the low number of women artists to an imbalance in the power structure. According to author, women historically have been denied access to training and have failed to receive due recognition because painting has been perceived as male profession. Remarks on accomplishments of Cristina Emmanuel .

1314. Tió, Teresa. "Sincretismo en la obra de Cristina Emmanuel." *El Mundo* (Puerto Rico) 27 Mar 1986: 32.
Review of artist's first solo exhibition, "Altares y secretos," shown at Liga de Arte in Viejo San Juan. Considers multiple interpretations of artist's religious imagery.

Fernández Zavala, Margarita, 1949- San Juan Drawing

1315. *Mujeres niñas: serie de dibujos de Margarita Fernández Zavala.* Catalogue. San Juan, Puerto Rico: Museo de la Universidad de Puerto Rico, [1983]. Bibl. Essay, Teresa Tió. Brief biography.

Gutiérrez, Marina U.S.A.

1316. "Marina Gutiérrez." *Art Journal* 51.4 (Winter 1992): 9.
Artist describes the imagery in her work "Enchanted Island," remarking that it is "a visual metaphor for five hundred years of history." *Reproduction: "Enchanted Island" (1986).*

Landing, Haydée, 1956- Santurce Printmaking

1317. Tibol, Raquel. "Haydée Landing: grabadora puertorriqueña." *Proceso* 3 Oct 1988: 50-51.
Raquel Tibol reproduces fragments of correspondence between Landing and herself on the occasion of the artist's solo exhibition at Liga de Estudiantes de

Arte de San Juan. These offer a glimpse into her career, style and technique. Includes untitled reproduction of one of the artist's works.

O'Neill, Mari Mater, 1960- San Juan Painting

1318. *Paisajes en tiempos de ansiedad.* Catalogue. Hato Rey, Puerto Rico: Galería Botello; Museo de Arte e Historia, 1991.

1319. Palomero, Federica. "III Bienal de Cuenca." *Art Nexus* 3 (Jan 1992): 136-139 [English trans., 209-210].
Federica Palomero considers the relative merit of works exhibited during the III Cuenca Biennial in Ecuador. Among the promising young women artists she identifies is Mari Mater O'Neill who walked away with first prize. *Reproduction: "Donde moran los temibles" (1991).*

1320. Romero-Cesareo, Ivette. "Art, Self-Portraiture, and the Body: A Case of Contemporary Women's Art in Puerto Rico." *Callaloo* 17.3 (Summer 1994): 913-915.
Romero-Cesareo considers artist's use of the body in her work as a means of "exploration, construction, and affirmation of self and racial, gendered, and/or national identity."

Ordóñez, Maria Antonia Cuba Drawing/Painting

1321. Ramírez de Arellano de Nolla, Olga. "Las pintoras ayer y hoy." *Homines* 13.1 (Feb-July 1989): 54-58.
Review essay by Puerto Rican poet attributing low number of women artists to imbalance in power structure. According to author, women historically have been denied access to training and have failed to receive due recognition because painting has been perceived as male profession. Remarks on accomplishments of María Antonia Ordóñez.

1322. Romero-Cesareo, Ivette. "Art, Self-Portraiture, and the Body: A Case of Contemporary Women's Art in Puerto Rico." *Callaloo* 17.3 (Summer 1994): 913-915.
Ivette Romero-Cesareo explores way in which the artist "questions and attempts to integrate opposing categories attributed to women, particularly the Virgin/Prostitute or Mother/Whore models. . . to propose a reconstruction of the self."

Padín, Betsy, 1933- U.S.A. Painting

1323. *Betsy Padín: pinturas recientes.* San Juan, Puerto Rico: Galería Liga Estudiantes de Arte, [1989]. Essay, Marianne de Tolentino (in Spanish and English). Trans. Andrew Hurley. Includes chronology.

Pérez, Marta, 1934- Río Piedras

1324. Ramírez de Arellano de Nolla, Olga. "Las pintoras ayer y hoy."
Homines 13.1 (Feb-July 1989): 54-58.
Review essay by Puerto Rican poet attributing the low number of women
artists to an imbalance in the power structure. According to author, women
historically have been denied access to training and have failed to receive due
recognition because painting has been perceived as a male profession. Remarks
on accomplishments of Marta Pérez.

Suárez, Bibiana, 1960- Mayagüez Drawing

1325. *Bibiana Suárez: de pico a pico = Beak to Beak, Face to Face: Sazama
Gallery, Chicago, April 30 - May 29, 1993, Interamerican Art Gallery, Miami,
September 23 - November 19, 1993.* Catalogue. Bibl. Essay, Sue Taylor.
Includes chronology.

1326. *Bibiana Suárez: In Search of an Island: September 6 - October 12,
1991.* Catalogue. Chicago: Sazama Gallery, 1991. Essay, Juán Sánchez.
Includes chronology.

1327. Hixson, Kathryn. "Bibiana Suárez." *Arts Magazine* 66.4 (Dec 1991):
88.

1328. Holg, Garrett. "Bibiana Suárez." *Art News* 90.9 (Nov 1991): 152.
Review of "In Search of An Island" exhibition at Chicago's Sazama Gallery.

1329. Snodgrass, Susan. "Bibiana Suárez at Sazama." *Art in America*
81.11 (Nov 1993): 137.
In this review of artist's drawings shown in Chicago, Susan Snodgrass
considers artist's depictions of the cockfight as a symbol for her "personal
struggle as an artist, as well as Puerto Rico's search for economic freedom and
national identity."

1330. Yood, James. "Bibiana Suárez." *Artforum* 30.4 (Dec 1991): 108.
Review of "In Search of An Island " exhibition at Chicago's Sazama Gallery.
Yood writes that Bibiana Suárez's "skills and position as an artist allow her to
make visible the incredible irony and cruelty of the Puerto Rican's status in
America today - to investigate what it means to be seen as a foreigner and an
expatriate within one's own nation." *Reproduction: "Isla erizo/Urchin Island"
(1991).*

URUGUAY

Buzio, Lidya, 1948- Montevideo Ceramics/Painting

1331. Beardsley, John. "Lidya Buzio." *Hispanic Art in the United States.* Houston: Museum of Fine Arts, 1986. 153+.

Dicancro, Agueda

1332. Haber, Alicia. "Agueda Dicancro: Instalación 'Otras Visiones' detrás de un vidrio clar/o/scuro." *Arte en Colombia* 45 (Oct 1990): 64-66 [English trans., 153-154]. Bibl.
 Alicia Haber writes, "In 'Other Visions,' one of her most recent installations, Dicancro proposes monumental constructions in glass, metal pipes, neon lights, iron and metallic plaques, establishing herself definitively in the field of sculpture and environments. [It] is the result of an aesthetic approach based on permanent investigation, on persistent experimentation, an audacious and risky search. . . in a country in which there are no mechanisms to promote and finance artistic innovation and in a society in which the impetus for innovation is very weak."

González, Mercedes, 1951- Sculpture

1333. *Mercedes González: escultura cerámica.* Catalogue. Montevideo, Uruguay: Galería Latina, 1991. Essay, Alicia Haber.

Kohen, Linda, 1924- Italy Painting/Drawing

1334. *Linda Kohen.* Catalogue. [São Paulo: Museu de Arte, 1981]. Text, P.M. Bardi. Includes chronology.

1335. *Linda Kohen.* Catalogue. [São Paulo: Museu de Arte, 1988]. Includes chronology.

Romero, Nelbia, 1938- Durazno

1336. Adams, Beverly Eva. *The Subejct of Torture: The Art of Camnitzer, Nuñez, Parra and Romero.* Bibl. Master's Thesis. University of Texas at Austin, 1992.

1337. Camnitzer, Luis. "Recent Latin American Art." *Art Journal* 51.4 (Winter 1992): 6.
 In a discussion considering artistic responses to the Columbian "encounter," Luis Camnitzer makes reference to Nelbia Romero. He examines the significance of her "Sal-si-puedes" installation, a piece which questions the historical record of the decimation of the Charrúas indigenous population in Uruguay.

1338. *Mas allá de las palabras.* Catalogue. Montevideo, Uruguay: Centro de Exposiciones del Palacio Municipal, 1992.

1339. "Nelbia Romero." *Art Journal* 51.4 (Winter 1992): 12.
Reflects on facts of Salsipuedes massacre which inspired artist's installation. *Reproduction: "Sal-si-puedes" (1983).*

Tiscornia, Ana Architecture/Painting

1340. Barrett Stretch, Bonnie. "Six Latin American Women Artists." *Art News* 91 (Nov 1992): 138-139.
Review of exhibition at Humphrey in New York which Bonnie Barrett Stretch notes "shattered any stereotypes of Latin art that a visitor may have had." Briefly comments on Ana Tiscornia's "automatic writing," suggesting that her "marks. . . live as layers of memory."

VENEZUELA

Abbo, Doris New York Painting

1341. Rodríguez, Bélgica. "Doris Abbo: una joven pintora." *Arte en Colombia* 44 (May 1990): 109 [English summary, 162].
Considers recent exhibition of artist's paintings, remarking that the human figures are rendered as "amorphous complex of forms and colors." Rodríguez writes that Abbo's works "closely follow the postulates of expressionism and the trans-avantgarde, although she clearly has her own language." Includes an untitled reproduction of one of her works.

Amundaraín, Susana, 1954- Painting

1342. Rodríguez, Bélgica. "Susana Amundaraín." *Art Nexus* 2 (Oct 1991): 147 [English summary: 198].
Review of exhibition of artist's work at Venezuelan Embassy in Washington, D. C. Bélgica Rodríguez comments on the "metaphysicial" quality of her work, remarking that it can be interpreted as an examination of the Latin American "psyche." Includes reproduction of a 1991 untitled work.

1343. *Susana Amundaraín: explosión de una memoria.* Catalogue. Caracas: Fundación Museo de Bellas Artes, septiembre-noviembre de 1994. Text, Carmen Hernández (in English and Spanish). Includes chronology.

1344. Tuchman, Phyllis. "Susana Amundaraín: Coping with Culture Shock." *Art News* 93.10 (Dec 1994): 111.
Profile tracing artist's education, training and development. Includes some biographical information, as well as comments by Amundaraín. Artist's portrait accompanies article. *Reproduction: "Red Stripe. Bar" (1991)*

Arraíz, Leonor, 1952- Caracas Painting

1345. *Leonor Arraíz.* Catalogue. [Caracas: Sotavento Gallery, 1987]. Text, María Luz Cardenas. Includes chronology.

Blanco, Beatríz, 1944- Sculpture

1346. Rodríguez, Bélgica. "Beatríz Blanco." *Art Nexus* 2 (Oct 1991): 127 [English summary, 188].
 Artist's work was exhibited at Galería Arte Hoy in Caracas. Reviewer comments that Blanco's concept of sculpture is "far from traditional," noting play of positive and negative images which she creates from iron and her experimentation with color. *Reproduction: "El kaleidoscopio" (1991).*

Casanova, Teresa

1347. Rodríguez, Bélgica. "Teresa Casanova." *Art Nexus* 7 (Jan-Mar 1993): 155-156 [English trans., 225].
 Artist exhibited two- and three-dimensional pieces which she executed using a combination of figurative and abstract approaches and a variety of mediums. Bélgica Rodríguez comments on the exhibition which was presented at Centro Cultural Consolidado in Caracas, writing that "the fine laboriousness with which she works wood. . . constructing impossible architectural forms on the aesthetic scale of a jewel. . . contain a special attraction that invites the viewer to live in them and dream." *Reproduction: "Marea tranquila" (1991).*

Chappelin Wilson, Helena

1348. *Helena Chappellin Wilson.* Catalogue. Caracas, Venezuela: Adler Castillo Gallery, 1976. Includes chronology.

Damast, Elba, 1944- Pedernales Painting

1349. *Elba Damast: Recent Work = trabajos recientes.* Catalogue. Caracas: Galería Freites; New York, NY: Littlejohn-Smith Gallery, 1985. Essays, Judd Tully, Frederick Ted Castle, Juan Calzadilla (in Spanish and English). Includes biography and chronology.

1350. Rodríguez, Bélgica. "Elba Damast." *Art Nexus* 4 (Apr 1992): 178 [English summary, 230-231].
 Review of artist's paintings shown at Moss Gallery in San Francisco. "Damast's painting create a symphony of images, full of delirious colors which take the spectator on a voyage of emotions, a celebration of man's nature and his innermost psyche," writes Rodríguez. *Reproduction: "Edrat edrev" (1991).*

1351. _____. "Elba Damast: Instalación." *Arte en Colombia* 45 (Oct 1990): 119-120 [English trans., 170-171].

Four of the artist's works were shown at New York's Museum of Contemporary Hispanic Art. Remarking on her "perfect mastery of technical materials and artistic objectives," Bélgica Rodríguez writes that the constructions "were not so much installations as enormous sculptures which the public could visit and explore." *Reproduction: "Pórtico" (1990).*

1352. Windhausen, Rodolfo A. "Women Artists in Latin America." *Latin American Art* 5.1 (1993): 89 [Spanish trans., 117-118].

An exhibition in New York's Americas Gallery gathered together works by eleven Latin American women painters reflecting a wide range of tendencies and themes. In his review Rodolfo Windhausen briefly discusses work by Damast.

Escobar, Marisol, 1930- France Mixed Media Sculpture

1353. Barnitz, Jacqueline. "La máscara de Marisol = The Marisol Mask." *Artes hispánicas = Hispanic Arts* (Autumn 1967): 35-49.

Comprehensive Spanish/English language study of artist whose achievements have earned for her worldwide attention. Discusses her inventive technique for mixing media and self-portraiture to create sculpted works which satirize various aspects of contemporary society. Gives background information on artist, including her development in Venezuela. *Reproductions: "Mayflower" (1961-1962), "Purgatory" (1956), "Family" (1956), "Printers Box" (1956), "Baby Boy" (1962-1963), "Baby Girl" (1962-1963), "From France" (1961), "The Party" (1965-1966), Untitled Drawings (1965), "Women Sitting on a Mirror," (1965-1966), "Viet Nam" (1965-1966), "Women Leaning" (1965-1966), "Couple" (1965-1966).*

1354. Berman, Avis. "A Bold and Incisive Way of Portraying Movers and Shakers: The Cutting Art of Marisol." *Smithsonian* 14 (Feb 1984): 54-63.

Based on interview with Marisol, this is a highly readable, indepth profile of sculptor that reveals many biographical details, as well as firsthand information about her background, development and technique. Includes portraits of artist. *Reproductions: "Louise Nevelson" (1981), "Willem de Kooning" (1980), "Georgia O'Keeffe" (1980), "Martha Graham" (1977), "The Party" (1965-1966), "Charles de Gaulle," "LBJ," "Madonna, Child, St. Anne and St. John," "Baby Girl."*

1355. Bernstein, Roberta. "Marisol's Self-Portraits: the Dream and the Dreamer." *Arts Magazine* 59.7 (Mar 1985): 86-89.

Comprehensive examination of satirical, large-scale mixed media sculptures which, Bernstein writes, gained widespread recognition for the artist in the '60s because of their often autobiographical portrayal of restrictive female sex role stereotypes. Traces her development into the '70s, remarking on the non-Western influences in her later work. Includes a discussion of her fish sculptures, as well as the erotic drawings which she executes using tracings of her own body to depict themes related to women and their sexuality. Contains

some biographical information. *Reproductions: "Self-Portrait" (1961-1962), "Baby Girl" (1983), "Women with Dog" (1964).*

1356. Boime, Albert. "The Postwar Redefinition of Self: Marisol's Yearbook Illustrations for the Class of '49." *American Art* 7.2 (Spring 1993): 6-21. Bibl.

Interesting look at the artwork which Marisol produced for the 1949 Westlake School yearbook. Intended by Boime to explore the roots of her mature work, this study includes some biographical information and details of her early training, as well as direct statements by the artist. Includes Marisol's yearbook portrait, as well as reproductions of various of the "cartoon vignettes" she produced for the project.

1357. Campbell, Lawrence. "The Creative Eye of the Artist." *Cosmopolitan* (June 1964): 62-69.

Abundantly illustrated with portraits of the artist, this profile gives information on the philosophy underlying Marisol's art, as well as details about her technique and style. Some biographical information is included, as well as numerous personal statements. Marisol says, "People say they pinch temselves to see if they are awake. This restores them to reality. When I do a portrait, but really do myself in the portrait, or use my own hands or shoes, it brings me back to reality." *Reproductions: "Women with Dog," "Dinner Date," "The Wedding," "The Visit," "The Jazz Musicians."*

1358. Chapman, Daniel. "Marisol. . . A Brilliant Sculptress Shapes the Heads of State." *Look* 14 Nov 1967: 78-83.

Sketch accompanied by photographs of Marisol at work. Provides background information on the development of her "Heads of State" project. Includes statements by the artist. *Reproductions: "LBJ and Birds," "Charles de Gaulle," "Royal Family," "Harold Wilson."*

1359. Creeley, Robert. *Presences.* New York: Charles Scribner's Sons, 1976. Bibl.

1360. De Prenger, Kim. "On Understanding the Artist as a Model." *School Arts* 85 (Nov 1985): 14-15.

Article intended for teachers of art. Uses Marisol and her artwork as models for children to create their own art objects. Includes outline of a lesson. *Reproduction: "Picasso" (1977).*

1361. Dreishpoon, Douglas. "Marisol: Portrait Sculpture." *Art Journal* 50.4 (Winter 1991): 94-96.

Review of "Magical Mixtures" exhibition at Smithsonian Institution's National Portrait Gallery. Dreishpoon examines artist's eclectic approach to portrait sculpture, focusing on her technique for combining media and incorporating found objects into her work. Reflects on her large-scale block protraiture of celebrities such as friend Andy Warhol, Bob Hope, Lyndon B.

Johnson, Georgia O'Keeffe, Willem de Kooning and Bishop Desmond Tutu. *Reproductions: "Andy Warhol" (1962-1963) and "Self-Portrait" (1961-1962).*

1362. García-Johnson, Ronie-Richele. "Marisol Escobar." *Notable Hispanic-American Women.* Detroit: Gale Research, 1993. Ed Diane Telgen, Diane and Jim Kemp. 250-252. Bibl.

1363. Gardner, Paul. "Who is Marisol?" *Art News* 88 (May 1989): 146-151.
Interesting study containining numerous direct statements by the artist. Gives insight into her views on life and the meaning of her work. Includes artist's portrait. *Reproductions: "Trigger Fish," (1970), "The Party," (1965-1966), "Georgia O'Keeffe with Dogs," (1977), "The Last Supper," (1984), "Working Woman," (1987).*

1364. Gold, Barbara. "Portrait of Marisol." *Interplay* (Jan 1968): 52-55.
Marisol provides much direct commentary in this indepth discussion of her life and career, making it an engrossing account of her thoughts and opinions on a variety of subjects. *Reproductions: "Sunbathers" (1967), "LBJ" (1967), "The Party" (1965-1966).*

1365. Goldberg, Jeff. "Pop Artist Marisol -- 20 Years After Her First Fame Recalls Her Life and Loves." *People Weekly* 24 Mar 1975: 40-43.
In this interview Marisol reveals details of her childhood, personality and lifestyle. Includes several portraits of the artist.

1366. González, Miguel. "Marisol en el espejo." *Arte en Colombia* 29 (Feb 1986): 34-36.
Indepth analysis that compares and contrasts Marisol's work to that of Leo Jensen, William King, Louise Nevelson, Eduard Keinhold and George Segal. Includes some biograpical data. *Reproductions: "Figura de Cristo" (fragment of "Last Supper"), "Figuras de Santiago y San Andres" (fragment of "Last Supper"), "Last Supper" (1983), "La familia de Estefanía" (1983), "La Virgen con el niño, Santa Ana y San Juán" (1978).*

1367. Grove, Nancy. *Magical Mixtures: Marisol Portrait Sculpture.* Catalogue. Washington, D.C.: Smithsonian Institution Press for the National Portrait Gallery, 1991. Bibl.

1368. Loring, John. "Marisol's Diptych: Impressions, Tracings, Hatchings." *Arts Magazine* 47 (Apr 1973): 69-70.
Discussion of artist's printing style, including her technique for making impressions of her own body, or parts of it, and the motifs and symbolism expressed in her images. *Reproductions: "Diptych," "Hand and Purse" (1965).*

1369. _____. "Marisol Draws." *Arts Magazine* 49 (Mar. 1975): 66-67.
Focuses on varied attributes and imagery present in artist's drawings executed in colored pencils and crayons. Calls attention to bi-polar themes that critic

identifies in her work, including "touching and not touching," "sacredness and profanity," "modesty and eroticism," "violence and tenderness." *Reproductions: "All My Shoes for Ten Years" (1974), "The English are Coming" (1974), "Double Flower" (1973), "Lick the Tire of My Bicycle" (1974).*

1370. *Marisol.* Caracas, Venezuela: Ediciones Armitano, 1968.

1371. Nemser, Cindy. "Marisol." *Art Talk: Conversations with 12 Women Artists.* New York: Charles Scribner's, 1975. 179-199. Bibl.
 Interview appended by a chronology and reproductions of various of Marisol's works.

1372. Steinem, Gloria. "Marisol: The Face Behind the Mask." *Glamour* 51 (June 1964): 92-97+.

Escobar, Mercedes, 1949- Painting

1373. *Mercedes Escobar: acuarelas, temples y gouaches.* Catalogue. México, D. F.: Polyforum Cultural Siqueiros, 1981. Essay, Antonio A. Riambau. Includes chronology.

Gamundi, María, 1952- Sculpture

1374. *Permanencia del oficio y la materia: esculturas de María Gamundi, junio-julio, 1993.* Catalogue. Caracas: Centro Cultural Consolidado, 1993. Text, Elizabeth Schon.

Gego(GertrudisGoldsmichdt),1912-1994 Germany Painter/Sculptor/Printmaker

1375. Escallón, Ana María. "Gego." *Arte en Colombia* 25 [n.d.]: 75 [English summary, 97].
 Review of "Paperless Drawings" exhibition by this German-born artist at the Museo de Bellas Artes in Caracas. Ana María Escallón writes that she became one of the country's "most relevant figures on the artistic scene" following her immigration to Venezuela in 1939. Likens her constructions to "sculptures. . . of space. . . wires of steel which become poetic spatial networks." Includes artist's portrait.

1376. Ossot, Hanni. *Gego.* Caracas: Museo de Arte Contemporáneo, 1977.

1377. Traba, Marta. "Gego: Caracas tres mil." *Mirar en Caracas.* Caracas: Monte Avila Editores, 1974. 51-59.

González, María Luisa (Nan) Performance/Video

1378. Rodriguez, Bélgica. "Nan González." *Art Nexus* 3 (Jan 1992): 156-157 [English summary, 216].
Analysis of multimedia installation shown at Museo de Bellas Artes in Caracas. *Reproduction: "El vuelo del cristal" [detail] (1991).*

Palacios, Luisa, 1923-1990 Painting/Printmaking/Ceramics

1379. Rodríguez, Bélgica. "Luisa Palacios: maestra de tintas." *Art Nexus* 2 (Oct 1991): 125 [English summary, 187-188].
Essay on occasion of exhibition at Galería de Arte Nacional in Caracas to honor recently deceased artist who, Rodríguez asserts, was Venezuela's greatest printmaker. "Although she worked in several media, her great passion was printmaking and she belonged to a generation which believed in the spiritual and cultural connotations of art and creation," writes Rodríguez. Includes reproduction of untitled work.

1380. Stásik, Andrew. "Interview with Luisa Palacios." *Print Review* 18 (1983): 67-73.
Focuses on personal involvement of the artist in the development of Taller de Artistas Gráficos Asociados in Venezuela, a government-funded center established to promote awareness of, and markets for, art prints through training, exhibitions and edition printing. *Reproduction: "Untitled," (1973).*

1381. Traba, Marta. "Para los grabados de Luisa Palacios." *Mirar en Caracas.* Caracas: Monte Avila Ediores, 1974. 75-78.

Pardo, Mercedes, 1921 - Painting/Printmaking/Collage

1382. Chacón, Katherine. "Mercedes Pardo." *Art Nexus* 3 (Jan 1992): 155 [English trans., 216].
Review of exhibition in Galería de Arte Nacional, Caracas which offered panoramic view of artist's development from 1941 to 1991. *Reproduction: "Un arlequín para Picasso" (1989).*

1383. *Mercedes Pardo.* Catalogue. [México, D.F.: Museo de Arte Moderno, 1978]. Text, José Balza.

1384. Romero, Armando. "Ver para (no) ver." *Revista Nacional de Cultura* (Venezuela) 41.247 (12 Apr 1981): 228-233.
Reflections on artist's introspective works.

Pereda, Ana María Painting

1385. Benko, Susana. "Ana María Pereda y Guido Eigenmann." *Art Nexus* 12 (Apr-June 1994): 139-140 [English trans., 200].
Review of artist's work shown at Sala Alternativa in Caracas. Susana Benko comments on the "idea of repeating images ad infinitum and the infinite nature of repetition" which characterized the show, writing that Pereda "used mathematics and the study of proportion as a conceptual basis for her work." *Reproduction: Partial view of exhibition (1993).*

Richter, Luisa, 1928- Germany Drawing/Painting/Printmaking

1386. Calzadilla, Juan. "El cuadrado amarillo: borrador para presentar una exposición de Louise Richter." *Revista Nacional de Cultura* (Venezuela) 30.193 (May-June 1970): 72-76.
Reflections on artist and her paintings.

1387. *Luisa Richter.* Caracas, Venezuela: Armitano, [1992]. Bibl. Text, Federico Bayerthal and others.

1388. *Luisa Richter, planos y reflejos: Museo de Arte Contemporáneo de Caracas, septiembre 1981.* Catalogue. Caracas, Venezuela: Museo de Arte Contemporáneo, [1981].

1389. Richter, Louise. "Textos de Louise Richter." *Revista Nacional de Cultura* (Venezuela) 39.232 (Jul-Aug 1977): 100-112.
Writings and poetry by artist. *Reproductions: "Libertad obstaculizada," "Aún caminando siempre en sueños," "Hedgemon Lewis, Retrato de un boxeador" (1976), "Transformación de anhelo en nostalgia," "Dentro del círculo," "Sillas y montañas," "La abeja."*

1390. Rodríguez, Bélgica. "Luisa Richter: oleos y collages." *Arte en Colombia* 41 (Sept 1989): 96 [English summary, 151].
Review of exhibition at Galería Durbán in Caracas emphasizing artist's individualistic style. Bélgica Rodríguez writes that her art is "a celebration of the power of the imagination and invention marked by a force which is both sublime and poetic." *Reproduction: "El clavo" (1989).*

Romer, Margot, 1938- Caracas Drawing/Painting/Printmaking

1391. La Rocca, Graziana. "Las estrellas de Margot Romer." *Arte en Colombia* 35 (Dec 1987): 48-49.
Profile including information about artist's training and development, as well as excerpts of reviews by Marta Traba and Roberto Guevara. La Rocca describes the giant stars which fill her canvases as "sensuous, voluptuous and aggressive." Guevara suggests they are "not icons, but organic, pulsating force." *Reproductions: "Gran estrella madre" (1986), "Tepuy" (1986), "Pentesilea" (1976).*

Torras, María Teresa, 1927- Spain Tapestry/Mixed Media

1392. Palenzuela, Juan Carlos. "María Teresa Torras: palmeras." *Arte en Colombia* 45 (Oct 1990): 110 [English summary, 167].

Describing María Teresa Torras in this review as "one of the busiest artists in Venezuela," Juan Carlos Palenzuela briefly traces her career, beginning with an early interest in tapestry and jewelry design to her most recent work in sisal. "Her recent show in the Museum of Fine Arts of Caracas consisted of a series of 120 palm trees, all in earth colors, chestnuts, ochers, grays, and measuring 2-4 meters high. It was an event which clearly reaffirmed the artistic stature which María Teresa Torras has attained in her career," writes Palenzuela. Includes artist's portrait.

1393. Salvador, José María. *María Teresa Torras: testigos silentes = Silent Witnesses*. Catalogue. Caracas: Editorial Edisigma, Museo de Bellas Artes de Caracas, 23 de mayo al 8 de julio, 1990. Bibl. In Spanish and English. Includes chronology.

Valdirio Pozzo, Evelyn Painting

1394. Damian, Carol. "Evelyn Valdirio Pozzo." *Latin American Art* 5.3 (1993): 65 [Spanish trans., 85].

In this brief review Carol Damian describes technique and style used by the artist to express color and movement in her abstract compositions. *Reproduction: "Mujer" (1993).*

General Works

Latin America

1395. Goldman, Shifra M. "Mujeres de California." In *Yesterday and Tomorrow: California Women Artists*. Ed. Sylvia Moore. New York: Midmarch Arts Press, 1989. 202-229. Rpt. as "Mujeres de California: Latin American Women Artists" in Shifra M. Goldman, *Dimensions of the Americas: Art and Social Change in Latin America and the United States*. Chicago: University of Chicago Press, 1994. 212-235. Bibl.

Considers artistic presence of various Latin American women in California. Discusses the work of Susana Lago (Argentina), Valeria Pequeño (Chile), Linda Haim (Colombia), Magda Santonastasio (Costa Rica), Martivón Galindo (El Salvador), Paz Cohen, Guadalupe García, Armandina Lozano, Esperanza Martínez, Josefina Quesada, Olivia Sánchez, (Mexico), Anna de León (Puerto Rico), Consuelo Méndez, Linda E. Picos-Clark (Venezuela).

1396. Growel, María. *Presencia femenina en la plástica continental.* Montevideo, Uruguay: Barreiro y Ramos, 1992.

1397. La Duke, Betty. *Compañeras: Women, Art & Social Change in Latin America.* San Francisco, CA: City Lights Books, 1985. Bibl.
 This book is the product of Betty La Duke's travels and interviews with artists from various Latin American countries. Arranged by topic and country, she has compiled information on background and development of each artist, frequently including statements by them that reveal the driving force behind their creative energy and their artistic intention. La Duke also considers the social and historical environments in which these women produce their work. Among the artists profiled are María Adair, Sonia Castro,Yedamaría (Brazil), Mirta Cerra, Antonia Eiriz, Flora Fong, Nancy Franko, Ana Rosa Gutiérrez, Juana Kessel, Noemi Perera Clavería, Julia Valdés, Lesbia Vent (Cuba), Rosemarie Deruisseau, Françoise Jeanne, Vierge Pierre, Louisiane Saint Fleurant, Mariléne Villedrouin (Haiti), Teresita Fortin (Honduras), Susana Campos, Fanny Rabel (Mexico), Julia Aguirre, María Gallo, Gloria Guevara, Marita Guevara, Cecilia Rojas, Hilda Vogl (Nicaragua), and Margarita Fernández (Puerto Rico). Includes artist's portraits and reproductions of various of their works.

1398. Prado Villarmarzo, Cecilia and Werther O. Bodden Hernández. *La producción femenina en las artes plásticas latinoamericanas, 1980-1987.* Río Piedras: Universidad de Puerto Rico, Recinto de Río Piedras, Sistema de Bibliotecas, Colección de las Artes, [1987?].
 Bibliography.

Argentina

1399. Caride, Vicente P. "La mujer en el proceso histórico de la pintura en Argentina." *Sur* (Argentina) 326-328 (Sept 1970-June 1971): 147-153.
 Historical review of women's contribution to the world of Argentine art beginning with the 19h century. Refers briefly to the work of 20th century artists Susana Aguirre, Luna Alston de Gallegos, Andreina Bai de Deluca, Emilia Bertolé, Norah Borges, Elena Cid, Dora Cifone, Elina de Correa Morales, Lía Correa Morales, Aurora De Pietro de Torras, María Escudero, Raquel Forner, Lía Gismondi, Luisa Isabel Isella, Biyina Klapenbach, Eugenia Krenovich, Catalina Mórtola de Bianchi, Laura Mulhall Girondo, María Mercedes Rodrigué, Anita Payró, Julia Peyrou, Sofía Posadas, Luisa Sánchez de Arteaga, Eugenia Sarmiento, María de Soto y Calvo, Angela A. Vezzetti.

1400. Fletcher, Lea. "Del taller al salón: las artistas plásticas argentinas." *Feminaria* 1. 2 (Nov 1988): 39.
 Works by 270 women in a variety of mediums were shown in "La mujer en la plástica argentina" exhibition at Centro Cultural "Las Malvinas." Among organizers were artists Alicia Contreras, Fanny Corazzin Guevara, Clementina Di Primio, Noemia Paviglianiti, Susana Raffo, Elsa Sábato, María Laura San Martín, Flora Stilman and Teresa Volco.

1401. *Primer diccionario de escritoras y plásticas de Mendoza, Républica Argentina.* Mendoza, Argentina: Inca Editorial, 1985.

1402. Velásquez, Susana, Esther Moncarz and Gilda Mancuso. *Mujer y expresión plástica: testimonios.* Buenos Aires, Argentina: Centro de Estudios de la Mujer, [1984].
 Interviews with artists who presented their work in Centro de Estudios de la Mujer in Buenos Aires. Includes Nora Correas, Clara Coria, Ana Kozel, Silvia Ocampo, Carlota Petrolini, Ana Pich, Ester Zeller.

Bolivia

1403. Ayllón, Virginia and Fernando Machicado. *Volar entre sonidos, colores y palabras: (mujer y actividad cultural en la prensa boliviana* 1991). La Paz, Bolivia: CIDEM, 1992.
 References to articles published in nine Bolivian dailies during 1991 recording women's contribution to the arts, including more than 50 painters.

Brazil

1404. Amaral, Aracy A. "Brazil: Women in the Arts." In *Ultramodern: The Art of Contemporary Brazil.* Catalogue. Washington, D.C.: National Museum of Women in the Arts, 1993. 17-33.

1405. Bell, Lindolf. "Sobre o I Salão Barriga-Verde: Artes Plásticas da Mulher." *Revista de Cultura Vozes* 70.4 (May 1976): 54-56.
 Works by twenty-five women in a variety of mediums were presented at Salão da Mulher. Bell briefly comments on the artwork of Suely Beduschi, Nini and Rosi Darius, Albertina Ferraz, Berenice Gorini Rodrigues, Freya Gross, Eli Heli, Elke Hering Bell, Neusa Lorita Leite, Astrid Lindroth, Ondina Mayr, Miriam Medeiros, Lucimar Bello Pereira Frange, Edia Pfau, Maria Edith Poerner, Graziela Reis, Vera Sabino.

1406. Lombardi, Mary. *Women in the Modern Art Movement in Brazil: Salon Leaders, Artists and Musicians, 1917-1930.* Bibl. Ph.D Dissertation. UCLA, 1977.
 Lombardi identifies women and their accomplishments, exploring reasons for their "neglect in the literature." Considers the "stars of Brazilian Modernism in art," Anita Malfatti (1896-1964) and Tarsila do Amaral (1897-1973) at some length, and secondarily the work of Zina Aita (1900-1968) and Regina Gomide (dates not given). Also mentions Georgina de Albuquerque (1885-1962), Haydéa Lopes Santiago (1896-?), Sarah Vilela de Figuereido (1903-1958), Regina Veiga (?-1968), Sylvia Meyer (1889-1955).

1407. Luz Tavora, Maria Luisa. "A gravura brasileira - anos 50/60: como un movimento genese de um mito." *Gavea* (Brazil) 5 (Apr 1988): 42-56. Bibl.
 Reflects on the birth of printmaking in Brazil and the pioneers which

contributed to giving it life, among them Lygia Pape, Fayga Ostrower, and Edith Behring.

1408. Ostrower, Fayga. "Algunas consideraciones acerca del grabado en el Brasil." *Revista de Cultura Brasileña* 46: (June 1978): 17-30.
Brief review of history of printmaking in Brazil which identifies figures who have been prominent in its development, among them Solange Araujo (1943), Vera C. Barcelos (1938), Edith Behring (1916), Maria Bonomi (1935), Ivone Couto (1949), Anna Bella Geiger (1933), Marlene Hori (1939), Renina Katz Pedreira (1926), Thereza Miranda (1928), Tomie Ohtake (1913), Fayga Ostrower (1920), Isabel Pons (1912), Marilia Rodrigues (1937), Anna Letycia Quadros (1929). Includes reproductions of works by Fayga Ostrower, Anna Bella Geiger and Ana Letycia Quadros.

Chile

1409. Bocaz, Luis. "Mujeres en la plástica chilena." *Araucaria de Chile* 24 (1983): 180-181.
Remarks on *Chili femmes,* a Paris exhibition which presented works by Chilean artists, fourteen of whom were exiled at the time and worked in Paris. Show commemorated women's commitment to restoring democracy in Chile. Included Agna Aguadé, Ximena Armas, Concepción Balmes, Veronica Barraza, Gracia Barrios, Roser Bru, Mónica Bunster, Irene Domínguez, M. Eugenia Bush, Ester Chacón, Delia del Carril, Luz Donoso, Virginia Errázuriz, Diamela Eltit, Antonia Ferreiro, Nancy Gewölb, Gilda Hernández, Virginia Hurreeus, Patricia Israel, Lea Keliner, Beatríz Leyton, Gala Martinoya, Teresa Montiel, Chantal de Rementería, Lotty Rosenfeld, Josefina Santa Cruz, Vivian Scheihing, Clara Schneider, Marcela Serrano, Adriana Silva, María Luz Torres, Patricia Vargas, Cecilia Vernal, Teresa Vicuña, Luisa Waiser.

1410. *Mujer en el arte: homenaje, Año Internacional de la Mujer: exposición, pintura, escultura, dibujo, grabado.* Catalogue. Santiago, Chile: Secretaría Nacional de la Mujer, Museo Nacional de Bellas Artes, 1975. Bibl.
Contains brief survey of women's contribution to the history of 20th century Chilean art. Includes brief biographical information on 76 painters and sculptors, as well as reproductions of various of their works.

1411. Olea, Raquel. "Pintoras chilenas en Berlin." *Araucaria de Chile* 26 (1984): 215-217.
Considers *Chilenas,* Berlin exhibition of paintings by Chilean women, some of them expatriates, remarking on the testimonial nature of their work. (see Appendix I for listing of artists). Examines approaches of exiled and non-exiled artists to themes of censorship and repression, with remarks by one of the show's organizers, Cecilia Boisier. Comments on work by Gracia Barrios, Roser Bru, Paz Errázuriz, and Cecilia Boisier.

1412. Ossa, Nena. *La mujer chilena en el arte.* Santiago: Editorial Lord Cochrane, 1987.

Costa Rica

1413. Rodríguez, Bélgica. "Aproximación al arte de Centroamérica III: Costa Rica." *Art Nexus* 4 (Apr 1992): 127-131 [English trans., 214-218].
 Author provides brief history of the development of Costa Rican art, with particular emphasis on the contributions made by 20th century artists. Bélgica Rodríguez mentions that women such as Margarita Bertheau (1913-1975), Lola Fernández, Ana Isabel Martén and Marjorie Avila have played a prominent role in shaping artistic trends in this country. *Reproduction: Lola Fernández, from the series "Los volcanes" (1964).*

Cuba

1414. La Duke, Betty. "Women and Art in Cuba: 'Feminism is Not Our Issue'" *Woman's Art Journal* 5.2 (Fall 1984/Winter 1985): 34-40. Bibl.
 Considers pre- and postrevolutionary contexts framing the creation of art by women. While remarking on Amelia Peláez's distinguished position within Cuban artististic tradition, La Duke's primary intention is to profile the life and works of other women who have contributed to the history of Cuban art: Mirta Cerra (35-36), Antonia Eiriz (36-37), Lesbia Vent (37-38), Flora Fong (38-39), Nancy Franko (39-40), and Julia Valdés (40). Based on interviews the writer conducted with these women, portraits include biographical details, information on training and personal statements by the artists. *Reproductions: Mirta Cerra: "Still Life" (1982), Antonia Eiriz: "Annunciation" (1963), Lesbia Vent: "Who is Guarding Whom?" (1975), Flora Fong: "The Cyclone," (1983), Nancy Franko: "Children and Fish" (1981), Julia Valdés: "Santiago Landscape #2" (1982).*

1415. Stellweg, Carla, et al. "Mujeres, arte, femineidad: 'Margaret Randall.'" *Artes Visuales* 9 (Mar 1976): 13-14.
 Margaret Randall, a specialist on the topic of women's struggles for equality in prerevolutionary Cuba and their subsequent gains after the Revolution, relates advances which the change in political systems brought about in the arts for would-be artists of both genders.

1416. Veigas, José. "La mujer en la plástica cubana." *Revolución y Cultura* (Oct 1974): 21-31.
 Historical review of women's contribution to the Cuban art scene beginning with the 19th century. Briefly mentions 20th century artists Marta Arjona, Mirta Cerra, Antonia Eiriz, Luisa Fernández Morrell, Julia González, Ana Rosa Guitérrez, Rita Longa, Victoria Nanson, Amelia Peláez, Dolores Soldevilla, Uver Solis, Lesbia Vent Dumois, Odenia Vent Dumois.

Jamaica

1417. Craig, Christine. *The Changing Status of Women in the Arts: A Preliminary Reference.* [Kingston, Jamaica: Women's Bureau, 1975].

Mexico

1418. Cortina, Leonor. "Artes visuales: las místicas, las dóciles, las rebeldes." In *La mujer mexicana en el arte*. México, D.F.: Bancreser, 1987. 134-179. Bibl.

Leonor Cortina surveys the artistic accomplishments of 19th and 20th century Mexican women, making brief reference to Lola Alvarez Bravo, Angelina Beloff, Pilar Calvo (1913-1986), Susana Campos, Lilia Carrillo, Leonora Carrington, Vita Castro (1904-1987), Olga Costa, Helen Escobedo, Ana Teresa Fierro, Antonieta Figueroa, Angela Gurria, Esther Hernández Olmedo (1898-1957), María Izquierdo, Frida Kahlo, María Lagunes, Joy Laville, Paulina Lavista, Teresa Morán, Emilia Ortíz, Marta Palau, Carmen Parra, Alice Rahon, Consuelo Revueltas, Remedios Varo, and Mariana Yampolsky. Examines the work of Maris Bustamante, Lola Cueto, Kati Horna, Myra Landau, Magali Lara, Agueda Lozano, Rocío Maldonado, Mónica Mayer, Fanny Rabel, Nunik Sauret, and Susana Sierra.

1419. Eder de Blejer, Rita. "Las mujeres artistas en México." *Anales del Instituto de Investigaciones Estéticas* 13.50 part 2 (1982): 251-260. Bibl. Rpt. in Fem 33 (Apr-May 1984). 7-11.

Art historian examines sociocultural basis which has contributed to Latin American women's limited participation in -- and recognition by -- the artistic establishment. Briefly describes themes and styles of various women born, or residing, in Mexico who have made major contributions in a variety of mediums to the history of Mexican art during the 20th century. Included are Fiona Alexander, Lola Alvarez Bravo, Geles Cabrera, Victoria Campagni, Susana Campos, Lilia Carrillo, Leonora Carrington, Gilda Castillo, Olga Costa, Helen Escobedo, Lourdes Grobet, Angela Gurria, Judith Gutiérrez, Kati Horna, María Izquierdo, Frida Kahlo, María Lagunes, Mayra Landau, Magali Lara, Teresa Morán, Mónica Mayer, Dulce María Núñez, Irma Palacios, Marta Palau, Carolina Paniagua, Carmen Parra, Alice Rahon, Carla Rippey, Coco Riviello, Herlinda Sánchez Laurel, Nunik Sauret, Cordelia Urueta, Remedios Varo, Mariana Yampolsky, and Marta Zarak.

1420. Mayer, Mónica. "Propuesta para un arte feminista en México." *Fem* 33 (Apr-May 1984): 12-15.

1421. Ocharán, Leticia. "Pintoras mexicanas tradicionales." *Plural* 2a. epoca 19 (Sept 1990): 89.

Leticia Ocharán comments on "Las discipulas de Germán Gedovius" exhibition in Mexico City's Museo de San Carlos, presenting the work of artists born during the latter 19th and early 20th centuries. Refers to Leonor Cortina's writings on the subject, pointing out cultural factors which, according to author, kept these women from artistically expressing "their true selves." In her inventory Ocharán mentions Clara Argüelles, Magdalena and María de la Luz Brassetti, Elena Capetillo, Margarita Gorozpe, Esther Hernández Olmedo,

Carmen Jiménez Labora, Gloria Magdalena Macedo, Jeanette Müller, Dolores Ortega and Amalia Viesca.

1422. _____. "La mujer en la gráfica mexicana." *Fem* 33 (Apr-May 1984): 20-21.
Historical overview of women's contribution to the field of Mexican graphics during the 20th century.

1423. Stellweg, Carla, et al. "Mujeres, arte, femineidad." *Artes Visuales* 9 (Jan-Mar 1976):1-25. Trans. "Feminine Sensibility as Viewed in Mexico by Some Artists, Art Critics, and Art Historians." 53-62.
Several scholars (Sara Chazán, Teresa del Conde, Rita Eder de Blejer, Alaide Foppa, Eugenia Hoffs, Margaret Randall, Ida Rodríguez Prampolini, Berta Taracena, María Eugenia Vargas de Stavenhagen) and artists (Fiona Alexander, Helen Escobedo, Antonia Guerrero, Angela Gurría, Myra Landau, Paulina Lavista) respond to gender-related questions regarding art produced by Mexican women. Includes some portraits, as well as reproductions of various artworks.

1424. Sullivan, Edward J. "Mexican Women Artists." In *Mujer en México=Women in Mexico*. Catalogue. New York, NY: National Academy of Design, 1990. XXIV-XCIII. Bibl.
Extensive catalogue essay (in Spanish and English) considering social factors that have impacted on the status of women in Mexico and their contribution to the artistic arena (see Appendix I for listing of artists).

1425. Toledo, Angeles. "De la cocina al cuarto oscuro." *Fem* 5.19 (June-July 1981): 82-83.
In-brief look at women's contribution to Mexican photography beginning with the 19th century. Considers in a general way the change in social contexts leading to a wider participation of women in the arts.

Nicaragua

1426. Arostegui, Alejandro, et al. *Mujeres: 19 de mayo-2 de junio de 1993*. Catalogue. Managua, Nicaragua: CODICE, Galería de Arte Contemporáneo, 1993.

Puerto Rico

1427. Rodríguez Vega, Myrna E. "Mujeres artistas de Puerto Rico: apuntes para un investigación histórica." *Mujeres artistas: protagonistas de los ochenta, 7 de marzo al 6 de abril de 1990. Santo Domingo: Museo de las Casas Reales; 18 de mayo al 9 de julio de 1990, Museo de Arte Contemporáneo de Puerto Rico, San Juan*. Bibl.

1428. *Nuestro autorretrato: la mujer artista y la autoimagen en un contexto multicultural, exposición y ciclo de conferencias.* San Juan, Puerto Rico: Mujeres Artistas de Puerto Rico, Inc., 1993. Introduction, María Mater O'Neill.

Collection of papers presented at a conference organized in conjunction with an exhibition at Museo de Arte Contemporáneo de Puerto Rico by Mujeres Artistas de Puerto Rico, Inc., an association founded in 1983 to heighten awareness of women's contributions to Puerto Rican art. Essays consider issues of identity as represented in women's art.

1429. Somoza, María E. "Visual Language and the Puerto Rican Woman Artist." *Callaloo* 17.3 (Summer 1994): 905-908. Bibl.

The efforts of women artists in Puerto Rico "were suppressed until the middle of this century when award-winning women painters . . . began to be mentioned, albeit briefly, by art historians," writes María Somoza. She gives examples of women who have contributed to the field, naming such artists as Olga Albizu, Myrna Báez, Isabel Berbal, Clarissa Biaggi, Lorraine de Castro, Edna Coll, Pilar Geigel, Susanna Herrero, Rosa Irigoyen, Cleto Noa, Mari Mater O'Neill, Luisa Ordoñez, María Luisa Penne de Castillo, María Elena Perales, Consuelo Peralta, Marta Pérez, Bernadina Rubin, Noemí Ruíz, Milagros Señeriz, and Myriam Zamparelli. *Reproductions: Noemí Ruíz: "Ritmo y energía" (1992); María Antonia Ordóñez: "El closet de la loca," "Retrato familiar," "Para hacer florecer una rosa de los vientos."*

Uruguay

1430. Tiscornia, Ana. "Art and Feminism in Uruguay." *Flash Art* 173 (Nov-Dec 1993): 56.

Artist Ana Tiscornia offers commentary on women's show presented at Galería del Notariado in Montevideo, remarking that the exhibition challenges a statement made by the director of Montevideo's Museo de Artes Visuales in 1991 that "there are no important women artists in Uruguay." Briefly remarks on the accomplishments of Claudia Anselmi, Agueda Dicancro, Lucy Duarte, Diana Mines, Nelbia Romero, and Nancy Urrutia.

Appendix I:
Collective Exhibitions

A1. Ades, Dawn. *Art in Latin America: The Modern Era, 1820-1980: London: Hayward Gallery (May 18-August 6, 1989), Stockholm: National Museum: Stockholm: Moderna Museet (September 16-November 19, 1989), Madrid: Palacio de Velásquez (December 19, 1989-March 31, 1990).* New Haven, CT: Yale University Press, 1989. Bibl. Contributions by Stanton Loomis Catlin and Guy Brett.

Includes Tarsila do Amaral, Lygia Clark, Anita Malfatti, Lygia Pape, Mira Schendel (Brazil), Amelia Peláez (Cuba), Leonora Carrington, María Izquierdo, Frida Kahlo, Alice Rahon, Remedios Varo (Mexico).

A2. *Al filo del tiempo: exposición fotográfica.* Catalogue. Ed. Alejandro Castellanos. México, D.F.: Museo Estudio Diego Rivera, 1992.

Alicia Ahumada, Lourdes Almeida, Yolanda Andrade, Oweena Fogarty, Lourdes Grobet, Tina Modotti, Vida Yovanovich

A3. Amaral, Aracy A. and Paulo Herkenhoff. *Ultramodern: The Art of Contemporary Brazil.* Catalogue. Washington, D.C.: National Museum of Women in the Arts, 1993. Bibl. Chronologies.

Includes Frida Baranek, Maria Bonomi, Leda Catunda, Lygia Clark, Clementina Duarte, Anna Bella Geiger, Ester Grinspum, Jac Leirner, Beatriz Milhazes, Tomie Ohtake, Fayga Ostrower, Lygia Pape, Rosângela Rennó, Mira Schendel, Regina Silveira, Ana Maria Tavares, Amélia Toledo, Regina Vater.

A4. *Ante América: cambio de foco.* Bogotá, Colombia: Banco de la Republica; Biblioteca Luis Angel Arango, [1992]. Bibl. Essays, José Hernán Aguilar, Carolina Ponce de Leon, Charles Merewether, Gerardo Mosquera.

Includes María Fernanda Cardoso, Beatríz González, María Teresa Hincapié, Doris Salcedo (Colombia), Ana Mendieta (Cuba).

A5. *Argentina 1920-1994: Art from Argentina.* Ed. David Elliott. Oxford: The Museum of Modern Art, 1994. Bibl. Chronologies.

Includes Raquel Forner, Mónica Girón, Marta Minujín, Lidy Prati.

A6. *Arte en Iberoamérica: Palacio de Velázquez, 14 de diciembre de 1989 - 4 de marzo de 1990.* Dawn Ades with contributions by Guy Brett, Stanton Loomis Catlin and Rosemary O'Neill. [Madrid]: Turner, [1989?]. Bibl. Biographies.

Includes Lygia Clark, Tarsila do Amaral, Anita Malfatti, Lygia Pape (Brazil), Amelia Peláez (Cuba), Leonora Carrington, María Izquierdo, Frida Kahlo, Alice Rahon, Remedios Varo (Mexico), Tilsa Tshuchiya (Peru).

A7. *Aspects of Contemporary Mexican Painting.* Catalogue. Edward Sullivan, curator. New York, N.Y.: Americas Society, 1990. Bibl.

Includes Rocío Maldonado, Dulce María Núñez, Georgina Quintana.

A8. Barnitz, Jacqueline. *Latin American Artists in New York since 1970.* [Austin, TX]: University of Texas, Archer. M. Huntington Art Gallery, 1987. Bibl. Essays, Jacqueline Barnitz, Janis Bergman-Carton, Florencia Bazzano Nelson. Bibl. Chronologies.

Includes Liliana Porter, Raquel Rabinovich (Argentina), Anna Bella Geiger, Marcia Grostein, Regina Vater (Brazil), Catalina Parra, Francisca Sutil, and Cecilia Vicuña (Chile),Vita Giorgi.

A9. Catlin, Stanton Loomis and Terence Grieder. *Art of Latin America since Independence.* New Haven, CT: Yale University, 1966. Bibl.

Includes Raquel Forner, Sarah Grilo (Argentina), María Luisa Pacheco (Bolivia), Tarsila do Amaral, Lygia Clark, Anita Malfatti, Fayga Ostrower (Brazil), Roser Bru, Delia del Carril, Dinora Doudchitzky (Chile), Julia Codesido (Peru), Gego, Luisa Palacios, Mercedes Pardo (Venezuela).

A10. *Chilenas: Drinnen und draussen, 40 Künstlerinnen zum Thema Zensur und Exil.* Catalogue. [Berlin: Kunstamt Kreuzberg, 1983]. Biographies. Bibl. *Texts (in German) by Cecilia Boisier, Anna Maria Foxley, Brigitte Scharafi and Constanza Lira. Catalogue of exhibition held in Berlin of painting and sculpture by exiled Chilean artists.*

Agna Aguadé, Paulina Aguilar Hess, Teresa Araya, Gracia Barrios, Cecilia Boisier, Roser Bru, Ana María Carvajal, Ester Chacón-Avila, Soledad Chuaqui, Amaya Clunes, Irene Domínguez, Pilar Domínguez, Luz Donoso, Diamela Eltit, Paz Errázuriz, Virginia Errázuriz, Antonia Ferreiro, Corina García, Tatiana Gaviola Artigas, María Teresa Guerrero, Patricia Israel, Susana Lehman-Mertens, Ana María López, Ana María Lorenzen, Alma Martinoya, Gala Martinoya, Patricia Mora, Catalina Parra, Inés Paulino, Margarita Pellegrini, Teresa Reyes Lorca, Ana María Rojas, Lotty Rosenfeld, Vivian Scheihing, Clara Schneider, Marcela Serrano, Adriana Silva MacIver, Julia Toro, Cecilia Vicuña, Leonora Vicuña Navarro, Alicia Villareal

A11. *Cinco escultoras: Gálvez, Macagno, Mutal, Rosello, Weiss.* Catalogue. Lima, Peru: Galería, Banco Continental, 1975. Chronologies.

A12. *Colombia: Contemporary Images.* Queens, NY: Queens Museum of Art, 1992.

Includes Lydia Azout, María Fernanda Cardoso, Marta Combariza, Consuelo Gómez, María de la Paz Jaramillo, Olivia Miranda (1950-, Barranquilla), Ofelia Rodríguez, Patricia Salamanca (1969-, Bogotá), Marlene Troll (Cali), Bibiana Vélez.

A13. *Colombian Figurative, October 12-November 20, 1990.* San Francisco, CA: Moss Gallery, [1990].

Includes Margarita María Monsalve (1948-, Bogotá).

A14. *Compañeras de México = Women Photograph Women.* Catalogue. [Riverside, CA]: University Art Gallery, University of California, Riverside, 1990. Bibl. Essays, Amy Conger and Elena Poniatowska (in Spanish and English).

Lola Alvarez Bravo, Laura Cohen, Lourdes Grobet, Graciela Iturbide, Eugenia Vargas, Mariana Yampolsky

A15. *Contemporary Art from Chile = Arte contemporáneo desde Chile.* Catalogue. New York, NY: Americas Society, 1990. Bibl. Fatima Bercht, curator. Essays, Pablo Ayarzun R., M. Antonella Russo, Adriana Valdés, Justo Pastor Mellado (in English and Spanish). Chronologies.

Includes Virginia Errázuriz, Alicia Villareal (1957-).

A16. *Contemporary Art from Havana.* Catalogue. London: Riverside Studios (Oct 18-Nov 26, 1989); Aberyswith, Wales: Aberyswyth Arts Centre (Apr 14-May 26, 1990); Seville, Spain: Museo de Arte Contemporáneo (June-July, 1990). Bibl. Text, Gerardo Mosquera (in English and Spanish). Biographies.

Includes María Magdalena Campos-Pons, Consuelo Castañeda.

A17. *Cross-Cultural Currents in Contemporary Latin American Arts: An Artists-In-Residence Profile and Exhibition.* London: Latin American Arts Association, [1992]. Essay, Edward Lucie-Smith. Chronologies.

Includes Adelina Boyle (1953-, Argentina) and Fabiola Sequera (Venezuela).

A18. *Cuba-U.S.A.: The First Generation: Exhibition Tour 1991-1992.* Catalogue. Washington, D. C.: Fondo del Sol Visual Arts Center, 1991. Curator, Marc Zuver, essays Mirta Gómez, Coco Fusco.

Includes María Brito, Nereyda García-Ferraz, María Lino, Sylvia Lizama, María Martínez Cañas, Ana Mendieta, Raquel Mendieta, Margarita Paz-Partlow, Amelia Peláez, Lydia Rubio, Caridad Salomé.

A19. *Cuerpos pintados - cuarenta y cinco pintores chilenos.* Catalogue. Santiago, Chile: Cochrane, 1991. Photographer, Roberto Edwards.

Includes Tatiana Alamos, Carmen Aldunate, Concepción Balmes, Gracia Barrios, Roser Bru, Paulina Humeres, Patricia Israel, Patricia Ossa, María José Romero, Francisca Sutil, Lucía Waiser.

A20. Day, Holliday T. and Hollister Sturges. *Art of the Fantastic: Latin America, 1920-1987.* Indianapolis, IN: Indianapolis Museum of Art, 1987. Ed. Sue Taylor. Bibl. With contributions by Edward Lucie-Smith, Damián Bayón, and others.

Includes Tarsila do Amaral (Brazil), Beatríz González (Colombia), Frida Kahlo, Rocío Maldonado (Mexico), Tilsa Tsuchiya (Peru).

A21. *De Venezuela: treinta años de arte contemporáneo (1960-1990) = From Venezuela: Thirty Years of Contemporary Art.* [Caracas]: Galería de Arte Nacional, 1992.

Includes Marisol Escobar, Gego, Elsa Gramcko, Mercedes Pardo, Luisa Richter, Margot Romer, María Teresa Torras.

A22. *Desires and Disguises: Five Latin American Photographers.* Catalogue. Ed and trans. Amanda Hopkinson. London, England: New York: Serpent's Tail, 1992. Bibl. Essay, Elena Poniatowska.

Sara Facio (Argentina), Paz Errázuriz (Chile), María Cristina Orive (Guatemala), Graciela Iturbide (Mexico), Sandra Eleta (Panama).

A23. *Dibujo de mujeres contemporáneas mexicanas: diciembre-marzo, Museo de Arte Moderno, México, D.F., 1990-1991.* Catalogue. [México, D.F.]: Instituto Nacional de Bellas Artes, [1990]. Text, Raquel Tibol.

Laura Anderson, Pat Badani, María Bustamante, Susana Campos, Estrella Carmona, Gilda Castillo, Antonia Guerrero, Gabriela Gutiérrez, Carmina Hernández, Bertha Kolteniuk, Perla Krauze, Magali Lara, Rocío Maldonado, Ofelia Márquez Huitzil, Lucía Maya, Mónica Mayer, Graciela Mazón, Miriam Médrez, Flor Minor, Yolanda Mora, Martha Pacheco, Irma Palacios, Georgina Quintana, Carla Rippey, Herlinda Sánchez Laurel, Teresa Serrano, Carla Spota, Begonia Zorrilla

A24. *Diez pintores: colección Winter.* Catalogue. Santiago, Chile: Museo Abierto, 1990. Chronologies.

Includes Carmen Aldunate, Gracia Barrios, Roser Bru.

A25. *Dominican Painting: Masters and Novices.* [New York, NY: Queens College, 1989]. Eva Pataki, curator.

Includes María Aybar, Fina Castellanos, Carolina Cepeda, Maggie Ferrua, Myrna Guerrero, Marianela Jiménez Reyes, Clara Ledesma, Ilonka Morel, Soucy Pellerano, Nidia Serra, Luz Dionisia Severino Rijo, Rosa Tavarez, Martha Valenzuela.

A26. Ferrer, Elizabeth. *Shadow Born of Earth: New Photography in Mexico.* Catalogue. New York, NY: American Federation of Arts in association with Universe Publications, 1993. Bibl. In English and Spanish.

Includes Alicia Ahumada, Yolanda Andrade, Laura Cohen, Laura González, Lourdes Grobet, Eugenia Vargas.

A27. *Contemporary Artists of Mexico.* Chicago: Mexican Fine Arts Center Museum, 1989. Text in English and Spanish.

Includes Anita Checchi, Carmina Hernández, Magali Lara.

A28. Fuentes-Pérez, Ileana, Graciella Cruz-Taura and Ricardo Pau-Llosa, eds. *Outside Cuba=Fuera de Cuba: artistas cubanos contemporáneos.* Catalogue. [New Brunswick, N. J.]: Office of Hispanic Arts, Mason Gross School of the Arts, Rutgers

University; [Coral Gables]: Research Institute for Cuban Studies, Graduate School of International Studies, University of Miami, Florida, 1989. Bibl. Artists' statements.

Includes María Brito, Carmen Herrera, Silvia Lizama, Connie Lloveras, María Martínez-Cañas, Gina Pellón, Zilia Sánchez, Susana Sori.

A29. *Growing Beyond: Women Artists from Puerto Rico.* Catalogue. [Washington, D.C.: Museum of Modern Art of Latin America, 1988]. Susana Torruella Leval, guest curator. Chronologies.

Myrna Arocho, Myrna Báez, Clarissa Biaggi, Sylvia Blanco, Rebecca Castrillo, Lorraine de Castro, Susana Espinosa, Margarita Fernández Zavala, Yolanda Fundora, Rosita Haeussler, Toni Hambleton, Carmen Esther Hernández, Susana Herrero, Lizette Lugo, Liza Miranda Johnson, María de Mater O'Neill, María Antonia Ordóñez, Betsy Padín, Marta Pérez, Mercedes Quiñones, Nora Rodríguez Vallés, Noemí Ruíz, María Emilia Somoza, Miriam Zamparelli

A30. *Grupo Montparnasse y la renovación.* Catalogue. Santiago, Chile: Instituto Cultural del Banco del Estado de Chile, (1990-1991). Chronologies.

Includes Ana Cortés, Enriqueta Petit (1900-), Inés Puyo (1906-), Marta Villanueva.

A31. *Hijos de Guillermo Tell.* Catalogue. Bogotá: Biblioteca Luis Angel Arango, [1991].

Includes Consuelo Castañeda, Ana Albertina Delgado (1963-), Marta María Pérez Bravo.

A32. *Hunting in Time: Six Colombian Artists.* London: Gimpel Fils, 1991. Essay, Edward Lucie-Smith.

Includes Claudia Cuesta, Ofelia Rodríguez, Julieta Rubio, Cecilia Vargas.

A33. *Images of Silence: Photography from Latin America and the Caribbean in the '80s.* Washington, D.C.: Organization of American States, [1989]. Essay, Diana C. Du Pont. Catalogue of touring exhibition organized by the Organization of the American States Museum of Modern Art of Latin America commemorating 150th anniversary of the invention of photography (also shown at Bronx Museum of the Arts and Museo de Arte Contemporáneo, San Juan, Puerto Rico).

Includes Paz Errázuriz (Chile), Elsa Borrero, Gilma Suárez (Colombia), Victoria Cabezas Green (Costa Rica), Marcela García (Ecuador), María Teresa Díaz Colocho, Muriel Hasbun (El Salvador), Graciela Iturbide (Mexico), Rossana Lacayo (Nicaragua), Rosa Palazón (Paraguay), María Cecilia Piazza (Peru), Frieda Medín Ojeda (Puerto Rico), Daniella Chappard (Venezuela).

A34. *Images of Mexico: The Contribution of Mexico to 20th Century Art.* Catalogue. Dallas, TX: Dallas Museum of Art, 1987.

Includes Olga Costa, María Izquierdo, Frida Kahlo, Cordelia Urueta.

A35. *Introspectives; Contemporary Art by Americans and Brazilians of African Descent.* Los Angeles, CA: California Afro-American Museum, 1989. Bibl. Henry Drewal and David Driskell, curators.

Includes Maria Adair (1939-), Maria Lidia Magliani.

A36. *Latin American Artists of the Twentieth Century.* New York, NY: Museum of Modern Art, 1993. Ed. Waldo Rasmussen with Fatima Bercht and Elizabeth Ferrer. Bibl. Contains brief briographies.

Includes Diyi Laañ, Liliana Porter, Lidy Prati (Argentina), Tarsila do Amaral, Frida Baranek, Leda Catunda, Lygia Clark, Jac Leirner, Mira Schendel (Brazil), Ana Mendieta (Cuba), María Izquierdo, Frida Kahlo, Rocío Maldonado (Mexico), Marisol Escobar, Gego (Venezuela).

A37. *Latin American Drawings Today.* San Diego, CA: San Diego Museum of Art, 1991. Bibl. Mary Stofflet, curator. Essays, Shifra M. Goldman, Gloria Zea, Bélgica Rodríguez.

Includes Norma Bessouet, Alicia Carletti, Liliana Porter, Silvia Rivas (Argentina), Lena Bergstein, Maria do Carmo Secco, Carmela Gross, Regina Vater (Brazil), Patricia Israel (Chile), Beatríz González (Colombia), Isabel Ruíz (Guatemala), Helen Escobedo, Lucía Maya (Mexico), Haydée Landing (Puerto Rico), Elba Damast (Venezuela).

A38. *The Latin American Spirit: Art and Artists in the United States, 1920-1970.* New York, NY: H.N. Abrams in association with the Bronx Museum of the Arts, 1988. Bibl. Introduction, Luis R. Cancel, essays, Jacinto Quirarte, et al.

Includes Raquel Forner, Sarah Grilo, Marta Minujín, Alicia Peñalba, Liliana Porter (Argentina), María Luisa Pacheco (Bolivia), Lygia Clark, Djanira, Anna Bella Geiger, María Martins (Brazil), Fanny Sanín (Colombia), Carmen Herrera, Amelia Peláez (Cuba), Frida Kahlo (Mexico), Olga Albizu, Myrna Báez, Irene Delano (Puerto Rico), Gego, Marisol (Venezuela).

A39. *Latin American Women Artists, 1915-1995 = Artistas latinoamericanas.* Miwaukee, WI: Milwaukee Art Museum, 1995. Bibl. Geraldine P. Biller, guest curator. Essays, Bélgica Rodríguez, Edward J. Sullivan, Marina Pérez de Mendiola (in English and Spanish).

Raquel Forner, Sarah Grilo, Alicia Peñalba, Liliana Porter (Argentina), Marina Nuñez del Prado, María Luisa Pacheco (Bolivia), Tarsila do Amaral, Leda Catunda, Lygia Clark, Jac Leirner, Anita Malfatti, Tomie Ohtake, Mira Schendel, (Brazil), Catalina Parra, Soledad Salamé (Chile), Olga de Amaral, Beatríz González, Ana Mercedes Hoyos, Fanny Sanín, (Colombia), María Magdalena Campos-Pons, Ana Mendieta, Amelia Peláez (Cuba), Leonora Carrington, Elena Climent, Olga Costa, María Izquierdo, Frida Kahlo, Rocío Maldonado, Cordelia Urueta, Remedios Varo (Mexico), Tilsa Tsuchiya (Peru), Mari Mater O'Neill (Puerto Rico), Rosa Acle (Uruguay), Elba Damast, Gego, (Venezuela)

A40. *Made in Havana: Contemporary Art from Cuba. Sydney: Art Gallery of New South Wales (October 7 - November 13, 1988); Brisbane, Australia: Museum of*

Contemporary Art (January 15 - February 26, 1989); Melbourne: Australian Centre for Contemporary Art (March 24 - May 8, 1989). Catalogue. Sydney, Australia: AG NSW, 1988. Charles Merewether, guest curator. Bibl. Chronologies.

Includes María Magdalena Campos-Pons, Consuelo Castañeda Castellanos, Marta María Pérez Bravo.

A41. *Mexico, 1920-1992: Photographie = fotografie.* Brussels, Belgium: Foundation Europalia International; Tervuren: Exhibitions International (distrib.), 1992. Biographies. In French and Dutch with captions in Spanish.

Includes Alicia Ahumada, Lourdes Almeida, Lola Alvarez Bravo, Colette Alvarez Urbajtel, Yolanda Andrade, Laura Cohen, Oweena Fogarty, Flor Garduño, Maya Goded (1967-), Laura González, Lourdes Grobet, Kati Horna, Graciela Iturbide, Eugenia Vargas, Mariana Yampolsky, Vida Yovanaovich.

A42. *Mexico Out of the Profane.* Catalogue. Adelaide, Australia: Contemporary Art Centre of South Australia (March 1 - April 1, 1990); Perth Australia: Art Gallery of Western Australia (May 1 - June 24, 1990); Wellington: National Art Gallery (July 14 - August 19, 1990). Text, Charles Merewether. Chronologies.

Includes Mónica Castillo, Rocío Maldonado, Georgina Quintana.

A43. *Mexico: Splendors of Thirty Centuries.* Introd. Octavio Paz, trans. Edith Grossman, et al. New York: Metropolitan Museum of Art; Boston: Little, Brown, 1990.

Includes Leonora Carrington, María Izquierdo, Frida Kahlo.

A44. *La Mujer en Mexico = Women of Mexico: National Academy of Design, septiembre September 27 - diciembre December 2, 1990, Centro Cultural/Arte Contemporáneo, Invierno-Winter, 1991, Museo de Monterrey, Primavera - Spring, 1991.* Catalogue. México, D.F.: Centro Cultural/Arte Contemporáneo, 1990. Bibl. Essays, Edward J. Sullivan and Linda Nochlin, trans. Leticia Leduc.

Lola Alvarez Bravo, Laura Anderson, Lilia Carrillo, Leonora Carrington, Elena Climent, Laura Cohen, Olga Costa, Flor Garduño, Kati Horna, Lucero Isaac, Graciela Iturbide, María Izquierdo, Frida Kahlo, Magali Lara, Rocío Maldonado, Tina Modotti, Sylvia Ordóñez, Marie José Paz, Alice Rahon, Eugenia Rendón de Olazabal, Remedios Varo, Mariana Yampolsky

A45. *Mujeres artistas: protagonistas de los ochenta: 7 de marzo - 6 de abril 1990; Museo de Arte Contemporáneo de Puerto Rico, San Juan: 18 May - 9 July 1990.* Catalogue. Santo Domingo, Republica Dominicana: Museo de las Casas Reales, [1990]. Essay, Myrna E. Rodríguez Vega.

Myrna Arocho, Myrna Báez, Clarissa Biaggi, Sylvia Blanco, Carmen Inés Blondet, Analida Burgos, Ada Carmona, Rebecca Castrillo, Lorraine de Castro, Allison Daubercies, Susana Espinosa, Margarita Fernández, Gloria Florit, Yolanda Fundora, Consuelo Gotay, Toni Hambleton, Tonita Hambleton, Rosita Haeussler, Anaida Hernández, Susana Herrero Kundhart, Rosa Irigoyen, Haydeé Landing, Lizette Lugo, Betsy Padín, Marina Palmer de Clinchard, María Luisa Penne de Castillo, María Elena

Perales, Marta Pérez, Mercedes Quiñones, Sandra Reus, Nora Rodríguez, Noemí Ruíz, Zilia Sánchez, María Emilia Somoza, Miriam Zamparelli.

A46. *Mujeres por el arte*. Catalogue. [Guatemala City, Guatemala: Museo Nacional de Arte Moderno, 1989]. Text, Antonio Gallo. Includes brief biographies and personal statements.

Julia Ayau de López, Margarita Azurdia, Michelle Behar, Eugenia Betronena, María Eugenia Braun Valle de Rudeke, Rebeca Calderón, Lucrecia Cofiño, Rita David, Marion M. de De Suremain, Diana Fernández, Concha Fortuny de Ibargüen, Sofía González Pérez, Sylvia Hastedt de Haese, Griselda Hernández de Monroy, Ingrid Klussmann, María Elena de Lamport, Rina Lazo, Irma Lorenzana de Luján, Marion Marsicovétere de Mirón, Antonia Matos de Masset, Luz Marina Menéndez, Blanca Eugenia Abril de Meschede, Rebeca Mombilla de Mirón, Eugenia Nájera Carazo, Blanca Niño Norton, Blanca Estela Norton, Suzana de Novella, Amalia Padilla de Gregg, Elsie Padilla de Wunderlich, Rosa María Pascual de Gómez, Carmen de Petersen, Ana María de Rademann, Beverly Rowley, Marina Ruíz de Valdéz, Margarita Sagastume Morales, Magda Eunice Sánchez, Mónica Serra, Ana Sobral-Segovia, Aracely Valladares de Willemsen, Nené Valls, Teresa Zarco de Castillo

A47. *Naturalezas*. Catalogue. México, D.F.: Universidad Autónoma Metropolitana, 1993.

Gilda Castillo, Ilse Gradwohl, Magali Lara, Irma Palacios

A48. *The Nearest Edge of the World: Art and Cuba Now*. Catalogue. Brookline, MA: Polarities, Inc., 1990. Bibl. Rachel Weiss and Gerardo Mosquera, curators.

Includes Ana Albertina Delgado (1963-), Marta María Pérez Bravo.

A49. *The New Generations*. Catalogue. San Antonio, TX: San Antonio Museum of Art, 1985. Bibl. Ed. Nancy L.Kelker. Bibl. Chronologies.

Includes Lilia Carrillo, Sylvia Ordónez, Susana Sierra.

A50. *Nuestro autorretrato: la mujer artista y la autoimagen en un contexto multicultural, exposición y ciclo de conferencias*. San Juan, Puerto Rico: Mujeres Artistas de Puerto Rico, Inc., 1993. Introduction, María Mater O'Neill.

Biographies are included for Clarissa Biaggi, Sylvia Blanco, Carmen Inés Blondet, Lorraine de Castro, Anaida Hernández, Rosa Irigoyen, Haydeé Landing, María de Mater O'Neill, Betsy Padín, María Elena Perales, Mercedes Quiñones and Noemí Ruíz.

A51. *Nuevos momentos del arte mexicano = New Moments in Mexican Art*. Catalogue. Mexico, New York : Turner Parallel Project, 1990. Bibl. Text in Spanish and English.

Essays by Edward J. Sullivan (Rocío Maldonado, 57-60), Elena Poniatowska (Dulce María Núñez, 117-119), Patricia García Cavazos (Sylvia Ordóñez, 123), Gilda Mekler (Joy Laville, 159) and Anne H. Hoy (Eugenia de Olazábal, 173-174).

A52. *Old World New World, Three Hispanic Photographers: Paz Errázuriz, Graciela Iturbide, and Cristina García Rodero.* Catalogue. Seattle, WA: Seattle Art Museum, 1991. Essay, Deborah Caplow.

A53. *Os ritmos e as formas: arte brasileira contemporanea.* São Paulo: Centro de Lazer SESC, [1988]. Brief biographies.

Includes Maria Bonomi, Renina Katz, Tomie Ohtake.

A54. *Otros juegos, otras miradas.* Bogotá, Colombia: Banco de la República, 1992. Essay, Carolina Ponce de León. Chronologies.

Includes María Fernanda Cardoso, Olga Lucía García, Consuelo Gómez, María Teresa Hincapié, María Margarita Jiménez, Luz Angela Lizarazo, Olga Low, Inés Wickmann.

A55. *Paper Visions.* New York, NY: Arch Gallery, 1988. Essay, Susana Torruella Leval.

Includes Norma Bessouet, Emma Piñeiro, Liliana Porter (Argentina), Catalina Parra (Chile).

A56. *Photographie contemporaine en Amerique Latine: 29 septembre - 21 novembre 1982. Centre Georges Pompidou, Musée national d'art moderne.* [Paris]: Le Musée, [1982]. Brief biographies and chronologies. Essay, Alain Sayag.

Includes Sara Facio, Annemarie Heinrich (Argentina), Claudia Andujar, Renata Falzoni, Rosa Jandira Gauditano, Ana Regina Nogueira, Mazda Pérez, Adriana de Queiros Mattoso (Brazil), María Eugenia Haya, [Marucha] (Cuba), María Alvarez, Yolanda Andrade, Victoria Blasco, Graciela Iturbide, María Inez Pérez Redondo, Mariana Yampolsky (Mexico), Sandra Eleta (Panama), Lydia Fisher (Venezuela)

A57. *Pintura mexicana = Mexican Painting: 1950-1980.* [Mexico]: IBM, 1990. Texts, Teresa del Conde, Victor Flores Olea, Fernando Gamboa and others.

Includes Lilia Carrillo, Leonora Carrington, Olga Costa, Joy Laville, Agueda Lozano, Alice Rahon, Susana Sierra, Cordelia Urueta, Remedios Varo.

A58. *Pintura y escultura abstracta contemporánea.* Catalogue. Monterrey, México: Galería Ramis F. Barquet, 1992. Chronologies.

Includes Ilse Gradwohl, Irma Palacios.

A59. Pitts, Terence. *Contemporary Photography in Mexico: 9 Photographers, An Exhibition.* Catalogue. Tucson, AZ: Center for Creative Photography, 1978. Bibl.

Includes Colette Alvarez Urbajtel and Graciela Iturbide.

A60. *Presencia femenina latinoamericana 1986: Galería Epoca, 3 de junio al 5 de julio de 1986.* Santiago, Chile: Galería Epoca, 1986.

Includes Delia Cugat, Marta Minujín, Liliana Porter, Josefina Robirosa, (Argentina), Inés Cordova, Beatríz Mendieta (Bolivia), Lena Bergstein (1946-Brazil), Carmen Aldunate, Roser Bru (Chile), Cristina Cortés, Maripaz Jaramillo, Mónica Meira, (Colombia), Ana Checchi, Olga Donde, (Mexico), Claudia Lacayo (Nicaragua), Alicia Viteri (Colombia/Panama), Elda Di Malio, Martha Vertíz, (Peru), Myrna Báez (Puerto Rico), Gladys Afamado, Elena Molinari (Uruguay).

A61. *Puerto Rican Painting: Between Past and Present: Museum of Modern Art of Latin America, Organization of American States, Washington, D.C., September 1-25, 1987.* (Princeton, NJ: Squibb Corp., 1987). Mari Carmen Ramírez, curator.

Includes Myrna Báez, Mari Mater O'Neill, Noemí Ruiz.

A62. *Recovering Histories: Aspects of Contemporary Art in Chile since 1982 – Historias recuperadas: aspectos del arte contemporáneo en Chile desde 1982.* Catalogue. New Brunswick, NJ: Center for Latino Arts and Culture/Centro Latino de Arte y Cultura, Rutgers University, 1993. Bibl. Julia P. Herzberg, curator. Essays, Sol Serrano, Julia P. Herzberg, Gaspar Galaz and Nelly Richard (in English and Spanish). Bibl. Biographies and chronologies.

Includes Roser Bru, Paz Errázuriz, Nancy Gewölb, Lotty Rosenfeld.

A63. *Reflections on the nuevo mundo: Artists Cristina Emmanuel, Alvaro García and Lydia Rubio.* Catalogue. New Brunswick, N.J.: Center for Latino Arts and Culture at Rutgers University, [1992]. Bibl.

A64. *Regards de femmes: 15 octobre-1er decembre 1993, Liege, Museé d'art Moderne.* Catalogue. Belgium: Foundation Europalia International, 1993. Bibl.

Lola Alvarez Bravo, Laura Anderson, Lilia Carrillo, Leonora Carrington, Elena Climent, Laura Cohen, Olga Costa, Flor Garduño, Kati Horna, Lucero Isaac, Graciela Iturbide, María Izquierdo, Frida Kahlo, Magali Lara, Rocío Maldonado, Tina Modotti, Sylvia Ordóñez, Marie José Paz, Alice Rahon, Eugenia Rendón de Olazabal, Remedios Varo, Mariana Yampolsky

A65. *Rooted Visions: Mexican Art Today.* Catalogue. [New York, NY: Museum of Contemporary Hispanic Art, 1988]. Bibl. Ed. Carla Stellweg. Essays, Teresa del Conde, Fernando Gamboa and Carla Stellweg (in English and Spanish). Includes chronologies.

Includes Mónica Castillo, Rocío Maldonado, Dulce María Núñez.

A66. *Sculpture in Clay from Puerto Rico = Escultura en barro de Puerto Rico.* Springfield, MA: Museum of Fine Arts, 1980. Essays by Ricardo Alegría and Marimar Benítez (in English and Spanish). Chronologies.

Sylvia Blanco, Cordelia Buitrago, Rosa M. de Castro, Lorraine Enid, Susana Espinosa, Toni Hambleton, Gilda Navarra, Beba Pazmiño, Ana Delia Rivera, Maribel Suárez.

A67. *Sculpture of the Americas into the Nineties.* Washington, D. C.: Museum of Modern Art of Latin America, 1990.

Includes Marta Minujín, Liliana Porter (Argentina), Gail Streat (1959-, Barbados), Marina Núñez del Prado (Bolivia), Carmen Barros Howell, Soledad Salamé (Chile), Beatríz Echeverri (1938-, Colombia), Gladys Triana (Cuba), Negra Alvarez, Patricia Salaverría (El Savador), Joyce Vourvoulias (Guatemala, b. Mexico, 1938), Helen Escobedo, Marta Palau (Mexico), Susana Arias (Panama), Lika Mutal (Peru), María Eugenia Bigott, Beatríz Blanco, Elba Damast (Venezuela).

A68. *Sentido X Sentido = Cinco: Adriana Mangual, Marta Palau, Liliana Porter, Ana Tiscornia, Cecilia Vicuña: febrero 25 - marzo 30, 1991.* San Juan, Puerto Rico: Luigi Marrozzini Gallery, 1991. Includes chronologies.

A69. *Signs of Transition: '80s Art from Cuba : A Project of the Center for Cuban Studies, 1988: opening exhibition, Museum of Contemporary Hispanic Art, New York, Jan 21-Feb 28, 1988.* Catalogue. New York, NY: Center for Cuban Studies, 1988. Coco Fusco, curator.

Includes Consuelo Castañeda, Zaida Del Rio, Marta María Pérez Bravo.

A70. *South American Art Today.* Catalogue. Dallas, TX: Dallas Museum of Fine Arts, 1959. Biographies and chronologies.

Includes Raquel Forner, Sarah Grilo (Argentina), María Luisa Pacheco (Bolivia), Elisa Martins da Silveira, Thereza Nicolao (Brazil), Carmen Silva (Chile), Elsa Gramcko, Mercedes Pardo (Venezuela).

A71. Sturges, Hollister. *New Art from Puerto Rico = Nuevo arte de Puerto Rico.* Catalogue. Springfield, MA: Museum of Fine Arts, 1990. Bibl. Catalogue entries by Susana Torruella Leval, essay by Efraín Barradas (in English and Spanish).

Includes Myrna Báez, Mari Mater O'Neill.

A72. *El Taller Torres-García: The School of the South and Its Legacy.* Austin, TX: Published for the Archer M. Huntington Art Gallery, College of Fine Arts, University of Texas at Austin by the University of Texas Press, 1992. Ed. Mari Carmen Ramírez. Cecilia Buzio de Torres and Mari Carmen Ramírez, curators. Bibl.

Includes Rosa Acle (Uruguay, b. Brazil 1916-1990), Elsa Andrada, Elizabeth Aro, Amalia Nieto.

A73. *Through the Path of Echoes: Contemporary Art in Mexico = Por el camino de ecos: arte contemporáneo.* Catalogue. New York, NY: Independent Curators, 1990. Bibl. Elizabeth Ferrer, guest curator. Essays, Elizabeth Ferrer and Alberto Ruy-Sánchez (in English and Spanish).

Includes Flor Garduño, Estela Hussong, Rocío Maldonado, Georgina Quintana, Eugenia Vargas.

A74. *Victoria Compañ, Ilse Gradwohl, Irma Palacios: tres voces, tres ámbitos.* Catalogue. [México, D.F.: Museo de Arte Moderno, 1986]. Text, Juan García Ponce. Chronologies.

A75. *Visiones y figuraciones: 10 artistas venezolanos.* Catalogue. Santo Domingo, República Dominicana: Museo de Arte Moderno, noviembre 1993 a enero 1994. Text, Bélgica Rodríguez. Biographies and chronologies.

Includes Elba Damast and Margot Romer.

A76. *Women in Mexican Art.* Catalogue. Los Angeles, CA: Iturralde Gallery, 1991. Essay by Shifra M. Goldman. Includes biographies.

Lilia Carrillo, Olga Costa, María Izquierdo, Frida Kahlo, Perla Krauze, Magali Lara, Joy Laville, Lucía Maya, Irma Palacios, Herlinda Sánchez Laurel, and Cordelia Urueta

A77. *Women of the Americas: Emerging Perspectives.* New York, NY: Center for Inter-American Relations, 1982.

Norma Bessouet, Marta Minujín, Liliana Porter (Argentina), Lygia Clark, Marcia Grostein, Tomie Ohtake, Lydia Okumura, Mira Schendel, Niobi Xando (Brazil), Catalina Parra, Cecilia Vicuña (Chile), Alicia Barney, Beatríz González, Ana Mercedes Hoyos, Becky Mayer, Sara Modiano, Fanny Sanín (Colombia), Ana Mendieta (Cuba)

Appendix II:
Artists by Country

Artists whose names appear in italics are listed in the Individual Artists section.

Argentina

Aguirre, Susana
Alston de Gallegos, Luna
Aro, Elizabeth
Bai de Deluca, Andreina
Bertolé, Emilia
Bessouet, Norma
Borges, Norah
Boyle, Adelina
Burton, Mildred
Carletti, Alicia
Carril, Delia del. *See* Chile
Cid, Elena
Cifone, Dora
Contreras, Alicia
Corazzin Guevara, Fanny
Coria, Clara
Correa Morales, Elina de
Correa Morales, Lía
Correas, Nora
Creus, Alicia
Cugat, Delia
D'Amico, Alicia
De Pietro de Torras, Aurora
Di Primio, Clementina
Escudero, María
Facio, Sara
Fasce, Hilda
Forner, Raquel
Girón, Mónica
Gismondi, Lía
Grilo, Sarah
Heinrich, Annemarie
Helguera, María
Isella, Luisa Isabel
Klapenbach, Biyina
Kohen, Natalia
Kozel, Ana
Krenovich, Eugenia
Laañ, Diyi
Lago, Susana
Madrid, Graciela
Malagrino, Silva

Marín, Matilde
Martínez, Cristina
Martorell, María
Minujín, Marta
Mora, Lola
Mórtola de Bianchi, Catalina
Mulhall Girondo, Laura
Ocampo, Silvia
Orensanz, Marie
Paviglianiti, Noemia
Payró, Anita
Peñalba, Alicia
Petrolini, Carlota
Peyrou, Julia
Pich, Ana
Piñeiro, Emma
Porter, Liliana
Posadas, Sofía
Prati, Lidy
Presser, Elena
Rabinovich, Raquel
Raffo, Susana
Rivas, Silvia
Rizzi, María Teresa. See also
 Colombia
Robirosa, Josefina
Rodrigué, María Mercedes
Romero, Susana. *See* Paraguay
Rosenberg, Sara
Rybak, Taty
Sábato, Elsa
San Martín, María Laura
Sánchez de Arteaga, Luisa
Sarmiento, Eugenia
Simón, María
Soibelman, Elsa
Solanas, Julia
Soto y Calvo, María de
Stilman, Flora
Vezzetti, Angela A.
Volco, Teresa
Zeller, Ester

Barbados
Streat, Gail

Bolivia
Baptista, Carmen
Córdova, Inés
Mendieta, Beatríz
Nuñez del Prado, Marina
Pacheco, Maria Luisa
Rodo Boulanger, Graciela

Brazil
Adair, Maria
Aita , Zina
Albuquerque, Georgina de
Amaral, Tarsila do
Andujar, Claudia
Araujo, Solange
Arditi, Iracema
Baranek, Frida
Barcelos, Vera C.
Barki, Monica
Barreto, Lia Menna
Barros, Mercedes
Beduschi, Suely
Behring, Edith
Bergstein, Lena
Bonomi, Maria
Caram, Marina
Carmo Secco, Maria do
Carvalho, Josely
Castro, Sonia
Catunda, Leda
Clark, Lygia
Correa de Oliveira, Yedamaria
Costa Pinto, Valéria
Couto, Ivone
Darius, Nini
Darius, Rosi
Duarte, Clementina
Falzoni, Renata
Ferraz, Albertina
Freitas, Iole de
Geiger, Anna Bella
Gomide, Regina
Gorini Rodrigues, Berenice
Grinspum, Ester
Gross, Carmela
Gross, Freya
Grostein, Marcia
Heli, Eli
Hering Bell, Elke
Hori, Marlene

Janacópulos, Adriana
Jandira Gauditano, Rosa
Katz, Renina
Leirner, Jac
Leontina, Maria
Lindroth, Astrid
Linnemann, Ana
Lopes Santiago, Haydéa
Lorita Leite, Neusa
Magliani, Maria Lidia
Malfatti, Anita
Martins, Maria
Martins da Silveira, Elisa
Mayr, Ondina
Medeiros, Miriam
Meyer, Sylvia
Milhazes, Beatríz
Miranda, Thereza
Moraes, Nina
Mota e Silva, Djanira da
Nicolao, Theresa
Nogueira, Ana Regina
Ohtake, Tomie
Okumura, Lydia
Olivera, Dina
Ostrower, Fayga
Pape, Lygia
Pereira Frange, Lucimar Bello
Pfau, Edia
Poerner, Maria Edith
Pons, Isabel
Quadros, Anna Letycia
Queiros Mattoso, Adriana de
Reis, Graziela
Rennó, Rosângela
Rodrigues, Marilia
Sabino, Vera
Saldanha, Ione
Santos, MarieJudite dos
Schendel, Mira
Sil, Selma
Silveira, Regina
Tavares, Ana Maria
Toledo, Amélia
Torbes, Denize
Tucci, Sandra
Vater, Regina
Veiga, Regina
Vilela de Figueiredo, Sarah
Vinci, Laura
Xando, Niobi

Chile
Aguadé, Agna
Aguilar-Hess, Paulina
Alamos, Tatiana
Aldunate, Carmen
Aranguiz, Ruby
Armas, Ximena
Araya, Teresa
Arroyo, Mónica
Balmes, Concepción
Barraza, Veronica
Barros Howell, Carmen
Barrios, Gracia
Boisier, Cecilia
Bru, Roser
Bunster, Mónica
Bush, M. Eugenia
Carril, Delia del
Carvajal, Ana María
Chacón, Ester
Chuaqui, Soledad
Clunes, Amaya
Colvin, Marta
Cortés, Ana
Domínguez, Irene
Domínguez, Pilar
Donoso, Luz
Doudchitzky, Dinora
Edwards, Alexandra
Edwards, Carolina
Eltit, Diamela
Errázuriz, Paz
Errázuriz, Virginia
Ferreiro, Antonia
Figueroa L., Patricia
García, Corina
Garafulic, Lily
Gaviola Artigas, Tatiana
Gewölb, Nancy
Guerrero, María Teresa
Guilisasti, Josefina
Hernández, Gilda
Humeres, Paulina
Hurreeus, Virginia
Israel, Patricia
Izquierdo, Alejandra
Keliner, Lea
Lehman-Mertens, Susana
Leyton, Beatríz
López, Ana María
Lorenzen, Ana María
Martinoya, Alma
Martinoya, Gala

Matte, Rebeca
Montiel, Teresa
Mora, Patricia
Morales, Carmengloria
Ossa, Patricia
Parra, Catalina
Parra, Violeta
Paulino, Inés
Pellegrini, Margarita
Pequeño, Valeria
Petit, Enriqueta
Puyo, Inés
Rementería, Chantal de
Reyes Lorca, Teresa
Rojas, Ana María
Romero, María José
Rosenfeld, Lotty
Salamé, Soledad
Santa Cruz, Josefina
Scheihing, Vivian
Schneider, Clara
Serrano, Marcela
Silva, Adriana
Silva, Carmen
Sutil, Francisca
Toro, Julia
Torres, María Luz
Varela, Mariana
Vargas, Patricia
Venturini, Ani
Vernal, Cecilia
Vicuña, Cecilia
Vicuña, Teresa
Vicuña Navarro, Leonora
Villanueva, Marta
Villareal, Alicia
Waiser, Lucía

Colombia
Aguirre, Constanza
Allina, Trixi
Amaral, Olga de
Arango, Débora
Azout, Lydia
Bajder, Perla
Barney, Alicia
Bernal, María Elena
Bonilla, Patricia
Borrero, Elsa
Boshell, Tutua,
Bursztyn, Feliza
Cardenas, Catalina
Cardoso, María Fernanda

Celis, Tina
Combariza, Martha
Cortés, Cristina
Cuesta, Claudia
Daza, Beatríz
Delgado, Cecilia
Duncan, Gloria de
Durán, Liliana
Echeverri, Beatríz
Fernández, Lola. *See* Costa Rica
Friedemann, Nancy
García, Olga Lucía
García McLean, Clara
Garzón, Amparo
Gilmour, Ethel
Gómez, Consuelo
Gómez, María Clara
González, Beatríz
González, Patricia
Haim, Linda
Hernández, Claudia
Hincapié, María Teresa
Holguín y Caro, Margarita
Hoyos, Ana Mercedes
Jaramillo, María de la Paz
Jiménez, María Margarita
Lizarazo, Luz Angela
Llano, Cristina
Low, Olga
Lozano, Margarita
Mayer, Becky
Meira, Mónica
Mejía, Catalina
Merino, Gloria
Miranda, Olivia
Modiano, Sara
Monsalve, Margarita María
Morán, María
Ordóñez, Cecilia
Ortíz, Gloria
Pinzón, Betty
Reyes, Emma
Rizzi, María Teresa. *See also*
 Argentina
Rodríguez, Marta
Rodríguez, Ofelia
Rubio, Julieta
Rueda, Ana María
Salamanca, Patricia
Salcedo, Doris
Sanín, Fanny
Sepúlveda, Regina
Suárez, Gilma

Tavera, Patricia
Tejada, Lucy
Torres, Alicia
Troll, Marlene
Uribe, Gloria
Varela, Mariana
Vargas, Cecilia
Vélez, Bibiana
Vieco, María Teresa
Viteri, Alicia
Wickmann, Inés

Costa Rica
Avila, Marjorie
Bertheau, Margarita
Borrase, Carmen
Cabezas Green, Victoria
Fernandez, Lola
Martén, Ana Isabel
Matamoros, Rossella
Rojas, Gioconda
Santonastasio, Magda

Cuba
Arjona, Marta
Badías, María Elena
Brito-Avellana, María
Campos-Pons, María Magdalena
Castañeda, Consuelo
Cerra, Mirta
Delgado, Ana Albertina
Del Río, Zaida
Del Sol, Dania
Eiriz, Antonia
Fernández Morrell, Luisa
Fong, Flora
Franko, Nancy
Galleti, Lia
García, Rocío
García-Ferraz, Nereyda
Gómez de Molina, Clara
González, Julia
González, María Elena
Gronlier, Hortensia
Guitérrez, Ana Rosa
Haya, María Eugenia
Herrera, Carmen
Kessel, Juana
Lazo, Lilia
Lino, María
Lizama, Silvia
Longa, Rita
Lloveras, Connie

Luna, Laura
Maggi, Jacqueline
Martínez-Cañas, María
Mendieta, Ana
Mendieta, Raquel
Nanson, Victoria
Morera, Clara
Paz-Partlow, Margarita
Peláez, Amelia
Perera Clavería, Noemí
Pellón, Gina
Pérez Bravo, Marta María
Quesada Collins, Hilda de
Ramos, Sandra
Rodríguez, Demi
Rodríguez, Marta
Rubio, Lydia
Salomé, Caridad
Sánchez, Zilia
Soldevilla, Dolores
Solis, Uver
Sori, Susana
Triana, Gladys
Trujillo, Carmen
Valdés, Julia
Vent Dumois, Lesbia
Vent Dumois, Odenia

Dominican Republic
Aybar, María
Azcárete, Graciela
Castellanos, Fina
Cepeda, Carolina
Ferrua, Maggie
Guerrero, Myrna
Jiménez Reyes, Marianela
Ledesma, Clara
Morel, Ilonka
Núñez, Elsa
Pellerano, Soucy de
Serra, Nidia
Severino Rijo, Luz Dionisia
Tavarez, Rosa
Tolentino, Inés
Valenzuela, Martha

Ecuador
García, Marcela

El Salvador

Alvarez, Negra
Díaz Colocho, María Teresa

Galindo, Martivón
Hasbun, Muriel
Mena Valenzuela, Rosa
Salaverría, Patricia

Guatemala
Ayau de López, Julia
Azurdia, Margaria
Behar, Michelle
Betronena, Eugenia
Braun Valle de Rudeke, María
 Eugenia
Calderón, Rebeca
Cofiño, Lucrecia
David, Rita
De Suremain, Marion de
Fernández, Diana
González Pérez, Sofía
Fortuny de Ibargüen, Concha
Hastedt de Haese, Sylvia
Hernández de Monroy, Griselda
Klussmann, Ingrid de
Lamport, María Elena
Lazo, Rina
Lorenzana de Luján, Irma
Marsicovétere de Mirón, Marion
Matos de Masset, Antonia
Menéndez, Luz Marina
Meschede, Blanca Eugenia Abril de
Mombilla de Mirón, Rebeca
Nájera Carazo, Eugenia
Niño Norton, Blanca
Norton, Blanca Estela
Novella, Suzana de
Orive, María Cristina
Padilla de Gregg, Amalia
Padilla de Wunderlich, Elsie
Pascual de Gómez, Rosa María
Petersen, Carmen de
Rademann, Ana María de
Rowley, Beverly
Ruíz, Isabel
Ruíz de Valdéz, Marina
Sagastume Morales, Margarita
Sánchez, Magda
Serra, Mónica
Sobral-Segovia, Ana
Valladares de Willemsen, Aracely
Valls, Nené
Vourvoulias, Joyce
Zarco de Castillo, Teresa

López, Julia
Lozano, Agueda
Lozano, Armandina
Macedo, Gloria Magdalena
Maldonado, Rocío
Marcos, Eugenia
Márquez-Huitzil, Ofelia
Martens, Carmen
Martínez, Esperanza
Maya, Lucía
Mayer, Mónica
Medrez, Miriam
Mercenario Pomeroy, Liliana
Metthez, Renatta
Miller, Carol
Minor, Flor
Modotti, Tina
Mora, Yolanda
Morales, Rowena
Morán, Teresa
Müller, Jeanette
Nuñez, Dulce María
Ocharán, Leticia
Olín, Nahui
Ordóñez, Sylvia
Ortega, Dolores
Ortíz, Emilia
Pacheco, Martha
Padín, Carmen
Palacios, Irma
Palau, Marta
Paniagua, Carolina
Parra, Carmen
Paz, Marie José
Peláez, Guadalupe
Pérez Redondo, María Inez
Polin, Marisa
Prado, Nadine
Quesada, Josefina
Quintana, Georgina
Rabel, Fanny
Rahon, Alice
Ramírez, Noemí
Rendón de Olazábal, Eugenia
Revueltas, Consuelo
Rippey, Carla
Riviello, Coco
Romero, Betsabée
Romero, Josefina
Sada, María
Sánchez-Laurel, Herlinda
Sánchez, Olivia
Sauret, Nunik

Serrano, Teresa
Siegmann, Naomi
Sierra, Susana
Spota, Carla
Tamborell-Guerrero, Gisela
Tanguma, Marta
Torres, Patricia
Urrusti, Lucinda
Urueta, Cordelia
Vargas-Daniels, Eugenia
Varo, Remedios
Viesca, Amalia
Vergara, Esperanza
Vourvoulais, Joyce. *See* Guatemala
Yampolsky, Mariana
Yovanovich, Vida
Zamora, Beatríz
Zarak, Marta
Zimbrón, Teresa
Zorilla, Begoña

Nicaragua
Aguirre, Julia
Gallo, María
Guevara, Gloria
Guevara, Marita
Lacayo, Claudia
Lacayo, Rossana
Ortíz de Manzanares, Ilse
Rojas, Cecilia
Vogl, Hilda

Panama
Arias, Susana
Calderón, Coqui
Eleta, Sandra
Icaza, Teresa
Lichacz, Sheila E.
Obaldía, Isabel de

Paraguay
Morselli, Margarita
Palazón, Rosa
Romero, Susana

Peru
Amorós, Grimanesa
Codesido, Julia
Gálvez, Cristina
Hamann, Johanna
Loli, Nelly
Macagno, Ana
Malio, Elda Di

Mutal, Lika
Noriega, Charo
Ortíz Osorio, Jeanette
Piazza, María Cecilia
Prager, Sonia
Rosello, Susana
Tsuchiya, Tilsa
Velarde, Kukuli
Vertíz, Martha
Weiss, Amelia

Puerto Rico
Albizu, Olga
Arocho, Myrna
Báez, Myrna
Berbal, Isabel
Biaggi, Clarissa
Blanco, Sylvia
Blondet, Carmen Inés
Buitrago, Cordelia
Burgos, Analida
Carmona, Ada
Castrillo, Rebecca
Castro, Lorraine de
Castro, Rosa M. de
Coll, Edna
Daubercies, Allison
Delano, Irene
Enid, Lorraine
Emmanuel, Cristina
Espinosa, Susana
Fernández-Zavala, Margarita
Fundora, Yolanda
Geigel, Pilar
Gutiérrez, Marina
Haeussler, Rosita
Hambleton, Toni
Hernández, Carmen Esther
Herrero, Susanna
Irigoyen, Rosa
Landing, Haydée
León, Anna de
Lugo, Lizette
Mangual, Adriana
Medín Ojeda, Frieda
Miranda-Johnson, Lisa
Navarra, Gilda
Noa, Cleto
O'Neill, Mari Mater
Ordóñez, Maria Antonia
Padín, Betsy
Palmer de Clinchard, Marina
Pazmiño, Beba

Penne-de-Castillo, María Luisa
Perales, María Elena
Peralta, Consuelo
Pérez, Marta
Quiñones, Mercedes
Reus, Sandra
Rivera, Ana Delia
Rodríguez, Nora
Rubin, Bernadina
Ruíz, Noemí
Señeriz, Milagros
Somoza, María Emilia
Suárez, Bibiana
Suárez, Maribel
Zamparelli, Miriam

Uruguay
Acle, Rosa
Afamado, Gladys
Andrada, Elsa
Anselmi, Claudia
Buzio, Lidya
Dicancro, Agueda
Duarte, Lucy
González, Mercedes
Kohen, Linda
Mines, Diana
Molinari, Elena
Nieto, Amalia
Romero, Nelbia
Tiscornia, Ana
Urrutia, Nancy

Venezuela
Abbo, Doris
Amundaraín, Susana
Arraíz, Leonor
Bigott, María Eugenia
Blanco, Beatríz
Casanova, Teresa
Chappard, Daniella
Chappelin-Wilson, Helena
Damast, Elba
Escobar, Marisol
Escobar, Mercedes
Fisher, Lydia
Gamundi, María
Gego
González, María Luisa
Gramcko, Elsa
Méndez, Consuelo
Palacios, Luisa
Pardo, Mercedes

Pereda, Ana María
Picos-Clark, Linda E.
Richter, Luisa
Romer, Margot

Sequera, Fabiola
Torras, María Teresa
Valdirio-Pozzo, Evelyn

Name Index

Artists who are listed in the Individual Artists section appear in this index with a country code in italics immediately following their name. To locate the entries look under the person's name in the country section according to the following key:

Ar = Argentina; *Bo* = Bolivia; *Br* = Brazil; *Ch* = Chile; *Co* = Colombia; *CR* = Costa Rica; *Cu* = Cuba; *DR* = Dominican Republic; *ES* = El Salvador; *G* = Guatemala; *Ha* = Haiti; *Ho* = Honduras; *J* = Jamaica; *M* = Mexico; *N* = Nicaragua; *Pa* = Panama; *Par* = Paraguay; *Pe* = Peru; *PR* = Puerto Rico; *U* = Uruguay; *V* = Venezuela

Entry numbers preceded by an A refer to references in Appendix I, Collective Exhibitions. Collective exhibition entry numbers for artists, as opposed to curators, essayists, etc., appear in boldface.

About the Author

CECILIA PUERTO is Latin American/Mexican American Studies Bibliographer at the San Diego State University Library.

ISBN 0-313-28934-4

HARDCOVER BAR CODE